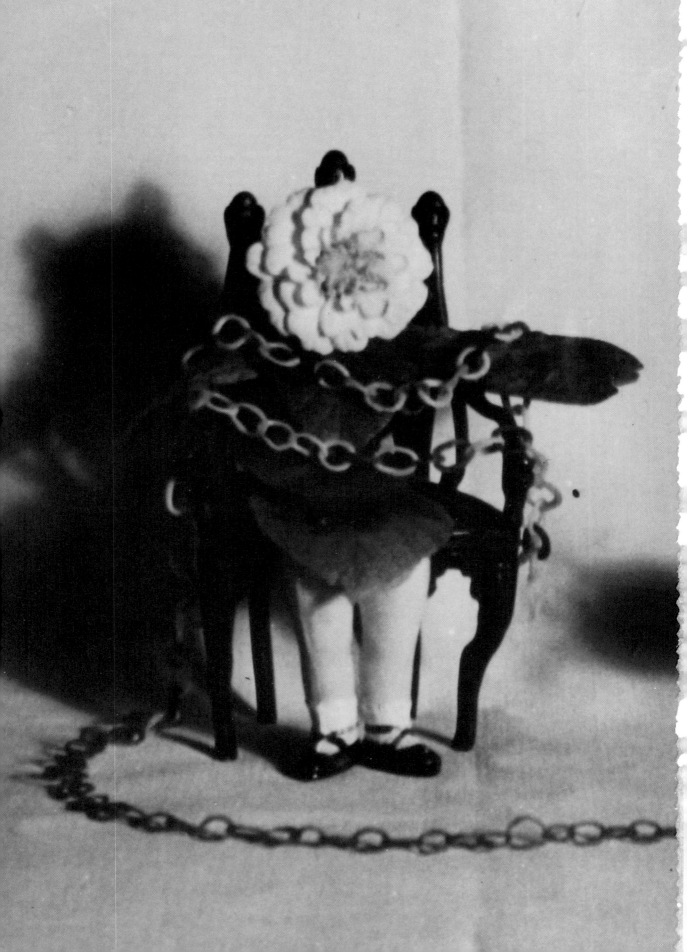

THE COLOUR
OF MY DREAMS

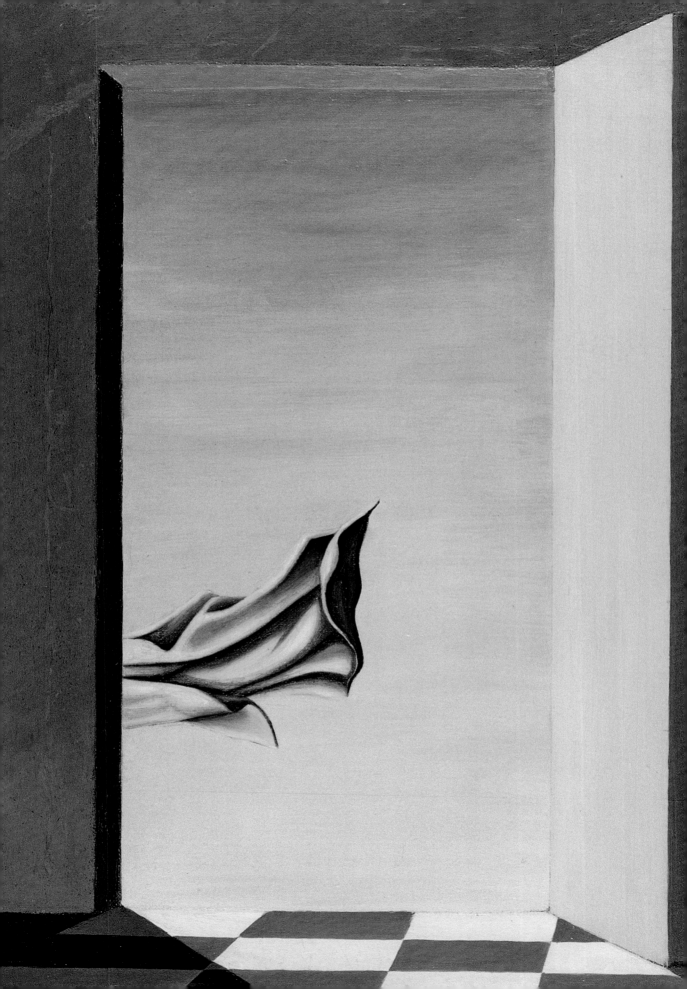

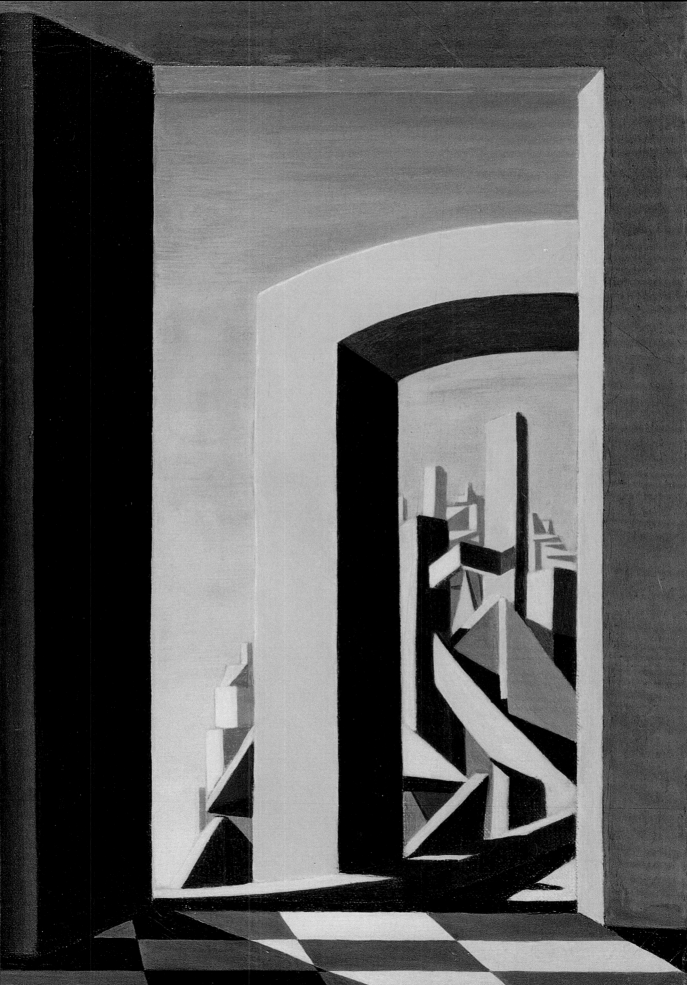

THE
OF MY
THE SU
REV

COLOUR DREAMS: RREALIST OLUTION IN ART

DAWN ADES

Curator and Editor

TEXTS

Dawn Ades

Quentin Bajac

Timothy Baum

Colin Browne

Whitney Chadwick

Robert Houle

Sharon-Michi Kusunoki

Yves Le Fur

David Lomas

Marie Mauzé

Andreas Neufert

Michael Richardson

Kurt Seligmann

Anthony Shelton

Anne Umland

VANCOUVER ART GALLERY

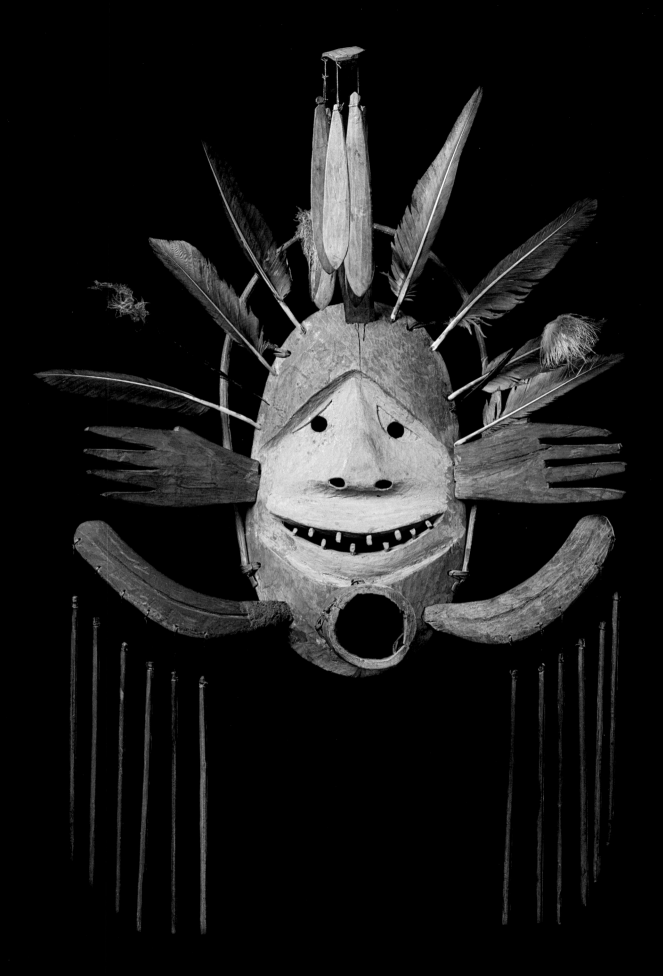

CONTENTS

WITHDRAWN

YUP'IK *Complex Mask*, c. 1890–1905, Private Collection, Courtesy of Donald Ellis Gallery, Dundas, ON and New York, NY, Formerly Enrico Donati Collection

FOREWORD

Surrealism forever changed the course of modern and contemporary art. Only a few years after its origins in 1925, Walter Benjamin wrote, "Surrealism broke over its founders as an inspiring dream wave...and seemed the most integral, absolute, conclusive movement." Over eight decades later the creative brilliance of surrealist artists continues to astound and inspire, so it is with great pride that the Vancouver Art Gallery has organized *The Colour of My Dreams: The Surrealist Revolution in Art*. A milestone in the Gallery's history, the exhibition features 350 works by all of the leading surrealist artists. The robust power of the paintings, sculpture, drawings, photography and films assembled here make evident the ceaseless experimentation of surrealist artists and the compelling themes — such as desire, violence, androgyny and dream imagery — that they explored so passionately.

For this exhibition the Gallery has been honoured to work with renowned art historian Dawn Ades. Her incomparable knowledge of and passion for Surrealism permeate every aspect of the project. As she affirms in this exhibition, Surrealism was a movement centred on a collection of ideas, consequently the works do not adhere to a single style. The dazzling array of works represented in these pages speaks eloquently to the diversity of visual exploration and technical innovation of the surrealist artists. Dawn has brought fresh perspective to an examination of Surrealism, and her insights do much to recapture the radical spirit in which these works — now widely accepted as icons of

modern art — were made. She also provides a new perspective on the development of surrealist film, revealing a myriad of surprising influences ranging from *Nosferatu* to the films of Charlie Chaplin. *The Colour of My Dreams* also breaks new ground by exploring, for the first time in an exhibition, the Surrealists' intense interest in indigenous art of the Pacific Northwest. Included here is an exquisite selection of First Nations work formerly in the collection of leading surrealist figures such as André Breton, in addition to documentation of the seminal journeys made to British Columbia by artists Kurt Selgimann and Wolfgang Paalen in the late 1930s. The Gallery has a distinguished history of organizing exhibitions of modern and contemporary art as well as those focusing on historical and contemporary First Nations art. It is a particular privilege, therefore, for us to organize this project focusing on one of the twentieth-century's most important art movements and explore its relationship to our own community. It has been a distinct pleasure to collaborate with Dawn, and I am grateful for her commitment, enthusiasm and warm generosity of spirit.

To the Board of Trustees of the Vancouver Art Gallery, led by Board Chair David Aisenstat, I extend my gratitude for their unfailing support of our ambitious exhibitions program. David, in particular, has been extraordinarily generous to the Gallery with his contribution through The Keg Steakhouse & Bar. As the Presenting Sponsor,

The Keg has once again provided instrumental support, helping to make this exhibition a reality. As well, my great appreciation is given to Concord Pacific, led by its President, Terry Hui, as the Supporting Sponsor. We are also grateful for assistance from the Canada Travelling Exhibitions Indemnification Program of the Department of Canadian Heritage.

The highly talented and dedicated staff at the Gallery are due much-deserved recognition for meeting the challenges involved in realizing such a major project. I extend my sincere gratitude to them for their dedication and expertise. Thomas Padon, Assistant Director/Director of International Partnerships, deserves special recognition. His ardent belief in this exhibition's potential, his astute curatorial advice and the extraordinary efforts he brought to bear in securing the unprecedented loans for this exhibition were transformative. I also would like to recognize Daina Augaitis, Chief Curator/Associate Director, whose instrumental oversight of the staff working on the exhibition and valuable insight throughout the organization of the project are greatly appreciated. Paul Larocque wisely managed the complex financial and administrative aspects of the exhibition; Karen Love oversaw all aspects of this major publication with great skill and sensitivity; and Emmy Lee adeptly and tirelessly coordinated the challenging array of details related to the project. The expertise of Tom Meighan, Heidi Reitmaier and Dana Sullivant and all their staff members further enhanced this presentation for our audience.

In addition to Dawn Ades, thirteen individuals have contributed to this book, which the Gallery proudly publishes on the occasion of this exhibition, reaffirming its commitment to scholarship. The essays featured here extend the art historical dialogue on Surrealism and shed new light on the evolution of Surrealist film and the place, in the Surrealists' imagination, of First Nations art of the Pacific Northwest. We thank all of the scholars represented here for their cooperation and insight.

The Colour of My Dreams would not have been possible without the extraordinary generosity of the lenders who have shared so many iconic works from their collections. To all of the museums, galleries and private collectors whose loans are represented in this historic exhibition, we extend our most sincere gratitude. Particular thanks go to Timothy Baum; The Art Institute of Chicago; Baltimore Museum of Art; Galerie 1900–2000; The Israel Museum; The Mayor Gallery; The Metropolitan Museum of Art; Musée du Quai Branly; San Francisco Museum of Modern Art; and Ubu Gallery & Galerie Berinson for allowing us to borrow such major groupings from their spectacular surrealist holdings.

It is with great excitement and anticipation that we present our audience with this rare opportunity to experience some of the best work created by surrealist artists.

Kathleen S. Bartels, Director, Vancouver Art Gallery

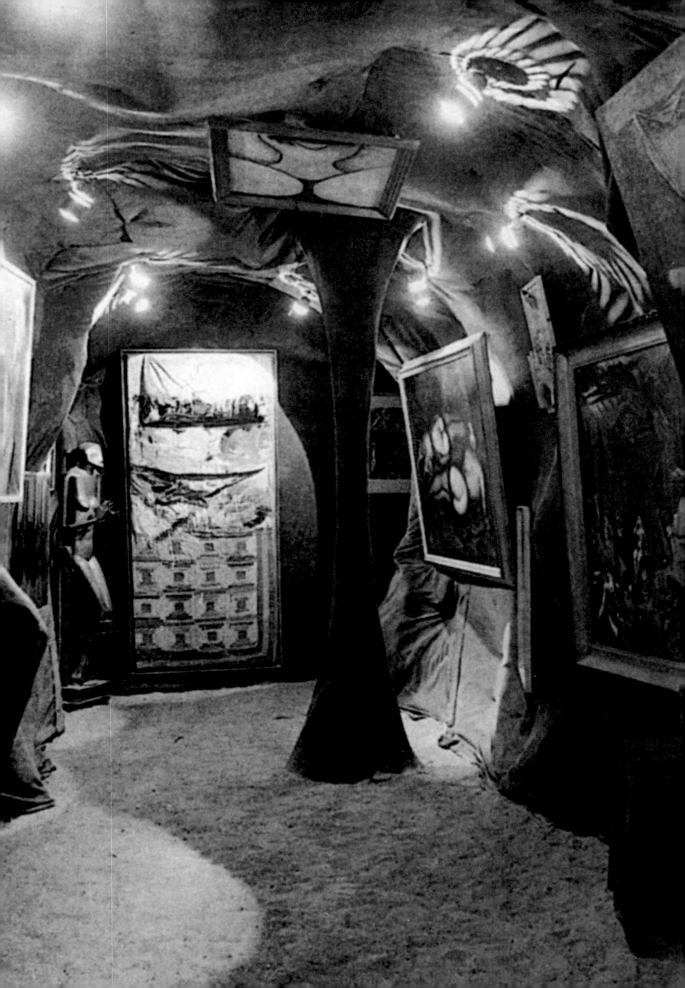

EXHIBITING SURREALISM

DAWN ADES

Within a decade of the launch of Surrealism in 1924 exhibitions about the movement were mounted in museums: the Wadsworth Atheneum's *Newer Super-Realism* opened in 1931 and Alfred Barr's *Fantastic Art, Dada, Surrealism* followed at the Museum of Modern Art in New York in 1936. During the 1930s the Surrealists shot to global prominence with international exhibitions in Japan, England, Denmark and elsewhere. However, there is a difference between those exhibitions conceived, selected and mounted by Surrealists, and exhibitions about Surrealism. The former exemplified Surrealism in action — they performed Surrealism, one could say. They assessed the current state of its visual language, presented new artists and kinds of objects and eventually invented the idea of the exhibition as installation or environment. Exhibitions about Surrealism, on the other hand, take a more or less objective approach: they may be broad-ranging or tightly focused but they are usually intended to interpret, inform and contextualize. The two kinds of exhibition should not be confused.

The hugely popular *Fantastic Art, Dada and Surrealism* yoked together two distinct movements because they shared artists and situated them in relation to a long tradition of fantastic art. It was the second in a series of general retrospective exhibitions about modern art at MoMA and was conceived as directly opposite in spirit and æsthetic principles to the first of these exhibitions, *Cubism and Abstract Art*, thereby sealing for decades the view of modern art as divided into two broad strands, Cubism/Abstraction and Surrealism. William Rubin's 1968 *Dada and Surrealist Art* traced the history of the two movements, up to the emergence of Abstract Expressionism, with the clear aim of establishing the latter's surrealist provenance in the painting of artists such as Arshile Gorky. *Dada and Surrealism Reviewed* at the Hayward Gallery in London (1978), by contrast, sought to re-establish the fuller context of the movement and its primary concerns with poetry, politics and philosophy. The dada and surrealist reviews provided the organizational structure of the exhibition and works were grouped in relation to them. In more recent decades the two movements, Dada and Surrealism, have been unyoked and women artists, who were barely present in Rubin's exhibition, for instance, have come to the fore. Exhibitions about Surrealism usually have an agenda that belongs to another discourse — historical, social, political, feminist, æsthetic — even if, as is also usually the case, they claim to be revealing or telling the truth about Surrealism or an aspect of it.

The present exhibition is no exception. It aims to trace the rich history of Surrealism's interventions in the visual arena and the ways its core ideas penetrated art, not in order to define surrealist art but to explain the absence of a surrealist style. This has always made Surrealism an oddity in histories of twentieth-century art. It cannot be slotted into categories like abstract or figurative, realist or expressionist, formalist or conceptual. As José Pierre wrote for the surrealist *Eros* exhibition of 1959, what most irritates the art pontiffs about painting with a surrealist character is "the absence of a unique, recognizable style: from [Giorgio] de Chirico to [Jean] Arp, from [Joan] Miró to [Yves] Tanguy, from Max Ernst to [Roberto] Matta, what formal 'common measure' can serve as the bench mark amid that prodigious diversity? There is none"[1] This has remained a point of contention and also raises large questions about who decides what

[1] José Pierre, "Le surréalisme et l'art moderne," exh. cat., *Exposition inteRnatiOnale du Surréalisme* (Paris: Galerie Daniel Cordier, 1959), 38.

is surrealist. Is it self-defined? What of the artists who were discovered and identified as surrealist without knowing anything of the movement? The only "possible identity," Pierre continued, "is in a common attitude of mind, with all the individual nuances of temperament, sincerity, integrity, and the means that this implies."

Paradoxically, Surrealism has been a generative force of surprising longevity and has touched every aspect of visual culture: painting, sculpture, photography, objects, installations, film, architecture, fashion. Its history in terms of art is complex, not least because artists came and went and not everything in the œuvre of those closely connected with the movement at a particular moment, such as Salvador Dalí or Alberto Giacometti or Arp, can be subsumed within it.

Exhibitions were a crucial part of surrealist activity from the start, and provide a trajectory of the way the visual arts developed in dialogue with the ideas, the poetry and writings of André Breton and other members of the group. The first was the 1925 exhibition *La peinture surréaliste* at the Galerie Pierre in Paris. This was, for reasons to be discussed below, a relatively conventional exhibition of painting, by comparison with some of the earlier dada exhibitions and manifestations in Zurich, Cologne and Paris, which prefigured surrealist assemblages and installations although in more aggressive guise. For the second dada exhibition in Cologne, for example, *The Dada Pre-Spring* in April 1920 masterminded by Max Ernst, Jean Arp and Johannes Baargeld, visitors entered past the urinals and a young girl in a white communion dress reciting obscene poetry, to be met by a wooden object with an axe attached and the invitation to destroy it. This was Dada at its most negative and offensive, but also one of the first vigorous examples of the crushing of barriers between viewer and viewed (ancestor of *audience participation* and *relational æsthetics*) and of distinctions between materials appropriate to art and those from anywhere else — the street, factory or kitchen, etc.

During the brief period of Paris Dada, between 1919–1922, the few exhibitions that took place fell into two categories: anti-exhibitions like the *Salon Dada* (June 1921) and solo exhibitions like Max Ernst's at the Au Sans Pareil gallery/bookshop in Paris in May 1921. The *Salon Dada* aimed for the maximum offence to its audience, taunting them with their assumptions about art and already playing with the anti-art possibilities of the readymade. An open umbrella and a cello with a white bow tie hung from the ceiling, and a line of ties, like a mock display of fashionable taste, was suspended along the balcony, while the exhibits included a framed mirror with the title *Portrait of an idiot*. Dada appeared to reach a dead end; it took a while for the Surrealists to re-activate

the object and the installation within a new context. In the meantime André Breton and his group were seeking a solution to what seemed like an impasse.

Although Max Ernst's 1921 exhibition was presented with a thoroughly dada character, the works themselves opened up something wholly new in terms of representation that helped define what was to become Surrealism. Publicity in the dada style proclaimed Ernst as the "Einstein of painting," with a poster that offered "Free entry — hands in pockets — exit surveillance — picture under the arm," but the catalogue preface by Breton pointed to a new spirit in the collages, to a new poetry born of the unexpected, the shock of juxtaposition, collisions of unlike things brought together on a common plane. The collages, dubbed *Fatagaga* (Fabrication de tableaux garantis gasometriques) by Arp and Ernst, had arrived from Cologne, where Ernst himself was still stuck because of the British military occupation following Germany's defeat in World War I. In his autobiographical notes Ernst later wrote of his delight at receiving Breton's courageous letter of invitation, acknowledging "it needed confidence at that time to show a German painter in France."[2] The poster does not mention the term *collage* but plays on the bewildering mixture of mediums in dada style: the works are "dessins mécanoplastiques plasto-plastiques peintopeintures anaplastiques ..." and significantly, "*au-delà de la peinture*" (beyond painting).

These unprecedented "mechanoartistic drawings" were indeed quite unlike cubist collage and Berlin dada photomontage. Ernst had grasped something very occasionally hinted at in Picasso's cubist *papiers collés*, when a fragment of flower-patterned wall-paper, for example, becomes roses growing up a wall. Such mild transformations, which don't really go beyond the core cubist concerns with the relationship between reality and representation, were taken by Ernst to extraordinary heights of invention. He created entirely new scenes, imaginary landscapes and interiors using wildly different materials: photographs; scraps of wallpaper; printed reproductions from natural history; anatomy, geology and botany textbooks; wall charts; illustrated fashion catalogues; embroidery patterns and so on, which he stuck down, overpainted, drew on, and to which he often added long inscriptions. In his text *Beyond Painting*, Ernst later emphasized the involuntary, fortuitous origins of these images:

In the days when we were most keen on research and most excited by our discoveries in the realm of collage, we would come by chance ... on (for example) the pages of a

2 Max Ernst, "Notes pour un biographie," *Ecritures* (Paris: NRF, 1927), 42.

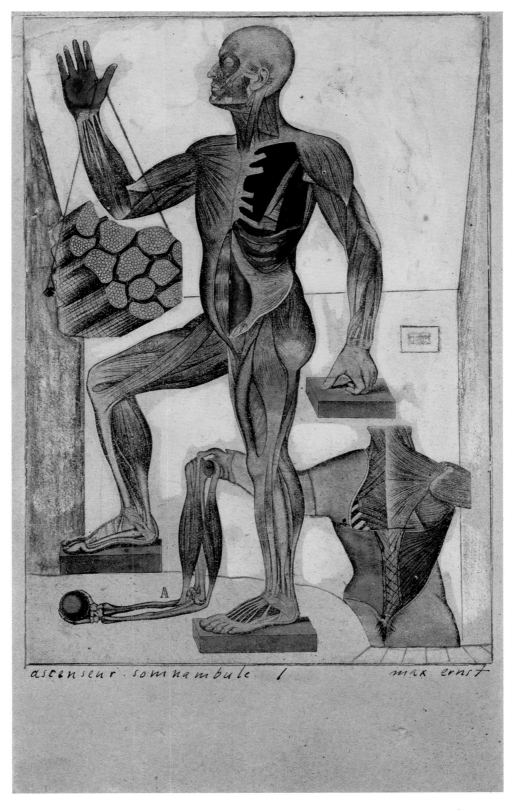

ascenseur. somnambule. 1 max ernst

MAX ERNST *Ascenseur Somnambule I* [Sleepwalker Rising I], 1921, Collection of Timothy Baum, New York

MAX ERNST *"... ou en bàs, cette indécente amazone ..." Rêve d'une petite fille qui voulait entrer au Carmel* ["... or below, that indecent amazon..." A little girl dreams of taking the veil], 1929–30, Collection of Timothy Baum, New York

catalogue containing plates for anatomical or physical demonstration and found that these provided continuously figurative elements so mutually distant that the very absurdity of their collection produced in us a hallucinating succession of contradictory images, super-imposed upon one another with the persistence and rapidity peculiar to love memories and visions of half-sleep[3]

What made these collages so revelatory at the time was the new kind of image they created, the conjunction of unlike things that nonetheless struck a spark of surprised

recognition. In his catalogue preface Breton describes their "marvellous ability to reach out, without leaving the field of our experience, to two distant realities and bring them together to create a spark."[4] These are virtually the same terms as those he later used to describe the "surrealist image" in the first *Manifesto of Surrealism* in 1924. Breton recognized in these collages a parallel with the marvellous poetic images obtained by automatic writing: visual equivalents to Lautréamont's phrase, made famous by the Surrealists, "…as beautiful as the chance encounter on a dissection table of a sewing machine and an umbrella."[5] Collages were to become ubiquitous in Surrealism, and Ernst himself returned to them many times, in his collage-novels, for example, such as *Une semaine de bonté*. Ernst's early collages owed a great deal to chance, but were also part of the early history of the surrealist notion of Automatism. Breton's first *Manifesto*, which was as much a summary of the experiences of the previous years as a call to the future, defined Surrealism as,

pure psychic automatism, by which it is intended to express, either verbally, or in writing, or in any other way, the real functioning of thought. The dictation of thought in the absence of any control exerted by reason, and outside all æsthetic and moral preoccupations.[6]

Experiments with automatic writing went back well before the dada interruption; Breton and Philippe Soupault published *Les champs magnétiques* in 1919, the first and in many ways best example of surrealist or automatic writing. It is interesting that whereas Breton clearly credits Freud as the inspiration for his experiments with automatic writing in the first *Manifesto* in 1924, he does not mention him in his earlier description of it in "Entrée des mediums" in 1922. In this text, an excited account of the "hypnotic trances" learned from the spiritualist mediums, Breton already adopts

[3] Max Ernst, *Beyond Painting*, in *The Documents of Modern Art* (New York: Wittenborn Schultz, 1948), 14. The reference to a "vision of half-sleep" recalls the incident recorded by André Breton in the first *Manifesto of Surrealism*. "One evening before I fell asleep, I perceived, so clearly articulated that it was impossible to change a word…a rather strange phrase, which was something like 'There is a man cut in two by the window.'" It was accompanied by a faint visual image. Had he been a painter, Breton notes, the visual representation would undoubtedly have taken precedence. [4] André Breton, "Max Ernst," in Ernst, *Beyond Painting*, 177. [5] Isidore Ducasse (Comte de Lautréamont), *Chants de Maldoror* (1869), *Œuvres complètes* (Paris: Librairie José Corti, 1963). Ducasse used the pseudonym Comte de Lautréamont. [6] André Breton, *Manifeste du surréalisme* (Paris: Editions du Sagittaire, 1924), 42. [This translation by D. Ades.]

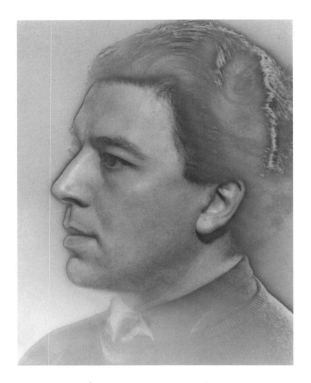

MAN RAY *André Breton*, c. 1930, San Francisco Museum of Modern Art, Sale of Paintings Fund purchase

the term *Surrealism* which, he says, he and his friends use in a "precise sense" to designate "a certain psychic automatism that corresponds rather well to the dream state."[7] They may have meant it in a precise sense, but there are several, contradictory sources for Automatism in psychology, psychoanalysis and spiritualism. From these, the Surrealists drew what they wanted and asserted the right to explore and experiment.

Freud's discoveries gave the Surrealists the richest authority to pursue Automatism even if to different ends. Breton credited his experiences as a young doctor, using what he understood as Freud's techniques for obtaining an uncensored monologue from his patients, as the inspiration for his own early experiments with automatic writing. In these, as we saw, he valued above all the quantity and beauty of the images produced spontaneously. The *Manifesto* offers a fuller justification for Automatism as the essential tool for investigating the unconscious, which is understood as no less a vital part of the human psyche than consciousness. It could be argued that the Surrealists still had only a partial knowledge of Freud and probably misunderstood some psychoanalytical practices, but for their purposes settled on basic, key points: that there are areas of the human mind that lie beyond conscious reach; that these depths "contain strange forces capable of augmenting those on the surface or of fighting against them"[8]; that the workings of the unconscious mind can be recognized in dreams. Unlike the psychologist Pierre Janet, who regarded the manifestations of Automatism as purely mechanical reflexes,

[7] André Breton, "Entrée des mediums," *Littérature*, no. 6, November 1922; trans. Mark Polizotti, "The Medium Enters," *The Lost Steps* (Lincoln: University of Nebraska Press, 1996), 90. [8] André Breton, *Manifeste du surréalisme*; Trans. Richard Seaver and Helen R. Lane, *Manifestoes of Surrealism* (Ann Arbor: University of Michigan Press and Seaver & Lane, 1965), 10.

Freud's discoveries pointed to the immense but hidden influence of the unconscious in human lives and to its power as a creative (or destructive) force.[9] The Surrealists were not concerned with psychoanalysis as cure or therapy; in fact, they maintained a sometimes ill-tempered dialogue with the medical profession. Their interest was in how and by what routes the unconscious could be revealed or recognized. The division between Automatism and dreams, which became a particularly significant factor in the development of surrealist painting, was not clear-cut at the beginning. "Surrealism believes in the superior reality of certain forms of association neglected until now, in the all-powerfulness of the dream, and in the disinterested play of thought."[10]

Artists had only been awarded a footnote in the first *Manifesto of Surrealism*, where Breton names, as those who are in some way surrealist, "[Paolo] Uccello, in the old epoch, and in the modern epoch, [Georges] Seurat, Gustave Moreau, [Henri] Matisse (in *Music*, for example), [André] Derain, [Pablo] Picasso (by far the purest), [de] Chirico (admirable for so long), [Paul] Klee, Man Ray, Max Ernst and, so close to us, André Masson." But there were from the start fierce debates about what a visual Surrealism could be, and this was the context for the first of the surrealist exhibitions, *La peinture surréaliste,* and the series of articles Breton began publishing in *La révolution surréaliste* (no. 4) in July 1925, on "Le surréalisme et la peinture" (Surrealism and painting), where he set about countering the attacks on painting published in the first issues of the review.[11]

Max Morise in "Les yeux enchantés" (The enchanted gaze) had questioned the right of paintings like those of de Chirico and, by extension, Ernst, to be called surrealist. The objection was that although they were analogous to dream narratives the secondary effort of memory distorted the dream images and painting was, anyway, too labour intensive and slow to correspond properly to the spontaneity, the swift succession of images and fleeting ideas that should characterize Surrealism. In de Chirico's painting,

[9] The French psychologist Pierre Janet published *L'automatisme psychologique* in 1889. Marguerite Bonnet, in *André Breton, Naissance de l'aventure surréaliste* (1988) analyzes the degree of Breton's familiarity with Freud. For an excellent account of Surrealism and the French psychoanalytical school see Elizabeth Roudinescu, *Jacques Lacan & Co.: A History of Psychoanalysis in France, 1925–1985* (Chicago: University of Chicago Press, 1990). [10] André Breton, *Manifestoes of Surrealism*, 26. [11] "Le surréalisme et la peinture" was published serially in *La révolution surréaliste* from the 4th issue (July 15, 1925) to issue 9/10 (October 1, 1927) and as a book in 1928. Trans. Simon Watson Taylor, *Surrealism and Painting* (New York, Evanston, San Francisco, London: Icon Editions, 1972).

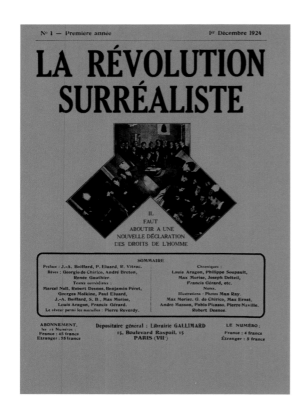
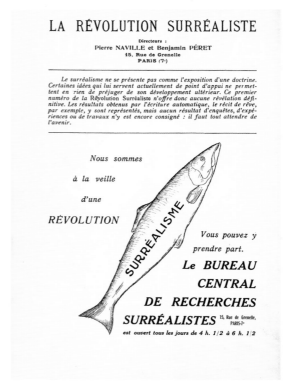

La revolution surréaliste, no. 1, Dec. 1924: cover and title page, Collection of Timothy Baum, New York

"the images are surrealist, their expression is not."[12] Pierre Naville followed up with a short article ironically called "Beaux-arts" in which he claimed, "Everyone now knows there can be no such thing as surrealist painting"[13]

Evident here is an idealization of the process of writing, both in narrating dreams and in automatic writing proper, as more apt than visual images to capture the movement of thought; what is ignored is the equivalent problem of distortion and the intervention of conscious interpretation in telling a dream in words, something Freud discussed in *The Interpretation of Dreams*. The argument is symptomatic of a rejection of painting itself among many of the Surrealists of the first hour, in favour of more technologically automatic processes such as photography and film, of the works of children and the mad, and more broadly of experience over expression. The first few issues of *La révolution surréaliste* contained almost no paintings, but instead, automatic drawings by André Masson, photographs and film stills.

[12] Max Morise, "Les yeux enchantés," *La révolution surréaliste*, no. 1, December 1924, 26. [13] Pierre Naville, "Beaux-arts," *La révolution surréaliste*, no. 3, April 15, 1925, 27.

YVES TANGUY *Untitled*, 1926, Courtesy of Virginia Lust Gallery, New York

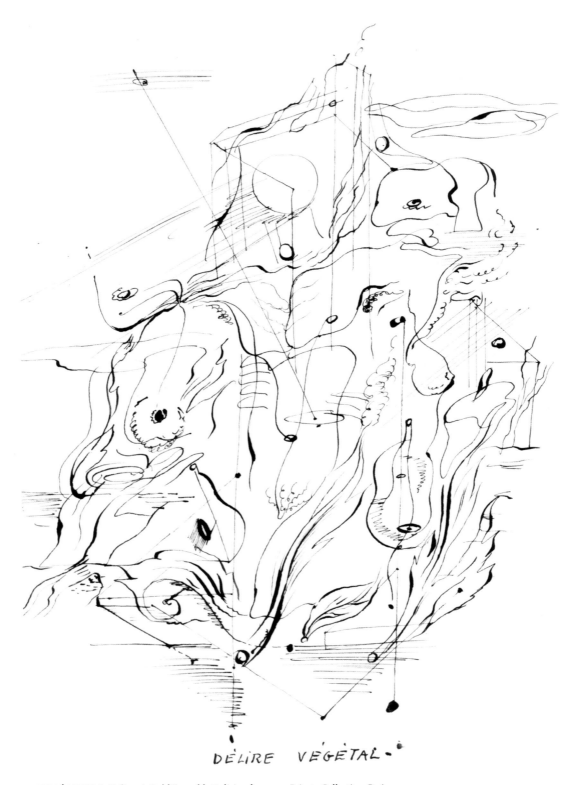

ANDRÉ MASSON *Délire végétal* [Vegetable Delirium], c. 1925, Private Collection, Paris

The drawings by Masson and by Tanguy use Automatism in a different way from Ernst in his collages. In the automatic drawings the swiftness of the line, which starts with no pre-conception of what will emerge — sometimes becoming a tangle and sometimes no more than a few scratches, subsequently developing into a recognizable image or remaining abstract — seemed to replicate unconscious thought.

It was only when Breton took over editorial control of *La révolution surréaliste* in 1925 and started his series of articles on "Le surréalisme et la peinture," (Surrealism and Painting) that the surrealist possibilities of the medium of painting were again in play, and only with the advent of Dalí and René Magritte in 1929 that dream painting returned to centre stage. "Le surréalisme et la peinture" was Breton's first sustained

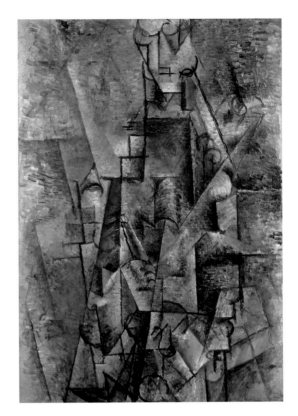

Fig. 2 Pablo Picasso, *Man with a Clarinet*, 1911–12, oil on canvas, Museo Thyssen-Bornemisza, Madrid, ©Picasso Estate/SODRAC (2011)

writing about the visual in Surrealism and it coincided with the exhibition *La peinture surréaliste* (1925); together, they were a demonstration that painting mattered and could genuinely be part of the experiments that Surrealism called for. The paintings in the exhibition included works by Klee, Miró, Masson, Pierre Roy, Man Ray, Ernst, de Chirico — and Picasso's *Man with Guitar*. Breton's first article on "Le surréalisme et la peinture," opened with a surprise. The first artist to be discussed was Picasso — not one of the artists in the immediate surrealist circle, such as Ernst or Masson. Breton never wavered from his desire for Picasso to "become one of them," and Picasso, while maintaining absolute independence, was closer to the movement at certain points; during the mid-1930s, for instance.[14] It was not just the collages and constructions Breton praised, but the cubist canvases with their

[14] Elizabeth Cowling, "Proudly we claim him as one of us: Breton, Picasso and the surrealist movement," *Art History*, vol. 8, no. 1, March 1985, 82.

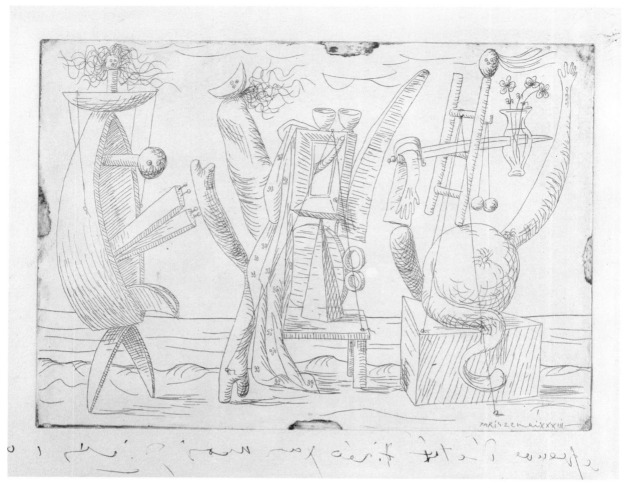

PABLO PICASSO *Figures surréalistes* [Surrealist Figures II], 1933, Private Collection, Courtesy of Timothy Baum, New York

grey-brown scaffoldings or grids, like *Man with a Clarinet*. But Breton was not trying to impose a version of Cubism on Surrealism. The variety of means remained as broad as possible. In this same issue of *La révolution surréaliste* there are photographs by Man Ray, a drawing by de Chirico, Miró's *Catalan Hunter*, Ernst's *Revolution by Night*, Masson's *Armour* and Picasso's *Les demoiselles d'Avignon*, *Three Dancers* and numerous cubist pictures. After beginning with Picasso in *Surrealism and Painting* Breton dismisses Matisse and Derain ("disheartened and disheartening old lions"), then discusses Georges Braque, de Chirico's incomparable metaphysical period around 1910–1917, and finally devotes a lyrical section to each of the surrealist artists. He discusses Max Ernst's collages ("the unrestorable fragments of the labyrinth"), paintings like *Revolution by Night* and his *frottages*, direct equivalents of automatic writing. Man Ray and Max Ernst both received an impetus from photography, but whereas Ernst utilized and

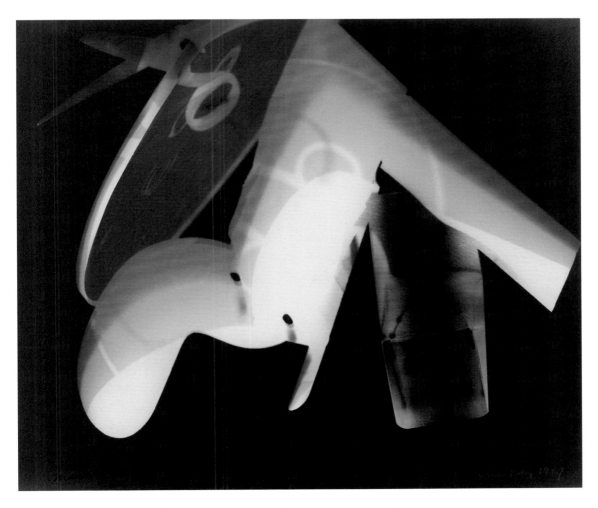

MAN RAY *Untitled Rayograph* [Scissors and cut paper], 1927, The J. Paul Getty Museum, Los Angeles

subverted it as readymade images, Man Ray set about to make a thorough examination of the medium itself, stripping photography of its claim to be the *"faithful* image ... of something that will soon be gone forever." His *Rayograms*, which are often inappropriately described as abstract and which Morise in "Les yeux enchantés" had suggested might be a solution to the problem of finding an equivalent to automatic writing, are startling revelations of the imaginative dimensions of this apparently realist medium. The series of articles in *La révolution surréaliste* end with a passionate evocation of Masson. Breton celebrates the "chemistry of the intellect" in Masson's work and evokes, though in more poetic terms, the same quality that Morise had sought in surrealist visual expression: the ability of the line or brush stroke to convey the movement of undirected, spontaneous thought.

Throughout his articles Breton is interested in weighing the "current state of the visual language," but is reticent about laying down any rules about what artists claiming to be surrealist should or shouldn't do in practice. The lyrical, evocative as opposed to analytical tone he adopts is part of his strategy and there were several reasons for this. One of the most important was that Surrealism was founded as an adventure, a journey into the unknown. The conscious, rational world could no longer claim absolute rights over peoples' lives. As well, he wanted to counter the idea that painting could never be surrealist, and to do this he had to avoid engaging in minutely discriminating assessments, the kind that concerned Morise and Naville, about the degree of Automatism in a given work. What he aimed to do was to demonstrate that Surrealism indeed could *enter* painting. But it was still essential to "demand a great deal" of this faculty of image-making, and to avoid any hint of the creation of a new æsthetic, of a notion of art and beauty separate from life. "The enchantments of the street . . . were a thousand times more real" for him than the portraits, landscapes, mythologies and history paintings on the walls of museums. "There is not a single work of art that can hold its own before . . . our integral *primitivism*."[15] The argument is certainly precarious. Breton was trying to balance his profound love of images with a deep conviction long-held by the avant-garde that art needed to regain connection with life, that experience could not be substituted by rule-bound, conventional forms of expression. In what appears to be another contradiction, having just spoken of the charms of the street, Breton states that "the plastic work of art will either refer to a *purely internal model* or will cease to exist." By the "internal model," he meant the withdrawal of the mind from everything except its own life. The censorship of the ego, external pressures such as "family, fatherland, society," had to be resisted in the interests of exploring fully the hidden depths of the mind. The routes to be taken were unmapped and a huge variety of other practices and activities invented or adopted by the Surrealists were brought into play, which included not only Automatism but games of chance, the *cadavre exquis* and the surrealist object.

The Galerie surréaliste opened in Paris in March 1926 with a new and sensational exhibition, yoking Man Ray with sculptures from New Guinea, New Ireland, the Marquesas and Easter Island: *Man Ray et les Objets des Îles*. On the catalogue cover was a photograph by Man Ray of a figure from Nias Island (off the shore of Sumatra),

[15] André Breton, "Surrealism and Painting," 3.

with an elongated headdress but otherwise naked, holding up a bowl. The photograph — aside from the figure's explicit nakedness which was regarded as scandalous — presents the sculpture in a very different manner from the way Steiglitz, for example, exhibited African sculptures in his Gallery 291, where their formal genius was emphasized. Man Ray photographs the figure so that it appears to be in a moonlit landscape. His intention was to restore the object to a life outside the gallery, museum or collector's study. This could be seen as ironic, when his colleagues were busy amassing collections of objects from Oceania, Africa and the Americas. But the Surrealists' hunger for non-Western art was inseparable from a deep interest in the cultures and civilizations that produced it, whose beliefs and rituals increasingly seemed to offer a refuge and alternative

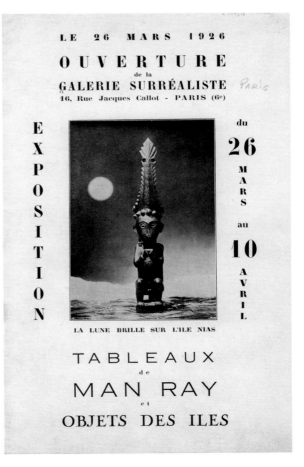

Tableaux de Man Ray et les objets des îles, April 1926, Collection of Timothy Baum, New York

to the jaded rationalism of Europe. An acute critique of the ambiguities of the European taste for the exotic, and of the anthropological study of any society so long as it wasn't European, is found in the pages of *Documents* (1929–30). Overseen by Georges Bataille, the review became a gathering point for many of the Surrealists disaffected by the movement towards the end of the 1920s.[16]

The second exhibition to put together contemporary and non-Western art at the Galerie surréaliste was *Yves Tanguy et Objets d'Amerique* (27 May – 13 June, 1927). On show were paintings by the new recruit, Tanguy, and sculptures and artefacts from British Columbia,

[16] See Dawn Ades and Simon Baker, *Undercover Surrealism: Georges Bataille and DOCUMENTS* (London: South Bank Centre and MIT), 2006.

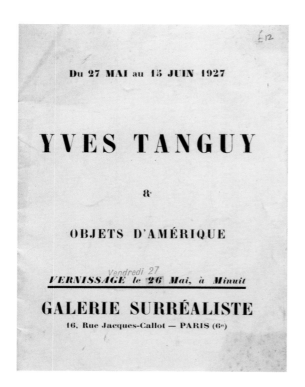

d'ailleurs avoir dépendu. Les Iroquois n'eurent qu'une divinité : le rêve. Ils lui obéirent strictement. Pris aux pièges de la nuit, la même lumière toujours les baigna. HOMMES PROPREMENT DITS, TROIS FOIS HOMMES, leur existence s'accordait à leurs rêves. Le moindre manquement à cette vie réelle devait causer leur mort. Leur destinée avait les yeux fermés. Et les voici aux prises avec tous les cauchemars, vaincus, livrés à toutes les terreurs, à tous les maîtres animaux et sublimes de l'angoisse humaine. Le frère de l'homme est un monstre qui l'empêche de s'apitoyer sur lui-même, qui en fait une citadelle déserte et imprenable. L'amour, on en a tant dit, mais on a complètement oublié son visage et ses baisers sont des lames si froides et si minces que la chair n'en est pas corrompue et ne peut plus entrevoir sa fin. L'extase, mais dans quelle trame de chevelures magiques, avec combien d'escaliers à descendre, le cœur plus lourd que le corps.

...

Vacance de l'homme, délivré de ces deux sens : le parler et le rire.

Paul ELUARD.

Amérique du Nord (Haida)

Tanguy et Objets d'Amérique, Galerie surréaliste, 1927, Collection of Timothy Baum, New York

New México, México, Colombia and Peru, at the time in the collections of Louis Aragon, Breton, Éluard and Roland Tual. Among these were a stone statue of the Aztec deity Coatlicue and a Haida open-work carving of creatures and human heads/masks. The poet Éluard's preface, "D'un veritable continent" (Of a true continent), exudes his fascination with its bizarre and wonderful peoples and their exotic customs: the Aztecs fatefully trapped in rivers of blood, the Iroquois who "had only one god: the dream."

The Surrealists on the whole, however, were more interested in the living First Nation Canadians and Native Americans than in archæology or ethnography. André Breton, during his war-time exile in the 1940s, visited the Hopi in the Southwest USA, and both Kurt Seligmann and Wolfgang and Alice Paalen made expeditions to the Northwest Coast of British Columbia. [see pp. 220 and 228] The Surrealists' embrace of other, non-Western cultures, first publicly manifested in the Galerie surréaliste exhibitions, had its ambiguities. At the time of the mammoth Colonial Exhibition in Paris in 1931, Breton and Éluard sold off their collections of African, American and Oceanic sculptures, over 300 works including more than 100 from the Americas. The reasons are not clear — had the exhibition celebrating France's colonies so disgusted them that they did not wish

to possess these symbols of colonialism, or were they taking advantage of a booming market? In any case, they subsequently rebuilt their collections. The Surrealists certainly mounted anti-colonial protests in 1931, such as the exhibition organized jointly with the French Communist Party, *La vérité sur les colonies* (The truth about the colonies). Slogans on the walls proclaimed, "a people that oppresses another cannot itself be free," and a display, including Catholic statues of the Virgin and a charity collecting-box in the shape of a black child, was labelled *European fetishes*.

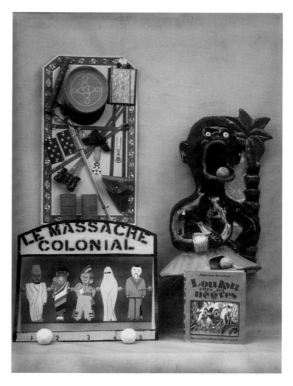

Fig. 3 Unknown photographer, *Le massacre colonial*, from the exhibition *La vérité sur les colonies*, Paris, 1931–32, The Getty Research Institute, Los Angeles (2003.R.20)

The affiliation with the Communist Party petered out in the early 1930s when the Surrealists refused to abandon their own experiments in the interests of concerted political action. They entered the debates organized by the fellow-traveller organization AEAR (Association des ecrivains et artistes révolutionnaires, or League of revolutionary writers and artists) about proletarian literature and "committed" art, but continued to defend the independence of expression and the value of poetry. In 1932 Aragon left the surrealist movement for the CP and declared himself henceforth a "realist," advocated socialist realism and praised Stalin. Similarly in 1938 Éluard chose Communism over Surrealism.

Internal dissension within the surrealist movement had also reached a crisis, and the *Second Surrealist Manifesto*, published in 1929, had excommunicated a number of Surrealists for various crimes, such as writing for unacceptable newspapers. But 1929 also saw the adherence of Dalí and Magritte, and the arrival soon after of other artists, including Alberto Giacometti, Hans Bellmer and Óscar Dominguez, and towards the end of the 1930s Wifredo Lam and Roberto Matta, made that decade a period of extraordinary creative originality.

Exhibitions played a more central role in the movement and those held were increasingly ambitious, culminating in a new concept of display as well as the development of

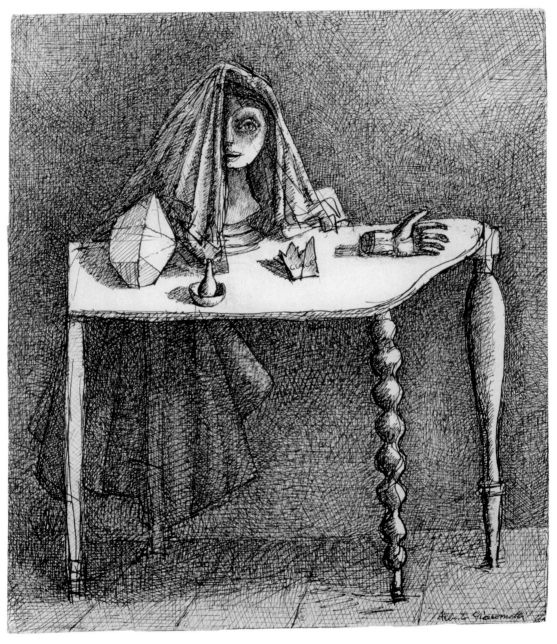

ALBERTO GIACOMETTI *La table surréaliste* [The Surrealist Table], 1933, Collection of Michael and Judy Steinhardt, New York

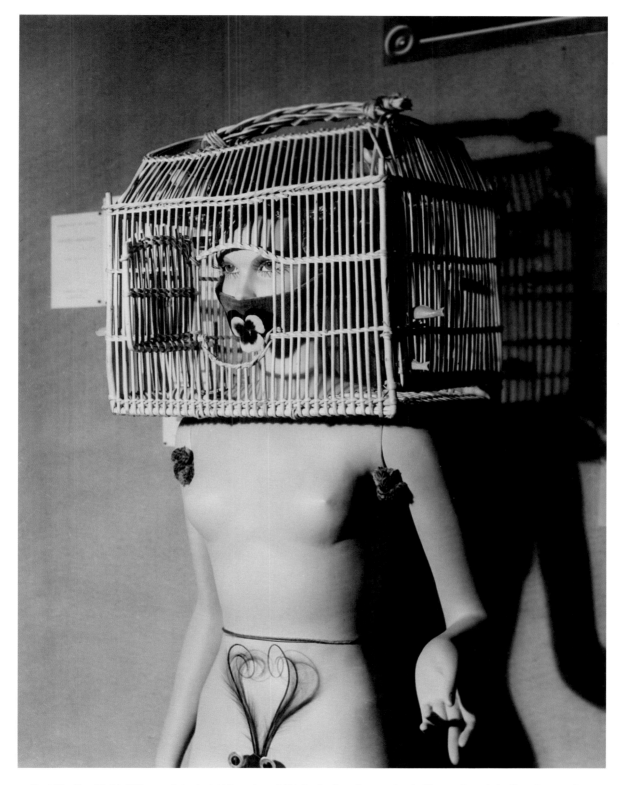

Fig. 4 Man Ray, *Untitled* (Mannequin by André Masson), 1938/66; Leaf 19 from *Resurrection des Mannequins*, gelatin silver photograph, National Gallery of Australia, Canberra, Purchased 1978, ©Man Ray Trust/SODRAC (2011)

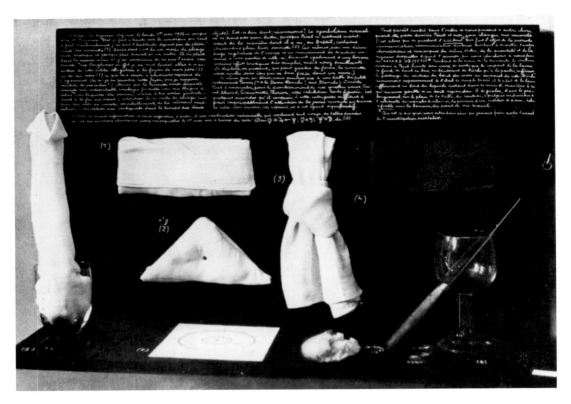

Fig. 5 André Breton, *Communication relative au hasard objectif* [Communication Relative to Objective Chance], 1933, © Estate of André Breton/SODRAC (2011)

the *surrealist object*, one of Surrealism's most radical projects.[17] The *Exposition surréaliste* at the Galerie Pierre Colle in June 1933 included "sculptures, objets, peintures, dessins" (sculptures, objects, paintings, drawings), with "object" being the odd one out.

For an outsider an *object* did not belong in the realm of the visual arts at all — it could be anything. For the Surrealists it had come to be a central preoccupation and was to mark the most extreme point in the progressive supercession of art. At the *Exposition surréaliste*, Giacometti showed *Mannequin*, which had the arm of a musical instrument as head, and *Table*, now known as *La table surréaliste* [p. 34], as well as sculptures such as *L'heure des traces*. Besides paintings, Dalí exhibited his *Bust of a Retrospective Woman*, *Atmospheric Chair* and *Atmospheric Spoon* and a work called *Planche d'associations dementielles*. Valentine Hugo showed her tantalizing erotic *Objet*,

[17] See Steven Harris, *Surrealist Art and Thought in the 1930s: Art, Politics and the Psyche* (Cambridge, UK: Cambridge University Press, 2004), for a discussion of the surrealist object in the context of the supercession of art.

which had been illustrated in *Le surréalisme au service de la révolution* in 1931. Miró is listed in the catalogue as exhibiting four objects. Breton presented *Communication relative au hazard objectif* (Communication relative to objective chance), 1933: a knife, wine glass and collection of table napkins encountered by chance on a particular day that had been folded into highly suggestive shapes. In the unconscious shaping of the linen, they recall the discarded scraps (torn bus ticket, toothpaste, bread roll) photographed by Brassaï in conjunction with Dalí and reproduced in *Minotaure* as *Sculptures involontaires* (Involuntary Sculptures) [p. 172]. For this first group exhibition since 1928, the letter of invitation stressed the collective ideals of Surrealism: "We have outgrown the period of individual exercises." Instead, they vigorously pursued games and other forms of collaboration and communal activity, such as the *cadavre exquis*. The 1936 *Exposition surréaliste d'objets* at Charles Ratton's gallery included an amazing range of objects both made and found, amongst them perturbed objects (such as those found after the eruption of a volcano), and American objects (including Hopi dolls).

From the mid 1930s a series of major *Expositions internationales du surréalisme* was to change the nature of exhibition installation and establish the visual arts as the primary public face of Surrealism all over the world. The 11th, *L'Ecart absolu* (Total separation) took place in Paris in 1965, the year before Breton's death. These *International Surrealist Exhibitions* re-asserted the collective character of the movement. The short-lived Galerie Gradiva, run by the Surrealists, alternated group and solo shows. Some international group displays took place within the context of a broader survey of contemporary art: these included *Abstract and Surrealist Art* at the Kunsthaus in Zurich (1929) and the *Minotaure* exhibition in Brussels (1934). The latter was organized by Skira Editions, the magazine's publishers, and installed by the Belgian Surrealist ELT Mesens, who carefully separated the Surrealists from Braque, Aristide Maillol, Matisse and other Skira artists. Magritte's *Le viol* and Dalí's *The Great Masturbator* were so shocking they were shielded from the public behind a curtain. Increasingly, those exhibitions that took place wholly under the control of the Surrealists themselves during the 1930s — in Copenhagen (1935), Santa Cruz de Tenerife (1935), London (1936), Paris (January 1938) and Amsterdam (March 1938) — turned the setting itself into a surrealist work. It was as though the surrealist objects that had initially entered the world to undermine rational notions of utility expanded to transform the environment completely.

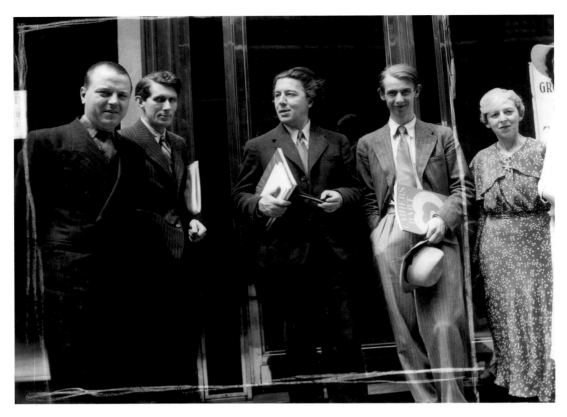

CLAUDE CAHUN *Untitled* [Surrealists ELT Mesens, Roland Penrose, André Breton, David Gascoyne and Claude Cahun, London], 1936, printed 2011, Jersey Heritage Collection

The most stunning was the 1938 *Paris International Surrealist Exhibition* at the Galerie des Beaux-Arts. The whole ambiance was invested with mystery and drama, and the central surrealist desire to find a point where waking and sleeping, the real and the imagined, "cease to be perceived as contradictions,"[18] was brilliantly embodied in a sequence of spaces which confused interior and exterior and shifted from street to underground cavern, from light to darkness, from urban to nature. Large objects in real space blurred the boundaries between art and life in ways that now have become clichés but then were unprecedented. Dalí's *Rainy Taxi*, a car with shark-faced driver and blonde-haired hysterical passenger, with live snails crawling over them, met the visitor in the courtyard. A passage lined with mannequins, each dressed by a Surrealist, led to a dark room whose ceiling was entirely covered with sacks of coal, suspended above a brazier. (The sacks were actually stuffed with papers and coal dust, which fell in a fine rain

[18] André Breton, *Second Manifesto of Surrealism*, in *Manifestoes of Surrealism*, 123.

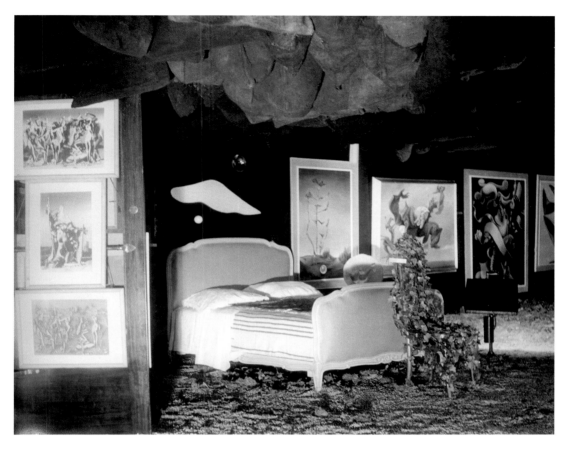

Fig. 6 View of *Exposition internationale surréaliste*, Galerie des Beaux-Arts, Paris, 1938, Archives du Wildenstein Institute, Paris

on the spectators.) This was the idea of Marcel Duchamp, who was *générateur-arbitre* of the exhibition. Paintings were attached to sets of revolving doors but couldn't be seen because the only lighting source was a brazier on the floor. Visitors were given flashlights, whose batteries quickly ran out. On the floor were twigs, a pool and a double bed, and the smell of roasting coffee pervaded the room. Among the objects were items of surrealist furniture, some of them sprouting human limbs, and an early version of Dalí's *Lobster Telephone*. It was all disorienting, enchanting and confusing. Although aiming "beyond the eyes," it was not like the traditional avant-garde *gesamtkunstwerk* aimed at engaging all the senses. Here visitors were immersed in the unexpected, their senses at the same time quickened and counteracted. Instead of Rimbaud's "salon at the bottom of a lake," it was a reed-fringed pool at the bottom of a mine, an environment that simulated both underground and open air — and could easily be understood as symbolic of the human unconscious.

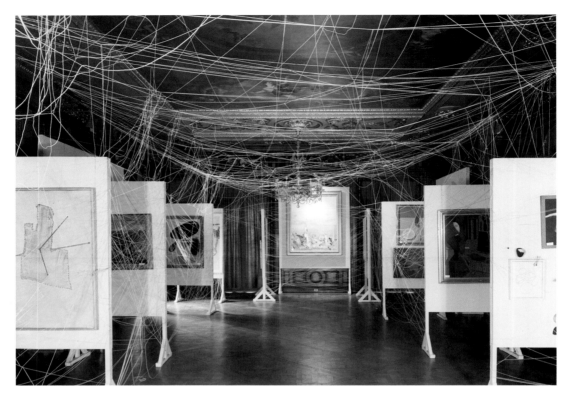

Fig. 7 John D. Schiff, view of exhibition *First Papers of Surrealism*, 1942, with Marcel Duchamp's string installation, gelatin silver print, Philadelphia Museum of Art, Gift of Jacqueline, Paul and Peter Matisse in memory of their mother Alexina Duchamp

This and subsequent surrealist exhibitions in Paris and New York prefigure later generations of installation and site-specific art, and also performance art. At the 1936 International Surrealist Exhibition in London, Salvador Dalí famously delivered his lecture wearing a diving helmet. In Paris in 1938 Hélène Vanel performed a wild dance on the opening night, wearing a torn nightdress, giving all too convincing cries of hysteria and seeming to bewitch her audience. She was, in a sense, performing both hysteric and sorceress, thus epitomizing two of the Surrealists' favourite aspects of *woman*.[19] The outbreak of war in 1939 and the fall of France in 1940 scattered the Surrealists, bringing to an end a decade that had seen the movement spread all over the world. In the face of the increasingly stark political choices, the Surrealists struggled to assert their position. During the war two notable International Surrealist Exhibitions

[19] For more detailed accounts of the surrealist exhibitions see Lewis Kachur, *Displaying the Marvelous: Marcel Duchamp, Salvador Dalí and Surrealist Exhibition Installations* (Cambridge, MA: MIT, 2001), and Alyce Mahon, *Surrealism and the Politics of Eros, 1938–1968* (London: Thames & Hudson, 2005).

took place in the Americas: one at the Galeria de Arte Mexicano in México City in 1940, and the other, *First Papers of Surrealism*, in New York in 1942. For *First Papers of Surrealism* Duchamp invented a new twist on installation: the first page of the catalogue announced, enigmatically:

hanging by André Breton
his twine Marcel Duchamp.

Duchamp had bought "sixteen miles" of string that, with the help of other Surrealists, he twined round the high-ceilinged room of the former Whitelaw Reid Mansion, obscuring the frescoes and chandeliers as well as the paintings on show.

In the post-war years, when many of the exiled Surrealists returned to Paris, the movement was re-launched with the exhibition *Le surréalisme en 1947*. Duchamp once again collaborated on the presentation and designed a catalogue cover consisting of a female breast in foam rubber, entitled *Please Touch*. Love, the erotic and desire in its widest sense, the themes that had driven Surrealism from the start, were foregrounded even more explicitly in the post-war exhibitions.

The 1947 exhibition catalogue contained an important text by Hans Bellmer, who had exhibited *Jointure de Boules* at the *Surrealist Exhibition of Objects* in 1936. "L'Anatomie de l'amour" offers an extended and lucid analysis of the disturbing anatomical inventions of his Doll (La poupée) in photographs, objects and drawings. Bellmer's approach to the body fragment differs completely from that of Max Ernst. Instead of the startling conjunction of unlike things — limb, stone flint, airplane etc. — Bellmer multiplies and divides the same body details:

Returning now from multiplication to division and thence to the question of details, it is but a small step before a leg... begins to lead its own life of sovereign triumph. It is free to duplicate itself at will ... and is likewise free to give itself a head and rest on two splayed breasts as a cephalopod with an elastic backbone which, like its two thighs, forms a forked bridge stretching from mouth to heels.[20]

But the overarching idea for the 1947 exhibition was the need for a "NEW MYTH," around which the Surrealists would unite. This was not the first time this chimera,

[20] Hans Bellmer, *The Doll*, Atlas Anti-Classic 14 (London: Atlas Press, 2005), 130.

a new myth for our age, had been mooted by Breton. In 1920 he had hailed de Chirico for fixing in our memory the "veritable modern mythology" that was in formation, noting that the old myths like the Sphinx, with a lion's body and woman's head, were replaced in the modern world by the umbrella, the sewing machine and the top hat.[21] In *Le surréalisme en 1947* elements of science fiction, fantasies of the future or deep past, mingle with the idea of "initiation." This model of rituals, which included a "room of superstitions" and "altars," was intended as a metaphorical enactment of myth and was clearly influenced by contact with ritual and magic in the New World, as well as drawing on the Tarot and astrology. The idea that superstitions are a part of human experience and a necessary corrective to a world circumscribed by narrow definitions of utility and expedience goes back to the first *Manifesto*:

Under the pretence of civilisation and progress, we have managed to banish from the mind everything that may rightly or wrongly be termed superstition, or fancy; forbidden is any kind of search for truth which is not in conformance with accepted practices.[22]

From the room of superstitions, the visitor passed through a *Salle de Pluie* (Rain room) designed by Duchamp, negotiating billiard players and curtains of multi-coloured rain, into a room honeycombed with cavities, each of which was dedicated to "a being, category of beings or object SUSCEPTIBLE OF BEING ENDOWED WITH MYTHIC LIFE, to each of which there is an 'altar,' in the manner of pagan cults (Indian or vaudou) for instance."[23]

The *Exposition inteRnatiOnal du Surréalisme* (*EROS*) opened on 15 December 1959 at the Galerie Daniel Cordier in Paris. Like its predecessors, a *mise-en-scène* by Breton and Duchamp enveloped the spectator: the floor was covered in thick sand, the walls and ceiling were curved, with works hung everywhere, there were "perfumes and smells," and the sound of deep breathing from hidden speakers. Toyen, Brauner and Enrico Baj were among the painters whose work stands out, but most surprising was the inclusion of Jasper Johns and Robert Rauschenberg, with the latter's *Bed* prominently displayed erect beside Giacometti's *Invisible Object*. The catalogue contained a "Lexique succinct de l'érotisme" (Succinct dictionary of eroticism), an impressive display of surrealist scholarship in the field of the erotic. The recurring criticism of Surrealism,

[21] André Breton, "Giorgio de Chirico," *The Lost Steps*, 66. [22] Breton, *Manifesto of Surrealism*, 1924, in *Manifestoes of Surrealism*, 10. [23] André Breton, "Projet initiale," *Le Surréalisme en 1947*, 136.

that it took a narrow view of human desire centred on heterosexuality, is belied by the work of many of the artists who exhibited with the Surrealists, for whom desire is a free-floating signifier that unsettles bodies and objects, while gender identity, as in the photographs of Claude Cahun and Pierre Molinier, is ambiguous and unstable. There had been tentative moves towards a surrealist æsthetic in the 1930s, but these evaded formal qualities. In "La beauté sera convulsive," (*Minotaure* no. 5, 1934) Breton locates beauty within desire in its widest sense:

I admit . . . my profound indifference before natural spectacles and works of art that do not, immediately, produce in me a physical agitation characterised by the sensation of a gust of wind on the temples entailing a real shiver. I can never resist relating this sensation to that of erotic pleasure and can find between them only differences of degree.[24]

From André Breton, "La beauté sera convulsive," *Minotaure*, Paris, no. 5, 1934, p. 10, Collection of Timothy Baum, New York

The desire that Breton evokes is by no means identified with erotic spectacle; the natural world as much as a work of art can cause this physical sensation, and the examples he gives are drawn from both domains: corals from the Great Barrier Reef, crystals, photographs by Man Ray. To three of them he attached phrases that for him constituted "convulsive beauty": "Convulsive beauty will be veiled-erotic, fixed-exploding, circumstantial magic." *Erotique-voilée* [p. 308] was linked to Man Ray's photograph of a naked Méret Oppenheim; *explosante-fixe* to Man Ray's photograph of a dancer at the moment she stopped whirling but before the floating layers of her skirt fell; *magique-circonstantielle* to a strange object photographed by Brassaï, which on closer inspection turns out to be a potato sprouting roots. "Convulsive beauty" possesses a spontaneity totally at odds

[24] André Breton, "La beauté sera convulsive," *Minotaure*, no. 5, 1934, 12. [This translation by D. Ades.] This became the first chapter of *L'amour fou* (Paris: Gallimard, 1937).

with the voluntary perfectionism of "formal beauty" and is present in the slow and mysterious formation of corals and crystals, in unexpected juxtapositions like those found in the images produced by automatic writing, and in the "expiration of movement" which contains not just the visible relationship between an object moving and at rest but the very idea of life in death as also embodied in the sprouting potato. These qualities are found unpredictably, in nature as in art.

No exhibition about Surrealism can be comprehensive, not least because its visual dimension is only one aspect of the movement. There is always a problem of how to frame such an exhibition, what choices to make about the historical and geographical parameters, where to start, where to end, what to include, whether to focus on medium, theme or artist. Surrealism identified its own genealogy and one could include its chosen ancestor-artists from the Western tradition such as Hieronymous Bosch, Giuseppe Arcimboldo, Henry Fuseli, Gustave Moreau as well as those, many anonymous, from Oceania, Africa and the Americas. André Breton died in 1966, but Surrealism continues to be a point of reference and inspiration for many contemporary artists; whether we are talking about legacies on a more or less individual basis or about tighter continuities is a matter of debate. In Prague, for instance, the filmmaker Jan Švankmajer is the centre of a flourishing surrealist group, and his work is included here, though it is beyond the scope of the exhibition to pursue fully the links to contemporary practices. Recently the exhibition *Subversive Spaces* successfully brought together contemporary artists and historical surrealist work.[25]

Surrealism was not an art movement and the reasons so many artists chose to join it after World War I is one of the questions this exhibition raises. The revitalization of painting was followed by radical developments in the realms of objects and installations, an anti-art impetus that paradoxically has turned into one of Surrealism's enduring legacies. The current exhibition charts the many directions Surrealism took in its visual dimension: the "communicating vessels" that were collage, painting, photography, sculpture, objects, film, and draws out key themes that provide shared ground in the absence of any surrealist style. Some of those themes form the chapters of this book.

There is a special emphasis in the exhibition on two very different areas, neither of which has hitherto been the focus of an exhibition on Surrealism: the First Nations art

[25] *Subversive Spaces: Surrealism + Contemporary Art* (Manchester: Whitworth Art Gallery, 2009).

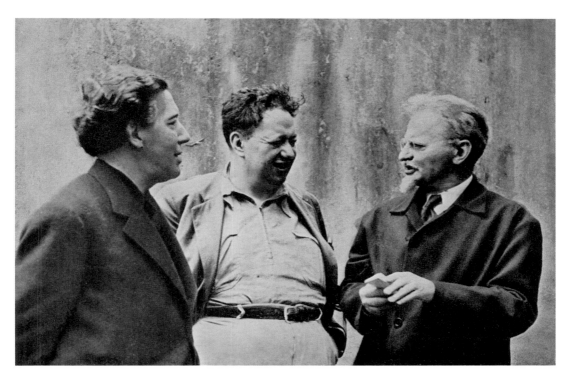

Fig. 8 Fritz Bach, *Breton, Rivera et Trotsky*, from André Breton, "Souvenir du Mexique," *Minotaure*, Paris, nos. 12/13, 1939, p. 48

of the Pacific Northwest Coast and Alaska, and film. Films, both by and admired by the Surrealists, will be threaded through the installation. The Pacific Northwest was a magnet for surrealist travellers and collectors, and masks and other objects were absorbed into their studios. Here, First Nations art will be integrated at key points in the exhibition, allowing us to better understand its power and its purposes, both on its own terms and in the context of Surrealism.

DAWN ADES is a Fellow of the British Academy and was awarded an OBE in 2002 for her services to art history. Over the past thirty years she has been responsible for many significant exhibitions in London and beyond, including *Dada and Surrealism Reviewed*, *Art in Latin America*, *Francis Bacon* and *Undercover Surrealism: Georges Bataille and DOCUMENTS*. She organized the exhibition to celebrate the centenary of Salvador Dalí, shown in Venice and Philadelphia in 2004, and has published standard works on photomontage, Dada, Surrealism, women artists and Mexican muralists. Ades is Professor of Art History and Theory at the University of Essex and Co-Director of the Centre for Studies of Surrealism and its Legacies.

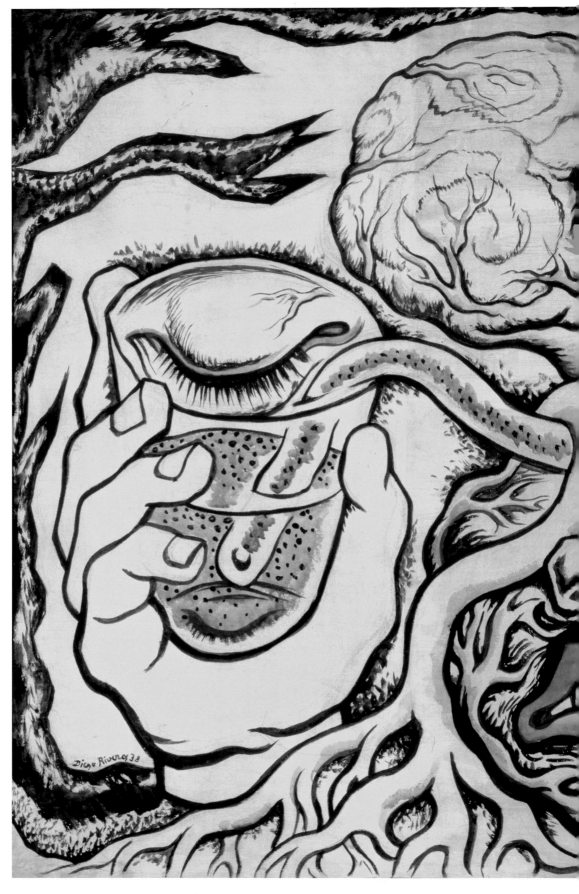

DIEGO RIVERA *Les vases communicants* [Communicating Vessels], 1938, Centre Pompidou, Paris, National Museum of Modern Art

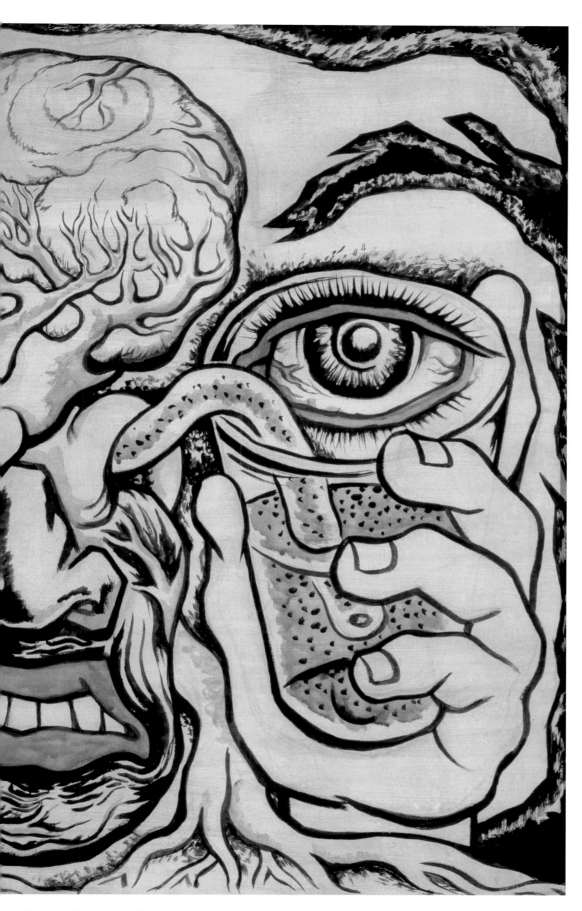

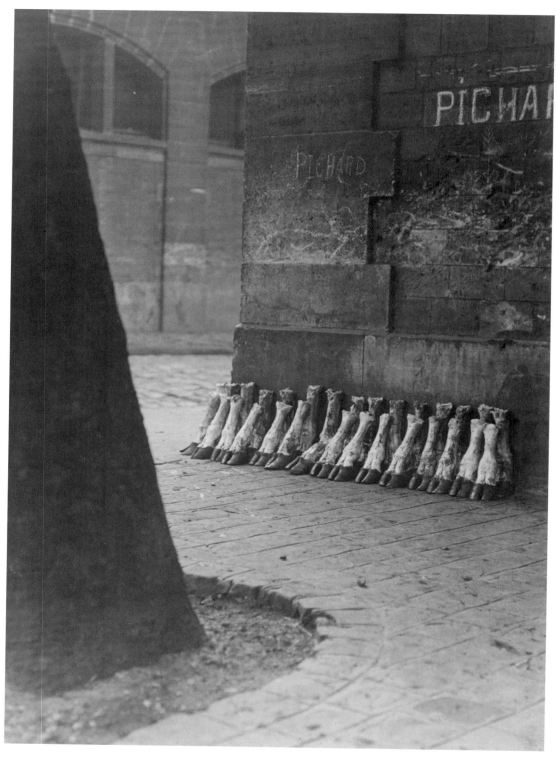

ELI LOTAR *Aux abbatoirs de La Villette* [Slaughterhouses at La Villette], 1929, The Metropolitan Museum of Art, Gilman Collection, Purchase, Denise and Andrew Saul Gift, 2005

MANUEL ALVAREZ BRAVO *Pintor de negro* [Painter of Black], 1972, Collection of Harry and Ann Malcolmson

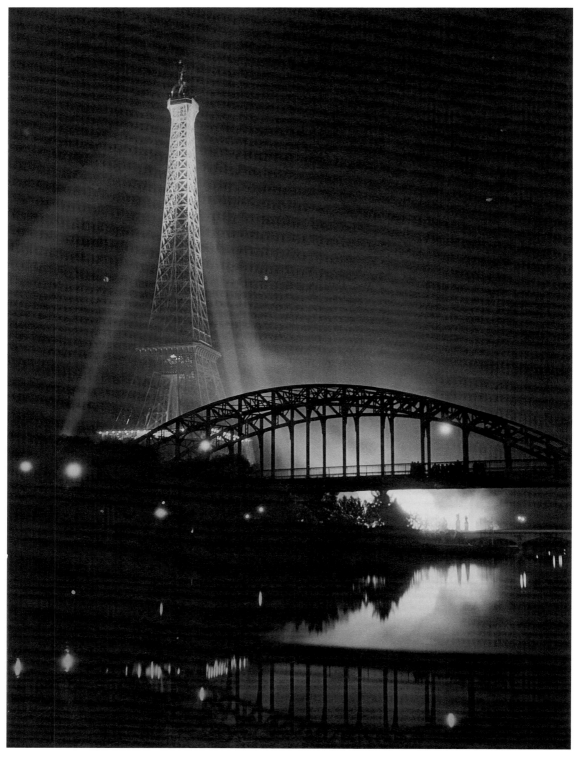

BRASSAÏ *Paris Exposition Universelle* [Paris Universal Exhibition], 1937, The Art Institute of Chicago, Gift of Michael Glicker

MAX ERNST *Hermes and Dorothea*, 1947–48, Collection of Timothy Baum, New York

AUTOMATISM

"SURREALISM, n.m. Pure psychic automatism by which it is intended to express, either verbally, or in writing, or in any other way, the true functioning of thought. The dictation of thought, in the absence of any control exerted by reason, and outside any æsthetic or moral preoccupations. … ENCYCLOPEDIA. Philosophy. Surrealism is based on the belief in the superior reality of certain forms of previously neglected associations, in the omnipotence of dream, in the disinterested play of thought. It tends to ruin once and for all all other psychic mechanisms and to substitute itself for them in solving all the principal problems of life." — André Breton, *Manifesto of Surrealism,* 1924

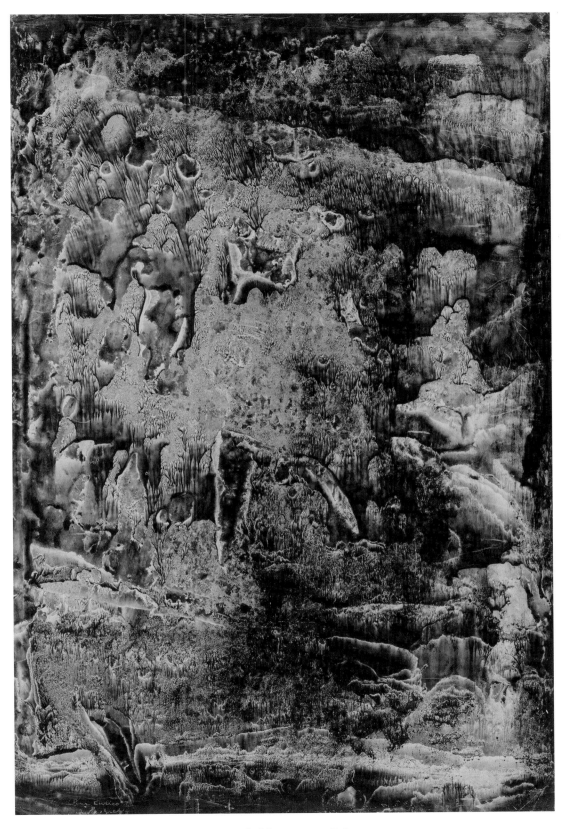

ANDRÉ BRETON *Decalcomania*, c. 1946, Collection of Adele Donati, New York

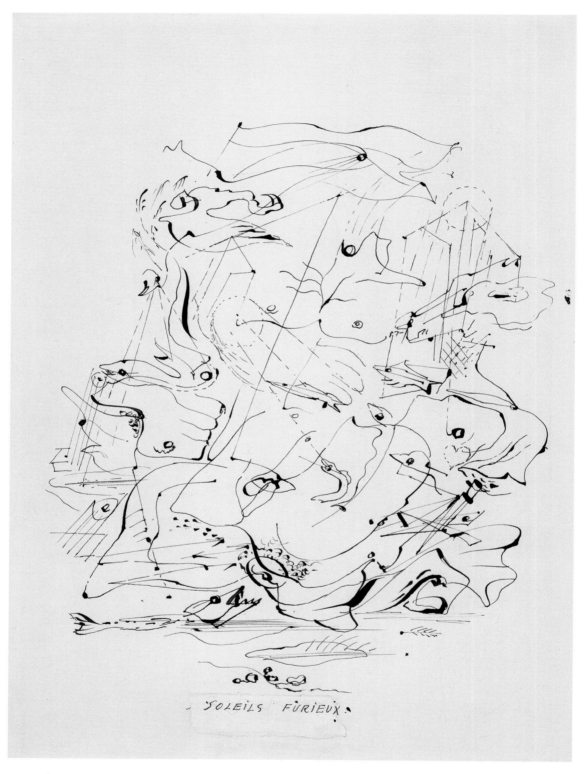

ANDRÉ MASSON *Furious Suns*, 1925, The Museum of Modern Art, New York, Purchase, 1935

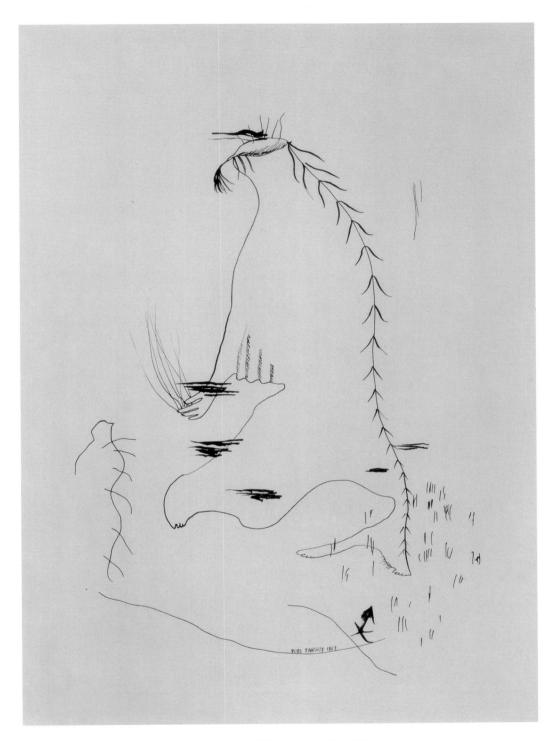

YVES TANGUY *Automatic Drawing*, 1927, Collection of Timothy Baum, New York

Automatism

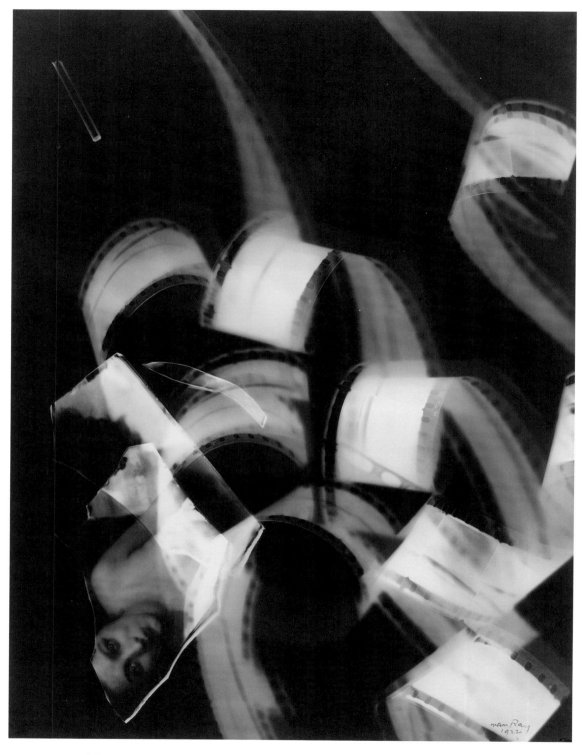

MAN RAY *Untitled Rayograph* [Kiki and Filmstrips], 1922, The J. Paul Getty Museum, Los Angeles

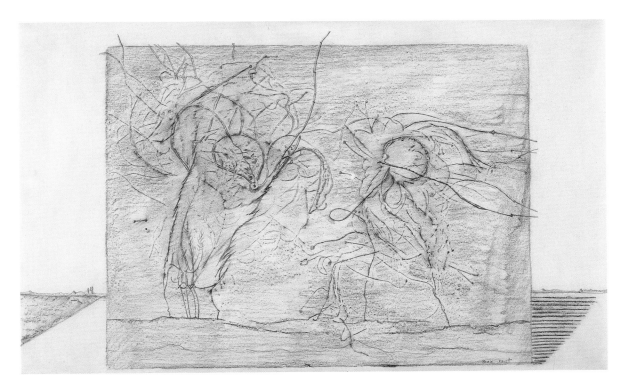

MAX ERNST *Whip Lashes or Lava Threads*, c. 1925, Baltimore Museum of Art, Gift of Mme. Helena Rubinstein

"I made from the floor-boards a series of drawings by placing on them, at random, sheets of paper which I rubbed with black lead. In gazing attentively at the drawings thus obtained, 'the dark passage and those of a gently lighted penumbra,' I was surprised by the sudden intensification of my visionary capacities and by the hallucinatory succession of contradictory images superimposed, one upon the other, with the persistence and rapidity characteristic of amorous memories."

"The procedure of frottage ... is revealed to be the real equivalent of ... automatic writing."

— Max Ernst, *Beyond Painting*, 1948

Automatism

REVOLUTION BY NIGHT

MAX ERNST *Pietà or Revolution by Night*, 1923, Tate, Purchased 1981

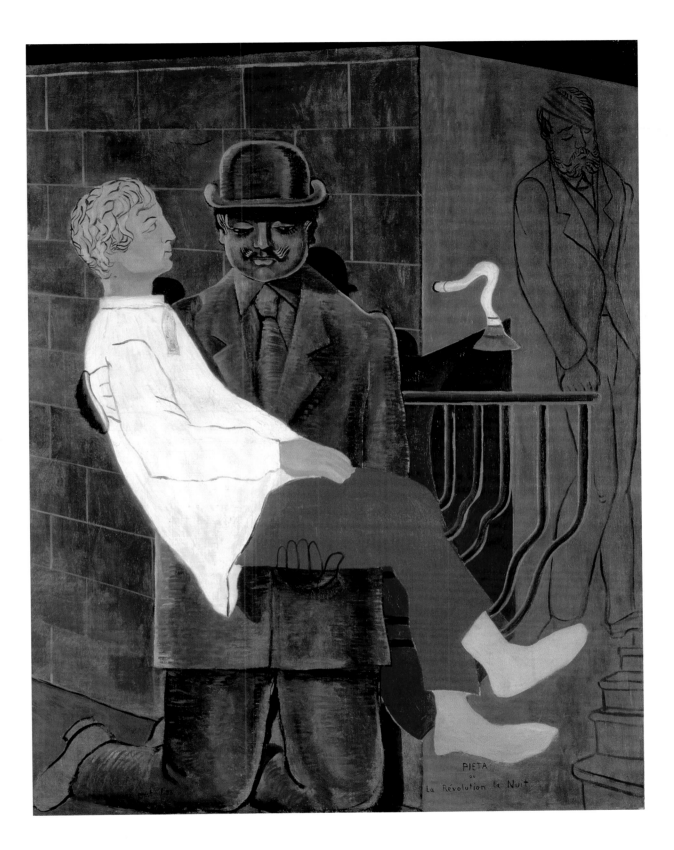

PIETA
ou
La Révolution la Nuit

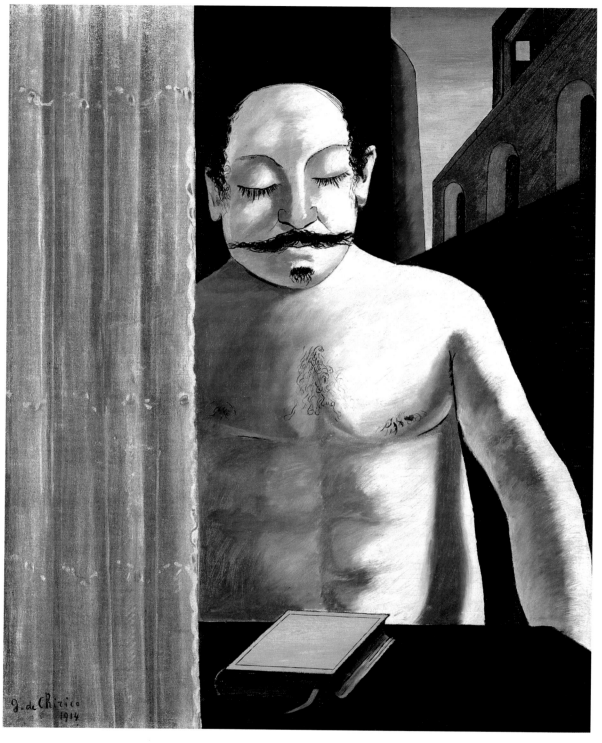

GIORGIO DE CHIRICO *Le cerveau de l'enfant* [The Child's Brain], 1914, Moderna Museet, Stockholm

HAUNTING FATHERS:

GIORGIO DE CHIRICO'S *THE CHILD'S*

BRAIN AND MAX ERNST'S *PIETÀ*

OR REVOLUTION BY NIGHT

DAWN ADES

Giorgio de Chirico's *The Child's Brain* (1914) possessed, in André Breton's opinion, exceptional powers to shock and to attract. This enigmatic image of the father continued to fascinate the Surrealists and inspired the themes of paternal threat and œdipal guilt in the work of Max Ernst and Salvador Dalí. Breton first glimpsed the painting in the window of Paul Guillaume's gallery in Paris from a bus, some time during World War I. He immediately got off the bus to look at it, and in about 1919 managed to buy it. The painting hung above his bed in his apartment on rue Fontaine for nearly fifty years, until he sold it to the Moderna Museet in Stockholm in 1964.

The Child's Brain was reproduced in the new series of the formerly dada-oriented *Littérature* (no. 1, March 1922). A full-page colour illustration in the final issue of *Minotaure*, May 1939, in association with Breton's article "Des tendances les plus récentes de la peinture surréaliste" was a reminder of its continuing power. In the *Almanach surréaliste du demi-siecle* (1950) it appeared in a startling and disturbing guise — with eyes wide open — and the caption: *1950: Réveil du cerveau de l'enfant* (The child's brain awakes).

Breton's decision to part with *The Child's Brain*, two years before his death, was partly due to recent "intolerable" remarks by de Chirico about Surrealism.[1] Relations between de Chirico and the Surrealists were complex; they had made no secret of their preference for his incomparable paintings from the period 1913–1917 and their contempt for his subsequent regression, as they saw it, to a traditional painterly style. In 1926, in "Le surréalisme et la peinture," Breton challenged de Chirico to have the courage to give up "the game he was playing that led him to ridicule his lost genius," and a recent painting by de Chirico was reproduced scribbled out.[2] Nonetheless, de Chirico

frequently spent time with the Paris group in the early years, was depicted together with the other members of the circle by Max Ernst in *The Meeting of Friends* (1922) and can be seen in photographs from 1924–5 of gatherings at the Bureau of Surrealist Research, an office in Paris where artists and writers met for discussions and research. Moreover, a "Dream" of de Chirico's was the first text published in the first issue of the first of the great surrealist journals, *La révolution surréaliste* (December 1924). This, significantly, was a dream about his father:

In vain I struggle with the man with shifty and very tender eyes. Every time I grasp him he detaches himself by spreading his arms, and these arms have an unsuspected strength, an incalculable power . . . it is my father who appears in my dream but when I look at him he is not at all as I saw him when he was alive, in my childhood. And yet it is him . . .[3]

However, de Chirico once admitted to Breton that *The Child's Brain* depicted a personage who haunted him, and appeared to be a compromise between his father and Napoleon III.[4] The contradictory combination of signs of authority and of vulnerability, such as the imperial moustache and the dormant nakedness of the body, the curtain or screen that partially hides it, the book that lies facing the viewer rather than the man, the curved red shape behind him that does not fit with the architecture, all contribute to the enigmatic quality of the painting. This, together with the title, invites a psychoanalytic reading, which Robert Melville provided in 1940. Melville draws on Freud's thesis that the child goes through a phase of desiring his mother and wishing to kill his father, named the Œdipus complex after the Greek myth.[5] *The Child's Brain*, Melville writes, is

a jealous and malicious image of the father, and we see him as Ham saw his father, Noah, "uncovered within his tent." A curtain has been drawn aside to reveal a middle-aged man stripped of every emblem of authority except his comic moustaches and little rag of a beard. Nothing could be more ludicrous than this flabby, naked father The father's eyes are closed; they are closed for the simple reason that the child would not dare to look if they were open They are sealed by the child's instinct of self-preservation. The father has a criminal power and must therefore remain unaware of his shaming.

Melville continues his Freudian reading by identifying the closed book and the buildings, including the curious red shape, as the mother. Breton was impressed with Melville's text, which he later quoted at length, but noted that it hardly exhausted the enigma of the painting.[6] The American painter Robert Motherwell, writing in the New York surrealist

Fig. 9 Giorgio de Chirico, *Réveil du cerveau de l'enfant* [The child's brain awakes], from *Almanach surréaliste du demi-siecle*, Paris, 1950, ©Estate of Giorgio de Chirico/SODRAC (2011)

journal *VVV*, also describes the ambiguity of the figure, but places more emphasis on its fearful and inescapable presence:

Yes, the father! Shockingly naked but unrevealed, hairy, immovable, inescapable, standing like a massive rock on the silent shore of the unconscious mind, a rock unseeing, with its closed eyes, but a rock resisting all attempts to pass beyond . . . a rock eternally waiting, waiting for when it will be at once judge and executioner, judge of the guilt inherent in killing the origin of one's being in order to be, and executioner by virtue of one's fear of being free.[7]

Max Ernst would have seen *The Child's Brain* frequently in Breton's apartment after arriving in Paris in September 1922. He was in time to participate in the *époque des*

sommeils or *expérience des sommeils* during the autumn of 1922, when the group of former Dadaists and future Surrealists experimented with hypnotic trances. When in this state the subject was able to speak, respond to questions, write and draw, but could recall nothing on awakening. The results were strange and poetic, and seemed to open a window onto the unconscious. Ernst's *Pietà or Revolution by Night*, greeted by Breton as a "revelation," refers to these trances that often dwelt on themes of death, suicide and madness, and is also a kind of homage to de Chirico. Like *The Child's Brain* it is an apparently simple image, rudimentarily painted but highly charged, enigmatic and apparently dense with meaning. And it is very like a dream, or rather the way a dream works as Freud described it: the condensation of ideas, the multiple and sometimes contradictory identities of beings and the irrationality that is experienced as thoroughly logical.

The three figures in *Pietà* have multiple overlapping identities. The young man wearing a white gown is a self-portrait suggesting, "La blouse blanche de Fraenkel à la Salpetrière," what the poet Robert Desnos, while in a trance, had replied when asked what he knew of Max Ernst. The reference is to a doctor in a white gown at the hospital where the French neurologist Jean-Martin Charcot worked. The young man is in the arms of an older man who can be identified, via Ernst's description of a childhood dream, or rather "a vision of half-sleep," as his father. In this infantile vision a man with turned up moustaches and a bowler hat draws with a large pencil in thick black lines terrifying creatures which he then gathers into a top and starts whipping with his pencil/crayon. The child Ernst suddenly recognizes this strange painter as his father.[8] Ernst concludes his recollections by noting that he was reminded of it during puberty when he speculated about his father's conduct on the night of his conception, "of which he decided he had a distinctly unfavourable impression."

The young man in the painting is turned to stone, recalling paintings by de Chirico, such as *The Uncertainty of the Poet* (1913) and *Portrait of Apollinaire* (1914), with similarly uncanny melding of flesh and marble. So the figures are both father and son, and (God the) Father and (Christ the) Son. The title *Pietà* normally shows the dead Christ in the arms of his mother, but there are examples in South German wood carvings of the Father cradling the son. In this context the third figure, drawn in the background, could complete the trilogy as the Holy Ghost. (Other possibilities include Freud, and Ivan from Dostoevsky's *The Brothers Karamazov*, who wrapped his head in a towel after discovering he was indirectly responsible for his father's death.)[9] Several paintings

by Ernst of this period have a pronounced sacrilegious character, such as *Resurrection of the Flesh*, also known as *The Last Judgement*, in which an animated naked statue gesticulates along a prison-like corridor lined with carcasses of beef.

In *Pietà*, although the subject is Œdipal, the relations are reversed and it is the son rather than the father who is dead. Ernst may be summoning up here the notion of "self-punishment for a death-wish against a hated father," or he may be relating an inverted Œdipal wish, as in Freud's case history *The Wolf Man*, in which the patient's neurosis springs from conflicting emotions of desire for and fear of the father.[10] This should not be taken as psychoanalyzing Ernst himself. Unlike de Chirico, who always denied knowing the work of the founder of psychoanalysis, Ernst was familiar with Freud, knew his case histories and used them brilliantly in the charged discovery period of Freud's revelations about the unconscious and its links to dreams: a hidden world to be made visible. Whether or not he is recreating an actual dream one can never know.

Pietà or Revolution by Night is often taken as a proto-surrealist painting, given that it pre-dates the formation of the surrealist movement. In the intense period between the end of Dada in 1922 and the publication of Breton's first *Manifesto* in 1924, when the hypnotic trances, dreams and what Breton calls "psychic automatism"[11] were all explored and he began to annex the term Surrealism, *Pietà* was undoubtedly a revelation. Ernst's painting was already, in this respect, fully surrealist.

[1] Paule Thévenin, "Les énigmes du 'Cerveau de l'enfant,'" *André Breton: La beauté convulsive* (Paris: Éditions du Centre Georges Pompidou, 1991), 104. [2] André Breton, "Le surréalisme et la peinture," *La révolution surréaliste* no. 7 (1926), 5. [3] Giorgio de Chirico, *La revolution surréaliste* (December 1924), 3. [4] André Breton, "Lettre à Robert Amadou," *Perspective cavalière* (1970), 39. [5] Robert Melville, "The Visitation," *London Bulletin* (1940), 18–20. There are various versions of the Œdipus legends, but this is the basic story. Following a prophecy that the king of Thebes, Laius, would be killed by his son, the child was left to die on a hillside. Rescued and brought up in ignorance of his origins, Œdipus returned to Thebes, unwittingly kills his father and marries his mother, Jocasta; when he discovers the truth he blinds himself. [6] "Lettre à Robert Amadou," 42. [7] Robert Motherwell, "The Art of Reaction: The Late de Chirico," *VVV* no. 1 (1942), 60. [8] *La révolution surréaliste* nos. 9/10 (October 1927), 7. [9] For more extended analyses of the painting see Malcolm Gee, "Max Ernst, God and the Revolution by Night," *Arts Magazine* 55 (7 March 1981); Dawn Ades, "Between Dada and Surrealism: Painting in the *Mouvement flou*," *In the Mind's Eye: Dada and Surrealism* (Chicago: The Museum of Contemporary Art, 1984) and Uwe Schneede, "Sightless Vision: Notes on the Iconography of Surrealism," *Max Ernst: A Retrospective* (London: Prestel, 1991). [10] See Gee, ibid. [11] André Breton, "Entrée des mediums," 1.

THE COLOUR OF MY DREAMS

JOAN MIRÓ *Personnage* [Person], 1925, Solomon R. Guggenheim Museum, New York, Estate of Karl Nierendorf, by purchase

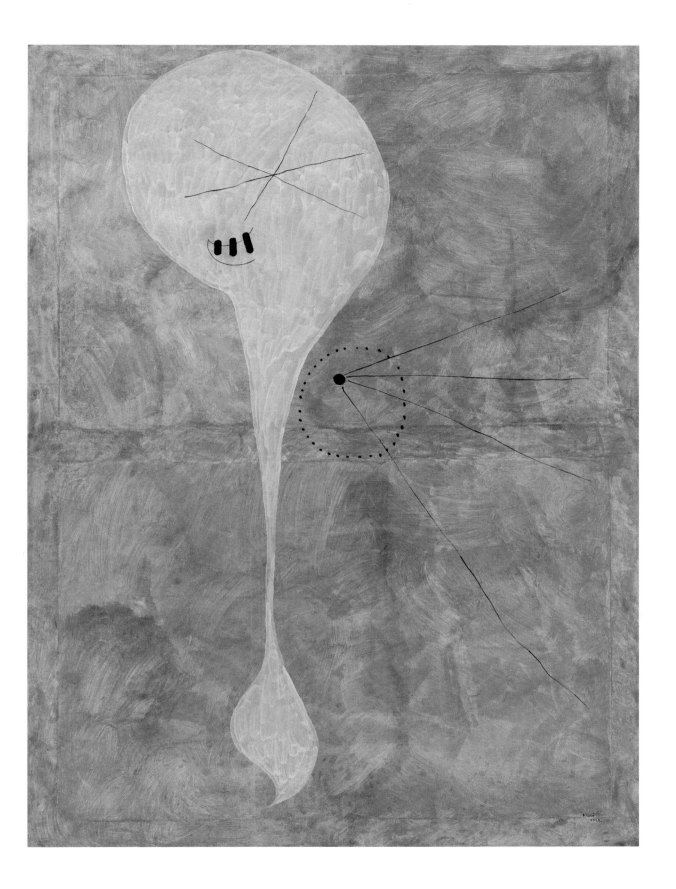

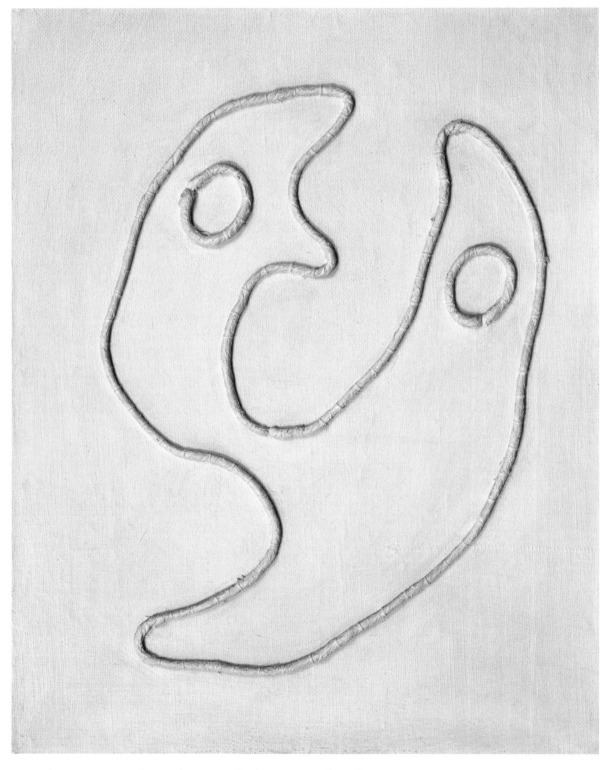

JEAN (HANS) ARP *Two Heads*, 1927, The Museum of Modern Art, New York, Purchase, 1936

THE COLOUR OF MY DREAMS

What made Surrealism such a magnet for artists? Unlike other trends in the visual arts after the First World War, such as Cubism, Neo-classicism, Magical Realism, or Futurism, it offered no particular formula for painters, who were only mentioned in a footnote in André Breton's first *Surrealist Manifesto*. Nonetheless, the artists who gravitated to its orbit were to revolutionize painting, though each in their own way. Drawn to the movement that became the most powerful intellectual and poetic force in the 1920s and 30s, artists responded to surrealist ideas that invited a radical approach to expression, re-opened the possibilities of experiment and removed the dada veto on creativity. Several artists of the first hour were inherited from Dada; for example, Max Ernst, Jean Arp, Man Ray. Others like André Masson and Joan Miró were invited to join the group in 1924.

Automatism, the key founding principle of Surrealism, didn't offer a straightforward route for artists, and at first was not clearly differentiated from dream narratives. Moreover, painting was regarded by many of the Surrealists as irretrievably dated and unsuited to the exploration of the unconscious. The battle over painting as a medium suitable for Surrealism ended when Breton took control of the surrealist journal in 1925 and began his series of articles on "Surrealism and Painting." Breton recognized the liberating effects of Automatism in the Surrealists' very diverse paintings. In Miró's canvases, often blue-washed, the surfaces are alive with freely-applied colour. *Photo: Ceci est la couleur de mes rêves* plays with the idea of capturing inner worlds, painting as a snapshot of dreams. Paintings in Surrealism's first decade ranged from the near abstraction of Miró, Arp and early Salvador Dalí to the imaginary landscapes of Yves Tanguy. In the early 1940s Masson returned to the free associations and unexpected juxtapositions in canvases like *Meditation on an Oak Leaf*.

[D.A.]

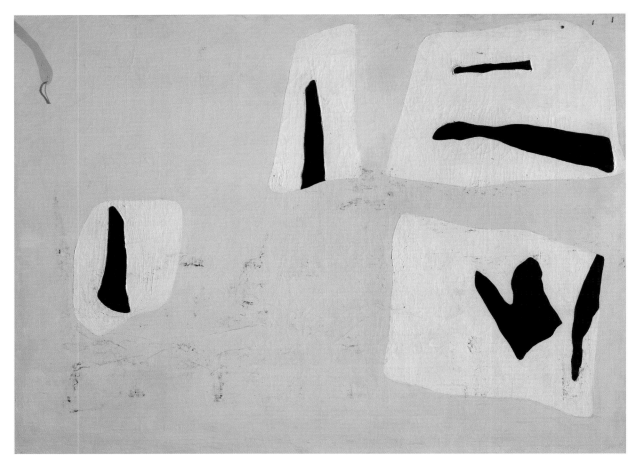

SALVADOR DALÍ *Sin título* [Abstract Composition], c. 1928, Museo Nacional Centro de Arte Reina Sofía, Madrid

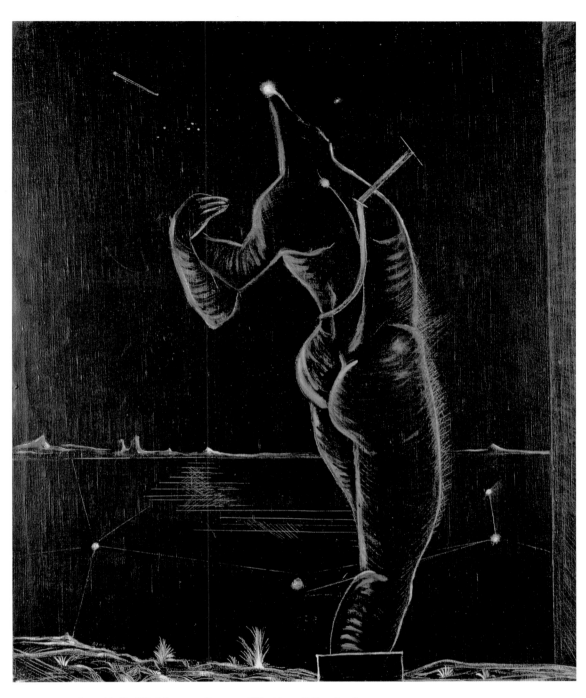

MAX ERNST *Roter Akt* [Red Nude], c. 1923, Courtesy of The Mayor Gallery, London

JOAN MIRÓ *Photo: Ceci est la couleur de mes rêves* [Photo: This is the Colour of My Dreams], 1925, The Metropolitan Museum of Art, The Pie▶

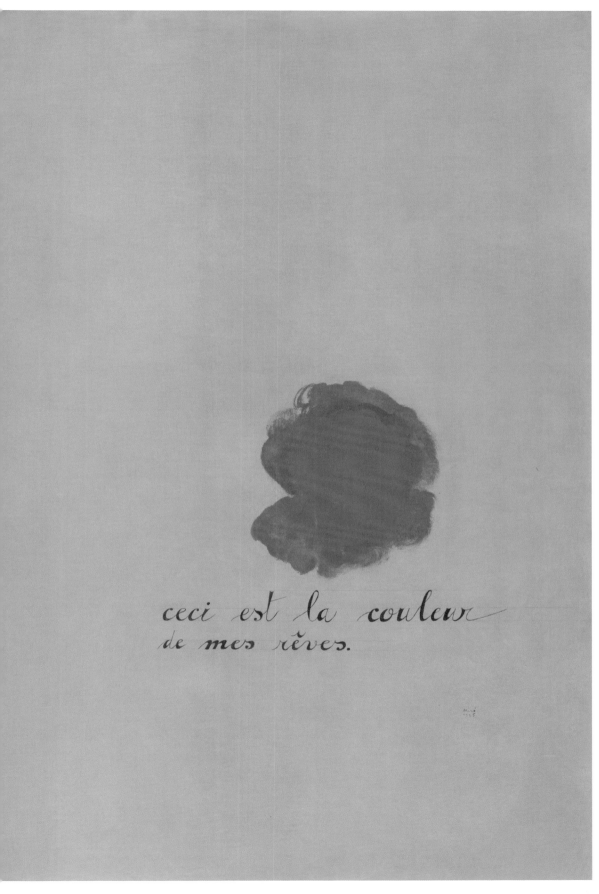

PAINTING AS OBJECT: JOAN MIRÓ'S *PHOTO : CECI EST LA COULEUR DE MES RÊVES*, PARIS 1933

ANNE UMLAND

In June of 1933, the lavishly illustrated French photojournal *VU* published a photograph captioned *Joan Miró Objets*, part of a two-page photographic essay with text by the surrealist writer René Crevel, titled "Surréalisme."[1] The suggestion that the photograph shows multiple *objects* by Miró is misleading, given that it features only one single — and singular — work attributable to him. That work, moreover, is not an object per se, but a painting: the enigmatic 1925 canvas *Photo: Ceci est la couleur de mes rêves* (Photo: This is the Colour of My Dreams). This painting, perhaps more than any other, has been considered emblematic of the profound relationship between painting and poetry in Miró's work of the mid 1920s. Through the formless splotch of blue paint on the work's right side, it also epitomizes, arguably, Surrealism's foundational preoccupation with dreams and with Automatism — understood as the seismic registration of unprocessed thought. The photograph published in *VU*, however, taken some eight years after the making of *Photo: Ceci est la couleur de mes rêves*, captures Miró's canvas and Surrealism itself at a very different moment.

The *VU* article that June appears to have been prompted by two back-to-back Paris exhibitions held the same month at the Galerie Pierre Colle. From June 7 through 18, the gallery presented a collective *Exposition Surréaliste*. This was followed, from June 19 through 29, by a monographic exhibition devoted to the painter, filmmaker, theoretician and object-maker Salvador Dalí, a Catalan compatriot of Miró's and the sensation of Surrealism's second generation. Dalí and Miró had worked together closely in the past, and Miró had done much to support the younger artist's work, but by 1933 their relationship had soured. So too had Dalí's attitude toward the surrealist ideals of the 1920s, as

Within the figure image:

perception, Baudelaire entrevit sans leur donner des contenants aux contours objectifs. Grâce au surréalisme, il n'y a plus de cloisons étanches entre les choses et leurs reflets dans l'homme, les idées ; plus de cloisons étanches entre le monde extérieur et le monde intérieur. Un pont de mouvantes images fait la navette du sujet à l'objet, permet au premier de transformer le second et vice versa.

En tout temps, en tout lieu, le surréalisme sait trouver son laboratoire où métamorphoser, toutes portes ouvertes, en réalité vivante, en réalité vécue cette injonction de Lautréamont : la poésie doit être faite par tous et non par un.
René CREVEL.

SALVADOR DALI
Buste de femme rétrospectif

PHOTOS BUFFOTOT

JOAN MIRO
Objets.

N° 275 VU P. 923

Fig. 10 *Joan Miró Objets*, in "Surréalisme," in *VU*, Paris, no. 275, June 21, 1933, p. 923; page includes works by André Breton, Buffotot, René Crevel, Salvador Dalí, Max Ernst, Alberto Giacometti, Valentine Hugo, Joan Miró, photomechanical print; The Getty Research Institute, Los Angeles (84-S406)

evidenced by his aggressive promotion of his paranoid-critical method as an alternative to the movement's prior (in his view) passive reliance on Automatism and dreams.

Careful scrutiny of the *VU* photograph reveals that many of the objects pictured have direct connections to Dalí. A tea set, which features images of Jean-François Millet's ubiquitously reproduced 1857 painting *The Angelus*, appears identical to Dalí's so-called Angelus tea set.[2] The square, shadowy object at the photograph's lower centre is one of the small painted glass and wood dioramas that Dalí made in the 1930s, this one connected to his 1932 film scenario *Babaouo* [p. 76].[3] Even the bust at the left, which may be a plaster copy of one of the nineteenth-century German sculptor Christian Daniel Rauch's many idealized likenesses of Charlotte, Princess of Prussia, may prove to be Dalí related.[4] Like the other objects in the photograph, it is carefully positioned in relation to Miró's painting: the princess's meticulously rendered curls rhyme humourously with the calligraphic curlicues of Miró's script, while her profile — crowned and captioned by the word "Photo"— points toward and mirrors Miró's abstract blob of paint. The confrontation staged between flattering figuration and lyrical painterly abstraction, and between photographic realism and the intangible matter of dreams, realigns and contests the original terms of Miró's work.

Fig. 11 Salvador Dali, *Babaouo*, 1932, wood and painted glass diaorama, Fundació Gala-Salvador Dalí,
Figueres, ©Salvador Dalí, Fundació Gala-Salvador Dalí/SODRAC (2011)

No evidence has so far been located to prove Dalí's involvement in the *VU* photograph, but the objects it shows, their compositional positioning and the dramatic lighting and shadows point to his directorial hand.[5] And the photograph forces Miró's painting to announce the mechanism of its own undoing. Reproduced in black and white, the word "Photo" gains status, as the blue that outweighs it in the painting is neutralized by the achromatic medium (photography) that the work names. At the same time, the material and æsthetic differences between Miró's work and the objects in front of it are seamlessly collapsed. The caption *Joan Miró Objets* makes Dalí's likely intervention even more insidious, naming Miró as the agent of an act of aggressive appropriation and intentional violation that actually disseminates Dalí's paranoid method of double-viewing.[6]

"Paranoiac-critical activity no longer considers surrealist phenomena and images by themselves," wrote Dalí in *The Conquest of the Irrational* (1935), "but on the contrary as a coherent whole of systematic and significant relations."[7] By positioning a naturalistic portrait bust, images mechanically reproduced on porcelain and a dimensional diorama connected to film in front of Miró's painting, Dalí — or if not Dalí, surely someone familiar with his ideas and work — effectively created a "coherent whole of systematic and significant relations," relegating Miró's painting to the background, presenting it as one object among others, rendering it symptomatic of painting's increasingly contested status within Surrealism in the 1930s. The closing line of Crevel's essay, printed directly above the photograph *Joan Miró Objets* quotes Lautréamont: "La poésie doit être faite par tous et non par un" (Poetry must be made not by one person but by everyone). By photographing Miró's 1925 canvas in relation to his own choice of objects, Dalí did just that, transforming a unique work made by Joan Miró into a component part of a visual performance orchestrated by Salvador Dalí.

[1] René Crevel, "Surréalisme," *VU* (Paris), no. 275 (June 21, 1933), 922–23. [2] Salvador Dalí later reproduced the tea set in his book *Le Mythe tragique de l'Angélus de Millet, Interprétation "paranoïque critique"* (Paris: Jean Jacques Pauvert, 1963). This reproduction is in turn reproduced in Jordana Mendelson, *Documenting Spain: Artists, Exhibition Culture, and the Modern Nation, 1929–1939* (University Park: The Pennsylvania State University Press, 2005), 197, fig. 145. [3] I am grateful to Montse Aguer, Director of the Fundació Gala-Salvador Dalí, Figueres, for identifying this object. [4] For a closely related bust by Christian Daniel Rauch, see Jutta von Simson, *Christian Daniel Rauch: Œuvre-Katalog* (Berlin: Gebr. Mann Verlag, 1996), 108–9, cat. 61. [5] All the photographs in this spread of *VU* related to the Galerie Colle *Exposition Surréaliste* installation are credited Photos Buffotot, the name of a photo agency. The actual photographer is unidentified. [6] The chronology of Miró's movements makes it virtually impossible for him to have composed the arrangement of objects attributed to him by *VU*: he was in Barcelona through June 18 and arrived in Paris a few days later, most likely after the *VU* article appeared. [7] Salvador Dalí, *The Conquest of the Irrational* (New York: Julien Levy, 1935), 16. Quoted in Mendelson, *Documenting Spain*, 155.

ANNE UMLAND, Blanchette Hooker Rockefeller Curator in the Department of Painting and Sculpture at The Museum of Modern Art in New York, recently organized the MoMA exhibitions *Picasso: Guitars 1912–1914* (2011), *Joan Miró: Painting and Anti-Painting 1927–1937* (2008–09) and *The Erotic Object: Surrealist Sculpture from the Collection* (2009–10). In 2006 she coordinated MoMA's presentation of *Dada*, organized by the National Gallery of Art, Washington, DC and the Centre Georges Pompidou, Paris, and co-edited *Dada in the Collection of The Museum of Modern Art* (2008).

"The tide ebbs, revealing an endless shore where hitherto unknown composite shapes creep, rear up, straddle the sand, sometimes sinking below the surface or soaring into the sky. They have no immediate equivalent in nature and it must be said that they have not as yet given rise to any valid interpretation." — André Breton, "What Tanguy veils and reveals," *View*, 1942

Death Watching his Family, 1927, was included in the exhibition *Yves Tanguy et Objets d'Amérique* at the Galerie surréaliste in Paris in 1927. Tanguy and Breton had found titles for all the paintings in the exhibition in psychiatry textbooks, and all had the same variant title: *Quand on me fusillera* (When They Shoot Me). Breton wrote the preface to the exhibition catalogue, where he muses on Tanguy's mysterious landscapes and their inhabitants, who belong to neither sea nor sky. This was a theme he returned to several times, while warning against attempts to interpret and explain Tanguy's paintings.

[D.A.]

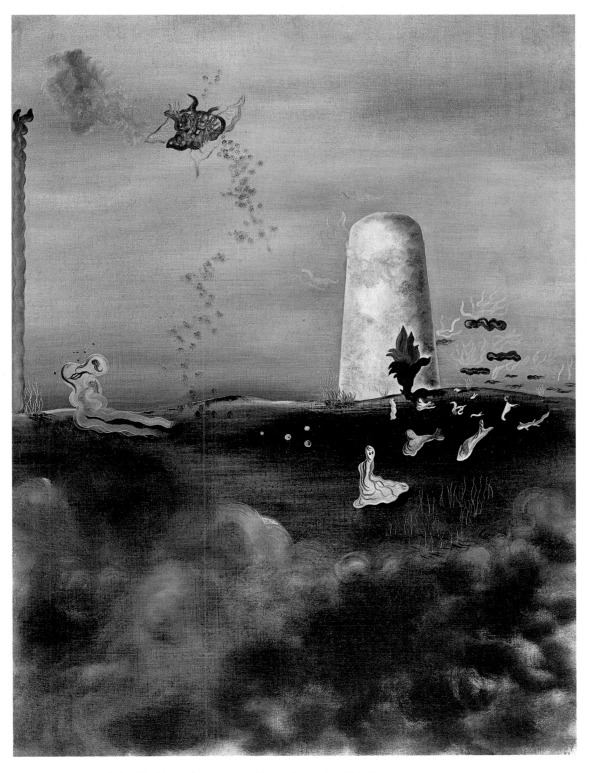

YVES TANGUY *Death Watching his Family*, 1927, Museo Thyssen-Bornemisza, Madrid

JOAN MIRÓ *Personnage de la nuit* [Person of the Night], 1944, The Pierre and Tana Matisse Foundation Collection, New York

JOAN MIRÓ *Shooting Star*, 1938, National Gallery of Art, Washington, Gift of Joseph H. Hazen

ANDRÉ MASSON *Paysage aux prodiges* [The Landscape of Wonders], 1935, Solomon R. Guggenheim Museum, New York, Bequest, Richard S. Zeisler, 2007

PHILOSOPHY IN A PAINTING:
ANDRÉ MASSON'S *OPHELIA* (1937)

DAVID LOMAS

In 1940 the modernist critic Clement Greenberg accused the Surrealists of an egregious "confusion of literature with painting as extreme as any of the past."[1] There is no escaping Masson's susceptibility to the charge. Masson was redeemed in the eyes of these critics, to an extent, by his later influence on the Abstract Expressionists who learned the automatist technique from him and shared his passion for myth and instinct. While not indifferent to the formal aspects of his medium, Masson in the 1930s evolved a concept of painting as primarily a vehicle for the expression of a complex philosophical vision.

Not coincidentally, Masson was designing stage sets for Cervantes' *Numance* when he painted *Ophelia* [p. 84], whose subject is taken from *Hamlet*. Shakespeare's Ophelia is famous as a prototype of female madness. Masson has chosen to represent her drowning, as recounted by the Queen in Act IV, Scene VIII, in a monologue that served as a literary pretext for nineteenth century artists like the pre-Raphælite John Everett Millais or the French academic painter Alexandre Cabanel.[2] In the play Ophelia climbs out on a branch of an overhanging willow ("There is a willow grows aslant a brook") which breaks, causing her to fall in. It is this interlude before she sinks beneath the water, when she is held afloat by her clothes spread wide, that Masson depicts. Note the truncated willow at upper left. Ophelia has fallen into a stagnant pool where reeds poking through a layer of algæ will soon close over her. Her pallid profile and its sombre shadow are contained within an inverted thought bubble. Her mouth is open as she sings. She is adorned with a flower garland ("crow-flowers, nettles, daisies, and long purples") and a daisy in place of her eye, flowers symbolic of her madness.

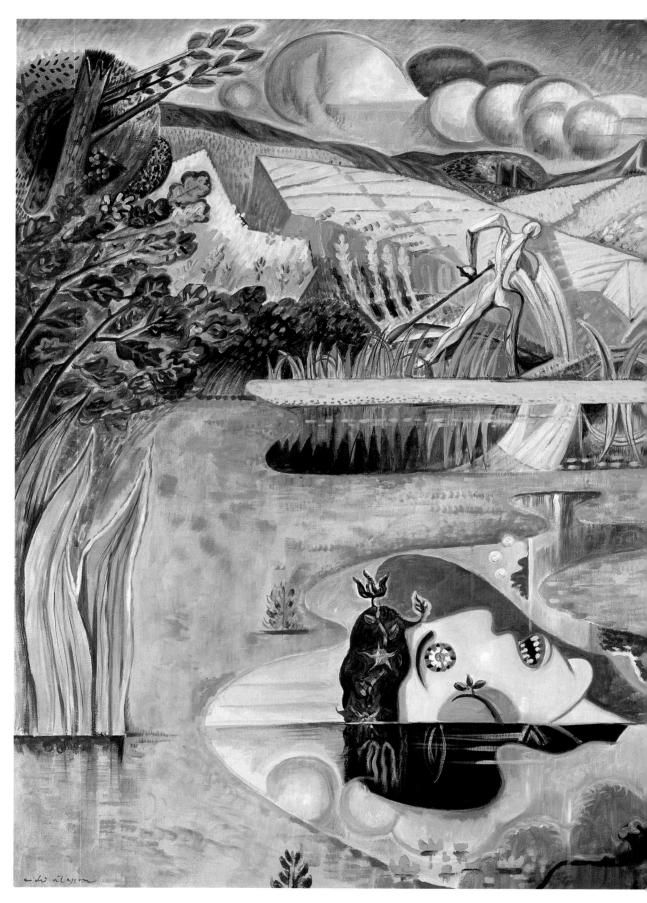

ANDRÉ MASSON *Ophelia*, 1937, Baltimore Museum of Art, Bequest of Sadie A. May

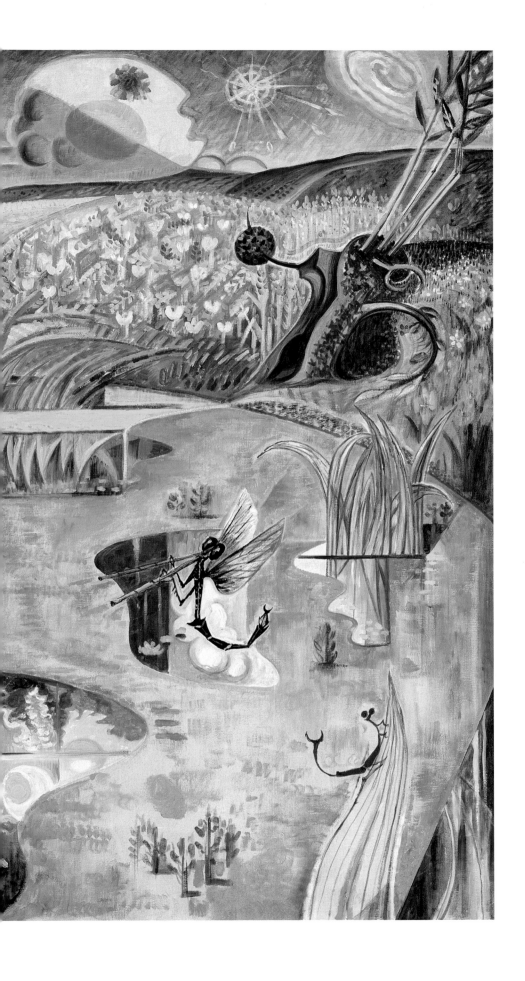

While conveying with great immediacy the countryside of the Isle de France where Masson took up residence after fleeing the Civil War in Spain at the end of 1936, *Ophelia* also condenses a number of motifs from the previous years. Masson had used the figure of death the reaper in his images of war-torn Spain. The cosmic spectacle of shooting stars and constellations recalls *The Landscape of Wonders* (1935) from the period of his association with Georges Bataille, who wrote of the vertiginous, spiralling energies in such pictures: "there exists neither ground nor bottom, but a blazing festival of stars."[3] At the same time, we have accounts of Masson kneeling in the grass and holding tiny insects in his large hands, absorbed in nature at a microcosmic level. His fantastical pictures of praying mantises and other insects, to which the flute-playing dragonfly in *Ophelia* is related, reminded Masson's friend Georges Limbour of Shakespeare.[4] Overall, there is greater lyricism and less violence and cruelty in *Ophelia* than in the preceding Spanish landscapes; despite the omnipresence of death, there is a pantheistic solace to be found in nature. *Ophelia* recapitulates the decade or more before it was painted, but it also looks ahead, containing in germ the themes that would bear fruit during Masson's years in exile in the United States. The oak sapling at the left hand border matures into *Meditation on an Oak Leaf* (1942), a major canvas of Masson's years in exile.

Masson's choice of a Shakespearean theme goes hand in hand with his growing pre-occupation with German Romanticism — with Goethe[5] especially, and with Novalis and the other German Romantics who remade Shakespeare in their own image. Goethe himself undertook an analysis of the character of Hamlet in *Wilhelm Meister's Apprentice* (1796), describing him as an "oak tree planted in a precious pot which should only have held delicate flowers."[6] A series of portraits from 1940 attests to Masson's interest in Goethe, and particularly the latter's writings about science, although his interest certainly had begun before that. The *Metamorphosis of Lovers* of 1936 reveals an awareness of *Die Metamorphose des Pflanzen* (1790), Goethe's treatise on botany. Goethe sought to prove that all the parts of a tree derive from differentiation of a leaf-form, a notion that informs the painting *Meditation on an Oak Leaf*. The inclusion of what appears to be a germinating plant at the bottom edge of *Ophelia* may stem from this source: Goethe refers to his direct observations of plant growth. More generally, Masson was receptive to German *Naturphilosophie*, which posited the existence of a vital force animating and infusing all of nature.

The other key area of Goethe's scientific investigations that engaged Masson was his colour theory (*Fahrbenlehre*). Goethe thought that perception of colour originated in the interaction of light and darkness, from which he adduces the primacy of the tonal colours of yellow and blue:

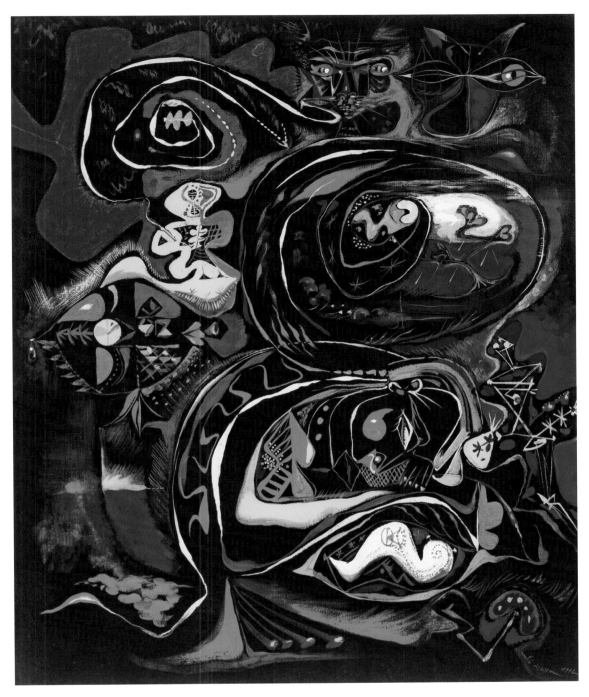

ANDRÉ MASSON *Meditation on an Oak Leaf*, 1942, The Museum of Modern Art, New York, Given anonymously, 1950

Philosophy in a Painting

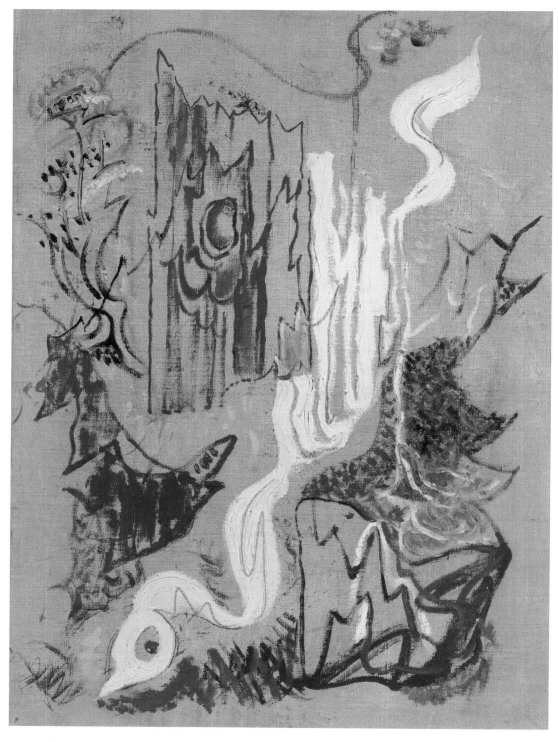

ANDRÉ MASSON *Paysage au serpent* [Landscape with Snake], 1927, Courtesy of The Mayor Gallery, London

Light and darkness, brightness and obscurity, or if a more general expression is preferred, light and its absence, are necessary to the production of colour. Next to light, a colour appears which we call yellow; another appears next to the darkness, which we name blue. When these, in their purest state, are so mixed that they are exactly equal, they produce a third colour called green.[7]

Goethe believed that painting was able to demonstrate the truth of these theorems better than nature herself, because it is "an art which has the power of producing on a flat surface a much more perfect visible world than the actual one can be."[8] Masson would have been in sympathy with this view. Ophelia's Janus-like head with its doubled reflection (recalling Picasso's female heads) contains both light and dark, a duality reflected secondarily in the yellow (light) and blue (dark) hues that dominate the landscape. The unnatural green of the sky represents their mixture. In metaphysical terms, dark and light are symbolic of death and renewal.

In Masson's *Narcissus*, another large picture from 1937, he combines the central motif of drowning with the idea of botanical metamorphosis. The idea that Narcissus drowned, though not present in Ovid, is found in some later versions of the myth.[9] The two subjects are connected by the suicide of the main protagonist. The presence of narcissi on the water's edge at the right of *Ophelia* offers a clue to their correspondence.[10] Can we say that Ophelia plays Echo to Narcissus? Ophelia's madness was interpreted as lovesickness, from which the nymph Echo also suffered in her frustrated desire for Narcissus. Another link can be found in Masson's focus on the play of reflections across the water and the visual echo between Ophelia and the head-like form of a distant cloud. In the latter case, Masson may have taken a cue from the dialogue between Polonius and Hamlet in Act III, Scene II, "Do you see yonder cloud . . . ," in which they discern the forms of animals.[11] Hidden profile self-portraits occur in other pictures by Masson. Were that true in this case, it would imply an analogy between the artist's projection or immersion (of the self in the landscape) and Ophelia's.

What is the underlying meaning of this subject for Masson? In the philosopher Gaston Bachelard's instructive analysis of the Ophelia complex,[12] he interprets her drowning as the return to an essentially feminine domain. This reference to "son propre élément" suggests a link with other works by Masson, such as *Le Fil d'Ariane* (1938), that represent burial in, or a return to, a nurturing mother earth. Ophelia's fall and death by drowning can be understood in the framework of neo-Platonic thought as the passage of spirit into the sensuous material world. Michel Leiris, the surrealist writer who was in

many ways nearest to Masson, surmises that "the drowning represents abandonment, disappearance, fusion in the flux of springtime."[13] Like Nietzsche, Masson found a kindred spirit in the pre-Socratic philosopher Heraclitus, who believed that constancy was an illusion and that the universe was in eternal flux. Such views are consonant with Goethe's ideas of dynamic transformation and metamorphosis. *Ophelia*, as an attempt to encapsulate this worldview, demonstrates Masson's lofty ambitions for painting. It also shows just how much, at his most successful, he was able to pack into a single image.

[1] Clement Greenberg, "Towards a Newer Laocoon," *Partisan Review* (July–August 1940), 296–310. [2] See Kimberly Rhodes, *Ophelia and Victorian Visual Culture* (Aldershot: Ashgate, 2008). [3] "[I]l existe pas de sol, ni de bas, mais une fête fulgurante d'astres." Georges Bataille, "Les Mangeurs d'étoiles," in *André Masson* (Marseille: André Dimanche, 1940), 28. [4] Georges Limbour, "La Saison des insectes," in *André Masson*, 102. [5] Recalling the early 1920s, Masson reports: "Avec Limbour, avec Artaud, avec Leiris, une de nos délectations était de lire et relire à voix haute les prodigieux Elisabéthains, leur théâtre de la violence — de la cruauté — la plus incisive, et du lyrisme le plus éperdu. C'était *notre* théâtre." André Masson, *Le Rebelle du surréalisme*: *Écrits*, ed. Françoise Will-Levaillant (Paris: Hermann, 1976), 77–78. (David Lomas' translation: "With Limbour, with Artaud, with Leiris, one of our delights was to read and reread at top voice the amazing Elizabethans, their piercing theatre of violence — of cruelty — and boundless lyricism. It was our theatre.") [6] From this we can infer Hamlet's symbolic presence in Masson's picture. [7] Johann Wolfgang von Goethe, *Theory of Colours*, trans. Charles Eastlake (Cambridge, MA and London: MIT Press, 1970), lvi. [8] Ibid., liii. [9] cf. Plotinus, *Enneads*: "Is there not a myth telling in symbol of such a dupe, how he sunk into the depths of the current and was swept away to nothingness?" [10] Persephone's abduction and descent to the underworld is connected with the narcissus flower, which (owing to its supposed narcotic properties) has associations with sleep, dreams and death. [11] This kind of vision is analogous to Dalí's "double images" of which the *Metamorphosis of Narcissus* (1937) affords a notable illustration. [12] Gaston Bachelard, *L'Eau et les rêves* (Paris: José Corti, 1942), 109–23. [13] "[L]a noyade n'est qu'abandon, evanouissement, fusion dans le flux du printemps." Michel Leiris, "Mythologies," in *André Masson and his Universe* (Genève-Paris: Ed. des Trois Collines, 1947), 128–9.

DAVID LOMAS is Professor of Art History at the University of Manchester and co-director of the Centre for the Study of Surrealism and its Legacies. His books include *The Haunted Self: Surrealism, Psychoanalysis and Subjectivity* (2000) and the forthcoming *Simulating the Marvellous: Psychological Medicine, Surrealism, Postmodernism* (2011). Lomas co-curated *Subversive Spaces: Surrealism and Contemporary Art* for the University of Manchester's Whitworth Art Gallery (2009) and *Narcissus Reflected*, an exhibition that came out of his project on Surrealism and sexuality funded by the UK Arts & Humanities Research Council, which opened in April 2011 for The Fruitmarket Gallery, Edinburgh.

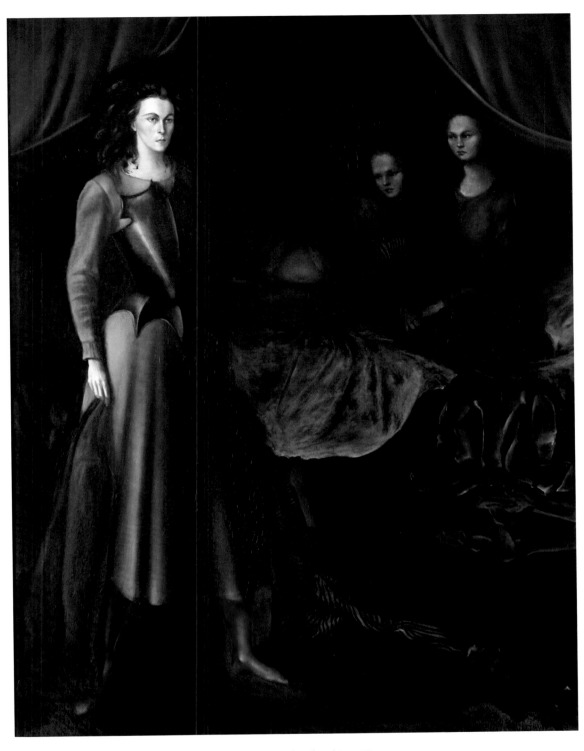

LEONOR FINI *The Alcove: An Interior with Three Women*, 1939, The Edward James Trust

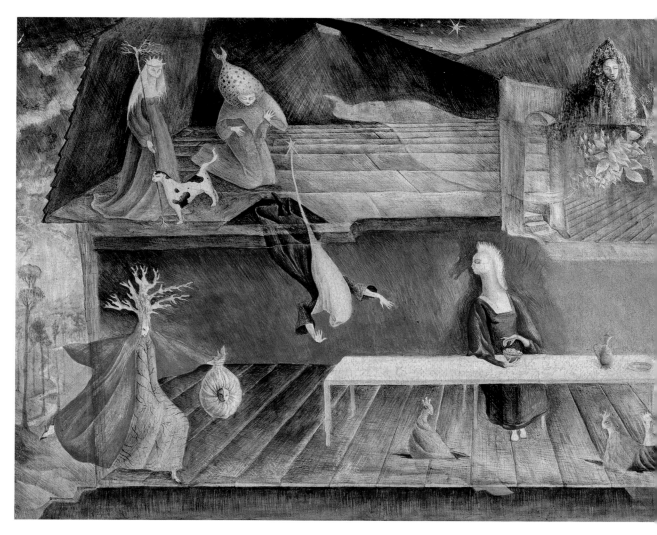

LEONORA CARRINGTON *The House Opposite*, 1945, The Edward James Trust

THE COLOUR OF MY DREAMS

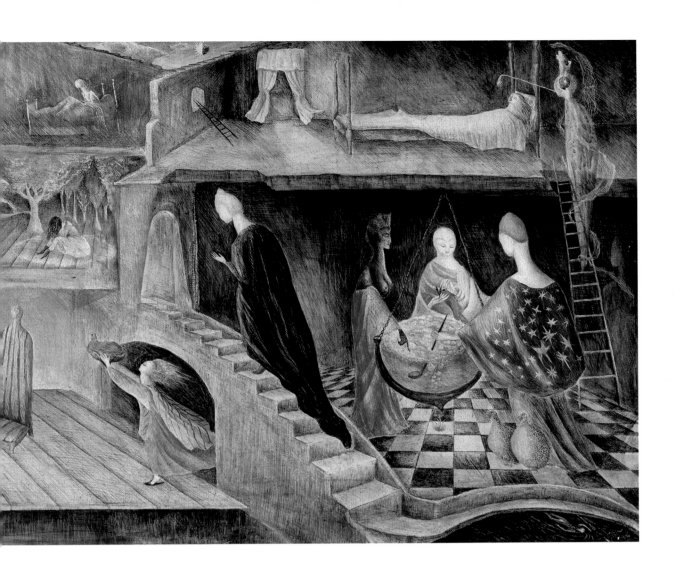

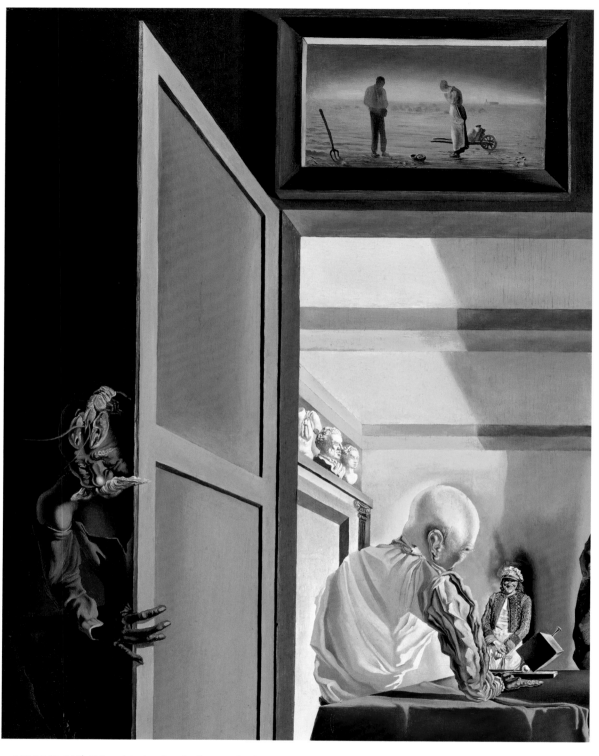

SALVADOR DALÍ *Gala and the Angelus of Millet Immediately Preceding the Arrival of the Conic Anamorphoses*, 1933,
National Gallery of Canada, Ottawa, Purchased 1975

"In June 1932, with no recent memory nor conscious association that would have explained it, the image of Millet's *Angelus* suddenly appeared in my mind. This image was a very precise, coloured representation … . It left a tremendous impression and thoroughly disturbed me because, although my vision of this image corresponded exactly to the reproductions of this picture I was familiar with, it nonetheless 'appeared' to me totally modified and charged with such latent intentionality that Millet's *Angelus* 'suddenly' became for me the most troubling, the most enigmatic painting, the densest and richest in unconscious thought, that there has ever been."

— Salvador Dalí, *Le Mythe Tragique de l'Angelus de Millet* (written c.1933), 1963

Millet's innocent, devotional painting of two peasants pausing to pray at the sound of the evening bell appears frequently in Dalí's paintings of the early 1930s. The figures are often distorted or reconfigured to express the hidden meaning Dalí gave them, in his psychoanalytical reading of the picture, as a "tragic myth" of sex and death. Here, though, they are more or less as they appear in Millet's painting. Facing Gala, Dalí's muse and lover, is the Russian revolutionary leader Lenin, while Maxim Gorky peers around the door with a lobster on his head. Presiding over the mysterious scene is a plaster bust of the surrealist leader André Breton.

[D.A.]

BEHIND THE
SCREEN

MAN RAY *Emak-Bakia* [Leave me alone], 1926, film stills

SURREALISM AND FILM

MICHAEL RICHARDSON

Surrealism began as cinema was coming of age. Indeed, the experience of cinema was formative for first generation Surrealists. André Breton himself came into the world in 1896, just a few weeks after the first Lumière brothers' screenings that, according to legend, "gave birth" to cinema, and the future Surrealists spent their youths witnessing the new medium's emergence. They had been charmed by the wondrous early films of Georges Méliès, which explored the possibilities cinema had to explode the confines of realism, and by the webs of anarchic violence and subversive comedy spun by Louis Feuillade. Equally seductive was Early German cinema, in which dark tales permeated with ideas culled from Romanticism were combined with a visual style influenced by Expressionism.

By 1924, however, Hollywood was already becoming dominant. Slow to make its international mark, the American industry only came into its own when early monopolistic practices broke down, thus allowing second generation Jewish immigrants who migrated to California to establish the first Hollywood studios. Taking advantage of the economic devastation caused to European cinema by the First World War, Hollywood was able to step into the space this opened up. The Surrealists found in this new American cinema an energy and excitement that eluded, at least for a time, the urge towards standardization that would soon exemplify Hollywood production methods.

The Surrealists were especially interested in fast-moving, quickly made films that entered the popular unconscious, eluding the controls that would increasingly constrain the cinema as it entered adulthood. Their reading of Freud made them aware of how society's repressed thoughts (both collective and individual) could emerge in off-guard

GEORGES MÉLIÈS *Le Voyage dans la lune* [A Trip to the Moon], 1902, film stills

moments, and early cinema offered a rich vein for exploration of how such thoughts gained expression. Hollywood, at this time largely populated by exiles and misfits, was making films for an audience perceived principally to be working class (the middle and upper classes disdaining such a vulgar medium), cinema that equally fascinated the Surrealists as a medium of the communication of otherness.

Throughout the 1920s Hollywood films were complemented for them on the one hand by films from a Germany in the depths of depression, dark films of doom and despair, and on the other by the dynamic Soviet cinema, with its faith in the future as a new society was being built.

Oddly enough, the Surrealists had little time for the cinema into which they have largely been corralled by academic criticism: that resulting from avant-garde and experimental practices. Their dislike of this cinema lay in its calculated and fastidious concern with detail, and most especially for its elevation of cinema as the *seventh art*. For them, the fascination of cinema lay precisely in the fact that it eschewed the criteria

Fig. 12 Poster for the film *Les Vampires*, 1915, by Louis Feuillade

BUSTER KEATON AND EDWARD F. CLINE *One Week*, 1920, film still

of art to plunge into the reserve of the popular unconscious, as noted above, undeterred by strictures of technique and taste. It was in fact as a kind of quintessence of popular culture that cinema appealed to the Surrealists, one which resisted incorporation into the processes of consumption by which the media sought, then as now, to control mass art. Characterized by its insolent and disrespectful colouring, it was quite different from what has been reified today as "popular culture."

The Surrealists grew up with the comedies and serial films — most notably *Fantômas* (1914–15), drawn from a series of novels which had entranced them as adolescents, and *Les Vampires* (1915) — of Louis Feuillade. Fast moving films of enormous energy made much as the Surrealists would later conceive automatic writing, they seemed to overflow their own confines, extolling an anarchic violence in a way that was probably contrary to the filmmakers' conscious intentions.

Feuillade's methods would be replicated in the US in serials like *The Perils of Pauline*, and more especially in the films of comic genius initiated by Mack Sennett that,

BUSTER KEATON AND EDWARD F. CLINE *One Week*, 1920, film stills

rejoicing in what the Surrealist Petr Král would later call "custard-pie morality," came into full flower throughout the 1920s and 1930s with the films of Charlie Chaplin, Buster Keaton, Larry Semon, Harry Langdon, W.C. Fields and the Marx Brothers, all of whom the Surrealists adored. A similar spirit pervaded the animated film. The Fleischer studios gave us Betty Boop, a surrealist heroine incarnate, at least in her early films, while the animation sections at Warner Bros and MGM seethed with restless exuberance, seen most outrageously in the work of Tex Avery, the "Shakespeare of the cartoon," as the Surrealist Franklin Rosemont considered him.

A remarkable convergence with surrealist notions about love, desire and the imagination could also be found in a whole series of Hollywood films. Breton, for instance, saw *Peter Ibbetson* (Henry Hathaway, 1935) as representing a "triumph of surrealist thought." Many others could be similarly designated.

Prohibitive costs meant the Surrealists had limited opportunities to make their own films. Even so, their contribution is not negligible. Mostly short, made on small

Surrealism and Film

JOSEPH CORNELL *Rose Hobart*, 1936, film stills

MAN RAY *Retour à la raison* [Return to Reason], 1923, film still

budgets, the films made by Surrealists in total still comprise an impressive body of work. We might note those of Man Ray, Joseph Cornell and Michel Zimbacca or one-off productions by Marcel Mariën, Ludvík Sváb or Ernst Moerman. Most remarkable are the two films by Wilhelm Freddie. Just a couple of minutes long, they are of such cinematic power that his lack of further filmic opportunities must be regretted. In a different domain, the natural history films of Jean Painlevé show the range of surrealist cinematic involvement.

Aside from this marginal activity, others like Pierre Prévert, Henri Storck, Humphrey Jennings, Nelly Kaplan and Walerian Borowczyk, made their mark in cinema history. Two filmmakers, however, dominate: Luis Buñuel and Jan Švankmajer. In collaboration with Salvador Dalí, Buñuel made *Un Chien andalou* (1928) and *L'Age d'or* (1930), which stand at the apogee of surrealist filmmaking, and went on to an illustrious career as one of cinema's great artists, while Švankmajer, over fifty years, has established uncompromisingly an impressive body of work that challenges and amuses in equal measure.

JAN ŠVANKMAJER *Do pivnice* [Down to the Cellar], 1983, film stills

JEAN PAINLEVÉ *Crabes et crevettes* [Crabs and Shrimps], 1929, film still

MICHAEL RICHARDSON is currently Visiting Fellow at the Centre for Cultural Studies, Goldsmith's College, University of London. From 2004–2007 he was Visiting Professor in Cultural Studies at Waseda University, Tokyo. He has published widely on Surrealism, film and anthropological themes, having edited *The Absence of Myth* (1991), a collection of Georges Bataille's writings on Surrealism, and *Refusal of the Shadow* (1996) on Surrealism and the Caribbean. Richardson is the author of *Georges Bataille* (1994), *The Experience of Culture* (2001), *Surrealism and Cinema* (2006) and most recently, *Otherness in Hollywood Cinema* (2010).

SPACES OF THE UNCONSCIOUS

LEE MILLER *Portrait of Space, near Siwa, Egypt,* 1937/2011, Lee Miller Archives, Sussex, UK

"It seems certain that visual or tactile images (primitive, not preceded or accompanied by words, like the representation of whiteness or elasticity …) freely operate in the immeasurable region that stretches between consciousness and unconsciousness." — André Breton, "The Automatic Message," *Minotaure,* 1933

The unconscious only exists, and can only be understood, in relation to what is defined as the conscious. These notions are abstractions, and possess no actual topography, but have commonly been explained by means of spatial models: architectural, archæological, anatomical. Freud once likened the system of the unconscious to the entrance hall of a house, and the conscious to a second, narrower drawing room; between the two a watchman acted as censor, turning away from the threshold of the drawing room mental impulses that displeased him. Breton envisaged the mind as a sea or well, whose depths contained strange forces that could augment or fight those on the surface.

Space and time in the unconscious do not correspond to those in everyday life. We know how places in dreams — the site, Sigmund Freud proved, where the workings of the unconscious are glimpsed — mutate and shift, while time follows incomprehensible patterns. The surrealist artists' explorations, into the fundamental but mysterious relationship between unconscious and conscious, present striking spatial analogues for the psychic totality that makes up our reality. House, body, cavern, labyrinth, cosmos, together with veils, windows and mirrors, become metaphors for this unknowable realm: Kay Sage's double doorways, Jan Švankmajer's dark cellar, Max Ernst's forests. Diego Rivera's print *Communicating Vessels* was inspired by Breton's study of dreams, *Les vases communicants* (1932), the alchemical metaphor expressing the inter-relationship between conscious and unconscious, dream and wakefulness, interior and exterior. Salvador Dalí, who rejected Automatism as "too passive," thought of his work as "hand-painted dreams," their pictorial spaces often distorted or distended. Giorgio De Chirico deliberately used clashing, incompatible perspectives to disrupt his city streets and plazas. Roberto Matta, on the other hand, returned to the spontaneous methods associated with Automatism to create vistas whose veils and layers of space are simultaneously of the cosmos and of the mind.

[D.A.]

BRASSAÏ *Untitled* [Shadows and Sidewalk, Quai Malaquais, Paris], c. 1932,
The Art Institute of Chicago, Restricted Gift of Leigh B. Block

MARUJA MALLO *Tierra y excrementos* [Earth and Excrement], 1932,
Museo Nacional Centro de Arte Reina Sofía, Madrid

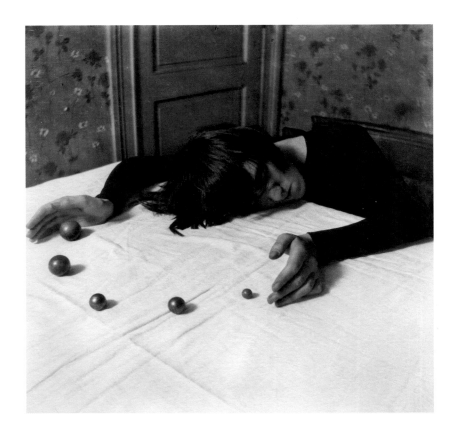

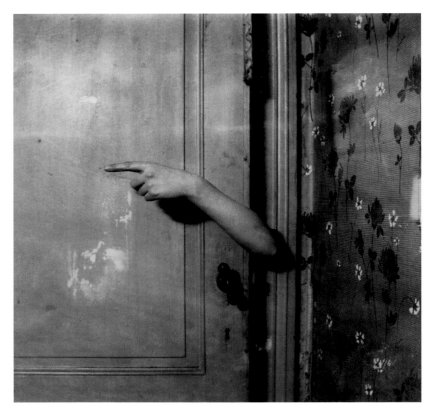

PAUL NOUGÉ from *La subversion des images* [The Subversion of Images], 1929–30, printed by Marc Trivier, 1995:
La jongleuse [The Female Juggler]; *La bras révélateur* [The Revelatory Arm],
Courtesy of M. Trivier and Archives & Musée de la Littérature, Brussels

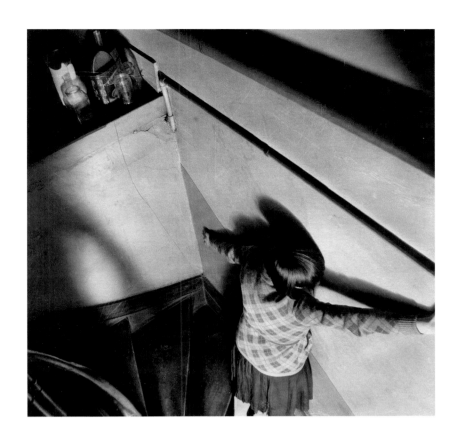

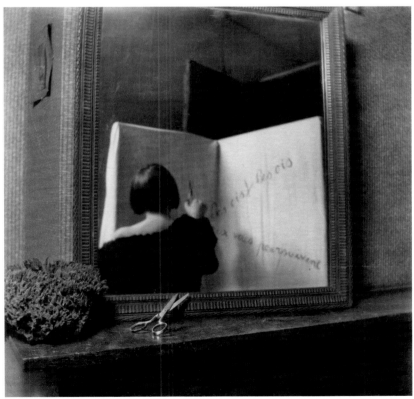

PAUL NOUGÉ from *La subversion des images* [The Subversion of Images], 1929–30, printed by Marc Trivier, 1995:
Femme dans l'escalier [Woman on the Stairs]; *Oiseaux vous poursuivent* [Birds Pursue You],
Courtesy of M. Trivier and Archives & Musée de la Littérature, Brussels

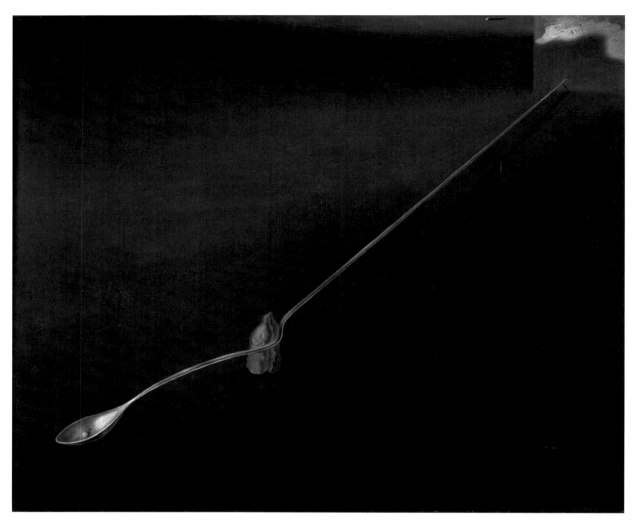

SALVADOR DALÍ *Agnostic Symbol*, 1932, Philadelphia Museum of Art, The Louise and Walter Arensberg Collection, 1950

ROBERTO MATTA *Star Travel (Space Travel)*, 1938, The Gordon Onslow Ford Collection,
Courtesy of Lucid Art Foundation, Inverness, CA

LEE MILLER *Exploding Hand*, 1930, Victoria and Albert Museum, London

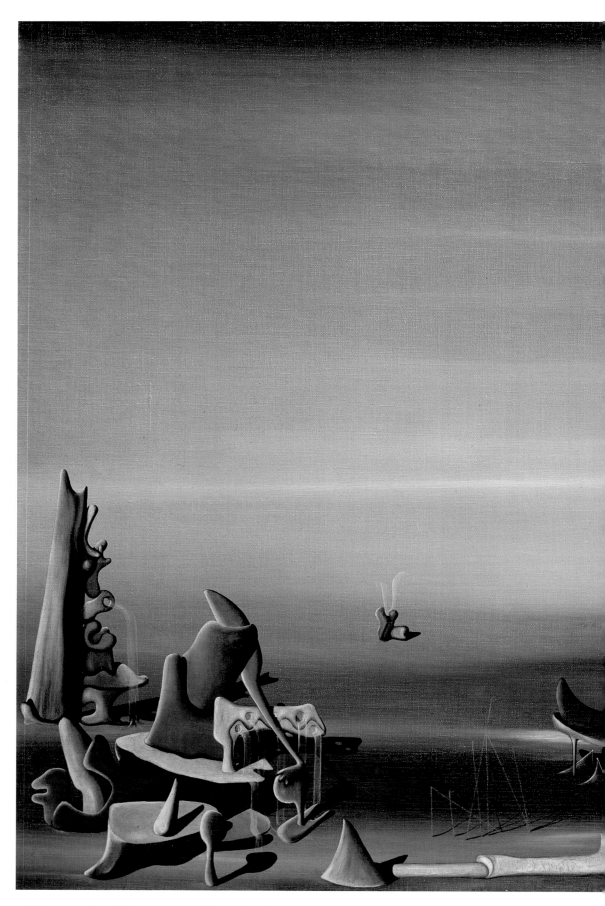

YVES TANGUY *Second Message III*, 1930, Collection of Rowland Weinstein, Courtesy of Weinstein Gallery, San Francisco

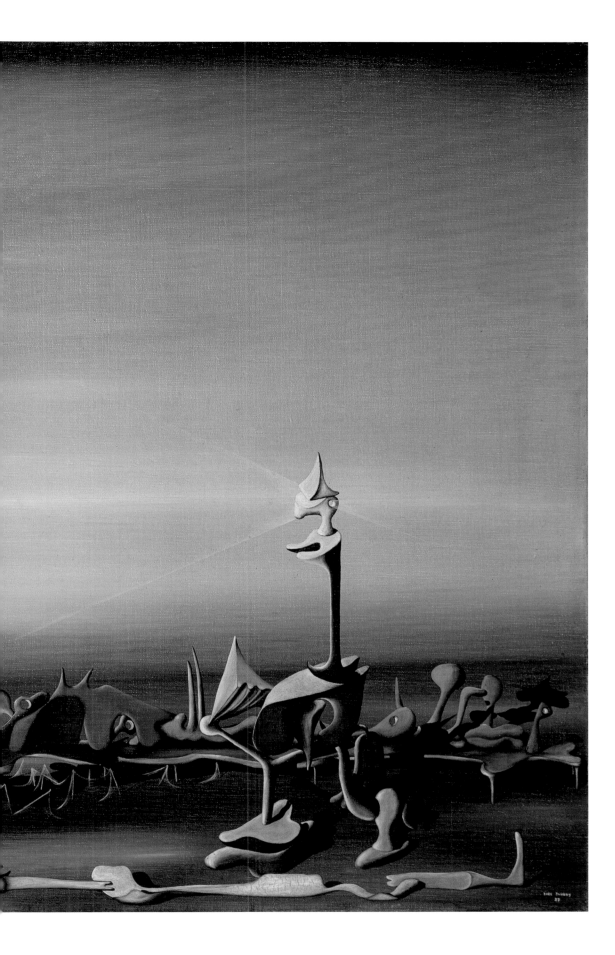

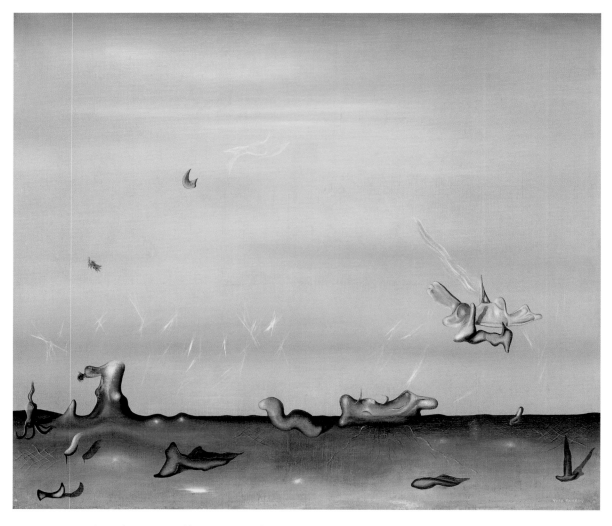

YVES TANGUY *The Doubter*, 1937, Hirshhorn Museum and Sculpture Garden, Smithsonian Institution, Washington, DC, Gift of Joseph H. Hirshhorn, 1972

SPACES OF THE UNCONSCIOUS

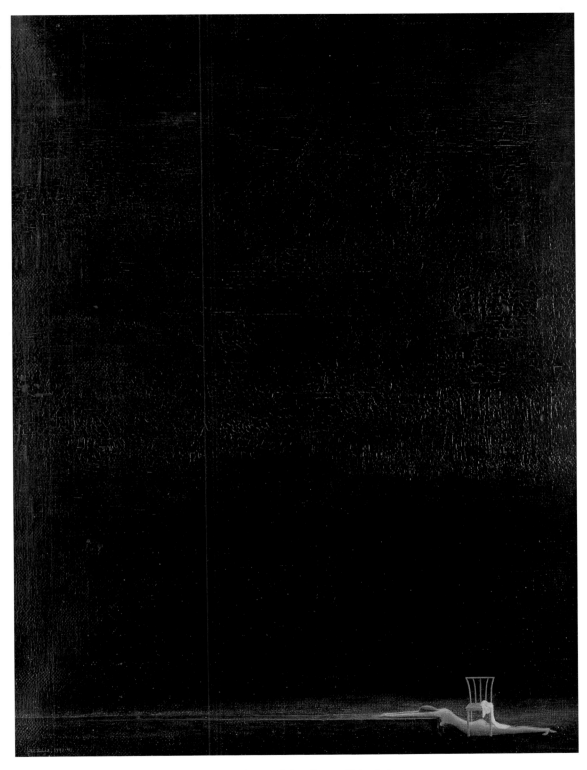

WILHELM FREDDIE *La prière* [The Prayer], 1940, Collection of Clo and Marcel Fleiss, Paris

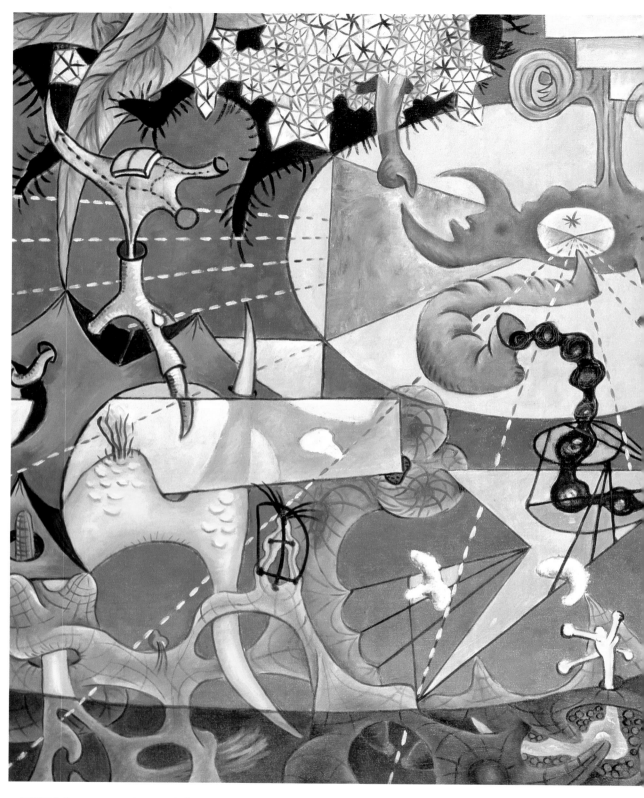

GORDON ONSLOW FORD *Propaganda for Love*, 1940, The Gordon Onslow Ford Collection, Courtesy of Lucid Art Foundation, Inverness, CA

ROBERTO MATTA *Listen to Living*, 1941, The Museum of Modern Art, New York, Inter-American Fund, 1942

KURT SELIGMANN *Melusine and the Great Transparents*, 1943, The Art Institute of Chicago, Mary and Earle Ludgin Collection

"*Automatism,* handed down to us by the mediums, remains one of the two main trends of *Surrealism*… . It is possible, I agree, for *Automatism* to enter into the composition of a painting or a poem with a certain degree of premeditation; there is a grave risk, however, that a work of art will move out of the *Surrealist* orbit unless, underground at least, there flows a current of *Automatism.* The *Surrealism* in a work is in direct proportion to the efforts the artist has made to embrace the whole psycho-physical field, of which consciousness is only a small fraction. In these *unfathomable* depths there prevails, according to Freud, a total absence of contradiction, a release from the emotional fetters caused by repression, a lack of temporality and the substitution of external reality by psychic reality obedient to the pleasure principle and no other. *Automatism* leads us straight to these regions. The other road *Surrealism* might have followed — the setting up of dream images in the form of *trompe l'œil* (and that is its weakness) — has been proved by experience to be far more dangerous and the risks of straying into error are innumerable." — André Breton, "Genesis and Perspective of Surrealism," *Art of This Century,* ed. Peggy Guggenheim, 1942

KAY SAGE *The Upper Side of the Sky*, 1944, The Israel Museum, Jerusalem, The Vera and Arturo Schwarz Collection of Dada and Surrealist Art in the Israel Museum

ÓSCAR DOMINGUEZ *Souvenir de Paris* [Memory of Paris], 1932, Museo Nacional Centro de Arte Reína Sofia, Madrid

PAUL DELVAUX *El viaducto* [The Viaduct], 1963, Collection of Carmen Thyssen-Bornemisza,
on loan at Museo Thyssen-Bornemisza, Madrid

GIORGIO DE CHIRICO *The Piazza*, 1914, Seattle Art Museum, Gift of Mrs. John C. Atwood Jr.

MAN RAY *Studio Door*, 1939, Scottish National Gallery of Modern Art, Edinburgh, Bequeathed by Gabrielle Keiller, 1995

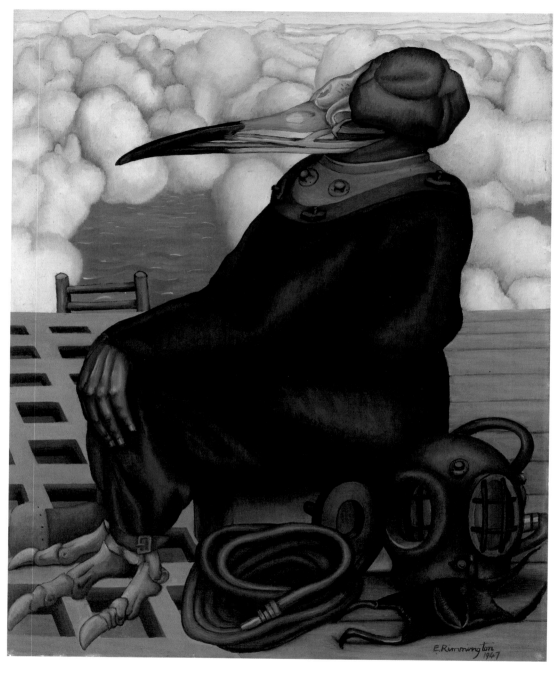

EDITH RIMMINGTON *The Oneiroscopist*, 1947, The Israel Museum, Jerusalem, The Vera and Arturo Schwarz Collection of Dada and Surrealist Art in the Israel Museum

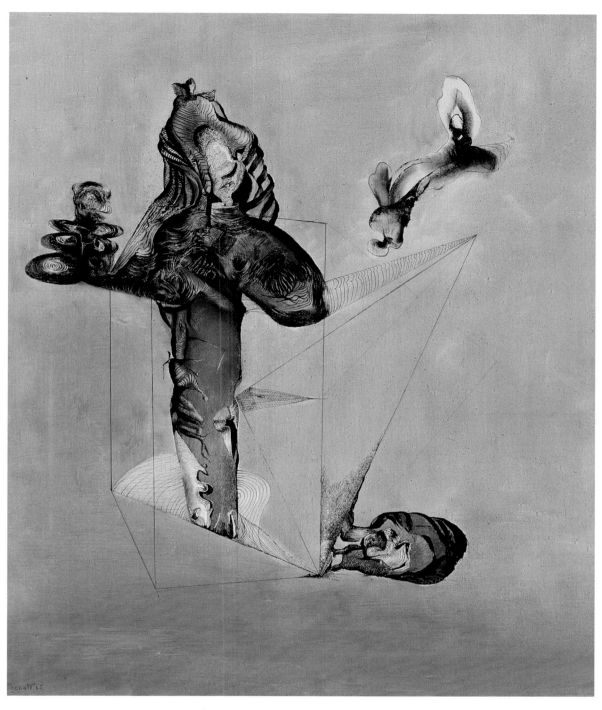

ENRICO DONATI *Le Roi de Mandragora* [The King of Mandragora], 1945, Collection of Adele Donati, New York

FORESTS/LABYRINTHS

"Are there still forests down there? They are, apparently, wild and impenetrable, black and russet, extravagant, secular, ant-like, diametrical, negligent, fierce, fervent and likeable, with neither yesterday nor tomorrow." — Max Ernst, "Les mystères de la Forêt," *Minotaure*, 1934

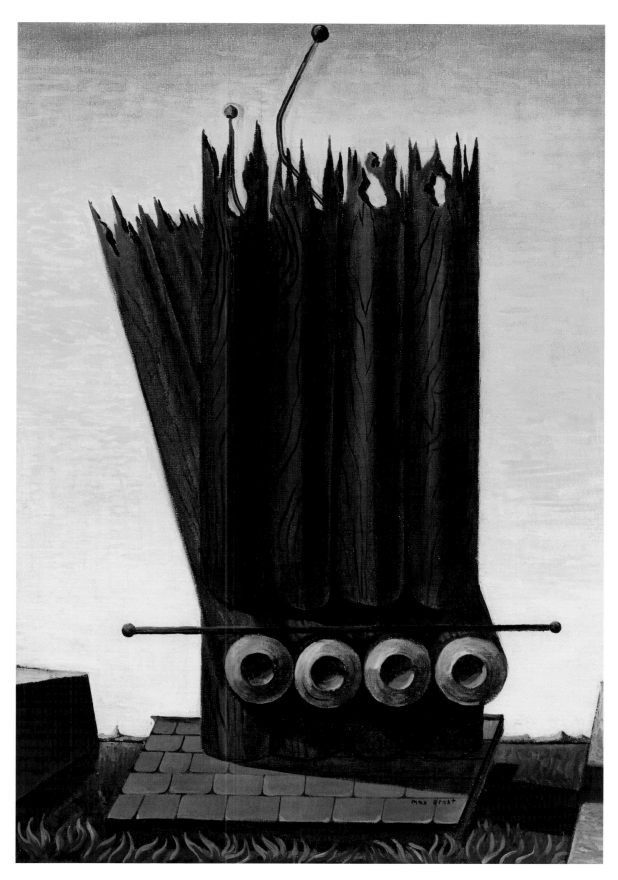

MAX ERNST *The Forest*, 1923, Philadelphia Museum of Art, The Louise and Walter Arensberg Collection, 1950

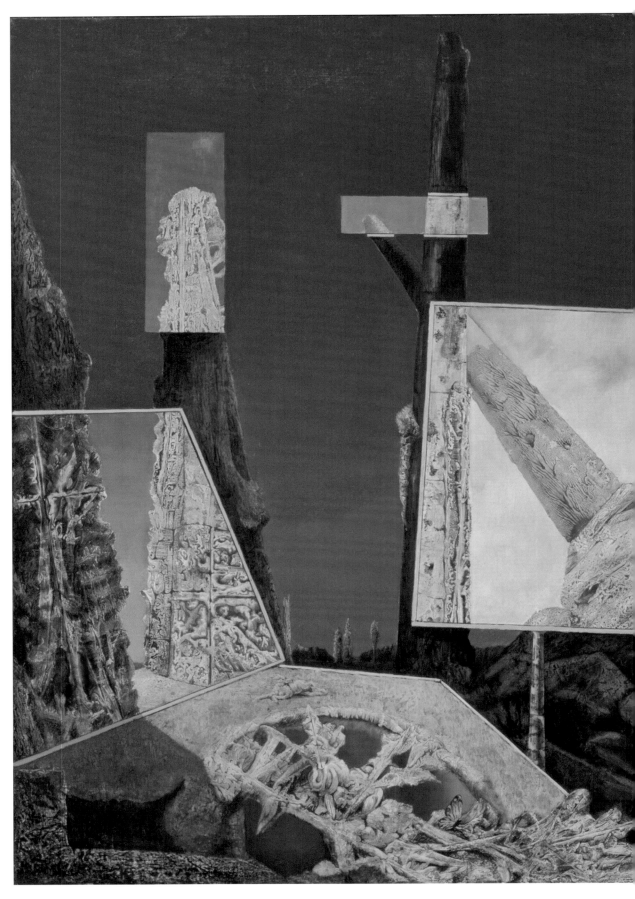

MAX ERNST *Day and Night*, 1941–42, The Menil Collection, Houston, Purchased with funds provided by Adelaide de Menil Carpenter

MAX ERNST *La Ville entière* [The Whole City], 1935, Private Collection, Courtesy of Timothy Baum, New York

MAX ERNST *Chimeras in the Mountains*, 1940, Baltimore Museum of Art, Bequest of Sadie A. May

THE
SURREALIST
OBJECT

MAN RAY *Puericulture II*, 1964, Collection of Timothy Baum, New York

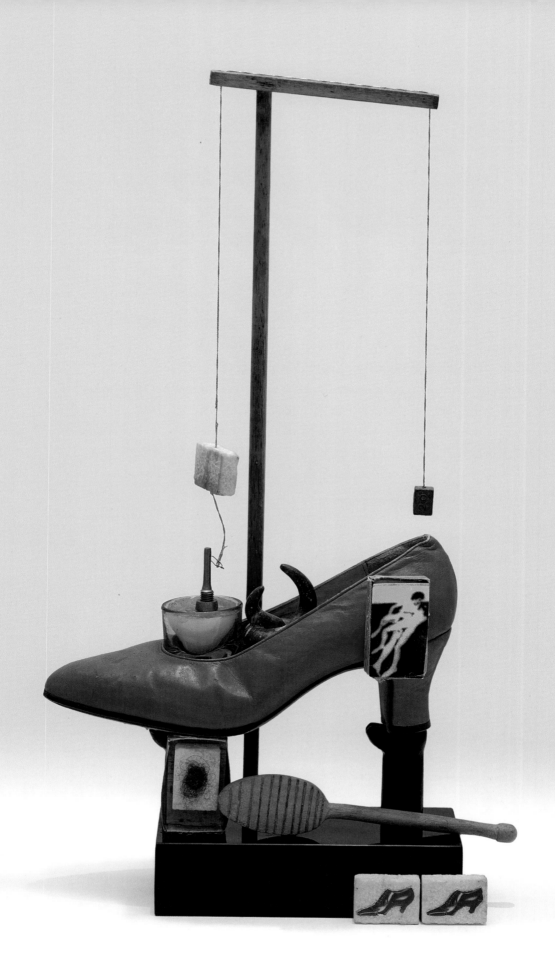

THE SURREALIST OBJECT:
PROGENY OF POETRY AND ART

TIMOTHY BAUM

It is all about transformation. In the beginning is a thought or a feeling, a word or a succession of words. Next comes an image: a visualization reaffirmed in a three-dimensional form or forms. The poem, through the intervention of art, gives birth to an object now standing on its own, the offspring fully created.

Man Ray, who delighted in such transformations, called his creations "objects of my affection." The spirit that underlay the creation of objects by Surrealists was a spirit imbued with pleasure, often merriment. Surrealists created them for their own but also for each other's amusement. The *object* was a fulfillment of cleverness and creativity combined, usually seasoned with spontaneity. Unlike sculpture, its more formal and serious cousin, the surrealist object is born of whimsy, not of commercial seriousness. The value lies in its charm and personality, not in its weight in bronze or gold, nor necessarily in the fame and reputation of its creator.

On the day of the opening of his first exhibition in Paris (in 1921) Man Ray saw a pressing iron in a shop window, purchased it along with a box of carpet tacks and some glue, affixed the tacks in a line down the center of the flat side of the iron, named the newly-created object *Cadeau*, then bestowed this spontaneously-evolved "gift" to the ever-mirthful elder statesman Erik Satie, who surely appreciated this gesture immensely. Thus was the nature of the creative mind of a true Surrealist, at that time still in its embryonic state of playfully irreverent and passion-filled Dadaism. This particular object was either lost or discarded by its affable recipient, but since Man Ray had the presence of mind to photograph it that afternoon he was able to make replicas later on to satisfy the requests of dealers and collectors.

SALVADOR DALÍ *Objet surréaliste à fonctionnement symbolique — le soulier de Gala* [Surrealist object that functions symbolically — Gala's Shoe], 1932/1975, San Francisco Museum of Modern Art, Purchase by exchange through a Gift of Norah and Norman Stone

Fascination with, even reverence for, objects created by human hands or by nature has existed for centuries (the Cross, a shooting star, *The Origin of the World* as intimately viewed by Monsieur Courbet, and others). The Futurists and de Chirico loved the mightiness of a passing train, Picasso a cube of sugar resting on a spoon atop an Absinthe glass, or a guitar. From 1913 on a new form of art object was conceived by the great Marcel Duchamp. By titling a snow shovel *In Advance of the Broken Arm* he transformed an ordinary household object into a work in his own amusing repertoire, and later renamed a commonplace and discarded urinal so that in the blink of a twinkling eye it re-emerged beatifically as *The Fountain*.

From the time of its inception in 1924, Surrealism (and the Surrealists) took the realm of the object very seriously. Searches for and discoveries of *found objects* took place daily. Flea markets, garbage cans and alleyways were scoured. In May of 1936, for one week only, an official *Exposition surréaliste d'objets* was presented in the Paris gallery of Charles Ratton. The accompanying eight page brochure contained a purposely nebulous text by André Breton, beginning "Enfin voici des allées de jardin pavées d'agates, bordées de feux-follets …" ("Here at last we may tread garden paths paved with agates and bordered by will-o'-the-wisps"), followed by a four page catalogue of the contents of the show, classified by individual subjects: *Natural Objects*, *Interpreted Natural Objects*, *Incorporated Natural Objects*, *Disturbed Objects*, *Found Objects*, *Interpreted Found Objects*, *American* (i.e. North and South American) *Objects*, *Oceanic Objects*, *Mathematical Objects*, *Ready-made and Assisted Ready-Made Objects*, and finally *Surrealist Objects*. The *Natural Objects* category was subdivided into respective mineral, vegetable and animal sub-categories. Represented in the vegetable category was a man-eating plant loaned by the diminutive surrealist poet Lise Deharme. The animal kingdom was represented by a stuffed giant anteater and a prehistoric Æpyornis egg. Among the surrealist objects were works by thirty-two different contributors, from Picasso's aforementioned *Absinthe Glass* to Dalí's *Aphrodisiac Jacket*, Marcel Jean's ominous head with zippered eyes (*Le Spectre du gardénia*) and the first appearance of Méret Oppenheim's fur teacup, saucer and spoon (*Déjeuner en fourure*), the latter two now both permanent residents of New York's Museum of Modern Art.

The nineteen thirties was assuredly the great decade of the surrealist object. By mid decade Surrealism was ten years old and had blossomed into a very sophisticated and talented child. Unlike other elitist prodigies it enjoyed the everyday world of more playful games and related pursuances. One especially popular pastime was the game

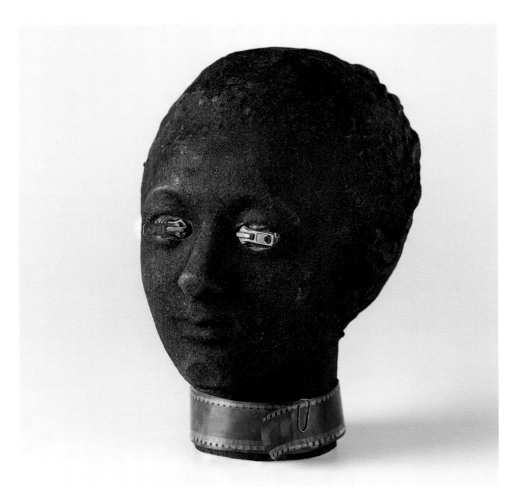

MARCEL JEAN *The Spectre of the Gardenia*, 1936/1968, The Israel Museum, Jerusalem, The Vera and Arturo Schwarz Collection of Dada and Surrealist Art in the Israel Museum

they called Exquisite Corpse, drawings done by groups of three or four participants, sometimes with elements of collage added. Each player saw only the section containing his or her contribution to the work (the head, the torso or the legs and feet segment) and only after all sections of the work had been completed was the paper unfolded and viewed in its entirety. Thus was the Exquisite Corpse, born in the late nineteen twenties and continuing in quite good health into the late nineteen sixties. Each resulting *Exquisite Corpse* was an object unto itself.

Another form of object, first conceived in 1921 or 1922, was the *Rayograph*. This wonderful marriage of the object with the photographic darkroom was the plaything of its namesake, Man Ray (the only American member of the dadaist and early surrealist groups). Rayographs were made in the darkroom, but without the use of a camera. Man Ray

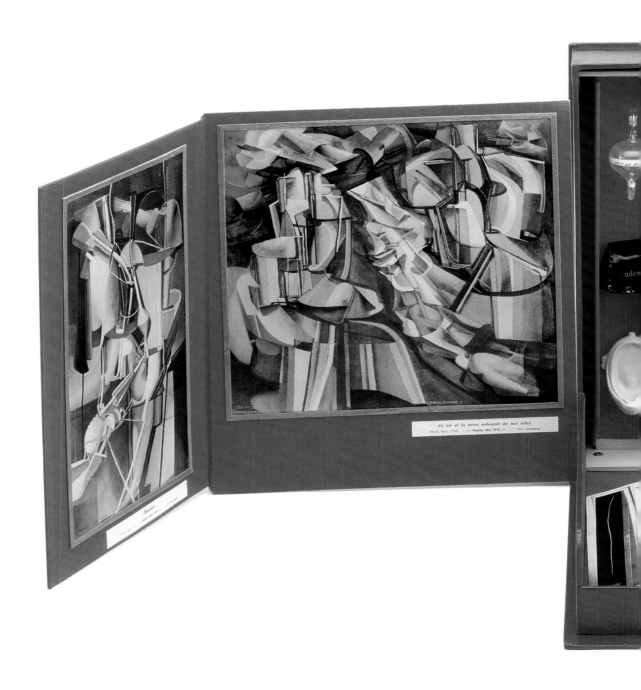

MARCEL DUCHAMP *Boîte-en-valise* [Box in a Suitcase], 1936–68, Courtesy of Francis M. Naumann Fine Art, New York

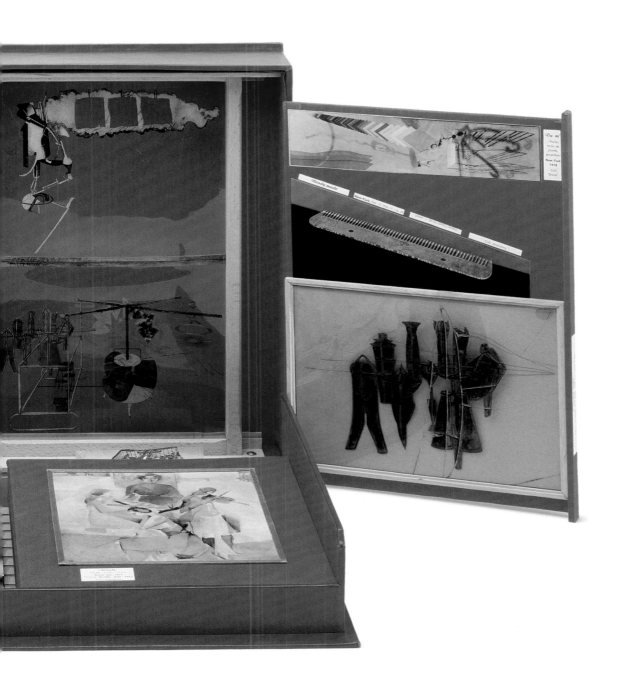

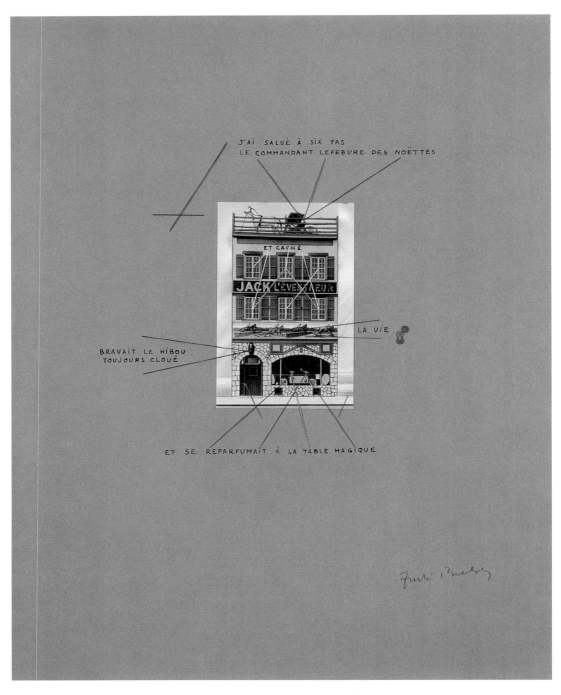

ANDRÉ BRETON *I Saluted at Six Paces Commander Lefebvre des Noettes* [from *VVV Portfolio*], 1942, published 1943, Baltimore Museum of Art, Gift of Sadie A. May

placed objects — usually quite random ones — on the surface of a sheet of photo paper, flashed the light on the subject for a few seconds, soaked the paper in the usual chemical bath for development, then hung the resultant work of art to dry. The visual results of these briefly-lived, random adventures were usually quite extraordinary [see Rayographs, pp. 29, 56, 308]. Man Ray also made *Le Retour á la raison* (1923), an entire short film composed of Rayographs in motion.

For André Breton, the object was perhaps the most exquisite aspect of Surrealism, and maybe of life's complete experience as well. As a young man he inspired himself by amassing, with his good friend Paul Éluard, a distinguished collection of so-called primitive art. The bulk of that collection was sold early on (in the summer of 1931) but certain favourite pieces were retained by Breton and surrounded him until the end of his life in 1966.

Perhaps the greatest joy for Breton, in his endless search for things exquisite and spectacular, was the discovery of something marvellous (one of his pet words) and unexpected, often an *object trouvé* (found object). He wrote once on the subject of such a discovery that it "rigorously fills the same function as the dream, in the sense that it liberates the individual from harmfully paralyzing scruples." Breton understood and admired the autonomy of objects, and marvelled at the thrill of encountering and possessing them.

Breton's own objects — those created by his own hand and exquisite imagination — rank highly in the pecking order of surrealist treasure. Most of these works — fewer than twenty — fall into a category invented by Breton himself, that of the *poème-objet*. For Breton a work of this sort balanced the beauty of the written, poetic word with that of the object or objects, a delicate interweaving of one with the other. Occasionally, he was able to achieve this balance in a *poem-collage* as well. A notable one, executed during the war years he spent in self-exile in New York City, involved a common advertising postcard for a rather ordinary restaurant in Greenwich Village. In a sly sleight-of-hand he converted the original name, *Jack Delaney's*, to a slightly more sinister one, *Jack l'Eventreur* (which translates, affectionately, to Jack the Ripper). He then completed the adornment of the sheet to which the postcard had been affixed with the addition of a series of amusing couplets and some gaily coloured threads attached to sequins (obligingly sewn on by his wife at the time, Jacqueline).

Most of the surrealist artists created objects at one time or another. For some (Duchamp, Man Ray, Salvador Dalí and Marcel Jean, in particular) these objects were as important as their painted works. Duchamp opened the doors to this previously unexplored domain with the presentation of his *ready-mades* and *assisted ready-mades*,

Fig. 12 Enrico Donati, *Shoes*, for window display at Bretano's, New York, to publicize André Breton's
Le Surrealisme et la Peinture, 1945; *Shoes*, 1945, Collection of Adele Donati, New York

such as the straw birdcage filled with sugar-cube-like squares of marble affectionately titled *Why Not Sneeze?....* Later came Dalí, whose three-dimensional objects (rows of little burning votive candles, the famous melting watch, and the like) were virtual counterparts to those displayed in his paintings. Dalí thrived on eccentricity, but it was his imagination that superseded his personality. His famous moustache was an object in itself, but nothing to compare with his *Aphrodisiac Jacket* or his *Lobster Telephone*. For Dalí 1 + 1 was never meant to equal 2; rather, it always equalled just about anything. It might be a bread baguette with a surrealized bronze rendition of

ENRICO DONATI *Fist*, 1946, Collection of Rowland Weinstein, Courtesy of Weinstein Gallery, San Francisco

MAN RAY *Object of my Affection*, 1944, Collection of Timothy Baum, New York

MAN RAY *Blue Bread — Favourite food for the Blue Birds*, 1966, Courtesy of The Mayor Gallery, London

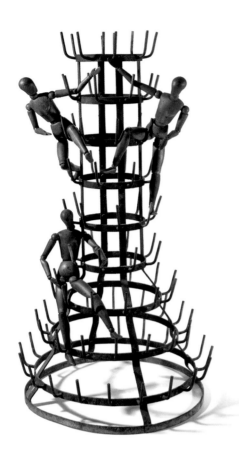

MAN RAY *Les Grandes Vacances* [The Long Holidays], 1947, Courtesy of The Mayor Gallery, London

MAN RAY *Self-portrait in Antibes studio*, 1938, Collection of Timothy Baum, New York

MAN RAY *Indestructible Object*, 1923,
remade 1933, editioned replica 1965,
Collection of Timothy Baum, New York

LAURENCE VAIL *Perfect Lady*, 1942,
Collection of Timothy Baum, New York

THE SURREALIST OBJECT

MAURICE HENRY *Silence, Hospital!*, c. 1950, The Israel Museum, Jerusalem, The Vera and Arturo Schwarz Collection of Dada and Surrealist Art in the Israel Museum

Millet's *The Angelus* couple balanced upon the head of a well-endowed plaster nude's bust, her shoulders adorned with twin husks of corn and her cheeks and lips faintly rouged, while a cluster of ants congregate upon her forehead and at the corner of her mouth. It could also add up to the work he created for the *International Surrealism Exhibition* in Paris in 1938: a full-size Paris taxicab on a simulated rainy night, with the rain falling inside the vehicle to the bewilderment of the scantily clad female passenger seated uncomfortably in a confusion of plants and crawling snails. Dalí — a wizard of transformation — was always able, quite deftly, to create reality from fantasy. At one point he defined a surrealist object as "an object which lends itself to a minimum of useless functionality." There is a certain purity and sense of calm in that kind of iconoclasm. Maybe Dalí was not only a wizard but a holy man as well.

Contemporary to Dalí was Magritte. This playful fellow, dressed always in sombre, respectful attire, painting at his easel in a corner of his furnished sitting room during the last decades of his seemingly orderly and bourgeois life, was the conjurer of more surrealist images and settings than any of his peers. Magritte adored irony, but always

in a playful way. He liked to rearrange the size of things, filling small, tidy rooms with a single, gigantic rose or apple or ominous garden rock. In one painting, *Personal Values*, he filled a small room with a single bed, a comb, a cake of soap and other basic bedroom objects, but made all of the objects (including the bed) the same size. Another of his pleasures was changing the names of things. In a painting divided neatly into six separate parts he presented six images: an egg, a shoe, a bowler hat, a burning candle, an empty glass and a hammer, and titled them, respectively: *the acacia, the moon, snow, the ceiling, fog* and *the desert*. The work is titled *The Key of Dreams*. To extend his repertoire of painted surfaces Magritte painted on wine bottles, transforming them into landscapes and nudes, the latter quite voluptuous with the addition of this third dimension. He also liked to intersperse human imagery with non-human, inanimate equivalents, such as a couple, human-shaped but fashioned as wooden-slated coffins, seated contentedly on a balcony on a sunny afternoon. Magritte delighted in the equality of objects; for him, a setting sun was no more important than a leaf or a kitchen spoon. Not surprisingly, one of his favourite works of literature was *Alice in Wonderland*.

Hans Bellmer was an admirer of nubile girls and young women, and that was largely the subject matter of his work. He painted and drew adroitly, but he yearned for more intimacy with his subjects. He constructed for himself a series of "poupées" (dolls), some of them headless but nevertheless voluptuous, composed of articulated torsos and limbs. Bellmer dressed these dolls on some occasions — scantily — but more often left them in their flesh-coloured nudity and placed them in settings (a badly-lit basement staircase, atop a broken chair, propped against a tree in a remote wooded area, upon an unmade bed), then photographed them. Although the dolls themselves, originally made of wood or plaster and later of aluminum or bronze, were Bellmer's primary objects, his overall work extended into all media. He transformed the foundational photographic images to drawings and paintings or elements of assemblages. Bellmer also wrote about the dolls, about his love and admiration for them, and described in loving detail the kind of worlds they might inhabit.

I will close this brief study with a trip across the Atlantic ocean. With the exception of some of Man Ray's and Marcel Duchamp's creations, so much of what I have written about occurred in Europe. Far away, however — in a wood-frame house on a street called Utopia Parkway, in an unglamorous town in Long Island, New York — a quiet and celibate gentleman named Joseph Cornell lived with his mother (until her death) and his wheelchair-bound brother. He also lived in the company of objects, accumulated

in endless containers and closets; in effect, an entire house crammed full of objects all waiting to be combined according to his whimsy in their final, frozen form. Joseph Cornell was an artist and a poet and a dreamer. His poems reflected his fantasies. He didn't make dolls, he didn't paint bottles, he didn't re-title snow shovels or abandoned urinals — he made boxes. Joseph Cornell fragmentized and compartmentalized the world and inserted these fragments into boxes, boxes he made with his own hands. He painted them within and without (often collaging the backs as well) and filled them with objects (either three-dimensional ones or photographic images) extracted from the storage containers that filled his shelves, his cupboards, his closets, his house. It was all very systemized and awe-inspiring, all these boxes that he filled with his dreams. There were boxes constructed as altars to those this gentleman so ardently admired — great prima ballerinas, beautiful actresses, Medici princes. But the world of Cornell was a world of vastness and variety. He was awed by and enamoured of famous and glamorous women, but also parakeets and cockatoos and fiercely-staring owls. He was at home amongst the constellations but also (in his mind) the great hotels of Europe. He never travelled, but his imagination took him as far from home as did the explorations of Marco Polo, Magellan or the astronauts. He sat there in that wood-frame house on Utopia Parkway and travelled everywhere. He was not a Surrealist in his own eyes, simply a medium. This role of the medium between the worlds of surrealist poetry and art was played by many of the surrealist artists. All of them are born again to you through their poems and their paintings and their objects. It is all about transformation. Let the transformation lead you to new places and discoveries as well. Open up your minds, my friends, and marvel.

TIMOTHY BAUM is an art dealer, collector and expert on all aspects of Dada and Surrealism, and a published poet and writer. He is a member of the committees presently working toward the completion of catalogues raisonnés of the paintings of Man Ray, Kurt Seligmann and Yves Tanguy, and a study of the complete graphic work of Victor Brauner. He is also the publisher and editor of Nadada Editions, a small press that he initiated in 1971. The artists, photographers and writers in this series to date include André Breton, Nusch Éluard, Max Ernst, Rebecca Horn, Georges Hugnet, Man Ray, Michael Putnam and Andy Warhol.

GAMES/CADAVRE EXQUIS

CADAVRE EXQUIS "Game in which several people compose a phrase or a drawing in successive folds of a sheet of paper in such a way that none of them can see what the previous player has written or drawn. The classic example gave the name to the game: Le cadavre — exquis — boira — le vin — nouveau." [The exquisite corpse will drink the new wine]

— *Dictionnaire abrégé du surréalisme,* 1938

VICTOR BRAUNER, JACQUES HÉROLD, YVES TANGUY *Cadavre exquis* [Exquisite Corpse], c. 1935–36,
Collection of Timothy Baum, New York

JACQUELINE BRETON, YVES TANGUY, ANDRÉ BRETON *Cadavre exquis*, 1938,
Collection of Timothy Baum, New York

YVES TANGUY, ANDRÉ BRETON, JACQUELINE LAMBA (BRETON) *Cadavre exquis, 9 février 1938*, 1938, Centre Pompidou, Paris, National Museum of Modern Art/Centre for Industrial Creation, Purchased 1986

ANDRÉ BRETON, ÓSCAR DOMINGUEZ, WIFREDO LAM, JACQUELINE LAMBA (BRETON)
Dessin collectif [Collective Drawing], 1940, Collection of Clo and Marcel Fleiss, Paris

ANDRÉ BRETON, VALENTINE HUGO and three unknown artists,
Brésil, Cadavre exquis, c. 1930, Collection of Clo and Marcel Fleiss, Paris

THE SURREALIST OBJECT

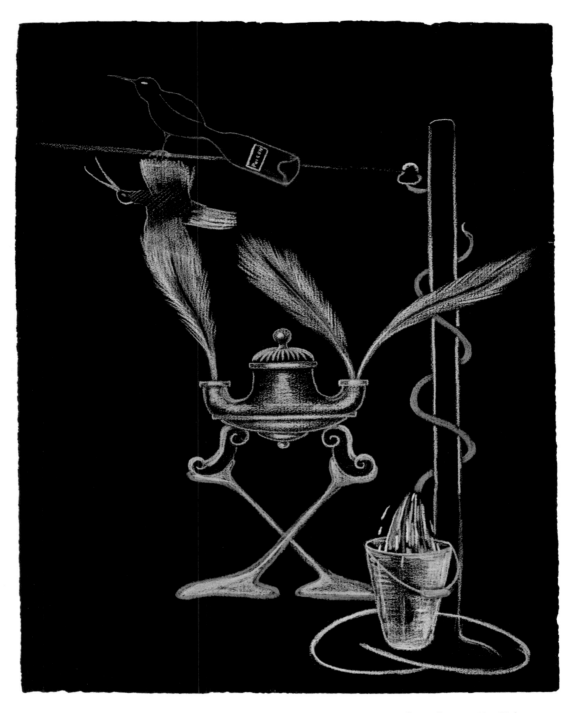

TRISTAN TZARA, VALENTINE HUGO, ANDRÉ BRETON *Cadavre exquis*, c. 1930, Collection of Timothy Baum, New York

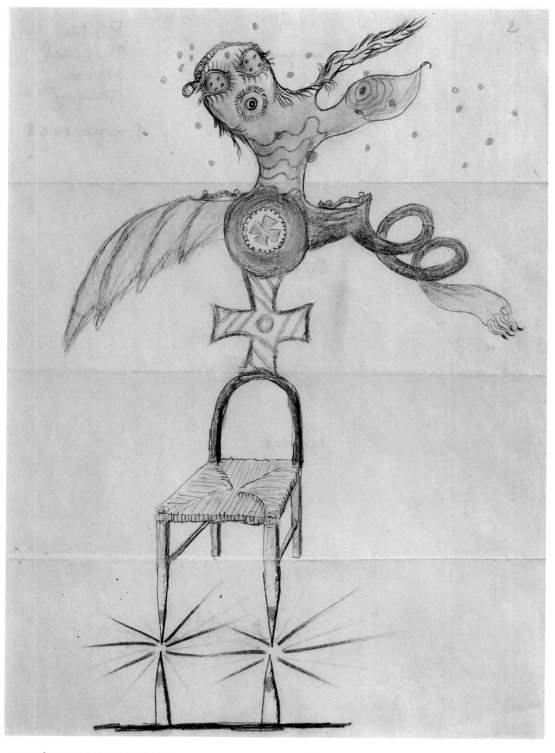

ANDRÉ BRETON, MARCEL DUHAMEL, MAX MORISE, YVES TANGUY *Cadavre exquis*, 1928,
Collection of Clo and Marcel Fleiss, Paris

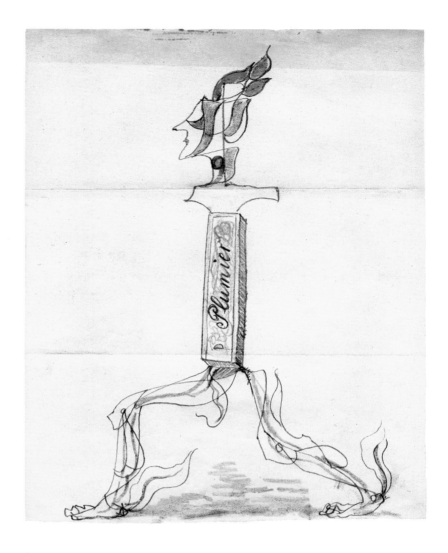

MAX ERNST, MAX MORISE, ANDRÉ MASSON *Cadavre exquis*, March 18, 1927,
Collection of David and Marcel Fleiss, Galerie 1900–2000, Paris

RENÉ MAGRITTE, PAUL NOUGÉ *Cadavre exquis*, 1929, Collection of David and Marcel Fleiss, Galerie 1900–2000, Paris

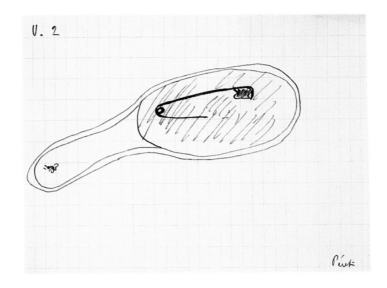

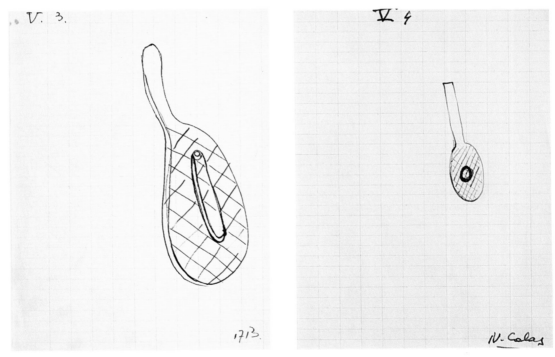

BENJAMIN PÉRET, ANDRÉ BRETON, NICOLAS CALAS *Dessin communiqué* [Transmitted Drawing], c. 1937–39, Collection of David and Marcel Fleiss, Galerie 1900–2000, Paris

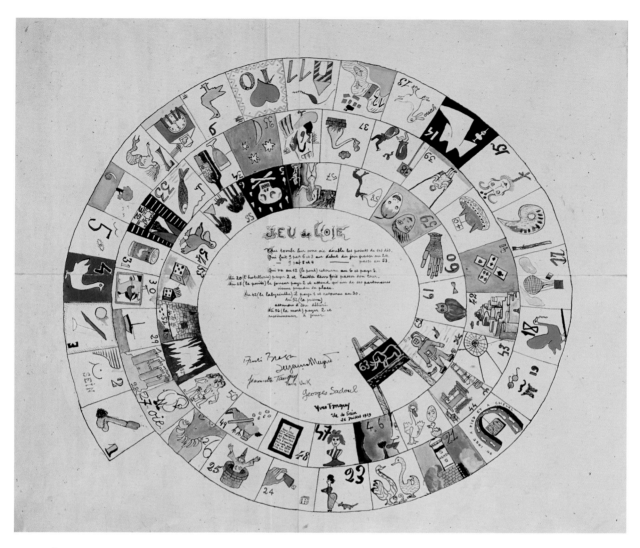

ANDRÉ BRETON, SUZANNE MUZARD, JEANNETTE TANGUY, PIERRE UNIK, GEORGES SADOUL, YVES TANGUY

Le Jeu de L'oie [The Goose Game], 1929, Private Collection, Courtesy of Galerie 1900–2000, Paris

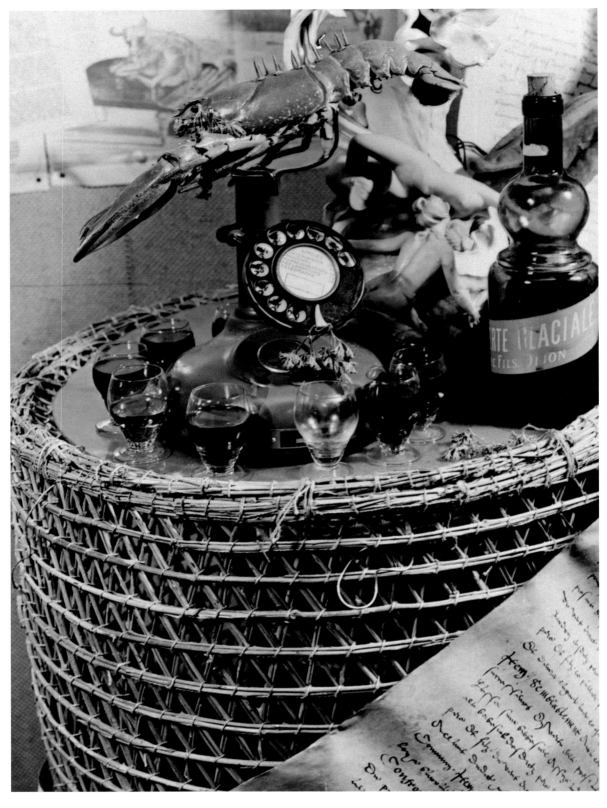

Fig. 13 Raoul Ubac, *Dalí's Aphrodisiac Table*, at the *International Surrealist Exhibition*, Paris, 1938, Courtesy of Timothy Baum, New York, ©Estate of Raoul Ubac/SODRAC (2011)

THE SURREALIST OBJECT

REORGANIZING THE VISIBLE WORLD: EDWARD JAMES, SALVADOR DALÍ AND THE *LOBSTER TELEPHONE*

SHARON-MICHI KUSUNOKI

I never set out with a view to making any "collection"... one day I heard people telling me that I was the owner of a "collection"— a word which has never appealed to me... it seems to indicate entirely the wrong attitude towards art. A true patron of artists is mainly interested in promoting talent and not in the vain or acquisitive appetite for personal "collecting" with a view to self-aggrandisement...my so-called "collection" of Surrealist works of art has already served its prime and initial purpose both by assisting financially and encouraging morally young painters at a time when they most needed encouragement at the incipience of their careers....[1]

The creation of Salvador Dalí's iconic *Lobster Telephone* epitomizes Edward James' relationship with Surrealism as friend, patron and active participant, whose central motivation was the stimulation of creative energy. Although James was directly involved in the creation of this work it is not clear whether the initial idea came from James or Dalí. James stated that the idea grew out of an incident that occurred when Dalí was a houseguest in his London home in June of 1936, but the phone was only manufactured in 1938 when James gave the commission to his decorative contractors, Green & Abbott of London, and then supervised the production.

Both the iconography and pseudo-innocence of *Lobster Telephone* echo the functional symbolism of Dalí's soft watches and conceal and project oro-genital desire onto the real. For Dalí, food and sex were analogous, and here the shell acts as protective armour, a temporary sanctuary for the soft, amorphous character of the womb that is soon to be dissected and consumed. At the time this object was created the motif of the telephone,

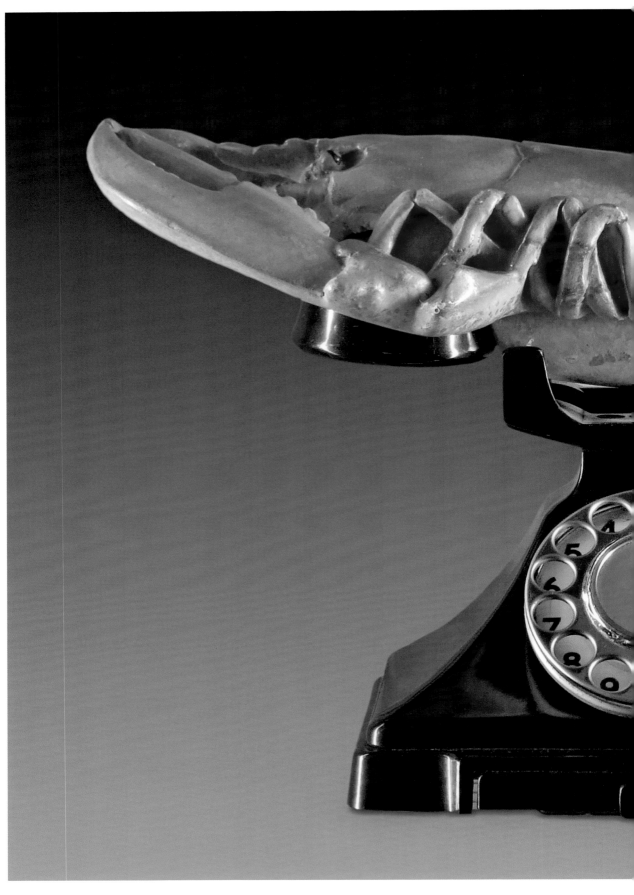

SALVADOR DALÍ AND EDWARD JAMES *Lobster Telephone*, 1938, The Edward James Trust

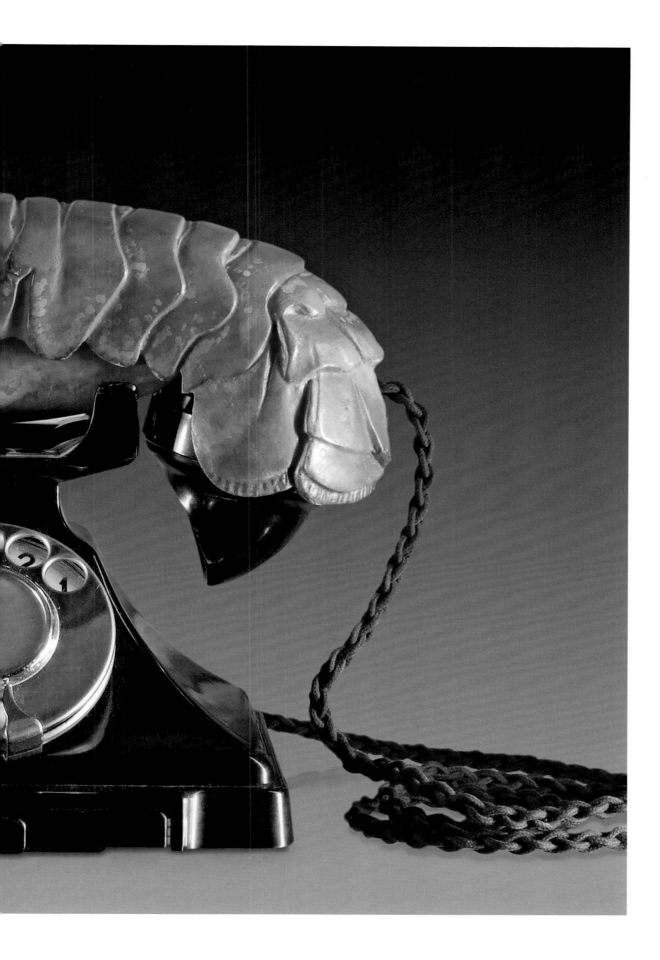

as the symbol of the negotiations taking place between Chamberlain and Hitler, appeared frequently in Dalí's work. Here, the intrinsic value of the objects themselves has been subverted; the receiver, now enveloped by the seemingly organic (and pre-industrial) lobster, is rendered virtually useless, suggesting that communication by telephone is deceptive, with fragile and comestible results.

Strictly speaking, Edward James was not a member of the surrealist movement, but he was certainly an important link in the chain that brought Surrealism to England and the work of a number of artists to the public eye. His relationships with the artists were most often collaborative; his closest were with Leonora Carrington, Dalí, Leonor Fini, René Magritte and the neo-romantic Pavel Tchelitchew.

To some degree James' style of collecting and support followed a tradition of aristocratic patronage that dated back to the Renaissance. He not only purchased works of art and financed ballets, but also sponsored concerts promoting the work of contemporary artists, writers and composers. By the age of thirty-two in 1939, James had amassed what is now being recognized as one of the finest collections of surrealist art in the world, with over two hundred works by Dalí. However, he saw his role as a facilitator and fellow creator rather than purely as a patron. His support of Carrington, for example, not only gave her some financial stability, but exposed her to a more international market, and his contract with Salvador Dalí between 1936 and 1938 allowed Dalí the independence he needed to work freely and without interruption.

[1] Edward James, letter to the Trustees of The Edward James Foundation, c. 1970s (The Edward James Archives).

SHARON-MICHI KUSUNOKI is the Head of House, Collections, Archives and Exhibitions at the Edward James Foundation, Chichester, UK. She has lectured and written extensively on Edward James and has curated exhibitions on, amongst others, British Surrealism, Lee Miller, Man Ray and Ana Maria Pacheco. Most notably, she curated *A Surreal Life, Edward James* for the Brighton Museum & Art Gallery in 1998. A contributor to a number of publications, Kusunoki is now in the process of completing an anthology on the letters of James, with Dawn Ades and Christopher Green, and is also writing his biography.

SURREALIST OBJECTS

1. OBJECTS FUNCTIONING SYMBOLICALLY

The objects of symbolic function were inspired by ... Giacometti's *Suspended Ball*, an object that already put forward and united all the essential principles of our definition but still held to the means special to sculpture. The objects of symbolic function leave no room for formal concerns. They depend only on the individual's amorous imagination and are beyond sculpture. ...

Huge automobiles, three times their natural size, will be reproduced ... in plaster or in onyx, wrapped in female clothing, to be enclosed...in tombs whose site would not be recognized but for the presence of a slim clock made of straw.

Museums will be quickly filled with objects whose uselessness, size and clutter will require the construction, in deserts, of special towers to contain them.

— Salvador Dali, "Objets surréalistes," in *Le surréalisme au service de la revolution*, no. 3, 1931. Trans. by D.A.

BILLET D'AUTOBUS ROULÉ " SYMÉTRIQUEMENT ", FORME TRÈS RARE
D'AUTOMATISME MORPHOLOGIQUE AVEC GERMES ÉVIDENTS DE STÉRÉOTYPIE.

NUMÉRO D'AUTOBUS ROULÉ, TROUVÉ DANS LA POCHE DE VESTON D'UN
BUREAUCRATE MOYEN (CRÉDIT LYONNAIS) ; CARACTÉRISTIQUES LES PLUS
FRÉQUENTES DE " MODERN'STYLE ".

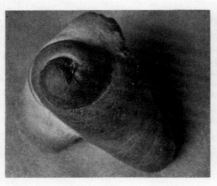

LE PAIN ORNEMENTAL ET MODERN'STYLE ÉCHAPPE A LA
STÉRÉOTYPIE MOLLE

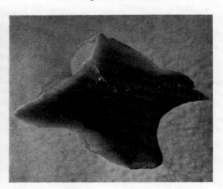

MORCEAU DE SAVON PRÉSENTANT DES FORMES AUTOMATIQUES
MODERN'STYLE TROUVÉ DANS UN LAVABO.

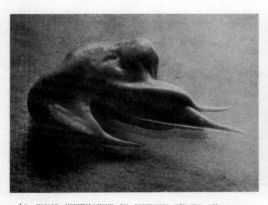

LE HASARD MORPHOLOGIQUE DU DENTRIFICE RÉPANDU N'ÉCHAPPE
PAS A LA STÉRÉOTYPIE FINE ET ORNEMENTALE.

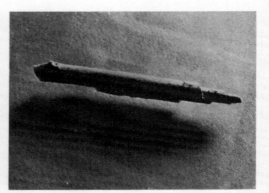

ENROULEMENT ÉLÉMENTAIRE OBTENU CHEZ UN " DÉBILE MENTAL ".

SCULPTURES INVOLONTAIRES

"Sculptures involontaires," *Minotaure*, Paris, nos. 3/4, 1933, p. 68, Collection of Timothy Baum, New York

BRASSAÏ: FROM AUTOMATIC OBJECTS TO INVOLUNTARY SCULPTURES

QUENTIN BAJAC

Reflecting late in life on his relationship to Surrealism, Brassaï[1] seemed to draw a distinction between his ambitions and those of the movement: "The surrealism in my images was nothing other than the *real* made fantastic through vision. I was seeking only to express reality, for nothing could be more surreal than that."[2] Was he entirely correct? Couldn't we posit that the quest to make the real into the fantastic, through vision, lay at the heart of the surrealist endeavour, and that the Surrealists considered such modern mechanical recording tools as photography and cinema to be the privileged instruments of this approach?

By the end of the 1920s the barriers between recording media and the capture of modern marvels were rapidly crumbling. Moreover, at the dawn of that decade cinema and photography had already become the preferred means of surpassing this same reality and attaining revelation, due in part to the writings of Robert Desnos, Pierre Mac Orlan, Albert Valentin, Louis Aragon, and others.[3] While this concern is not unique to Surrealism — we find echoes of it elsewhere in that same period (in Germany, for instance, with New Vision photographers such as Umbo) — nowhere is it more present than within surrealist circles.

Those years witnessed various attempts by Surrealists to define a new kind of surrealist document, primarily aimed at allowing them to combine a neutral, rigorous viewpoint with revelatory power, or to imbue the documentary with a magical dimension — the model, for those in Paris, being the work of Eugène Atget. It is in this light that we should view André Breton's decision to illustrate *Nadja* with photos, so as (in his words) to "create a much more disturbing book." In his narrative, which

aspires to absolute fidelity and the precision of clinical observations, and which reproduces a variety of documents, the photographic images act as so many "simple hallucinations." Though Breton claims, in his preface to the 1963 revised edition, that the primary goal of these images was simply to "eliminate the need for description," we could nonetheless say that the photographs are more disturbing for being placed in this context: set against the text's narrative order they evoke a wellspring of equivocal meanings. The idea of pictures as an indomitable force that cannot be reduced to words relates to Louis Aragon's notion of the "stupefying image."

It was in this context, notably with the publication of *Paris de nuit* in the winter of 1932–33, that Brassaï met the surrealist group. Like André Kertész and Pablo Picasso, Brassaï was among those artists of the *entre-deux-guerres* whose experiments and interests briefly intersected with the Surrealists' preoccupations, though they were sometimes speaking at cross-purposes. The clearest trace of this relatively brief association with the group, apart from close friendships with Salvador Dalí and Benjamin Péret, is the

BRASSAÏ *Coquillage* [Shell], 1933, Centre Pompidou, Paris, National Museum of Modern Art/Centre for Industrial Creation, Donated by Mme Gilberte Brassaï, 2002

publication of Brassaï's images in *Minotaure* (primarily 1933–35). These images define the corpus of Brassaï's so-called surrealist work: several views of nighttime Paris, but of a more populist, mysterious and deserted city than the one the photographer had recently shown in *Paris de nuit*[4]; images of graffiti that express the unschooled, street-level poetry found in art by non-artists, so beloved of various avant-gardists at the time[5]; sensuous nudes, reminiscent of distortions of the human figure during that same period by artists such as Picasso and Henry Moore[6]; and several photographs of natural curiosities certain to rouse the attention of the Surrealists, above all Breton[7].

All of these images (and themes explored by Brassaï) reach beyond a simple affiliation with Surrealism — which Brassaï like Picasso always took with a grain of salt. More closely related to the movement's history and preoccupations was his limited collaboration with Dalí for issue nos. 3–4, published in December 1933. Of the three aspects of this collaboration (illustrations for the article on Modern Style, images for the collage *Phénomène de l'extase* and the creation of "involuntary sculptures"), only

the latter seems a proper collaboration, whereas in the former two Brassaï appears to have acted mainly as a supplier of visuals.

Compared with their other contributions to the publication the *Involuntary Sculptures*[8] partnership seems rather more complex, and the precise genesis of the work remains obscure. A letter by Paul Éluard, who was then in charge of *Minotaure*, suggests that he thought little of Brassaï's efforts in this collaboration:

I'm pretty much the only one who is tenaciously *defending these Involuntary Sculptures. Help me out, insist. Breton is lukewarm, doesn't think they'll reproduce well. It's really a shame the photos are so poor, because I know what trouble I'll have getting them redone. Overall, I have to say Brassaï doesn't show much enthusiasm for anything that isn't his photography, his own work. Couldn't Dalí make some more Involuntary Sculptures in Barcelona and arrange to have them shot, either by Man Ray or someone else? It's crucial that we counter the tedium of the other sculptures.*[9]

Was Brassaï merely the executor of Dalí's wishes? That conclusion might be too hasty. What we do know is that Brassaï took a long time to claim paternity of this work, which he did not include in any of his exhibitions or publications after the war, as if none of it was really his. Nevertheless, on the contact sheets in his personal archive[10] Brassaï annotated in his own hand: "with Dalí, automatic objects, 1933," thereby further anchoring the *Involuntary Sculptures* in surrealist practice. As well, they fit into the context of an earlier group of works created by Brassaï alone. Called "large-scale objects," these twenty-one photos depict scissors, candles, a thimble, needles, thumbtacks, cufflinks, paperclips, shoelaces and clockworks. The images, which use extreme close-up and often play with effects of light and composition, suggest a metamorphosis of the manufactured object not unlike certain New Vision works. Distinct from this grouping are the seventeen "automatic objects," among them the six photos reproduced in *Minotaure* as "involuntary sculptures." While they observe a similar use of close-ups, these seventeen images respond to an entirely different iconographic register, amorphous and natural rather than fabricated. They depict soft materials and textures, such as bus tickets, paper, seashells and bits of soap, bread and cotton.

In this second series, Dalí seems to have played a preponderant role, as suggested by his annotations on the verso of a photo he rejected for publication:

Dear Brassaille [sic], thanks for the photos, which are terribly . . . good. They are of great beauty, the ones I'm sending you back will not be for my article, for they have too much

visual value in themselves, I suggest to rephotograph the 3 objects more ... analytically, if possible on an absolutely black or absolutely uniform background, to lose all sense of scale ... You have to make it stand up by fixing it with a drop of glue (in its glass) and light it from the side, for this rear lighting transfigures it and makes it become very photogenic ... [and] understandable.

And a bit farther down on the same print:

Caption of the sketch: Also standing as if it were a sculpture — Also missing are the bits of bread that look like (characters) and are essential, in any case, I'm sending new pieces of balled-up bread.[11]

While the two men seem to have collaborated in creating these images, and while the enigma of the "large-scale objects" might have acted as a trigger, both the transformation of automatic objects into "involuntary sculptures" and the text of the accompanying captions were strictly by Dalí. Moreover, it was Dalí who promoted himself as the mastermind of this issue of *Minotaure* over Breton and Éluard, whose dual supervision marked the Surrealists' complete takeover of the magazine. Indeed, Éluard might have been having second thoughts about Dalí's waxing influence over the issue when he proposed giving the commentaries "an impersonal (editorial) tone ... and not signing them — or else having Breton or me sign them???"[12]

Tiny material reveries, odes to the poetry of everyday banality, a brickbat to noble, conscious artistic practices: the *Involuntary Sculptures* are imbued with Dalí's personal obsessions. The formal parallels between their swirling, convoluted forms and the motifs found in certain of his previous drawings and paintings speak volumes. Already in 1929, in an article devoted to photography Dalí had intimated that "these are the spoils that artists value above all."[13] Three years later, in an article published in *This Quarter*, he proposed an "experimental scheme" in which the Surrealists were invited to undertake the creation of "automatic sculptures":

At every meeting for polemics or experiment let every person be supplied with a fixed quantity of malleable material to be dealt with automatically. The shapes thus made, together with each maker's notes (of the time and conditions of production), are later collected and analyzed. The series of questions regarding the irrational acquaintance of things might be used.[14]

This mode of irrational knowledge, then, borrows both its methods and its vocabulary from the hard sciences: experimentation, notes, neutrality in recording, the analytical

precision of the blow-up, the form of the typological table. Close-up views, a common feature of photography in the early 1920s,[15] seem to translate and espouse the transformation of vision induced by the paranoiac-critical method, which Dalí was then fine-tuning. Following their interest in hysteria, this method became a new model for the Surrealists: a kind of virtual radioscopy that draws so close to the object as to make it seem unreal, thereby partly or completely modifying its actual reality. Dalí's rejection of certain images on the grounds that they had "too much visual value" (whereas Breton, according to Éluard, wanted the images to "reproduce well"), like his suggestion to re-photograph some objects more "analytically," further inscribes these images in a documentary and experimental context: that of the "image without qualities" he so prized (as did Georges Bataille at the time of *Documents*).[16]

Did Brassaï subscribe to this approach — he who, in his earliest photos of Picasso's sculptures, was already trying to restore the "aura" of mechanical reproduction,[17] notably by his use of heightened lighting effects? We can't be sure. Nonetheless, and perhaps in spite of Brassaï, the *Involuntary Sculptures* photographs come across as the most Bataille-like images to appear in the surrealist periodical *Minotaure*.

[1] Brassaï, meaning 'from Brasso' (his birthplace) was the pseudonym of Gyula Halász, of Hungarian heritage but a resident of France from 1924 until he died in 1984. [2] France Bequette, "Rencontre avec Brassai," *Culture et Communication No. 2* (May 1980). [3] See Quentin Bajac, "Le fantastique moderne," in *La Subversion des images, surréalisme, photographie, film*, ed. Quentin Bajac and C. Chéroux, exh. cat. (Paris: Centre Pompidou, 2009), 123–128. [4] *Minotaure* nos. 6–7 (1935). [5] *Minotaure* nos. 3–4 (1933). [6] *Minotaure* no. 1 (1933). [7] *Minotaure* no. 5 (1934). [8] On *involuntary sculptures* and Dalí's relation to photography, see Katharine Conley, "Modernist Primitivism in 1933: Brassaï's Involuntary Sculptures in *Minotaure*," Modernism/modernity — Volume 10, Number 1, January 2003, 127–140. Astrid Ruffa, *Dalí et le dynamisme des formes* (Dijon: Les Presses du Réel, 2009), as well as Guillaume Theulière, *Sculptures involontaires, du photographique à l'objet*, unpublished research paper, École du Louvre, 2010. [9] Letter to Gala Dalí, early September 1933, in Paul Éluard, *Lettres à Gala* (Paris: Gallimard, 1984), 222. An abridged English version was published as *Letters to Gala*, trans. Jesse Browner (New York: Paragon House, 1989). Gala, married first to Éluard, then to Dalí, inspired a number of Surrealists. [10] Fonds Brassaï, contact sheets under "Arts," "Objets à grande échelle," Centre Pompidou, Paris. [11] Inscription in Dalí's hand on the back of a print from the "automatic objects" series, Paris, succession Brassaï. Reproduced in *Brassaï, La maison que j'habite*, exh. cat. (Nantes: Musée des Beaux-Arts, and Paris: Somogy, 2009), 46. [12] Letter to Gala, 20 September 1933, Éluard, *Lettres à Gala*, 226. [13] Salvador Dalí, "La dada fotografica," *Gaseta de les arts*, 6 (February 1929), 40–42. [14] Salvador Dalí, "The Object as Revealed in Surrealist Experiment," *This Quarter*, vol. 5, no. 1 (September 1932), 203. [15] See Dawn Ades and Simon Baker, *Close-Up: Proximity and De-Familiarisation in Art, Film and Photography*,

exh. cat. (Edinburgh: The Fruitmarket Gallery, 2008). **16** Published from 1929 to 1931, George Bataille's surrealist magazine *Documents* was a deliberate deviation from the kind of Surrealism espoused by André Breton, Bataille's rival during the early 1930s. *Minotaure* (1933 to 1939) was produced mainly under Breton's editorial direction. **17** A term used by German philosopher and literary critic Walter Benjamin in his 1936 essay "A Work of Art in the Age of Mechanical Reproduction" in discussing the effect of an original artwork, a quality of immediacy that is lost when works, like photographs, are reproduced through mechanical means.

QUENTIN BAJAC has been the Chief Curator of Photography at the Pompidou Centre, Musée national d'art moderne in Paris, since 2007. Curator of a number of exhibitions on modern photography such as *Jacques Henri Lartigue*, 2003; *La subversion des images — Surréalisme, film et photographie*, 2009; *Miroslav Tichy*, 2008; *Dreamlands*, 2010. Bajac has also written many articles on the work of contemporary (particularly French) photographers, including Valérie Belin, Christophe Bourguedieu, Stéphane Couturier, Luc Delahaye, Valérie Jouve and Eric Rondepierre. He has recently published a history of photography and a book of conversations with Martin Parr.

Translated from the French by **MARK POLIZZOTTI**. Author of eight books, including *Revolution of the Mind: The Life of André Breton* (rev. ed. 2009), and translator of over thirty books, he is currently publisher and editor-in-chief at the Metropolitan Museum of Art in New York.

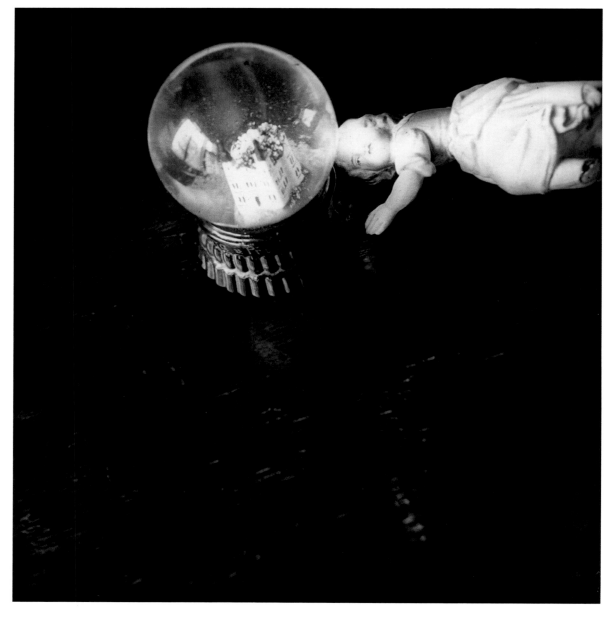

JINDŘICH ŠTYRSKÝ *Untitled* [Crystal Ball with Doll], 1934, printed 1941, San Francisco Museum of Modern Art, Accessions Committee Fund purchase

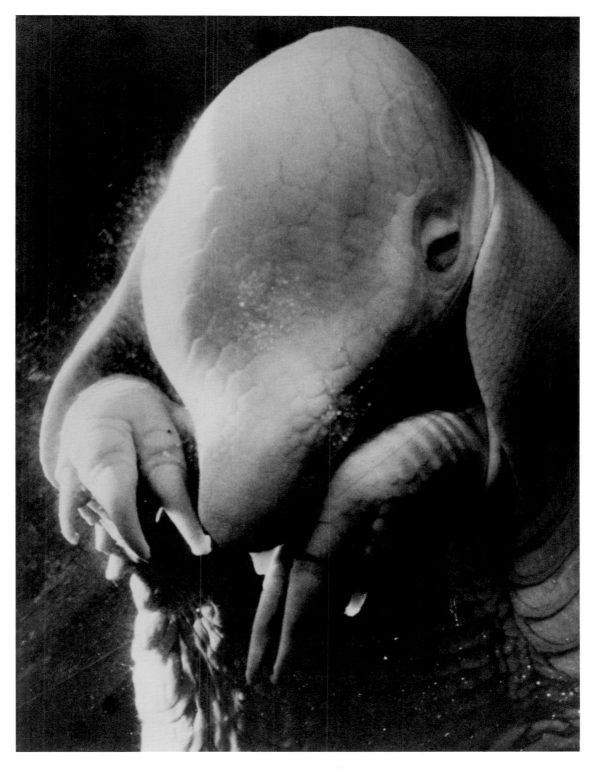

DORA MAAR *Père Ubu*, 1936, The Metropolitan Museum of Art, Gilman Collection, Purchase, Gift of Ford Motor Company and John C. Waddell, by exchange, 2005

CLAUDE CAHUN *Rendent hélas éternels* [Alas, Rendered Eternal], c. 1936,
Ubu Gallery, New York & Galerie Berinson, Berlin

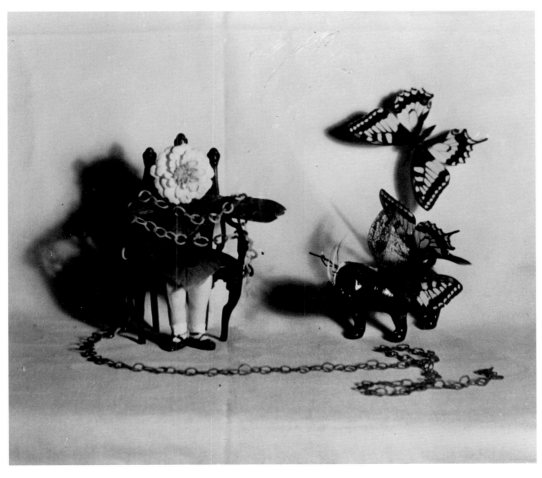

CLAUDE CAHUN *Heure des fleurs* [The Hour of Flowers], 1936, Ubu Gallery, New York & Galerie Berinson, Berlin

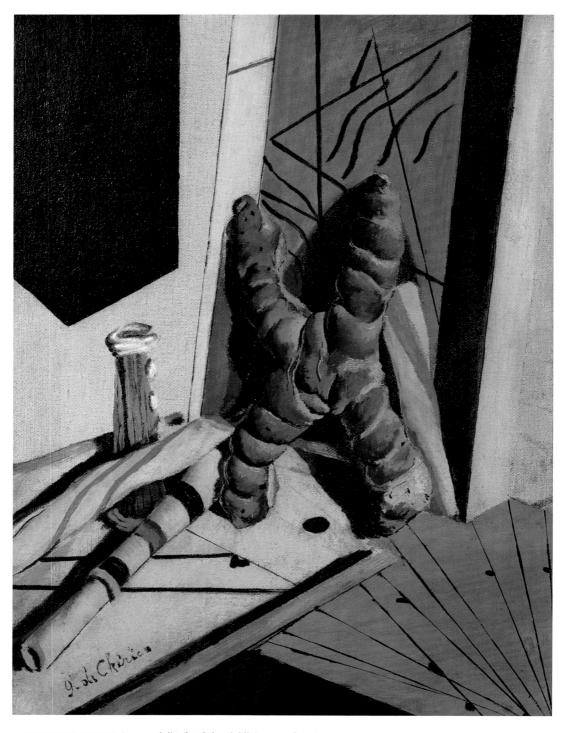

GIORGIO DE CHIRICO *Langage de l'Enfant* [The Child's Language], 1916,
The Pierre and Tana Matisse Foundation Collection, New York

MAN RAY *Main Ray*, 1935, The Israel Museum, Jerusalem, The Vera and Arturo Schwarz
Collection of Dada and Surrealist Art in the Israel Museum

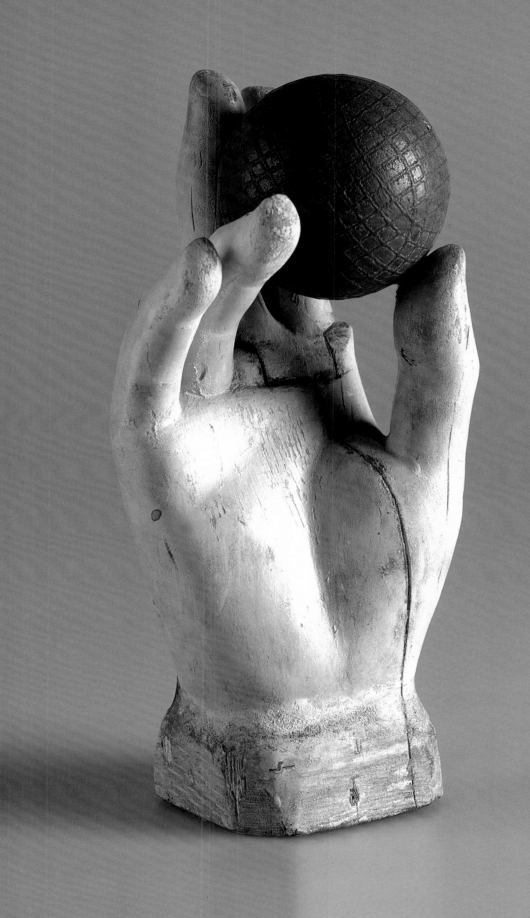

DREAM HABITATS: JOSEPH CORNELL

"The sap of Surrealism also rises from the great root-system of dream-life in the paintings of ... Delvaux as well as in the constructions of Bellmer and Cornell." — André Breton, "Genesis and Perspective of Surrealism," *Art of This Century*, 1942

JOSEPH CORNELL *Untitled* [bell jar with angel entrapped by spring], c. 1936, Collection of Timothy Baum and Karen Amiel Baum, New York

JOSEPH CORNELL *Trade Winds No. 2*, c. 1956–58, The Robert Lehrman Art Trust,
Collection of Aimee and Robert Lehrman, Washington, DC

"… a diary journal repository laboratory, picture gallery, museum, sanctuary,
observatory, key … the core of a labyrinth, a clearing house for dreams and
visions. It is childhood regained." — Joseph Cornell, on his *GC* file, 1944, Cornell Papers

JOSEPH CORNELL *Untitled*, c. 1945, Collection of Timothy Baum, New York

JOSEPH CORNELL *Souvenir Case (Lucile Grahn as "La Sylphide")*,
early 1940s, Collection of Timothy Baum, New York

JOSEPH CORNELL *Crystal Cage (Portrait of Berenice)*, c. 1943 – mid 1960s, Courtesy of Richard L. Feigen & Co., New York

JOSEPH CORNELL *Untitled* [Ship with Nude], c. 1964–66, The Robert Lehrman Art Trust,
Collection of Aimee and Robert Lehrman, Washington, DC

JOSEPH CORNELL *Grand Hotel de la Boule d'Or*, early 1950s, Dallas Museum of Art, Foundation for the Arts Collection, Gift of Mr. and Mrs. Alan M. May

Dream Habitats

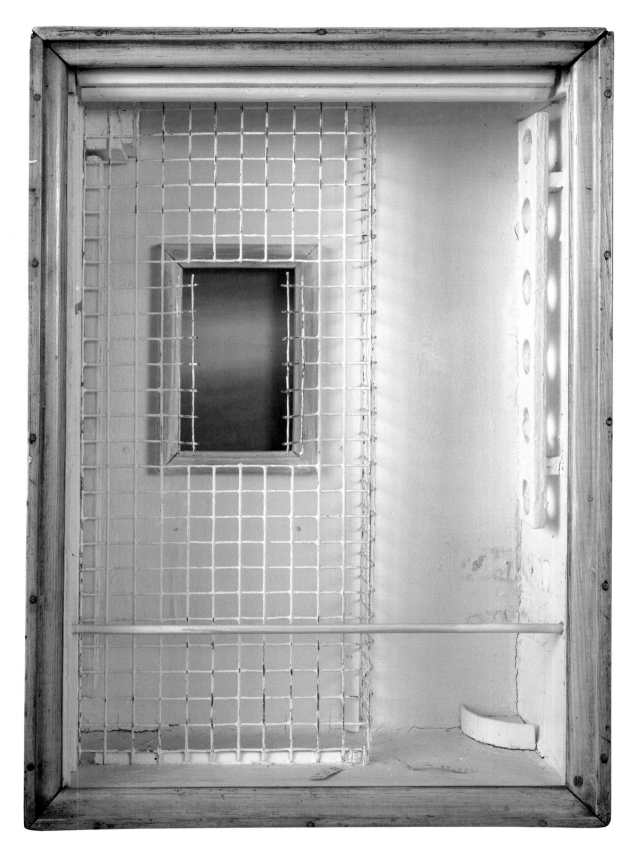

JOSEPH CORNELL *Toward the Blue Peninsula (For Emily Dickinson)*, c. 1953, The Robert Lehrman Art Trust,
Collection of Aimee and Robert Lehrman, Washington, DC

"You remember the crumbling wall that divides us from Mrs Sweetser —
and the crumbling elms and evergreens — and *other* crumbling things —
that spring, and fade, and cast their bloom with a simple twelvemonth —
well — they are here, and the skies fairer far than Italy, in blue eye look
down — up — see! — away — a league from here, on the way to Heaven! ...
Much that is gay have I to show, if you were with me, John, upon this April
grass — there there are *sadder* features — here and there *wings* half gone to
dust, that fluttered so, last year — a mouldering plume, an empty house, in
which a bird resided ..." — Emily Dickinson, letter to her cousin John Long Graves, April 1856

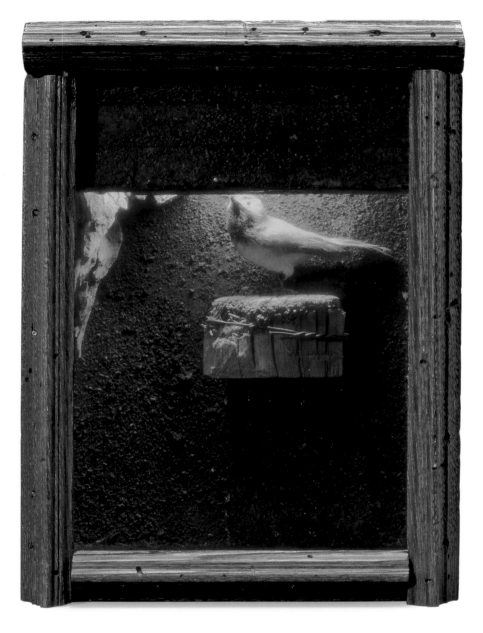

JOSEPH CORNELL *Untitled* [bird habitat, orange glass], c. 1960, Seattle Art Museum,
Gift of the Joseph and Robert Cornell Memorial Foundation

"magic windows of yesterday ... pet shop windows splashed with white and
tropical plumage the kind of revelation symptomatic of city wanderings
in another era." — Joseph Cornell, "PARROTS PASTA AND PERGOLESI," diary notes, 1960

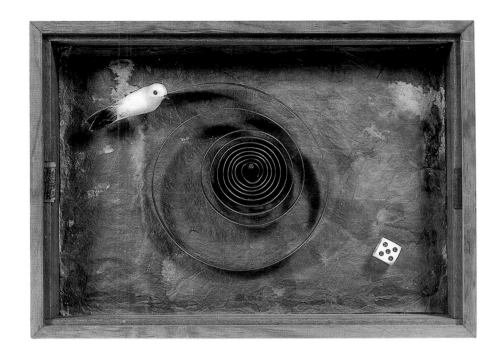

ELISA BRETON *Untitled*, 1970, The Israel Museum, Jerusalem, The Vera and Arturo Schwarz Collection of Dada and Surrealist Art in the Israel Museum

JOSEPH CORNELL *Untitled*, 1940, Collection of Timothy Baum, New York

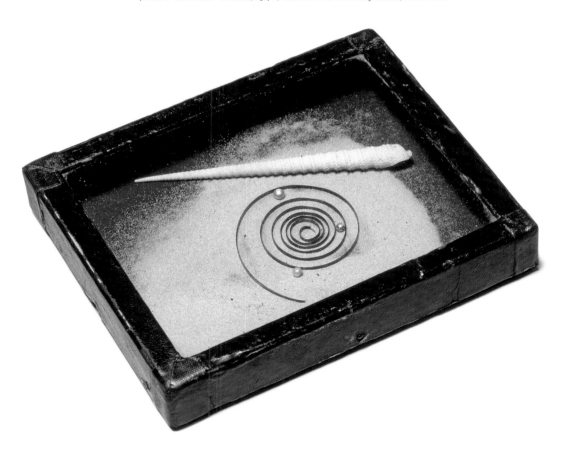

Dream Habitats

MYTHS, MAPS, MAGIC

Fig. 14 Gilles Ehrmann, *André Breton's apartment at 42, rue Fontaine* (detail), 1968, cibachrome, Collection Jean-Luc Mercié

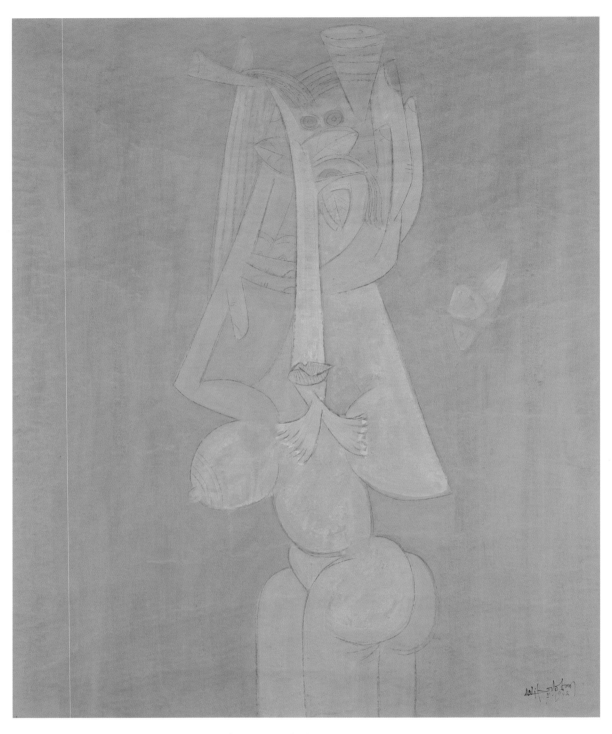

WIFREDO LAM *Deity*, 1942, Baltimore Museum of Art, Bequest of Sadie A. May

SURREALIST HYBRIDITY
AND WIFREDO LAM'S *DEITY*

WHITNEY CHADWICK

Wifredo Lam's large watercolour *Deity* (1942) belongs with a group of hybridized figure paintings, executed on his return to Cuba after an eighteen-year stay in Europe, that are characterized by fusions of male and female figures, women and horses, and humans, deities and personages.[1] In *Deity*, tube-like legs, bulbous buttocks and engorged breasts signify power and fecundity, lines and planes demarcate attributes and animal and human realms, chalky flesh in washes of pinks and blues suggests the rosy glow of breaking dawn. This and related works, including *Goddess With Foliage* and two untitled gouaches from 1942, show traces of the artist's European experience: the rigorous classicism of the Spanish Academy, the decorative impulse of Matisse's sinuous line and patterning, the Africanized forms of Picasso's Cubism, and the zoomorphic figures and psychically charged Automatism of surrealist drawings. Here they are synthesized in iconic figures that fuse the natural and the fantastic, the physical and the spiritual, in paintings that anticipate Lam's first monumental multi-figure canvas, *The Jungle* (1943) [p. 200].

Widely recognized as the masterpiece of the artist's first Cuban period, *The Jungle*, with its sources in Afro-Cuban and Caribbean cultures as well as its evocation of an animist nature, confirms Gerardo Mosquera's characterization of Lam as the first artist to introduce "a vision from the African element in the Americas in the history of gallery art."[2] In Cuba Lam joined images drawn from the natural world with the cosmic forces evoked in *Deity* and *The Jungle*, and with beliefs, rituals and symbols drawn from Santería, the African religion he knew from his youth, and Palo Monte Mayombe, an Afro-Cuban religion with roots in the Congo.[3]

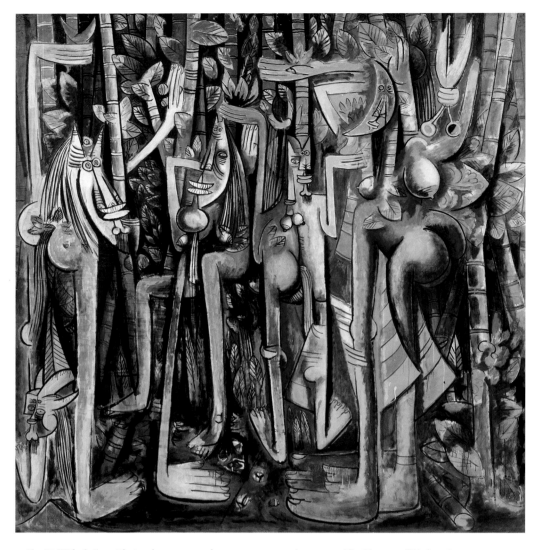

Fig. 15 Wifredo Lam, *The Jungle*, 1943, gouache on paper mounted on canvas, The Museum of Modern Art, Inter-American Fund, 140.1945, ©Estate of Wifredo Lam/SODRAC (2011), Image ©The Museum of Modern Art/Licensed by SCALA/Art Resource, NY

The European sources of Lam's artistic practice, and the importance of his time in Marseilles while awaiting transport out of Europe in the fall and winter of 1940–41, are well known. Lam joined a community of displaced European artists and intellectuals gathered around poet André Breton and his family at the Villa Air Bel, the headquarters of Varian Fry's Emergency Rescue Committee, a relief organization that helped intellectuals threatened by Nazism.[4] In Marseilles Lam was in daily contact with Breton and other Surrealists, among them Pierre Mabille, Victor Brauner, Max

Ernst, André Masson and Óscar Dominguez. His experiments there with Automatism led to the psychically-charged line drawings and hybrid forms that characterize the works of his first Cuban period. Invited by Breton to illustrate his long poem *Fata Morgana*, and using Spanish translations of the poems provided by Lam's wife, Helena Holzer, he produced a series of drawings in which figures mutate from male to female, human to animal, celestial to terrestrial. Suppressing illusionism, he relied on a sweeping but controlled line to produce a flow of visionary, mirage-like images that pulse with energy. Cascades of tiny stars transform a female figure's sweep of long hair into a kind of celestial display and dot the mane of this hybrid *femme-cheval*, later identified as the signature image of Lam's Cuban period, one often traced to Picasso and the influence of his 1935 etching *Minotauromachy*.[5]

Lam's artistic path through the 1930s and early 1940s is often viewed as a series of modernist stylistic stages in which European sources and images give way to those of Caribbean and Afro-Cuban cultures. More recently, Dawn Ades has demonstrated the continuity of Lam's European surrealist sources in Paris and Marseilles with his experiences on the journey from France to Martinique and Cuba in the company of Breton and Masson, and his encounter with the version of Surrealism expressed by the poet Aimé Césaire. Published in 1939, Césaire's long poem *Cahier d'un retour au pays natal* (Notebook of a Return to the Native Land) lays out a model of intercultural communications between Europe and the Americas.[6]

The Surrealism Lam encountered in Marseilles also provided additional sources for his emerging interest in a fluid and psychically complex set of images that extended beyond the often-remarked resurgence of Automatism embraced by Breton and evident in the *Fata Morgana* drawings. In Marseilles he renewed his friendship with Max Ernst, who arrived in the city in December 1940 from Saint-Martin d'Ardèche, where he had lived with the English Surrealist Leonora Carrington for two years prior to his arrest in 1939 and his imprisonment as an enemy alien. It is possible that Lam saw the paintings that Ernst brought with him. A photograph taken in the winter of 1940–41, during the period when Lam worked on the *Fata Morgana* drawings, shows a selection of Ernst and Carrington paintings being lifted up into a tree outside the villa in preparation for the weekly Sunday gathering and occasional sale. These include three works that were central to their incorporation of hybrid images, such as the hermaphroditic bird-man and the *femme-cheval*, into a personal mythology of physical, alchemical and spiritual transformation.

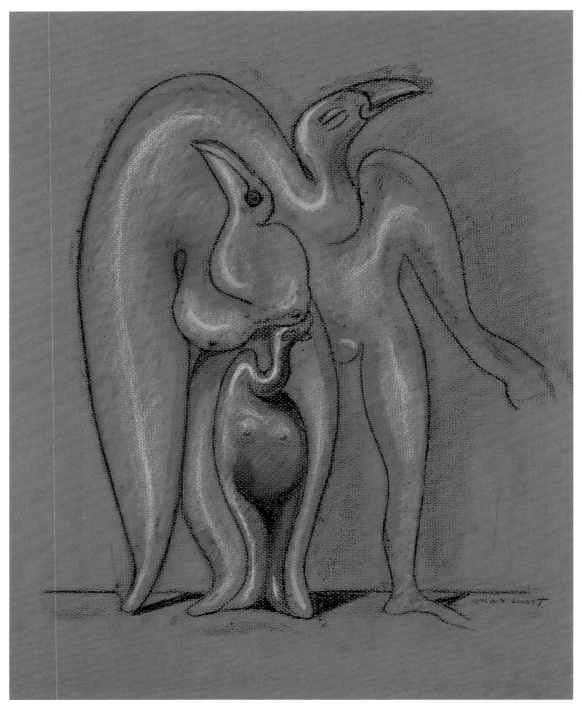

MAX ERNST *The Bird People* [from *VVV Portfolio*], 1942, Baltimore Museum of Art, Gift of Sadie A. May

Although he was clearly influenced by the automatic drawings of Masson and Roberto Matta from the late 1930s, any affinity between the artist and Ernst seems conceptual rather than stylistic. Lam's hybrid images of 1942–43 reflect the influences of Afro-Cuban rather than European cultures and beliefs. Even so, his focus on the powers inherent in earth, vegetation, stones, signs, objects, spirits and deities and their place within the cosmos resonates with existing tendencies in surrealist paintings.

The paintings that hung outside the Villa Air Bel in the winter of 1940–41 included Ernst's *The Robing of the Bride* (1940) (otherwise known as *Attirement of the Bride*) with its monumental hybrid bird-woman; Carrington's *The Inn of the Dawn Horse* (1938) with its fusing

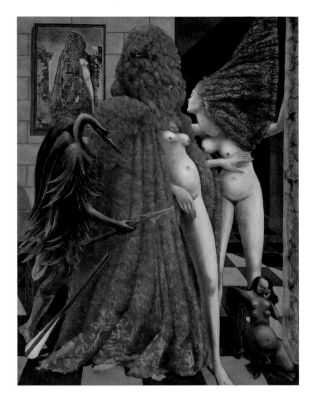

Fig. 16 Max Ernst, *La Toilette de la mariée* [Attirement of the Bride], 1940, oil on canvas, Peggy Guggenheim Collection, Venice (Solomon R. Guggenheim Foundation, NY), ©Estate of Max Ernst/SODRAC (2011)

of woman and horse; and her 1940 portrait of Ernst as a shamanic figure dressed in a feathered cloak. *The Robing of the Bride* relates to a series of forest paintings of the 1930s that were based on memories of Ernst's journey to French colonial Indochina in 1924. Carrington's self-portrait *The Inn of the Dawn Horse* with its sources in Celtic myth belongs to a group of paintings from the 1930s that includes images of the *femme-cheval*.[7]

Ernst's text "Les Mystères de la Fôret" (Mysteries of the Forest), published in *Minotaure* in 1934, animates and contrasts two forests: one is European, rigid, geometric, conscientious and boring; the other, far from Europe in Oceania, is "wild and impenetrable ... extravagant ... negligent, fervent and lovable ... dressed only in majesty and mystery," like the figure of Carrington, his "bride of the wind" in *The Robing of the Bride*.[8] Already familiar with the Uruguayan-born Comte de Lautréamont when he visited Indochina, Ernst remained haunted by that author's fantastic evocations of an animistic forest, a generative source of hybrid figures like the hermaphrodite with its doubled sexual organs.[9] By the late 1930s, the forest image functioned as a

privileged site for his elaboration of a mythos of hybridity and transformative power interwoven with the figure of the loved woman and her bird-man, in paintings that include the jungle-like *Nature at Dawn* (1936) and *Leonora in the Morning Light* (1940). In *The Robing of the Bride* (1940), among the last paintings Ernst executed before leaving for North America, he used imagery of physical, psychic and alchemical transformation to unite the image of the bride with the forest.

The mental images that Lam carried away from Marseilles in March 1942 would have included transitional creatures that participate in more than one realm of being and consciousness, hybrid figures and dynamic linear shapes now linked with the powerful, mysterious deities, goddesses and personages of his childhood in Cuba. These multiple sources would inform *Deity* and other paintings of Lam's first Cuban period.

[1] Lou Laurin-Lam, *Lam: Catalogue Raisonné of the Painted Work*, Vol. 1, 1923–1960 (Lausanne: Sylvio Acatos, 1966), 296. [2] Gerardo Mosquera, "Modernism from Afro-America: Wifredo Lam," in Gerardo Mosquera, ed., *Beyond the Fantastic: Contemporary Art Criticism from Latin America* (London: Institute of International Visual Arts, 1995), 123. [3] Gerardo Mosquera, "Modernidad y Africania, Wifredo Lam in His Island," *Third Text* 20 (Autumn 1992), 56–57; also Judith Bettelheim, "Lam's Caribbean Years: An Intercultural Dialogue," in *Wifredo Lam*, exh. cat. (Miami: Miami Art Museum, 2008), 11–21. [4] Martica Sawin, *Surrealism in Exile and the Beginning of the New School* (Cambridge, MA and London: MIT Press, 1995), 104–146; Dawn Ades, "Wifredo Lam and Surrealism," in *Wifredo Lam in North America*, exh. cat. (Milwaukee: The Patrick and Beatrice Haggerty Museum of Art, Marquette University, 2008), 37–47. [5] Lowry Stokes Sims, *Wifredo Lam and the International Avant-Garde, 1923–1982* (Austin: University of Texas Press, 2002), 6. [6] Ades, "Wifredo Lam and Surrealism," 37. [7] Les Mystères de la Fôret," *Minotaure* 5 (1934), 6–7; Susan Rubin Suleiman, "The Bird Superior Meets the Bride of the Wind: Leonora Carrington and Max Ernst," in *Significant Others: Creativity and Intimate Partnership*, eds. Whitney Chadwick and Isabelle de Courtivron (London and New York: Thames and Hudson, 1993), 112. [8] For an account of the importance of this trip, see Robert McNally, *Ghost Ship: A Surrealist Love Triangle* (New Haven and London: Yale University Press, 2004). [9] The painting is the subject of David Hopkins', "Max Ernst's 'La Toilette de la mariée'," *The Burlington Magazine* 133, no. 1057, April 1991, 237–244.

American art historian **WHITNEY CHADWICK**, Professor Emerita, San Francisco State University, has written extensively on women artists, Surrealism, gender issues and critical theory. Her books include *The Modern Woman Revisited: Paris Between the Wars* (editor, with Tirza True Latimer, 2003), *Framed*, an art historical crime novel (1999), *Leonora Carrington: La Realidad de la Imaginacion* (1994), and *Women Artists and the Surrealist Movement* (1985). *Women, Art, and Society* (1990), her notable book on feminist issues in art and art history, is now in its fourth edition.

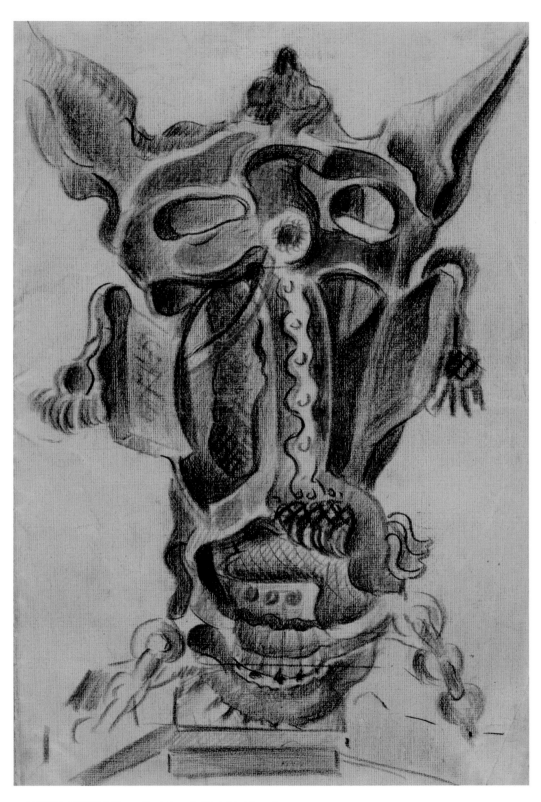

ALBERTO SÁNCHEZ *Mascarilla de la mula* [Mule Mask], 1926–30,
Museo Nacional Centro de Arte Reina Sofía, Madrid

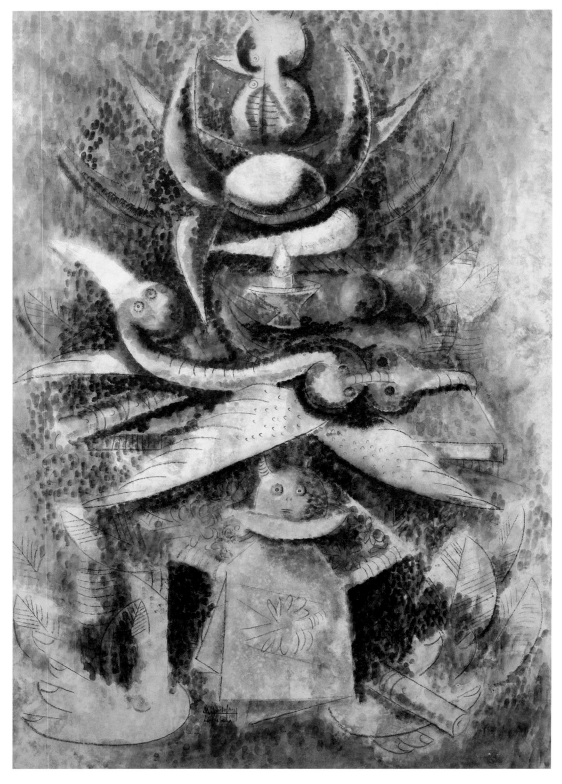

WIFREDO LAM Above and opposite: *Untitled*, 1942–44 [recto verso], Private Collection,
Courtesy of Mary-Anne Martin Fine Art, New York

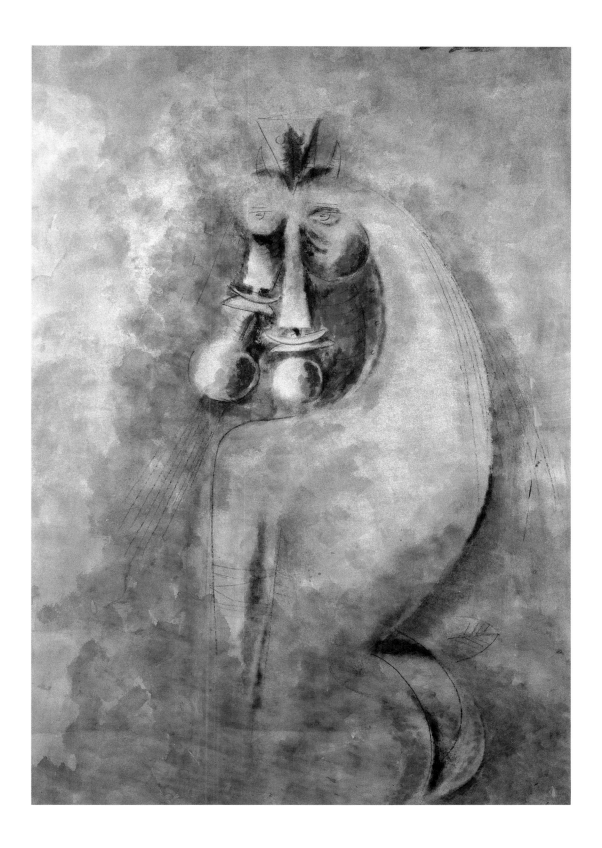

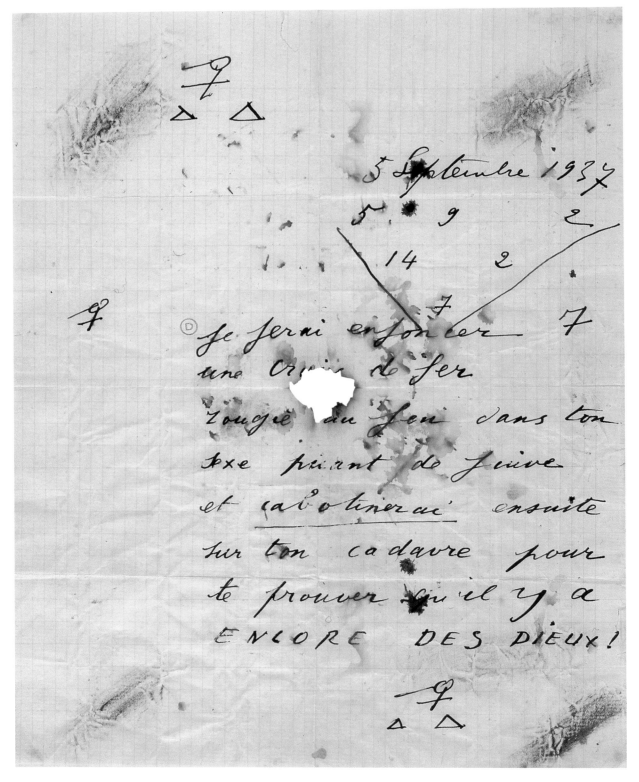

ANTONIN ARTAUD *Sort à Lise Deharme, 5 septembre 1937* [Spell, for Lise Deharme …], 1937, Chancellerie des Universités de Paris — Bibliothèque littéraire Jacques Doucet, Paris

In 1937, Antonin Artaud went to Ireland to continue his search for the "living sources" of culture that he had begun the previous year in México. His health deteriorated and he suffered "acute hallucinatory psychosis." He started sending *sorts*, written spells charged in his mind with magic power, some protective, some, like this to Lise Deharme, malevolent. He threatens her because she had denied that there were Gods. " There are Gods," he explained in a covering letter to André Breton, "even if there is no God. And above the gods the unconscious, criminal laws of Nature, of which the gods and Ourselves, that is to say We-the-Gods, are united victims."

Artaud had run the Bureau de Recherches surréalistes (Office for Surrealist Research) in 1925 and contributed some of the most passionate articles to *La révolution surréaliste*, attacking the pillars of European society (universities, the Pope, the directors of mental asylums) and calling for prisons to be opened and the army to be disbanded.

[D.A.]

42, RUE FONTAINE

ANTHONY SHELTON

*Like a vestible between two cars of a train, those phantoms you so love
await you in the doorway of Gradiva to guide you inside.*[1]

Between 1922–1939 and from 1946 until his death in 1966 André Breton lived in the same
Paris apartment: 42, rue Fontaine. Located near place Blanche, midway between the two
Montmartre cabarets Le Ciel and L'Enfer, the long time home of Surrealism's self-anointed
high priest became a potent site where surrealist technologies harnessed and channelled
considerable agency. At the beginning of this residency Breton disdained material
possessions, but during his wartime exile in Manhattan he eagerly joined his friends
Max Ernst, Georges Duthuit and Claude Lévi-Strauss in the search for exotic objects.[2]

With its diverse sedimentations of marvelous and transgressive objects, the apartment
must have gone through a number of metamorphoses. By 1960, when Sabine Weiss
photographed the apartment where he had lived since the end of the war with his
third wife, Elisa Claro, it had become a treasure trove of books, manuscripts, surrealist
works, non-Western art, folk art and toys, gathered together from near and distant
places. Breton confessed in *Free Rein* that he journeyed out of France mainly to discover
new and rare Oceanic objects, hunts that unleashed an unusual hunger.[3] In 1955, in
Communicating Vessels, Breton again acknowledged his passion for "discovering and
possessing all sorts of bizarre objects, 'Surrealist' objects."[4]

Although the juxtaposition of objects in his studio changed — even between Weiss's
1960 photographs and others taken at the end of his life — there was always an *anti-
order* which made his home, with its dark green and brown tonality,[5] rather sombre,
transforming Breton himself into "a fetishist among his fetishes."[6] The studio was
divorced from the world around it, capable of detaching from the bourgeois training
of their senses those who dallied to gaze on it.

Fig. 17 Gilles Ehrmann, *André Breton's apartment at 42, rue Fontaine*, 1968,
cibachrome, Collection Jean-Luc Mercié

Breton's studio can be interpreted as a laboratory for surrealist experimentation. Surrealism begins with the disruption of the language of common things and experiences for the sake of epiphanies, either through surprising encounters with surrounding objects and sites or through the juxtaposition of images and materials that might crystallize into a *poem-object*, for example. In this way, his studio contents and their order and arrangement can also be read as a poem-object, a eulogy to Gradiva, the muse of Surrealism based on a fictional woman.[7]

The surrealist gaze was focused on special geographies, which inflated Oceania, Mexico, Russia, the American Southwest and Northwest, Alaska and Labrador, while virtually erasing those countries and continents that had already succumbed to materialism. The *Surrealist Map of the World* (1929), a work that foreshadowed Breton's later travels and collecting expeditions, clearly illustrates the mapping of surrealist imaginations onto geographical space. The exaggerated geographical regions and the special Parisian sites reflected surrealist tastes and mirrored the areas in which they were most likely to search for and acquire the kind of works that filled 42, rue Fontaine.

For Breton's domestic altar, Oceanic and North American art captivated his attention. "Oceania Not only has it been inspiring enough to hurl our reverie into the most vertiginous bankless streams, but also so many objects bearing its trademark will have supremely aroused our desire."[8] As though on an altar behind the desk a large, standing Uli figure[9] with its massive condensed volume looked threateningly at the writer, the Uli taking the place of Christ. On the other side of his desk was a tall, elongated Tolai figure, almost the opposite of the Uli in its flightiness. Between the two figures, resting on a small Northwest Coast carved box, was a Kwakwa̱ka'wakw frontlet, a piece that decades later Breton's daughter would repatriate to Alert Bay, its community of origin.

The studio contained other pieces from the Bismarck Archipelago, including Malangan masks from New Ireland. From mainland New Guinea, Breton acquired a number of overmodelled skulls from the Asmat, ceremonial boards from the Papuan Gulf and masks and anthropomorphic hooks from the Sepik River region. His collection included rare Easter Island figures, two Janus-faced Marquesas clubs and coconut-fibre armour from the Kiribati Islands. A wide-mouthed squatting figure with outstretched arms, from the Nicobar Islands in the Indian Ocean, seemed to beckon from behind the desk.

On the rear wall of his desk were two tiers of *katchina* figures, spirit beings from the American Southwest, collected by Breton during his 1945 excursion to Zuni and Hopi villages in Arizona and New Mexico. There were Yup'ik masks from Alaska

and a few carvings from the Haida and Kwakwa̲ka'wakw peoples as well as minor pre-Columbian pieces. African objects, with the exception of a Bamun throne and a Bambara figure, were noticeably absent, as were pieces from Asia, apart from a few objects from Tibet and Indonesia.

His studio, the ark for all these marvels, Breton anticipated as

an ageless place located anywhere outside the world of reason. In that space would be stored those manmade objects that have lost their utilitarian purpose, or have not yet found it, or have markedly deviated from it and that therefore conceal some internal secret lock. Those objects could then emerge in an elective way and continuously from the river of ever-thickening sand that blurs adult vision, restoring to it the transparency that children enjoy.[10]

To these would be added natural objects whose function or meanings were difficult to fathom: paintings by the artists he admired, ancient coins, and children's games and toys. What better place could there be "outside the world of reason" than an apartment on a street named after one of the world's greatest writers of fables?

For him, "[t]he poem object is a composition which combines the resources of poetry and plastic art, and thus speculates on the capacity of these two elements to excite each other mutually."[11] His early poem-object *1713* was created in 1941 from the chance operation of bricolage. Examples of other attempts to bring about a revolution in the perception of objects were given a high profile in the studio: from Dalí's symbolic functioning objects; through Ernst's *interpreted* found objects, derived from the objectification of dreams; to Duchamp's *readymades*, stripped of function. As Breton wrote, "Our primary objective must be to oppose by all possible means the invasion of the world of the senses by things which mankind makes use of more from habit than necessity."[12]

He believed that rapture might also manifest in natural history, ethnographic and other kinds of museums, sites which can disrupt and suspend the hubris of the everyday world by juxtaposing it with the debris we strive to contain and hide. At the Musée Gustave Moreau he saw the illuminatory presence of Moreau's paintings for the first time, an experience he later transported to the studio through possession of one of the artist's relics, *Esquisse pour Jupiter et Sémélé* (Sketch for Jupiter and Sémélé). Moreau's mythological figures, the uncanny luxuriance and sublime looks and poses of the women he depicted, were a revelation:

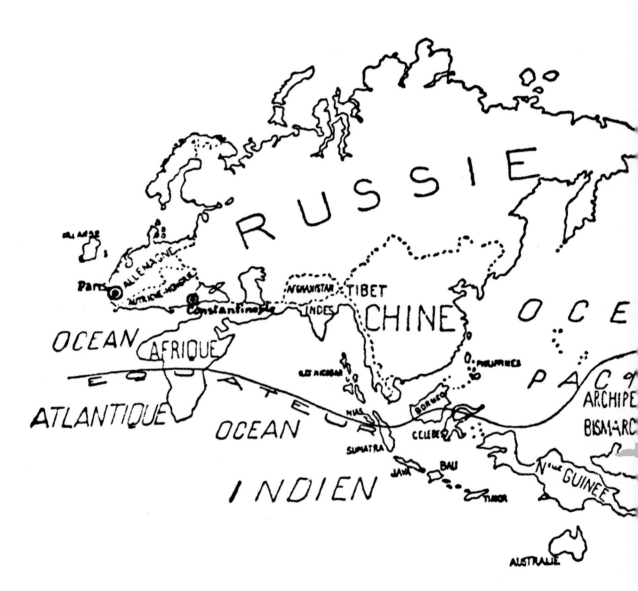

Fig. 18 *The World in the Age of the Surrealists*, *Variétés*, Brussels, 1929

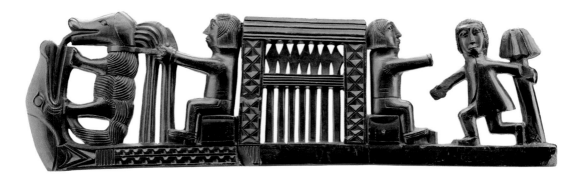

HAIDA *Panel Pipe*, 1830–1865, Private Collection, London, UK, Courtesy Donald Ellis Gallery, Dundas, ON and New York, NY, Formerly André Breton Collection

My discovery, at the age of sixteen, of the Musée Gustave Moreau influenced forever my idea of love. Beauty and love were first revealed to me there through the medium of a few faces, the poses of a few women.[13]

The woman who became Breton's muse is embodied in many women, but for him she took the name Gradiva. Breton even named his art gallery after her, André Masson made paintings to celebrate her name, while Dalí's wife, Gala, became Gala-Gradiva. Breton asked and ultimately answered:

Who could "she" be, other than tomorrow's beauty, as yet hidden from the multitude, and only glimpsed here and there as one draws near some object, goes past a painting, turns the page of a book? She adorns herself with all the lights of the never seen that forces [sic] men to lower their eyes. Yet she haunts their dwellings, gliding at dusk through the corridors of poetic premonitions.[14]

On the outside of his studio door, Breton hung an open carved polychromatic Maprik panel depicting a woman with outstretched legs, flanked on either side by two birds. Similar abstract female images appear on his decorated boards from the Papuan Gulf, his Sepik hooks and a Korwar circular platter. Gradiva reveals herself in multiple flashes of the surrealist demiworld: she manifests her presence in different images; she is the vertigo experienced by the surrealist revelation; the manifestation of "convulsive beauty." It is Gradiva who haunts Breton's studio. The instruments and apparatuses amassed there are the indispensible objects necessary for the surrealists' litany and the images are evidence of their devotion. 42, rue Fontaine was Breton's expression of the surrealist condition and æsthetic: "Convulsive beauty," he wrote, "will be veiled-erotic, fixed-explosive, magic-circumstantial, or it will not be."[15]

[1] André Breton, *Free Rein* (Lincoln and London: Nebraska University Press, 1995) (1953), 21. [2] Claude Lévi-Strauss, *The View from Afar* (Harmondsworth: Penguin, 1985), 261. [3] Breton, *Free Rein*, 172. [4] André Breton, *Communicating Vessels* (Lincoln and London: Nebraska University Press, 1990) (1955), 45. [5] J. Gracq, *42 rue Fontaine. L'atelier d'André Breton* (Paris: Société Adam Biro, 2003), 142. [6] Dawn Ades quoted in L. Tythacott, *Surrealism and the Exotic* (London and New York: Routledge, 2003), 44. [7] Based originally on the walking figure of an early Roman bas-relief, a copy of which Freud kept in his study, the inspiration for this femme-fatale came from the character in the 1903 novel *Gradiva* by Wilhelm Jensen. [8] Breton, Free Rein, 172. [9] A type of wooden statue from New Ireland in Papua New Guinea. [10] Breton, *Free Rein*, 20. [11] André Breton, *Surrealism and Painting* (New York: Icon Editions, Harper and Row, 1972) (1965), 284. [12] Breton, *Surrealism and Painting*, 279. [13] Ibid., 363. [14] Breton, Free Rein, 19. [15] M. Caws, *The Surrealist Look. An Erotics of Encounter* (Cambridge, MA: MIT Press, 1999), 239.

ANTHONY SHELTON has been Director of the Museum of Anthropology in Vancouver since 2004. A distinguished anthropologist, administrator, curator and teacher originally from Britain, Shelton is a leading scholar in museology, cultural criticism, and the anthropology of art and æsthetics. He has taught at several European universities and has curated or co-curated thirteen exhibitions, including *Exotics: North American Indian Portraits of Europeans* (1991), *Fetishism* (1995), and *African Worlds* (1999). Shelton has written on topics ranging from African visual culture to Chinese puppets to Western constructions of tropes of otherness: fetishism, primitivism and exoticism.

THE LURE OF THE PACIFIC NORTHWEST

NUXALK *Mask*, c. 1860–1880, Collection of Michael Audain and Yoshiko Karasawa, Vancouver

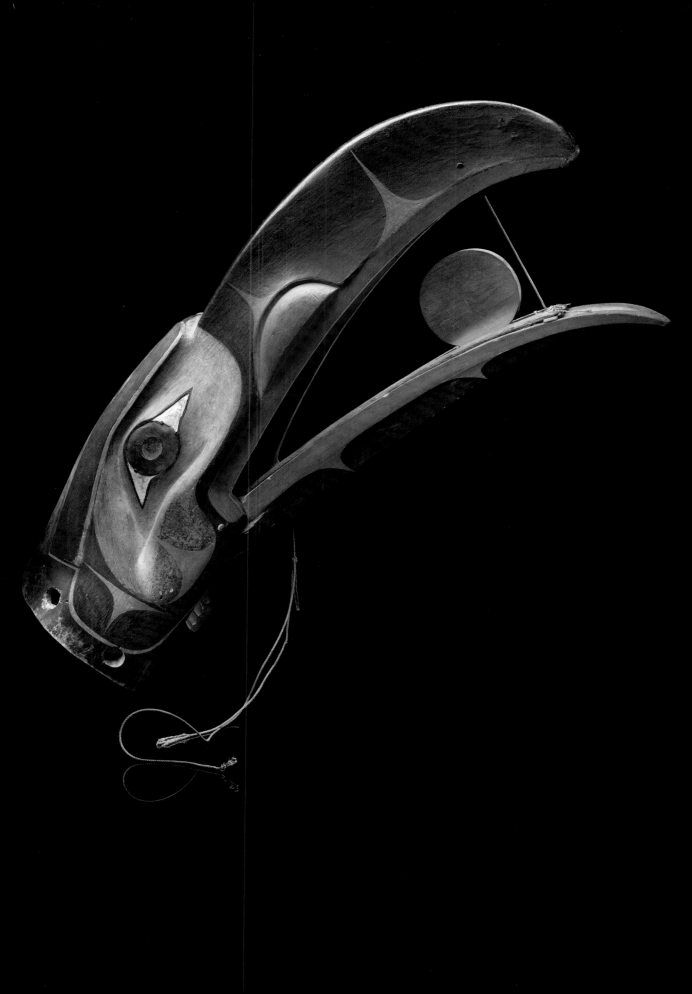

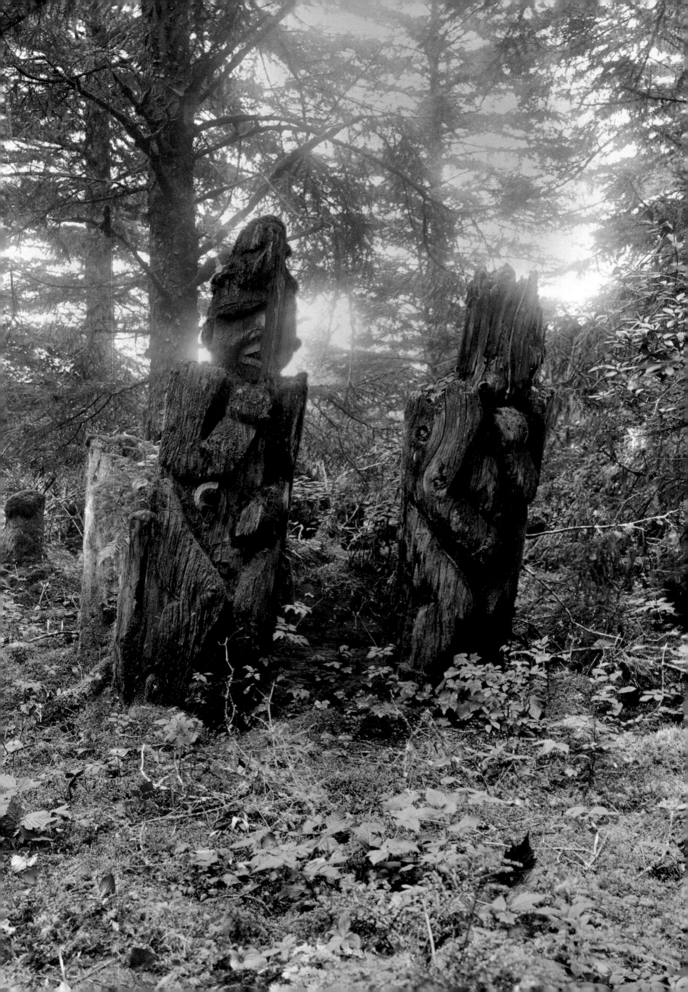

A CONVERSATION WITH A TSIMSHIAN

KURT SELIGMANN

Having reached port, the captain told me to cut off my moustache.
— Adalbert de Chamisso, *Voyage around the world*, c. 1827

In his smokehouse, hung with fillets of red salmon, the Indian Tsimshian, having explained the origins of his family, asked me whether in Europe we also had ancestors like his who fought monsters?

I recounted some of the exploits of our mythical heroes, adding that they often fought to rescue women who were being held captive or whom monsters were threatening to eat.

The Indian wanted to know whether the women subsequently gave birth to monsters? And he shook his head when I told him that none of them had sexual relations with their captors.

I explained that the original meaning of our myths has become garbled. Only a few details of these deeds of valour have withstood the distortions of time. It could well be that originally these rescued virgins had the same character as the female ancestors of the Indians.

"Your minotaurs, your dragons and your sea monsters," the Indian said, "must be former totems; for a woman to be carried away by them was, as for us, not simply a fearful thing but also a great honour. Didn't you tell me that this kind of adventure usually happened to princesses? Just so with us: the monster always chooses noble women. Neegyamks, who was carried off by a frog, was of royal blood. She lived for many years at the bottom of a lake and, when her brothers forced her to re-emerge, they found her covered with tiny frogs that came out of her eyes, her mouth and her breasts. She asked to be put to death, but begged her family to spare her frog children."

I asked whether the women, after such adventures, were always sacrificed.

"Not always," he told me. "Our ancestor Hrpeesunt did not come to this tragic end. She lived for a long time with a bear, and her children were bear cubs with human

hands. Sometimes the monster himself destroyed the abducted woman; this was the case with Keyghiett and his victim. But quite often they came back and continued their normal lives. In the history of the Gunarhnaesems family, their ancestor was walking on the beach when she was carried off by a fish, and her husband searched everywhere, finally discovering her in the depths of the clear water, surrounded by little fishes: her children. He managed to get her back, and the couple returned to their normal life as if nothing had happened. That husband was very proud of the fact that his wife had had a relationship with a magic animal. Another woman, carried off by an eagle, came home again bearing a nest on her head. But often the stolen women perished and the animal totem was killed. Curiously the latter never held it against its van-quisher. Sometimes, before dying, the monster speaks, as Fafner does in your story of Sigurd. Sometimes it predicts the future, or teaches the Indians magic songs." Then the Tsimshian asked me whether we had totems in Europe at the moment.

"I believe as you do," I answered, "that we had totems a very long time ago. But these totems have fled into the armorial bearings of families, and later, into those of towns and countries. In the canton of Uri, in Switzerland, whose coat-of-arms is the head of a bull, the standard bearer used to wear the skin of this animal when he led troops into battle. Doesn't that remind you of your Indians who, in similar conditions, wore the emblems of their totems? And in the town of Berne, whose coat-of-arms is marked with the bear, they keep these animals in a pit. The citizens believe it brings them good luck. However, apart from their presence on coats of arms, true totems have disappeared in Europe. Only one ancestor made his way into the Christian religion: St. George, the stylised imitation of Perseus, whose story I told you. Besides, the secret of the armorial bearings was lost in its turn, several centuries ago. But I would be curious to know what the missionaries thought of the totem poles?"

"Recently," the Indian said, "they burnt them. Currently, the state protects our relics, and the priests leave them alone. They think of them now like heraldic poles, stripped of all magic. For our young people they are outmoded objects and have lost their power. The magic of bicycles, cinemas, railways, seems infinitely more attractive to them, and they speak with little respect of the older people who know and jealously guard the ancient secrets."

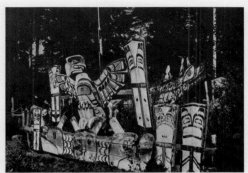

CIMETIÈRE INDIEN, ALERT BAY, COLOMBIE BRITANNIQUE — *Photo Kurt Seligmann*

ENTRETIEN AVEC UN TSIMSHIAN
par Kurt Seligmann

Arrivé au port, le capitaine me dit de couper mes moustaches.

ADALBERT DE CHAMISSO
« Voyage autour du monde »

Dans sa fumerie où pendaient des filets rouges de saumon, l'Indien Tsimshian, après m'avoir expliqué les origines de sa famille, me demanda si, en Europe, nous n'avions pas des ancêtres qui, comme les siens, avaient combattu des monstres?

Je lui racontais quelques exploits de nos héros mythologiques, et j'ajoutai que souvent ils les avaient combattu pour délivrer des femmes, retenues captives, ou menacées d'être dévorées par un être surnaturel.

L'Indien voulut savoir si dans la suite les femmes avaient enfanté des monstres? Et il hocha la tête quand je lui dis qu'aucune d'entre elles n'avait eu des rapports sexuels avec son ravisseur.

J'expliquai à l'Indien que le sens originel de nos mythes est devenu inintelligible. Seuls quelques détails essentiels de ces hauts faits ont résisté aux déformations. Il se peut fort bien, en effet, qu'à l'origine ces vierges délivrées aient eu le même caractère que les femmes ancêtres des Indiens.

Vos minotaures, vos dragons et vos monstres marins,

66

m'affirma l'Indien, sont certainement d'anciens totems; pour une femme, être emportée par eux était comme chez nous un grand honneur. Ne me dites-vous pas que ce genre d'aventure arrivait de préférence à des princesses? Ainsi, chez les Indiens, ce sont toujours des femmes nobles que le monstre choisit. Néegyamks, qui fut ravie par une grenouille, était de sang royal. Longtemps elle a vécu au fond d'un lac et, lorsque ses frères l'obligèrent à sortir, ils la trouvèrent couverte de petites grenouilles qui lui sortaient des yeux, de la bouche et des seins. Elle demanda à être tuée, mais pria ses parents d'épargner ses enfants grenouilles.

Je demandai si les femmes, après de telles aventures, furent toujours immolées.

— Pas toujours, me dit-il. L'ancêtre Hrpesunt n'a pas connu cette fin tragique. Elle a vécu longtemps avec un ours, et ses enfants furent des oursons aux mains humaines. Quelquefois le monstre lui-même anéantit la femme enlevée, comme le fit le géant Keyghiett avec sa victime. Mais assez souvent elles revirent et continuèrent leur vie normale. Dans l'histoire de la famille de Gunarhnaesems l'ancêtre se promenait sur la plage lorsqu'elle fut ravie par un poisson, et son mari qui la cherchait partout la découvrit finalement au fond des eaux limpides, entourée de petits poissons : ses enfants. Il réussit à la récupérer, et le couple reprit sa vie normale, comme si de rien n'était. Ce mari-là était très fier que sa femme eût eu des rapports avec un animal magique. Une autre femme, enlevée par un aigle, revint à la maison, portant un nid sur sa tête. Mais souvent les femmes volées périrent et l'animal totem lui fut cruel. C'est un fait curieux que celui-ci n'en veuille jamais à ses vainqueurs.

Quelquefois, avant de mourir, le monstre parle, comme le fit Fafner dans votre histoire de Sigurd. Parfois il prédit l'avenir, ou bien il apprend aux Indiens des chants magiques. Puis le Tsimshian me demanda si, actuellement, en Europe, nous avions des totems.

— Je crois comme vous, lui répondis-je, qu'il en a existé chez nous il y a très longtemps. Mais ces totems se sont réfugiés dans les armoiries des familles, et, plus tard, dans celles des villes et des contrées. Dans le pays d'Uri, en Suisse, qui a pour blason une tête de taureau, le porte-drapeau revêtait autrefois la peau de cet animal quand il conduisait les hommes au combat. Cela ne vous rappelle-t-il pas vos Indiens qui, dans les mêmes conditions, revêtent les emblèmes de leurs totems? Et dans la ville de Berne, dont l'ours est l'attribut des armoiries, on entretient des ours dans une fosse. Ils sont censés porter bonheur aux citoyens. Toutefois, à part leur présence dans les blasons, les vrais totem ont disparu chez nous. Un seul ancêtre a pu s'introduire dans la religion chrétienne : saint Georges, l'imitateur figé de Persée, dont je vous ai raconté l'histoire. D'ailleurs le secret des blasons fut perdu à son tour, il y a plusieurs siècles. — Mais je serais curieux de savoir ce que les missionnaires pensent des mâts-totem?

— Récemment, dit l'Indien, ils les firent brûler. Actuellement l'État protège nos reliques, et les prêtres n'y touchent plus. Ils les considèrent maintenant comme des mâts héraldiques, dépouillés de toute magie. Pour nos jeunes gens ce sont des objets de temps périmés, ayant perdu leur force. La magie des bicyclettes, des cinémas, des chemins de fer leur paraît infiniment plus attirante, et ils parlent sans beaucoup de respect de nos vieillards qui connaissent et gardent jalousement les anciens secrets.

LE MYTHE DES LANGUES LÉCHÉES

Lutrsaisult, enlevée par un chef haïda est forcée de devenir sa femme. Elle enfante plusieurs fils que le mari décapite dès leur naissance, afin d'éviter que des étrangers ne deviennent plus tard les chefs de son clan. Dans la nuit Lutrsaisult coupe la tête du mari endormi, puis, avec ce trophée et le dernier fils sauvé, elle s'enfuit dans un canot et regagne la côte Tsimshian, son pays natal. Pendant qu'elle rame, il lui est impossible d'allaiter son enfant. Pour le calmer, elle tire la langue de la tête décapitée et c'est cette langue que suce le nourrisson.

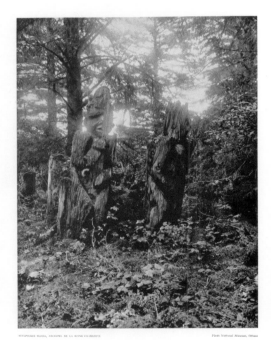

SCULPTURE HAIDA, ARCHIPEL DE LA REINE CHARLOTTE — *Photo National Museum, Ottawa*

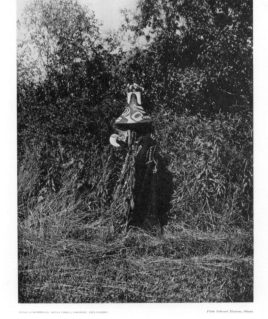

MASQUE D'CHAMPS, ALERT BAY, COLOMBIE BRITANNIQUE — *Photo National Museum, Ottawa*

Kurt Seligmann, "Entretien avec un Tsimshian" ["Conversation with a Tsimshian"], in *Minotaure*, Paris, nos. 12/13, 1939, pp. 66–69, Collection of Timothy Baum, New York

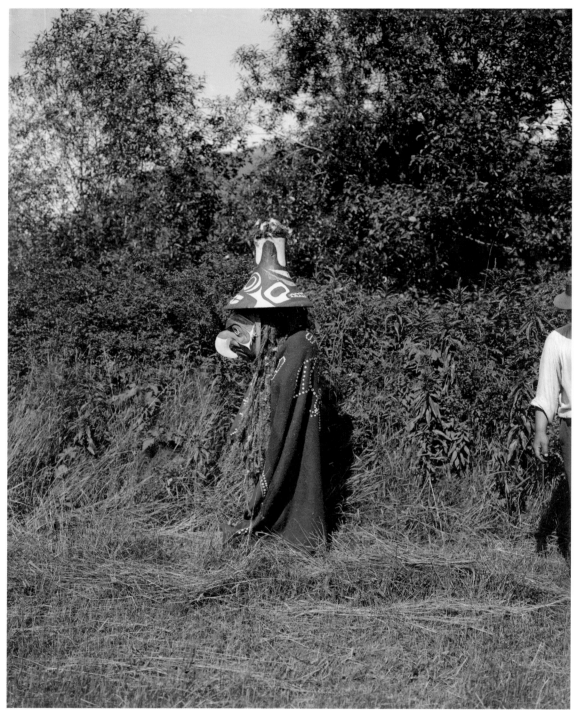

Fig. 20 Harlan Ingersoll Smith, *Masked dancer in ceremonial regalia, Bella Coola River Valley*, 1923, Canadian Museum of Civilization (58527)

MYTHS, MAPS, MAGIC

THE MYTH OF THE LICKING TONGUES

Lutraisuh, carried off by a Haida chief, is forced to become his wife. She gives birth to several sons whose heads the husband immediately cuts off, in order to prevent strangers from later becoming leaders of his clan. In the night Lutraisuh cuts off the head of the sleeping husband, then, with this trophy and the last born son whom she saved, she escapes in a canoe and reaches the Tsimshian coast, her native country. While she is rowing, it is impossible for her to nurse her child. To keep him quiet, she pulls out the tongue of the decapitated head and it is this tongue the baby sucks.

— Kurt Seligmann, "Entretien avec un Tsimshian," *Minotaure*, 12/13, 1939, 66–67 [see p. 223]. Translated from the French by Dawn Ades.

KURT SELIGMANN (1900–1962), a Swiss born painter and engraver, lived in Paris from 1929 to 1938, where he was formally accepted by André Breton as a Surrealist in 1937. In 1938 Seligmann journeyed with his wife to the Northwest Coast of British Columbia, where he amassed a collection, including the great totem pole now in the Musée du Quai Branly. He returned to Paris but left again in September 1939, the first European Surrealist to land in New York after war broke out. Seligmann lived in the US from then on, teaching, painting and producing some of his best work, including *The Myth of Œdipus* (1944), a set of fifty etchings.

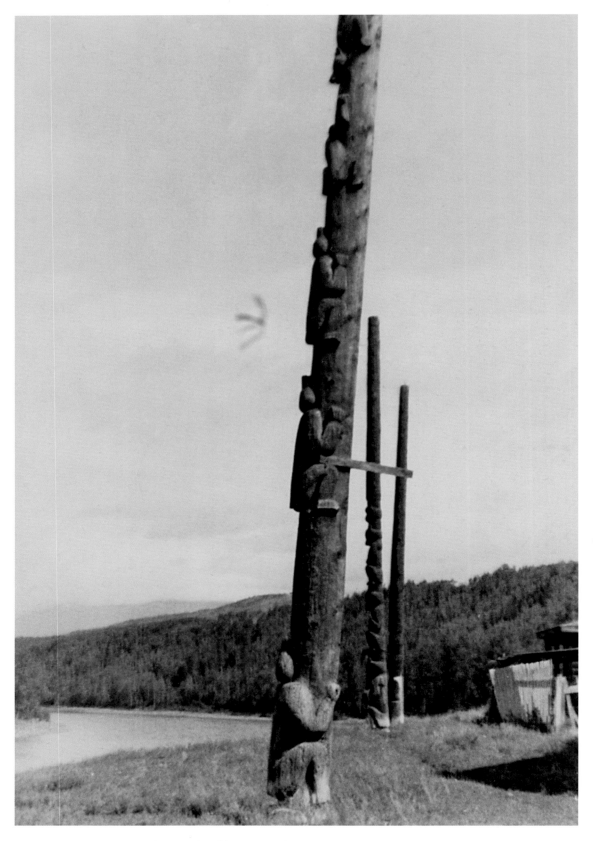

KURT SELIGMANN *Mat totem de Gitenmaks Hill* [Totem Pole of Gitanmaax Hill], n.d., Musée du Quai Branly, Paris

KURT SELIGMANN *Alaska*, 1944, Courtesy of The Mayor Gallery, London

KURT SELIGMANN *Mat totem tombé* [Fallen Totem Pole], n.d., Musée du Quai Branly, Paris

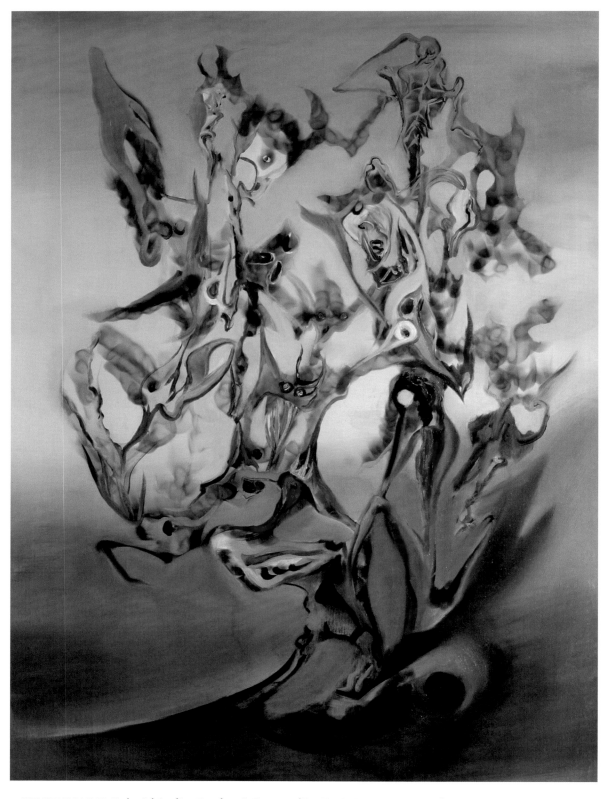

WOLFGANG PAALEN *Taches Solaires* [Sun Spots], 1938, Courtesy of Frey Norris Contemporary & Modern, San Francisco

MYTHS, MAPS, MAGIC

"When the door of this great community house opened as if by magic...."[1]

TEN ROLLS OF 8MM FILM DOCUMENTING WOLFGANG PAALEN'S JOURNEY THROUGH BRITISH COLUMBIA IN SUMMER 1939

ANDREAS NEUFERT

My dear friends ... all three of you are my great friends of the heart. We have gone far beyond the stage of mere intellectual affinity.... I have often, with great irritation, taken a stand against the idea people have expressed to me that you have abandoned Europe, and the terrible fear I have felt that we would never find that place of special sensitivity which united us. (France, July 23, 1939)[2]

By the time Wolfgang Paalen answered Andre Breton's letter on August 21st he was in Vancouver and his serendipitous Northwest Coast adventure was already over. Paalen, his wife and their companion Eva Sulzer had been planning to travel directly from New York to Mexico; all the preparations had been made, but then:

Old longings for these regions ... suddenly resurfaced.... I believe I am attaining a new perspective on this art — an art certainly greater than all the assumptions that are made about it in Europe.... The feeling of being on a long march through hidden depths ... allowed us to observe with great precision the final ray of light cast by a culture of alien lumininosity within a Nature of impenetrable wildness — and so we reached the terminus of our Northwest tour.

They had just completed more than two months of intensive travels, the exact course of which cannot be known even with the help of the laconic notebooks kept by Paalen in the style of Georg Christoph Lichtenberg's eighteenth-century *waste books*,[3] nor by reading Alice's diaries and the reports Paalen published in *Dyn* (*Paysage Totémique I, II, III, Rencontre totémique* or his important essay *Totem Art*) nor by consulting the more than 300 photographs and the handful of letters that remain. Recently added to

the pieces gathered to reconstruct this undertaking were the ten 8mm film rolls that Austrian historian and Paalen scholar Christian Kloyber[4] discovered among Paalen's estate in Tepoztlán and subsequently digitalized.

It's unlikely that any other films documenting this journey through Canada and Alaska exist. The film stock appears to have been purchased on impulse in a general store in Prince Rupert, and the filming itself was *heuristic*, with the camera being passed back and forth amongst the three members of the party at whim. The trio first travelled from Ottawa to Jasper by express train, after which point Paalen's diary[5] picks up steam: they sight "the first freestanding totem pole," and it becomes clear that for Paalen this journey is above all a voyage into the inner world of his images and his childhood. The train slows down, allowing time for contemplation, as they cross the Fraser and the Skeena Rivers to arrive in Prince Rupert around 3:00am on June 17th. On June 19th the three artists board the legendary passenger steamer HMCS Prince Robert, en route from Seattle through the magical island landscape of British Columbia to Alaska[6] that was so dear to Paalen's heart: "Making for Ketchikan. Islands, all of them magnificently wild, utterly uninhabited, with forests darker and more in the colouration of lichen than in Canada."

This, presumably, is where they start filming the careful views of islands, forests, water and sky that are described at length in the diaries. Shortly after Ketchikan the camera lingers in a passage where the "forest has silvergray trees, in the hues of very old whale bones. Oddly misshapen trees, natural totem poles ('ready-mades'). Exactly like certain of my pictures." The journey continues via Ketchikan to the Canada-Alaska customs station at Sitka, where the travellers disembark to observe the "Islands of Enchantment" from dry land:

An evening stroll. Silent bay, blue-gray in the full range of silver hues. Water steel blue, the colour of salmon belly. Strange shades of white on mountains obscured in the thick fog, the same qualities as that of the Eskimo masks. . . . Exceptionally beautiful gray-blue of the mountains around the bay, mountains without substance, without weight, mountains that have just been hung up there, the impression of the great North. The spirits of the cold.

After one night the three take an airplane to Juneau, looking down from above at "countless larger and smaller islands, like bearskins tossed on a huge parquet floor made of opal. A small lone iceberg is drifting across the smooth sea in dark steel, appearing to be illuminated from within by a green flame."

Paalen wants to start his explorations of the local terrain from the northernmost point possible. They acquire a few Native art works and then head south again, in a small seaplane that will take them to the Alaskan town of Wrangell, where legendary merchant Walter C. Waters[7] has his Bear Totem Store:

In the background I recognize the wonderful "house front". . . . a veritable 1001 Nights establishment where you can find absolutely everything: Tlingit and Haida dance masks, Chilkat blankets, narwhal teeth, Eskimo kayaks, Eskimo tools and whistles, countless teeth and tusks from mammoths.

Among other objects, Paalen acquires the famous *House Front* with its depiction of the great she-bear and "in a miserable dive" makes the acquaintance of George, who claims this wall served as a totem for the last Tlingit to be called Chief Shakes. Of the filmed scene of tomb-plundering Paalen observes:

The Waters family attacks the tombstone without visible hesitation, from above and below at the same time. The old man quickly manages to clamber all the way in, and his children divide the booty that he hands up to them through a hole he's made from below.

W.C. Waters appears in the picture flailing his arms. Paalen closes his *Voyage Nord-Ouest* diary with a long reflection on the philosophy of art in Kispayax (today Kispiox) and the footage ends with a shot of his Tsimshian totem poles.

In early August the three depart from Alert Bay[8] to visit the Queen Charlotte Islands (now Haida Gwaii). Strikingly extended shots, filmed while they were on a local fishing boat, show surreal-looking objects: a wooden post with a sort of rigged-up wind direction indicator and a stranded root as a work of art created by time, just as Paul Valéry described in *Eupalinos*[9]. We follow the camera's gaze to the triple totem with a headdress of wild-growing plants, as though looking ahead to the tripolar[10] pictures Paalen would create in Mexico in the 1940s. We pass by the colossal architectural fragments with crenellated masts that Paalen compares in *Dyn* to Doric columns[11] and in a long take we see the huge Kwakwaka'wakw mother-totem, with Paalen gently touching the rounded belly, and then — once alone, once with Alice — he is strolling past another totem as though it was standing in the Stadtpark in Vienna. Then we witness the spectacular landing on Gilford Island, slowly approach the totems, and with the three artists pass through the dilapidated gate of the big Community House[12], which in the third and last part of *Paysage Totémique* Paalen declares the lynchpin

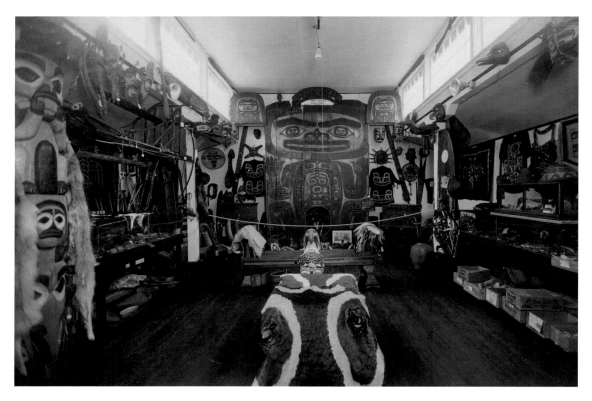

Fig. 21 Unknown photographer, *Walter C. Water's shop, Wrangell, Alaska*, 1939, Paalen Archiv Berlin

of his painting: "quand s'ouvrit comme par enchantement la porte de cette grande 'maison de communauté,' je vis que je n'avais fait rien d'arbitraire."[13]

1 ("Quand s'ouvrit comme par enchantement la porte de cette grande 'maison de comunauté'....") Wolfgang Paalen, *Paysage totemique III, De Jasper à Prince Rupert*, in: *Dyn 3*, Mexico City, 1942, 28. **2** André Breton to Wolfgang, Alice (Paalen) and Eva (Sulzer), Chermilieu, July 23, 1939, LAFoundation, Inverness. **3** Lichtenberg was a German physician and philosopher famous for his experimental thinking and his *Sudelbücher* ('wastebooks'): "I write down everything as I see it or as my thoughts put it before me" (Lichtenberg's *Notebook E*, quoted in Wikipedia.) **4** Dr. Christian Kloyber was formerly the director of the Fundacion Isabel y Wolfgang Paalen, Mexico. **5** All further citations are taken from Wolfgang Paalen, *Voyage Nord-Ouest*, ed. Christian Kloyber and José Pierre, in: *Pleine Marge, Cahiers de Littérature, d'Arts plastiques & de Critique*, Dec. 20, 1994, 7 ff. **6** The passenger liner Prince Robert sailed regularly from Seattle to Glacier Bay National Park, Ketchikan and Juneau between 1932 until the start of the war in 1939, when it was retrofitted as an anti-aircraft cruiser and employed against the German Luftwaffe. **7** Walter C. Waters ran his Bear Totem Store (named for the house front that Paalen purchased from him in 1939, now on display in the Denver Art Museum) from the 1920s until it burned down in the 1950s. **8** Alice Paalens's notes from Alaska — which are primarily poetical in tenor — begin with the entry: "Alert Bay 1er Aout 39." Alice Rahon Papers, Museo de Arte

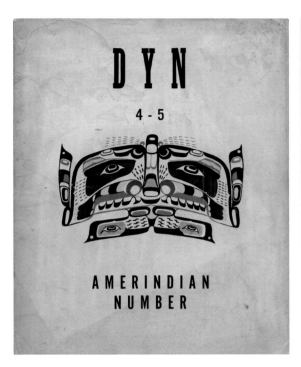

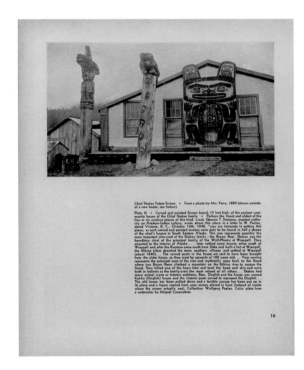

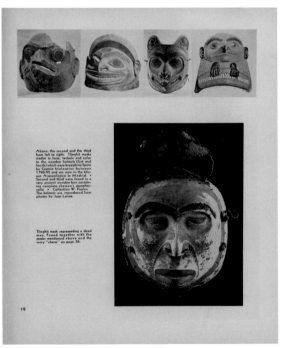

Dyn, nos. 4 and 5, December 1943, Collection of Timothy Baum, New York

WOLFGANG PAALEN *Pays Interdit* [No Entry, or Forbidden Country], 1936–37, Private Collection, Germany

Moderno, Mexico City. [9] Paul Valéry, *Eupalinos ou l'Architecte*, Paris 1921, was one of Paalen's favourite books. [10] *Tripolarity* is the title of a painting Paalen did in the 1940s along with *Messengers from the Three Poles* and others. I call these paintings *tripolar* to refer to Paalen's attempt to conceive human consciousness as tripolar rather than bipolar. [11] Wolfgang Paalen, *About the Origins of the Doric Column and the Guitar Woman*, in: *Dyn 2*, Mexico, 1942, 14. [12] Paalen's description in *Dyn* says: "Community House in Mamlilacoola, Gilford Island" but he may have confused the names and locations. According to Marianne Nicolson, a member of the Dzawada'enux̱w Tribe of the Kwakwa̱ka'wakw Nations, "Mamlilikala refers to the tribe, while 'Mimkwamlis was their main village site . . . on Village Island There is a neighbouring village on Gilford Island called Gwayasdams. Perhaps this caused the mix up" (emails to Ed., October 12 and 13, 2010) [13] "I saw that I had not done anything arbitrary." Paalen, *Paysage totemique III*, 28.

ANDREAS NEUFERT, a Berlin-based art historian, writer and curator, is the founder of an extensive archive on the Vienna-born painter Wolfgang Paalen. After a 1989 oral history project with surviving Surrealists in Paris, Neufert has gone on to publish extensively on modern and contemporary art. He is the author of *Im Inneren des Wals* (Inside the Whale), an intellectual biography of Paalen (1999). In 1964 he was co-curator of the Paalen retrospective for Museo de Arte Contemporaneo Carillo Gil, Mexico City, and later guest curator of many projects for the same museum, including one for Andre Breton's 100th birthday.

Translated from the German by **OLIVER E. DRYFUSS**. Originally from Toronto and now based in New York, Dryfuss regularly translates for *Art Forum* and other publications.

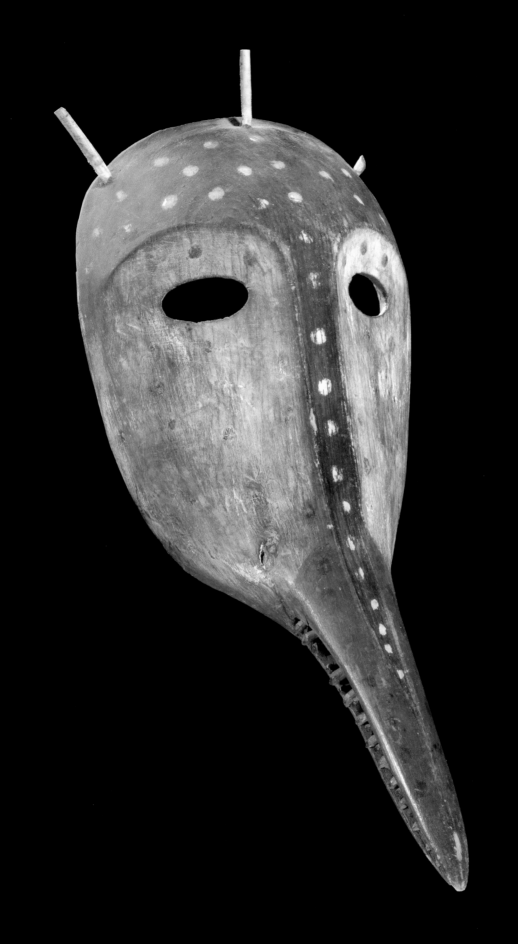

MAGICAL NOTEBOOKS

YVES LE FUR

On January 24, 2007, Jean-Jacques Lebel officially donated to the Musée du Quai Branly in Paris three precious documents that had belonged to his father, Robert Lebel. The first was a brown-covered notebook of fifty-eight pages featuring drawings of so-called Eskimo masks in coloured pencil. The second, a green-covered spiral sketchbook, contained two pen-and-ink drawings of masks and various notes taken by Robert Lebel, possibly during courses given by Claude Lévi-Strauss at the New School for Social Research. The third document was simply a typed list of five pages. The gift of these papers to the museum accompanied the purchase of three major Yup'ik[1] masks from the Lebel Collection and brought full circle a long history that is central to the recognition of the arts of North America — a history in which the major names of anthropology and Surrealism stand side by side.

The story begins at 943 3rd Avenue in New York[2] and is reported in detail by Robert Lebel in a page of the green notebook:

In 1941, Max Ernst, taking refuge in New York, walked into a small secondhand store owned by the German refugee Julius Carlebach. He noticed an Eskimo spoon[3] and asked how much, but Carlebach told him it was part of a collection from many sources and that he couldn't break it up by selling off individual items. Finally, when Max Ernst said who he was, a very surprised J.C. agreed to sell him the Eskimo spoon for five dollars, but asked Max Ernst why he was interested only in this piece.

Jean-Jacques Lebel later explained to me that Ernst, having seen the collection of spoons that Tristan Tzara owned in Paris, knew and highly admired such objects. The shop

YUP'IK *Mask*, 19th century, Private Collection, Courtesy of Donald Ellis Gallery, Dundas, ON and New York, NY, Formerly Robert Lebel Collection

237

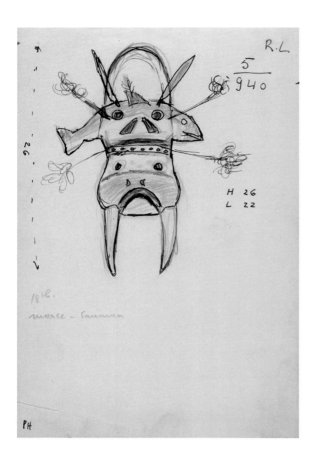

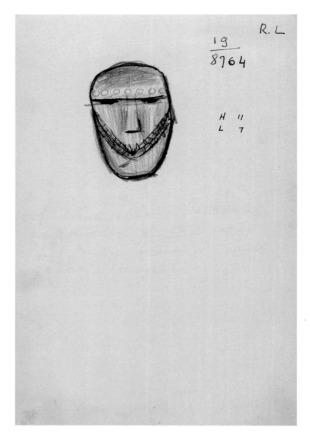

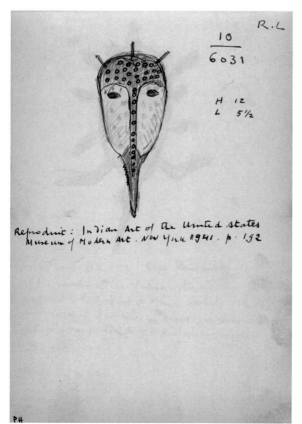

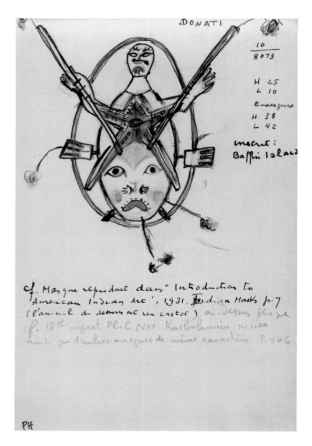

ROBERT LEBEL Pages from *Sketchbook of Yup'ik masks*, 1942–46, Musée du Quai Branly, Paris

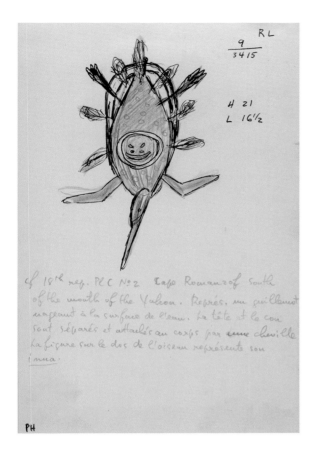

$\frac{9}{3415}$ RL

H 21
L 16½

cf 18th rep. Pl C N° 2 Cape Romanzof South
of the mouth of the Yukon. Représ. un guillemot
nageant à la surface de l'eau. La tête et le cou
sont séparés et attachés au corps par une cheville
La figure sur le dos de l'oiseau représente son
inua.

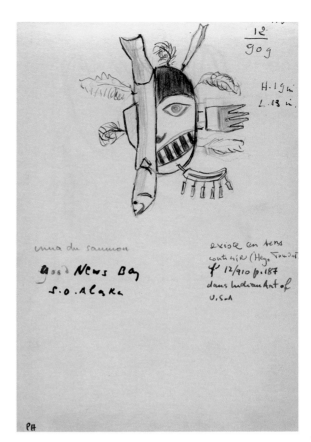

$\frac{12}{90g}$

H. 19 ii
L. 13 i.

inua du saumon

Good News Bay
S.O. Alaska

existe en sens
contraire (Heye Fondat
f° 12/910 p.187
dans Indian Art of
U.S.A

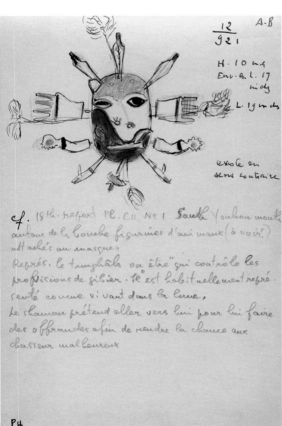

$\frac{12}{921}$ A.B

H. 10 ind
Env. en L. 17
widy
L. 19 inchs

existe en
sens contraire

cf. 18th. report Pl. CII N°1 South Yukon mouth
autour de la bouche figurines d'animaux (à voir)
attachés au masque.
Représ. le tunghâk ou être" qui contrôle les
profisions de gibier. Il est habituellement repré-
senté comme vivant dans la lune.
Le shaman prétend aller vers lui pour lui faire
des offrandes afin de rendre la chance aux
chasseur malheureux

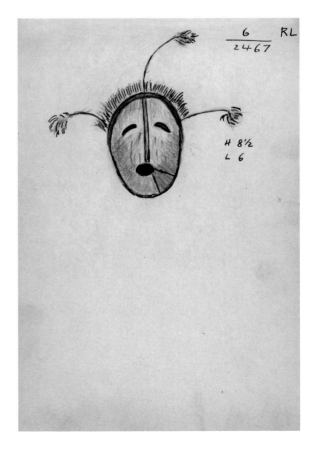

$\frac{6}{2467}$ RL

H 8½
L 6

then became a regular haunt for other Surrealist refugees like Ernst; it was a true "Ali Baba's cave," as Claude Lévi-Strauss put it. While Charles Ratton and André Breton had exhibited masks from Alaska during the Paris *Exhibition of Surrealist Objects* in 1936, Ernst's discovery clearly sparked a significant appreciation of the æsthetic, anthropological and philosophical qualities of works from the Northwest Coast of North America.

Julius Carlebach had bought a number of objects from George Gustav Heye,[4] founder and director of the Museum of the American Indian, who had been collecting Native works for over forty years. Heye's financial difficulties in the 1940s and the size of his collection, which numbered nearly a million, forced him to sell off his doubloons. He authorized Carlebach, who needed to satisfy his new clientele of enthusiastic Surrealists, to draw items from the Bronx annex of the MAI, which contained hundreds of thousands of Native American objects. Elsewhere, Roberto Matta has described his awestruck and self-interested visit[5] to this fantastic storehouse, which also contained Teotihuacan and Mexican pieces. As Lévi-Strauss noted, it was no mere repository of ethnographic documents. As if by miracle, visitors now had at their disposal exactly the kinds of things they had admired at the American Museum of Natural History. While many of the pieces on offer were too expensive for the impecunious refugees, there were plenty of items within their budget — though the informed taste and sure eye of these artists also gave rise to competition. The highly prolific Max Ernst, who liked to buy a work of North American or Oceanic art each time he finished a canvas, delayed announcing his discovery of Carlebach's, notably to Kurt Seligmann. Nonetheless, in 1943, as Isabelle Waldberg wrote:

We threw ourselves into the poetic atmosphere of the Eskimo masks: we breathe in Alaska, we dream Tlingit, we make love in Haida totem poles. Carlebach's on 3rd Avenue has become the place of our desires. And we pay. Robert [Lebel] has a fine collection, Dolores [Vanetti] is driving herself to the poorhouse, and André [Breton] turned handsprings to get two of them. I'm going to have one and I also own a small stone mask from Mexico given to me as a gift. Very beautiful.[6]

The works they unearthed were lengthily discussed, passed from hand to hand. Max Ernst, on his separation from Peggy Guggenheim, had to give up a Tlingit helmet-mask which he sold to Claude Lévi-Strauss for a hundred dollars in 1944.[7]

Robert Lebel no doubt planned to publish a book on the "great primitive arts of North America" for Jeanne Bucher's gallery, in collaboration with Max Ernst or André

Breton and Georges Duthuit, but the project eventually fell through. It was perhaps with this in mind that he drew up the inventory of masks. By and large, the notebook presents one mask per page, each mask sketched in the upper half of the sheet in coloured pencil, followed by the inventory number from the Heye Collection, dimensions, annotations, and bibliographic references. In the upper right figure the initials of the owner at the time: R.L. for Robert Lebel, A.B. for André Breton, I.W. for Isabelle Waldberg, and so on. This inventory is a precious document not only for the history of surrealist sensibilities but also for the totality of objects from a particular culture at a given moment. The hastily sketched appearance, the softness of the pastel pencil colours and the annotations give them a modern look that distinguishes them from most illustrations of so-called primitive artworks. Their apparent fragility and documentary aspect differentiate them from the dark patinas and massive bulk of African art, which many of the Surrealists rejected.

The history of these objects is related to that of the trapper-merchant Adams Hollis Twitchell (1872–1949). Twitchell arrived in Alaska in 1898 as a gold prospector and stayed in the area around Kuskokwim for the rest of his life. A passionate admirer of the area's flora and fauna, he created important ornithological collections, which he left to the Smithsonian. As a devotee of local culture and the husband of a Yup'ik woman, he attended and protected a certain number of ceremonies frowned upon by the missionaries. He took notes, unfortunately now lost, and bought masks created for the occasions that were meant to be destroyed but that he sold instead to George Gustav Heye.

By the time they came across these masks the Surrealists had enough ethnographic background to appreciate them more fully. They knew that these objects had been activated during magic ceremonies, during which the shaman made contact with the *yua*, or soul of animals. They perceived the power of their emblematic and symbolic assemblage. Mask no. 12 in the Lebel catalogue, for example, blends the depiction of a human face and that of a bird of prey (an owl, perhaps?). Also from the Lebel Collection, mask no. 10 combines in a more complex arrangement a walrus, a flying fish and a bird's head. Accompanying the notebooks is a five-page list of the masks in the collection, giving the titles of the objects and their provenance. This precious document, passed from Julius Carlebach to Robert Lebel, traces the path of shared knowledge about the creative works of a people whose sensitivity and clairvoyance they recognized and admired.

[1] The Yup'ik are a Central Alaskan Eskimo people, the most numerous of several in a language group that extends throughout parts of Alaska and Siberia. [2] See the study by Anne Fienup-Riordan, *The Living Tradition of Yup'ik Masks* (Seattle: University of Washington Press, 1966); and Marie Mauzé, "Des Surréalistes en exil/Surrealists in Exile," in *Collection Robert Lebel* (Paris: CalmelsCohen, 1996), 17–27. (Mauzé refers to Carlebach's store and Ernst's first visit on p. 20 in French and p. 21 in English.) [3] These were actually Haida spoons. (Confirmed in correspondence with Marie Mauzé, Feb. 1, 2011.) [4] George Gustav Heye established his foundation in 1908, although he began collecting as early as 1897. The Museum of the American Indian opened in New York City in 1922, with Heye as Chairman of the Board and Museum Director, in the building where Heye had housed his collection since 1917. The distinction between what he may have owned privately and what belonged to the museum, which he opened to the public on a very limited basis, is not always clear. The museum has been part of the Smithsonian Institution since 1989. [5] Germana Ferrari, *Matta, entretiens morphologiques. Notebook no. 1, 1936–1944* (London: Sistan, 1987), 149, cited in Mauzé, "Des surréalistes en exil/ Surrealists in exile," 22. [6] Patrick Waldberg and Isabelle Waldberg, *Un amour acéphale. Correspondance 1940–1949*, ed. Michel Waldberg (Paris: Editions de la Différence, 1992), 105, cited in Mauzé, "Des surréalistes en exil," 17. For an English translation see: Marie Mauzé, "Surrealists in Exile," in Alexis Maggiar (ed.), *Collection Robert Lebel* (Paris: CalmelsCohen, 2006). [7] Georges Wildenstein bought it at the Ratton auction in 1951 and gave it to the Musée de l'Homme that same year; the object is now at the Pavillon des Sessions du Louvre, Musée du Quai Branly.

YVES LE FUR, Director of Heritage and Collection at the Musée du Quai Branly in Paris, was previously conservator at the Musée National des Arts d'Afrique et d'Océanie. The author of *Musée du Quai Branly: The Collection* and many other publications, Le Fur has organized a number of exhibitions related to African and American Oceanic art. These include *La mort n'en saura rien, reliques d'Europe et d'Océanie* in 1999, and *D'un regard l'autre, Histoire des regards européens sur l'Afrique, l'Amérique et l'Océanie*, the 2006 Musée du Quai Branly inaugural exhibition.

Translated from the French by MARK POLIZZOTTI. Author of eight books, including *Revolution of the Mind: The Life of André Breton* (rev. ed. 2009), and translator of over thirty books, he is currently publisher and editor-in-chief at the Metropolitan Museum of Art in New York.

YUP'IK *Complex Mask*, late 19th century, Collection of Susan and Leonard Feinstein, Formerly Enrico Donati Collection

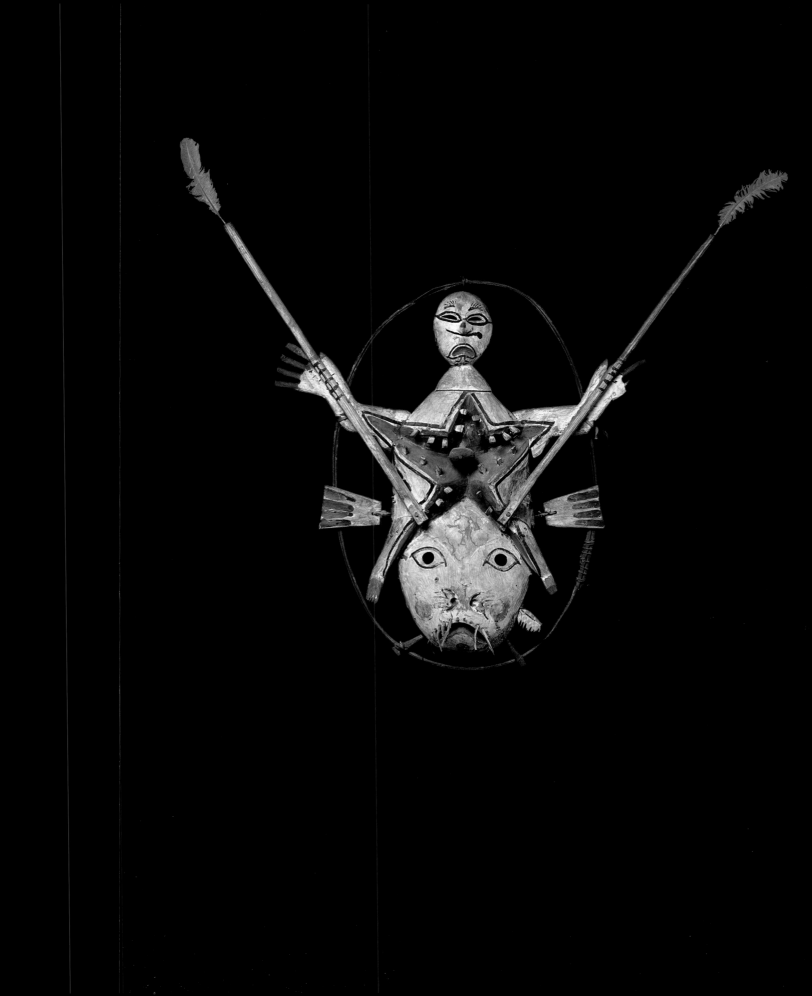

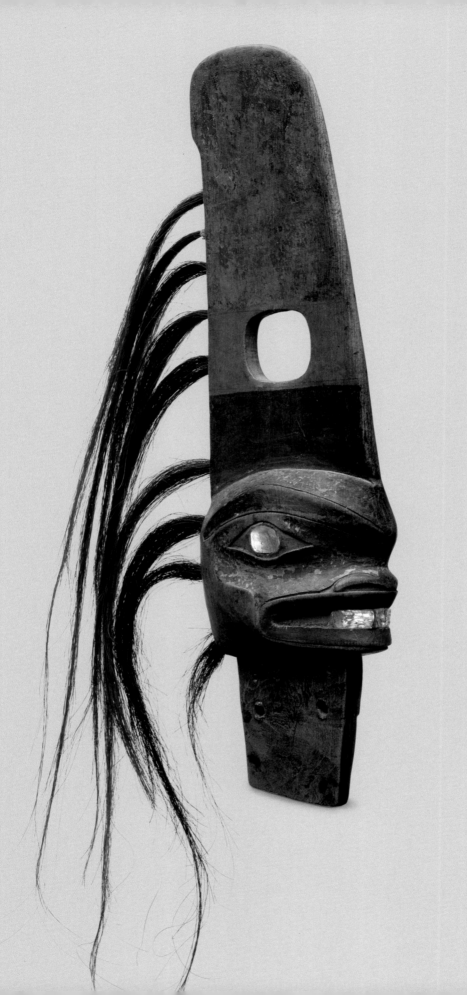

SCAVENGERS OF PARADISE

COLIN BROWNE

Today, it's above all the visual art of the red man that lets us accede
to a new system of knowledge and relations.
— André Breton, 1946[1]

Sparkling diamond
Vancouver
Where a train white with snow and night sparks flees winter
O Paris
From red to green all that's yellow dies
Paris Vancouver Hyères Maintenon New York and the Antilles
A window opens up like an orange
The beautiful fruit of light
— Guillaume Apollinaire, from "Les Fenêtres, 1912"[2]

The great revolutions of the twentieth century deceived almost all who believed in them. Perhaps only Surrealism, devised and kept afloat by a small group of poets and artists dedicated to the re-enchantment of the world, has retained its early promise. Its goal was the overthrow of civilized reason, convention, religion and tradition.

[1] André Breton, "Interview with Jean Duché" (*Le Littéraire*, October 5, 1946), in *Conversations: The Autobiography of Surrealism*, trans. and intro. Mark Polizzotti (New York: Marlowe & Company, 1993), 202. [2] "Étincelant diamante/Vancouver/Où le train blanc de neige et de feux nocturnes fuit l'hiver/O Paris/Du rouge au vert tout le jaune se meurt/Paris Vancouver Hyères Maintenon New York et les Antilles/La fenêtre s'ouvre comme une orange/Le beau fruit de la lumière," Guillaume Apollinaire, "Les Fenêtres" in Francis Steegmuller, *Apollinaire: Poet among the Painters* (Harmondsworth: Penguin Books, 1973), 206. (English translation used here is by Colin Browne.)

Its weapons were words and images, dreams and games — and objects, among them the astonishing, breathtaking ceremonial masks of the Northwest coasts of British Columbia and Alaska.[3] Today the spirit of Surrealism seems unbroken and, in defiance of Gertrude Stein's prediction, André Breton's name has not been forgotten — although the Surrealist encounter with what was called *l'art sauvage* or *primitive art* has been overshadowed by other aspects of Surrealism's ninety-year history.[4] Desperate for an alternative to their own violently decaying civilization, the Surrealists saw in the ceremonial art of the world's indigenous populations the possibility of deliverance. The art of the coastal communities of British Columbia and Alaska fired their imaginations. For André Breton, the movement's founder, British Columbia was "a place bristling with totem poles, not far from the city with a magical name: Vancouver, guarded by the drumming of beavers on the water."[5] Had he visited, he would have discovered Native people who were mill workers, fishermen and union organizers. The present exhibition provides an opportunity to explore the history of the surrealist encounter with the ceremonial art of the North Pacific Coast, and to reflect on its legacy today.

From the early nineteenth century to the middle of the twentieth century, many of the decorated and ceremonial objects of the Northwest Coast and Alaska were sold to, stolen by or otherwise taken away by visiting sailors, missionaries, merchants, government agents and anthropologists. Many went to collectors and distant museums as objects of scientific inquiry; others were destroyed by religious zealots. What follows is an account of how a few of these sacred, often fragile, objects came to be in the arsenal of a revolutionary movement devoted to sabotaging Western civilization, and how they came to be included among the great transformative works of humankind.

The phrase "scavengers of paradise" first appears in the radical text *Les champs magnétiques* (1919), composed automatically by Breton and his friend the poet Philippe Soupault.[6] It refers to the glory and the wreckage associated with being human. The scavengers of paradise are the dreamers and visionaries who pick through the discards of culture, seeking out scraps of grace in unconscious art, forbidden desire and mythological

[3] I am indebted to Serge Guilbaut for the term "weapons." [4] Mark Polizzotti, *Revolution of the Mind: The Life of André Breton* (New York: Farrar, Strauss and Giroux, 1995), 427. [5] André Breton, "Wolfgang Paalen." Preface to the catalogue for the Wolfgang Paalen exhibition, June 21 – July 5, 1938, Galerie Renou et Colle, Paris. Christian Kloyber (ed.), *Wolfgang Paalen's DYN: The Complete Reprint* (New York: Springer-Verlag Wien, 2000), XVII–XVIII. [6] André Breton and Philippe Soupault, *The Magnetic Fields*, trans. David Gascoyne (London: Atlas Press, 1997), 109.

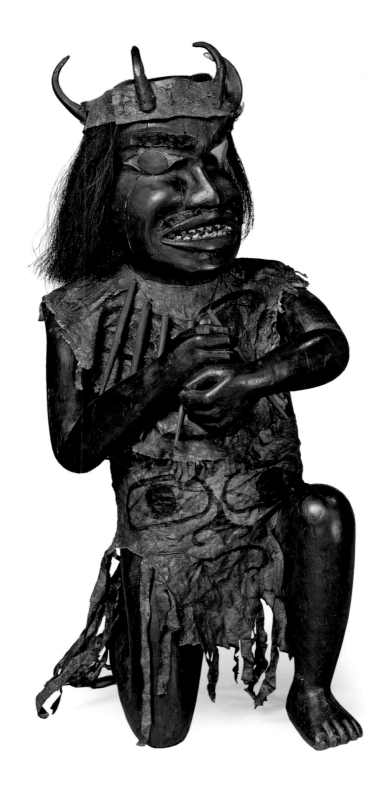

TSIMSHIAN *Statue de chaman* [Statue of a Shaman], early 20th century, Musée du Quai Branly, Paris, Formerly Claude Lévi-Strauss Collection

thinking. Surrealism was born out of the horrors of the First World War. As Europe slid helplessly into another inferno, André Breton began to search for traces of a once and future terrestrial paradise. In the ceremonial objects of indigenous people he encountered evidence of the sacred, and set his sights on the transformation of the Western mind.

It would be misleading to clump Surrealists into a homogeneous group. André Breton often spoke as if Surrealism was a coherent revolutionary movement, but it was in a constant state of upheaval. Breton himself was a prickly, contradictory, brilliant, affectionate, haunted, arrogant, dictatorial, acquisitive, paternalistic, petulant, childish, passionate, puritanical individual. To anthropologist Claude Lévi-Strauss he was "extremely courteous . . . but there was always a certain regal aloofness about him"[7] Dorothea Tanning described him by imitating his voice: "Severely: 'Dorothea, do you wear that low neckline just to provoke men?'"[8] In New York, Robert Lebel saw him as "a tragic figure."[9] After his death in 1966, Marcel Duchamp said: "Breton loved like a heart beats. He was the lover of love in a world that believes in prostitution."[10] Eugene Ionesco declared, "I put him on the same level as Einstein, Freud, Jung or Kafka. In other words, I consider him one of the four or five great reformers of modern thought."[11]

What is one to make today of Surrealism's engagement with *l'art sauvage*? Where some see a profound appreciation for the ceremonial art of indigenous people, others find misguided Eurocentric amateurism or, even worse, an ignorant, paternalistic form of appropriation, the familiar utopian projection of social, political and religious renewal onto North American Native culture. Addressing what she calls the "hubris" of primitivism, Amanda Stansell notes that early on the Surrealists "used indigenous art and thought principally in service of the Surrealists."[12] But they also actively campaigned against French imperialism and colonialism and boycotted the lavish 1931 *Exposition Coloniale* in Paris. Breton declared his position clearly in 1945:

[7] Claude Lévi-Strauss and Didier Eribon, *Conversations with Claude Lévi-Strauss*, trans. Paula Wissing (Chicago: University of Chicago Press, 1991), 28. [8] "Oldest living surrealist tells all." An interview with Dorothea Tanning by John Glassie. *Salon.com*, Feb. 11, 2002. <http://www.salon.com/people/feature/2002/02/11/tanning/print.html>. [9] Robert Lebel, "Marcel Duchamp and André Breton," in Anne d'Harnoncourt and Kynaston McShine (eds.), *Marcel Duchamp* (New York: The Museum of Modern Art, 1973), 138. [10] *Ibid.*, 140. [11] Polizzotti, 622. [12] Amanda Stansell, "Surrealist Racial Politics at the Borders of Reason: Whiteness, Primitivism, Négritude," in Raymond Spitieri and Donald LaCoss (eds.), *Surrealism, Politics and Culture* (Aldershot: Ashgate Publishing Ltd., 2003), 125.

Surrealism is allied with people of colour, on the one hand because it has always been on their side against every form of white imperialism and banditry, as demonstrated by the manifestos published in Paris against the Moroccan War, the Colonial Exhibit, etc.; on the other hand because there are very deep affinities between so-called 'primitive' thought and Surrealist thought: both want to overthrow the hegemony of consciousness and daily life, in order to conquer the realm of revelatory emotion.[13]

Nevertheless, the surrealist relationship with the ceremonial objects of North America was complex, fluid and often naively idealistic. Many surrealist artists became collectors of *primitive art* but were unaware of the provenance or function of the objects they acquired or that certain masks may not be shown in public. Collectors would have been startled to discover that some of the Alaskan Yup'ik masks they acquired in the 1930s and 1940s were not much more than twenty or thirty years old, and it's possible that those who made and/or danced them were still alive, although their names were unknown. The fiction of anonymity allowed for the suggestion that the objects were timeless and belonged to no one. The argument that an object might belong in its place of origin hardly occurred to collectors in 1930; today it cannot be ignored. Between the time that masks, rattles and totems began to appear on the market in Paris early in the twentieth century, and the day in 2005 when Breton's daughter returned a headdress acquired by her father to Alert Bay, the surrealist eye had altered considerably.[14]

In Breton's mind the turn toward *primitive art* and thought was a necessary response to the "great social and moral crisis" of his time.[15] The twentieth century nightmare of fascism, occupation and genocide had sensitized him to the traumatic histories of North America, at least in an abstract way. He was not a scholar of indigenous cultures, but his intuition was keen, his anti-imperialist passions were deeply felt and he was aware of the suffering of indigenous populations at the hands of settlers and their military occupiers. Having had no first-hand experience Breton wrote very little about the Northwest coast and Alaska, although it's evident that when writing about Oceania and the Caribbean he's thinking of all indigenous people. "We await with impatience the day when … the great mass of the men of colour will cease to be kept at such an

[13] "Interview with René Bélance" (*Haiti-Journal*, Haiti, December 12–13, 1945), in André Breton, *Conversations: The Autobiography of Surrealism*, 193. [14] The *Yaxwiwe'*, or headdress, was stolen in 1921 and sold to Breton in 1964 or 1965. It remained with him until he died in 1966. [15] Breton, "Speech to young Haitian poets," (December 14, 1945) in André Breton, *What is Surrealism? Selected Writings* (New York: Pathfinder Press, 2008), 341.

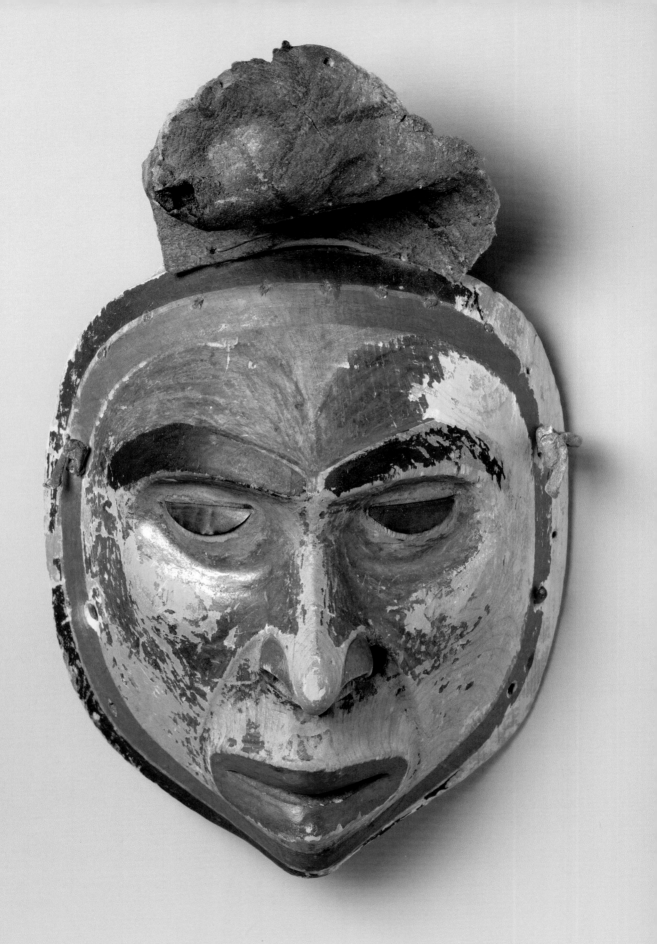

outrageous distance and confined to second-rate employment," he wrote in 1943, adding that, "the emancipation of people of colour can only be the work of those people themselves, with all the implications inherent in that"[16]

Breton always insisted that Surrealism was an anti-æsthetic movement. *Primitive art* appealed to him because it was not self-consciously artful. It was in the presence of a tribal mask in the home of the poet Guillaume Apollinaire that he first heard what he called, "the interior voice within each human being."[17] Apollinaire was among the first to demand that masks, fetishes and other objects being carted home from French colonies by explorers, missionaries and colonial officials be preserved and recognized as art.[18]

Apollinaire was a collector and an advisor to Paul Guillaume, a scholar, activist and dealer with an interest in objects from Alaska. Guillaume's first gallery opened in Paris in 1914, the year *Statuary in Wood by African Savages: The Root of Modern Art*, an exhibition of his collection, was shown in New York at Alfred Stieglitz's fifteen-foot-square gallery, 291. Two years later in Paris, Guillaume exhibited twenty-five "Negro sculptures, fetishes from Africa and Oceania" alongside paintings by Matisse, Picasso and Modigliani. At the *vernissage*, Breton, Blaise Cendrars and Apollinaire read poems, Erik Satie played the piano, and it seemed clear to everyone that modern art and *l'art nègre* were drawn from a common source.[19] In a moment like this we can identify the origin of Surrealism's longing for a new "collective myth."[20]

Having been initiated, Breton began to search for material evidence of the enchanted world, concentrating, unlike Picasso's generation, on Oceanic and North American objects. With Paul Éluard he travelled to England and Holland. They became buyers for dealers, including Charles Ratton, from whom Breton purchased his first Yup'ik mask. They were not above speculative thinking. In a 1929 letter to his wife Gala, Éluard writes, "In Holland I bought an absolutely unique fetish, New Guinea (2 m 50) 20,000 frs. A marvel. One day, I will sell it for 200,000. For

[16] André Breton, "A great black poet: Aimé Césaire," in André Breton, *What is Surrealism? Selected Writings*, 309. [17] Breton, "Speech to young Haitian poets," 340. [18] Guillaume Apollinaire, "Exoticism and Ethnography" (1912), in Guillaume Apollinaire, *Apollinaire on Art: Essays and Reviews 1902–1918*, ed. Leroy C. Breunig, trans. Susan Suleiman, (Boston: MFA Publications, 2001), 244–245. [19] Louise Tythacott, *Surrealism and the Exotic* (London and New York: Routledge, 2003), 86–87. See Cendrar's poem "*Les grands fétiches*" (1916). [20] André Breton, "Limits, Not Frontiers for Surrealism" (February 1937), trans. Jeffrey J. Carre, in O'Brien (ed.), *From the NRF* (New York: Meridian Books, Inc., 1959), 95.

TLINGIT *Mask*, c. 1820–1840, The Metropolitan Museum of Art, The Michael C. Rockefeller Memorial Collection, Bequest of Nelson A. Rockefeller, 1979, Formerly Wolfgang Paalen Collection

sure."[21] Short of funds, Breton and Éluard sold their collections in 1931 at the Hôtel Drouot in an auction entitled *Sculptures d'Afrique, d'Amerique et de l'Oceanie*. Three hundred and fifty-one pieces were offered; one hundred and forty-eight from America, including six Northwest Coast masks.[22] These hunting expeditions, Breton wrote later,

brought out in us a compelling need to possess that we otherwise hardly ever experienced, and, like none other, it fanned the flame of our greed: none of the things that others might list among worldly goods could hold its own beside it I am still as captivated by these objects as I was in my youth when a few of us were instantly enthralled at the sight of them. The surrealist adventure, at the outset, is inseparable from the seduction, the fascination they exerted over us.[23]

By the mid-1920s *primitive art* and Surrealism were intimately linked. The Galerie Surréaliste's first exhibition in 1926 featured twenty-four works by Man Ray and sixty-two Indonesian and Oceanic objects, including masks from New Guinea and New Ireland loaned by Breton and others.[24] Breton and Éluard contributed Northwest Coast objects to the *Yves Tanguy et objets d'Amérique* exhibition the following year.[25] In 1928, Breton provided objects for *Les Arts anciens de l'Amérique* at the Pavillion de Marsan (Louvre).[26]

Two significant exhibitions were held at the Galerie Ratton in Paris during the 1930s. The *Exposition de masques et ivories anciens de l'Alaska et de la côte nord-ouest de l'Amérique*, organized by Charles Ratton in 1935, included objects acquired from George Gustave Heye's Museum of the American Indian in New York.[27] (Man Ray

[21] *"En Hollande, j'ai acheté un fétiche unique au monde, Nouvelle-Guinée (2 m 50) 20 000 frs. Une splendeur. Un jour, je le vendrai 200 000. Sûrement."* Sylvie Leclercq, *"L'appropriation Surréaliste des objets d'art 'Indigènes',"* Centre d'Histoire de Science Po: *"Arts & Sociétés, Lettre du Séminaire 13, Séminaire du 23 novembre 2006 — Primitivismes."* [22] Tythacott, 95–96. [23] André Breton, "Oceania" (1948), in André Breton, *Free Rein (La Clé des champs)*, trans. Michel Parmentier and Jacqueline D'Amboise (Lincoln and London: University of Nebraska Press, 1995), 172. [24] *Exposition Tableaux de Man Ray et objets des îles* (March 26 – April 10, 1926), co-organized by Breton. See Wendy A. Grossman, *Man Ray, African Art, and the Modernist Lens* (Washington, DC: International Arts & Artists, 2009), 95. [25] *Yves Tanguy et objets d'Amérique*, Galerie Surréaliste (May 27 – June 15, 1927). Other *objets* came from Louis Aragon, Roland Tual and Nancy Cunard. The catalogue text was by Breton. See Leclercq, note 16. [26] Marie Mauzé, "Surrealists in Exile," in Alexis Maggiar (ed.), *Collection Robert Lebel* (Paris: CalmelsCohen, 2006), 18. [27] *Ibid.*, 20. See Note. 5, 29. Some of these objects were shown the following year in London at the International Surrealist Exhibition organized by Herbert Read with a catalogue preface by Breton.

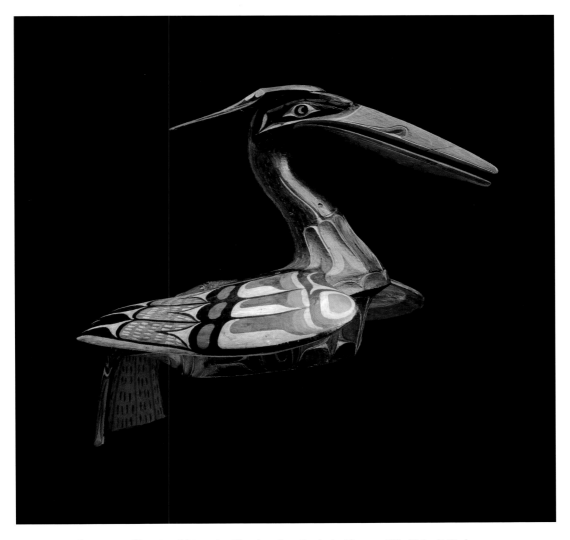

KWAKWA̱KA'WAKW *Kwak'wanigamł* [Heron headdress], c. 1890, Seattle Art Museum, Gift of John H. Hauberg

bought a Yup'ik mask.)[28] The 1936 *Exposition surréaliste d'objets* staged by Breton and Duchamp offered all manner of found objects, readymades, paintings, assemblages, etc., and eagerly folded Oceanic, Northwest Coast and Alaskan masks into the surrealist canon. Breton's intention was to bring about "*a total revolution of the object ... perturbation and distortion are sought for their own sake.*"[29] The exhibition's original title, *Exposition d'objets surréalists*, or *Exhibition of surrealist objects*, was altered at

[28] Leclercq, note 5. [29] André Breton, "Crisis of the Object (1936)," in André Breton, *Surrealism and Painting*, trans. Simon Watson Taylor (Boston: MFA Publications, 2002), 280.

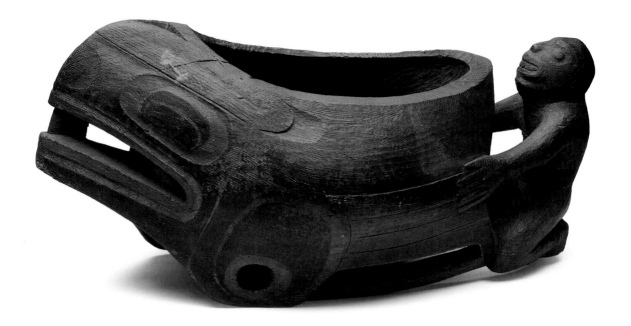

KWAKWA̱KA'WAKW Above and opposite: *Feast Dish*, n.d., The Museum of Anthropology, The University of British Columbia, Vancouver

the last minute, likely out of respect for the objects in the exhibition that were not produced by Surrealists or for surrealist purposes. It can be argued that self-conscious Surrealism is oxymoronic.[30]

Surrealist artists showed little interest in formal appropriation. Their antidote to producing something "like" something else was the concept of the *surrealist object*, which served to distance Northwest Coast, Alaskan and Oceanic objects from their quasi-scientific function as ethnographic curios. Their inclusion in the *Exposition surréaliste d'objets* was intended to reveal the promiscuously generative cauldron of the unconscious. In the art of Oceania and the North Pacific Coast, Breton saw the collapse of subject and object, "the expression of the greatest effort ever to account for the interpenetration of mind and matter, to overcome the dualism of perception and representation [T]hey lay bare the primordial fears that civilized life, or what passes as such, has masked"[31]

[30] Leclercq. The *Exposition surréaliste d'objets* took place at the Galerie Ratton, May 22–29, 1936.
[31] Breton, "Oceania" (1948), 172. A Yup'ik mask prominently exhibited during the exhibition was acquired by the Museum für Völkerkunde in Hamburg. Enrico Donati purchased a similar mask from Julius Carlebach in New York in 1945. (Thanks to Donald Ellis for this information.)

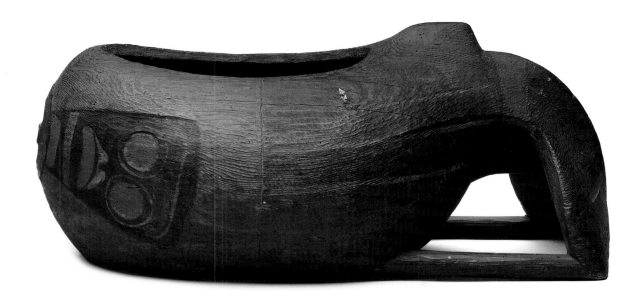

The only artists associated with Surrealism to visit the Northwest Coast were the painters Kurt Seligmann (1900–1962) and Wolfgang Paalen (1905–1959). Seligmann, a Swiss national, left Europe in June 1938 with his wife Arlette and spent four months in the Upper Skeena region of British Columbia. With a contract from the *Musée de l'homme* he collected ceremonial objects and a sixteen-metre Wetsuwet'en pole from Hagwilget on the Bulkley River. Seligmann had an ethnographic imagination; he respectfully interviewed elders, recorded stories and myths, drew maps and images of poles, took photographs, as did Arlette, and meticulously recorded his conversations with Chief Donald Grey concerning the pole shipped back to Paris. He published some of his findings, and his writings reveal his distress on encountering the Gitksan, who were struggling with the hardships associated with colonialism, disease and stolen resources.[32]

Seligmann's experience inspired Wolfgang Paalen to take a similar trip in 1939. Paalen, an Austrian, began in New York, where he purchased a Yup'ik mask. He visited

[32] Marie Mauzé, "Totemic Landscapes and Vanishing Cultures: Through the Eyes of Wolfgang Paalen and Kurt Seligmann," *Journal of Surrealism and the Americas* 2, 2008, 20.

the American Museum of Natural History and began to assemble ideas from surrealist manifestoes, myth, Freudian psychology, ethnography, anthropology, evolutionary thought and Frazer's *The Golden Bough* into an indefensible theory of "totemism," which, he claimed, "corresponds to a certain developmental stage of archaic mentality."[33] This research was published in the *Amerindian* issue of his journal, *Dyn*, along with speculation about "the *magic climate* in which the totemic world is to be found."[34]

With his wife, the poet and painter Alice Rahon, and their friend and patron Eva Sulzer, who took over 300 photos, Paalen sailed up the coast to Alaska. On his way south he visited Emily Carr. To Breton he wrote, "the scenery resembles my paintings more and more."[35] In every town, city and village he visited curio shops and was disappointed to see Indians selling souvenirs, which he took to be a form of decadence. While the photographs, the film and the texts form an irreplaceable archive, Paalen, it seems, already had his theory; he was looking for confirmation.

During World War II many of the artists and intellectuals in France associated with Surrealism escaped to New York, where they formed a complicated exile community. The list includes Breton, who arrived in 1941, Salvador Dalí, Georges Duhuit, Roberto Matta, Max Ernst, Arshile Gorky, Wifredo Lam, Robert Lebel, Fernand Léger, Lévi-Strauss, André Masson, Paalen, Seligmann and Yves Tanguy. New Yorkers were already familiar with them. Katherine Dreier, co-founder of the *Société Anonyme* with Man Ray and Marcel Duchamp in New York in 1920, had shown de Chirico, Ernst and Masson at the Brooklyn Museum in 1926.[36] Julien Levy's gallery had been exhibiting surrealist paintings since 1932. MOMA's *Fantastic Art, Dada, and Surrealism* exhibition in 1936 had provided institutional cachet. It was as a painter's rather than a poet's movement that Surrealism crossed the Atlantic, and for a time the painters from France were the toast of New York. Dorothea Tanning remembers: "They were a terribly attractive bunch of people. They loved New York, loved repartee, loved games. A less happy detail: They all mostly spoke French. But I learned it later."[37] With one or two exceptions, however,

[33] Wolfgang Paalen, *Dyn 4–5: Amerindian Number* (1943) in Christian Kloyber (ed.), *Wolfgang Paalen's DYN: The Complete Reprint*, 18. [34] *Ibid.*, 20. [35] Mauzé, "Totemic Landscapes and Vanishing Cultures: Through the Eyes of Wolfgang Paalen and Kurt Seligmann," 16. [36] Anton Gill, *art/lover: A Biography of Peggy Guggenheim* (New York: Harper Perennial, 2003), 277. [37] Tanning, "Oldest living surrealist tells all."

YUP'IK *Mask*, 19th century, Private Collection, Courtesy of Donald Ellis Gallery, Dundas, ON and New York, NY, Formerly Robert Lebel Collection

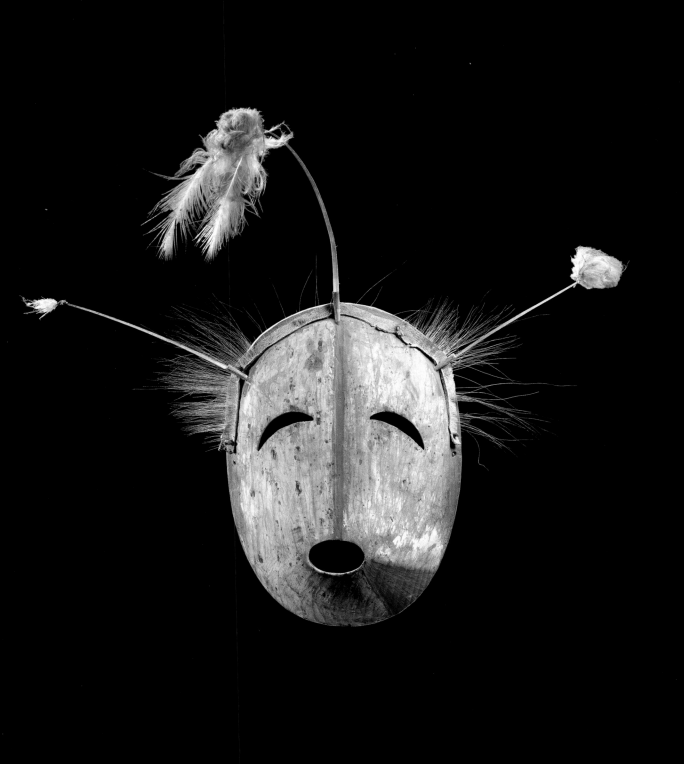

the "stranded" French and the Americans did not mix.[38] In response to a questionnaire in 1944, Jackson Pollock wrote, "I am particularly impressed with their concept of the source of art being the unconscious. This idea interests me more than these specific painters, for the two artists I admire most, Picasso and Miró, are still abroad."[39]

The exiles seem to have spent many hours at the American Museum of Natural History. Lévi-Strauss, who arrived at the age of thirty-three on the same overcrowded freighter as Breton,[40] was profoundly affected, in the Hall of the Northwest Coast Indians, by his discovery of an art form that "demonstrated an apparently inexhaustible talent for renewal"[41] The Surrealists in New York transformed his perceptions of the world; years later he would liken the "contorted outlines" of telegraph poles in the Brazilian jungle to "incongruous objects which float in a vast loneliness in the paintings of Yves Tanguy."[42] In *The Savage Mind* — which opens with an appreciation of Chinook jargon — he acknowledges Breton's concept of *le hazard objectif* (an encounter between chance and necessity) as a model for the workings of mythic thought and *bricolage*.[43] Like many of the exiles, some of his fondest memories were of visiting the Julius Carlebach Gallery at 943 3rd Avenue.[44]

Carlebach was a German refugee from Lübeck. In 1941, Max Ernst discovered a Haida spoon in his gallery window, and after Ernst revealed his identity, Carlebach agreed to sell it for five dollars. When Ernst returned with his surrealist cohorts Carlebach set out to satisfy their desires, stocking the gallery with rare Northwest Coast and Alaskan ceremonial objects.[45] The artists and their friends were able to assemble remarkable collections, often helping out when a colleague was short of money. Marcel Duchamp, who sometimes joined in, did not buy any masks.

[38] Lebel, 139. The word "stranded" is his. [39] Calvin Tomkins, *Off the Wall: The Art World of Our Time* (Garden City: Doubleday & Company Ltd., 1980), 43. Pollock was later inspired by Yup'ik masks. [40] The two became "firm friends" discussing "the relation between æsthetic beauty and absolute originality." See Claude Lévi-Strauss, *A World on the Wane*, trans. John Russell (New York: Criterion Books, 1961), 26. [41] Claude Lévi-Strauss, " The Art of the Northwest Coast at the American Museum of Natural History," reproduced, partially, in the first chapter of Claude Lévi-Strauss, *The Way of the Mask*, trans. Sylvia Modelski (Vancouver: Douglas & McIntyre, Ltd., 1982), 3. [42] Lévi-Strauss, *A World on the Wane*, 262. [43] Claude Lévi-Strauss, *The Savage Mind*, trans. John Weightman and Doreen Weightman (Chicago: The University of Chicago Press, 1970), 21. [44] Claude Lévi-Strauss, "New York in 1941," in *The View from Afar*, trans. Joachim Neugroschel and Phoebe Hoss (New York: Basic Books, Inc., 1985), 261. [45] Jean-Jacques Lebel, "From Mask to Man," in Maggiar (ed.), 9.

Peggy Guggenheim, Ernst's wife, was not amused. According to her memoir:

Carlebach used to phone Max almost every day to come around to his shop on Third Avenue to see some new things that he had found for him. He was perpetually scurrying around and finding things with which to tempt Max. There was no end to his ingeniousness and his activities. He even made deals with museums and got them to cede things to Max One day Max bought a beautiful wooden painted animal that looked like a burial object. He said he had bought a little table, but it certainly was more like a cradle . . . He also bought a British Columbia totem pole twenty feet high. It was a terrifying object and I hated to have it in the house.[46]

Ernst's bills with Carlebach were settled by Peggy, who acquired in return a number of her husband's most memorable paintings.[47]

Breton and his colleagues often met for lunch on Wednesdays at Larré's Restaurant and Café at 50 West 56th Street. The company might include Ernst, Duthuit, Lebel, Masson, Tanguy, Seligmann, Isabelle Waldberg, Matta, Donati, Vanetti, Duchamp or Robert Motherwell. After lunch they'd go hunting for surrealist objects, ending up, inevitably, at Carlebach's gallery.[48]

Carlebach's masks came from George Gustav Heye's Museum of the American Indian, dubbed "the Surrealist's Macy's." Heye, the Museum's formidable founder and director, was actively de-accessioning what he thought of as duplicates, or anything else he considered expendable. He'd spent the early years of the century obsessively collecting in Native communities across North America, making several collecting trips to Vancouver Island during the 1920s and 1930s. It's estimated that he acquired up to a million objects.[49] Documentation was often slight; he was not a scholar. He sold and traded objects without specialized knowledge of their function or relationship to other objects. The Surrealists loved the Museum, especially its hoard of Yup'ik masks. Matta describes a joyful trip to the Museum's Bronx Annex which resulted in his purchase from Carlebach of a Yup'ik mask and Breton's acquisition of "an asymmetrical

[46] Peggy Guggenheim, *Out of this Century: Confessions of an Art Addict*, foreword Gore Vidal, intro. Alfred H. Barr, Jr. (New York: Universe Books, 1979), 263. [47] Gill, 286. [48] Arthur C. Danto, "Surrealism and Exoticism" in *Unnatural Wonders: Essays from the Gap Between Art and Life* (New York: Farrar, Straus and Giroux, 2005), 167. [49] Clara Sue Kidwell, "Every Last Dishcloth: The Prodigious Collecting of George Gustav Heye," in Shepard Krech III and Barbara Hail (eds.), *Collecting Native America 1870–1960* (Washington: Smithsonian Institution Press, 1999), 232–258.

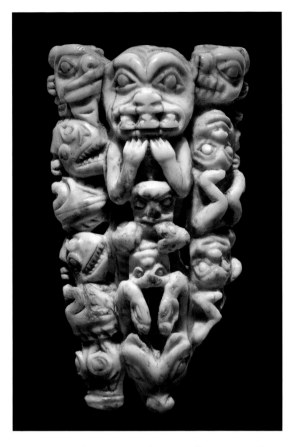

TLINGIT *Amulet*, 1820–1850, The Metropolitan Museum of Art, The Michael C. Rockefeller Memorial Collection, Bequest of Nelson A. Rockefeller, 1979, Formerly Wolfgang Paalen Collection

mask with an eye that blinks and a tube-like nose."[50] According to anthropologist Edmund Carpenter, "The Yup'ik collection at the MAI was the finest in the world, numbering in the hundreds. Heye called them 'jokes' (his choice of word)"[51] The Surrealists, writes Carpenter, acquired "masterpiece after masterpiece," adding that "they liberated American Indian art from centuries of neglect. They put it out there for the world to see."[52]

While in New York, Breton and his colleagues purchased fifty-six Yup'ik, Northwest Coast, Hopi, Zuni and other masks. They studied and discussed them, and art historian Robert Lebel made exquisite coloured drawings of each mask, carefully noting its attributes and provenance. Thanks to Lebel we have as full a history of each mask as we're likely to get.[53] He and Isabelle Waldberg attended Lévi-Strauss' lectures at the New School on "Split Representation in the Art of Asia and America."[54] Lebel himself acquired seventeen masks. His son Jean-Jacques told me it was like growing up with any art: "You wake up and you're in dialogue with it, everyday." Lebel's masks — there were four Hopi, two Navajo, one Bella Bella, one Coast Salish and nine Yup'ik masks — lived with his family from 1944 until 2006. They'd been in George Heye's museum from about 1920 until 1944. Acquired in the first decade of the twentieth century, they'd have spent very little time

[50] Mauzé, "Surrealists in Exile," 22. This mask is now in the Louvre's Pavillon des Sessions. [51] Edmund Carpenter, *Two Essays: Chief & Greed* (North Andover, MA: Persimmon Press, 2005), 116–120. Lévi-Strauss admitted he was "... reluctant to become the owner of such fragile masterpieces and feel responsible for their safekeeping to future generations. I even doubted that these masks belonged to the solid world of objects. I rather saw them as fleeting and almost immaterial embodiments of words, visions, and beliefs, eluding durable possession." [52] *Ibid.*, 120. [53] *Ibid.*, 9. [54] Lebel, 6.

with the men who carved them in the *qasqig* (the men's communal house). Often these masks were burned or left outside to return to the earth once they'd been danced.

At the end of the war, Breton, Lebel, Duthuit and Matta took their masks home to Paris where they became part of their domestic and interior worlds. "Their shared passion for the savage arts," writes Jean-Jacques Lebel, "and in particular for Eskimo art, which was practically unknown to historians, to the market, and to institutions at the time — pertained to a logic that was diametrically opposed to that of the colonialist ideology."[55] In Breton this passion remained undiminished; he continued to learn and study. As his friend Octavio Paz recalled, "the Eskimos' poems struck him as revolutionary prophecies."[56]

The communities from which the masks were taken often experience a bittersweet sensation when they reflect on the absence of their traditional regalia. Tahltan-Tlingit artist Dempsey Bob has asked, "Do you know what modern art took from us? They took freedom. We took off the blinders for them, but we never got the credit for it."[57] A contemporary Yup'ik artist has described a frightening encounter in a museum vault with a mask still charged with energy. He left quickly. When we encounter a Yup'ik mask in a museum, we owe it the respect of imagining a handful of men in an underground house lit by seal oil lamps, in a tiny village on the edge of the Bering Sea, devising and shaping that mask, transforming a dancer into a vessel capable of communicating with the invisible world. They were not producing "art" for a market, but carving and painting and praying and dancing to restore harmony to the world. Disease, starvation, accidents, derangement and the supernatural were constant dangers. Is it any wonder that the Surrealists, exiled from a home that had disgraced itself, broken its own laws and refused to acknowledge its complicity in mass murder, would be drawn to these masks that in their humility and sincerity were dedicated to restoring balance and order, to marking out a safe passage from the darkness into the light?

Today, Northwest Coast and Alaskan traditions are alive; masked dancing is a vital part of aboriginal communities as are the structures of thought that have for thousands of years sustained them. The Surrealists — scavengers of paradise — were no saints;

[55] *Ibid.*, 6–7. [56] Octavio Paz, "André Breton" in *On Poets and Others*, trans. Michael Schmidt (New York: Arcade Publishing, 1986), 75. [57] Quoted in Sarah Milroy, "The Eagle Down Dance," in Donald Ellis (ed.), *Tsimshian Treasures: The Remarkable Journey of the Dundas Collection* (Dundas, Ontario: Donald Ellis Gallery/Vancouver: Douglas & McIntyre, 2007), 36.

they were romantic, arrogant, combative, they stole each other's wives, and they both reviled and clung to convention, but their minds were intoxicated by dreams, visions and "convulsive beauty." Surrealism, Duchamp declared, "was the incarnation of the most beautiful youthful dream of a moment in the world."[58] The goal was to become fully, dangerously human, unfettered by repressive capitalism, religion or imperialism. Is it any wonder they gravitated to the genius of the North Pacific coast?

I suspect Breton would have felt a kinship with the words of Tsimshian artist Whe'X Hue (Victor Reece), who carved his mask *The Shaman's Journey* with eyes shut. "This is the *first mask* I have ever carved with the eyes closed," he observed.

All my other masks have open eyes gazing upon on-lookers, taking in the world, but now, this mask is turning inward to take in the Universe that is inside of us. The ancient ones say we are like our first mother Earth, with high mountains and deep oceans that carry the essence of our existence and time itself. They say in order to meet our full potential here on earth we must journey to the bottom of our inner ocean.[59]

Breton's commitment to the inner journey, to the source of the surreal, and his embrace of ceremonial masks, found its parallel in the conviction of those who carved and danced them, in the words of filmmaker Pierre Perrault, *pour la suite du monde* — for the continuation of the world.

[58] Lebel, 140. [59] I'm grateful to Wapse Panashi Equay (Sharon Jinkerson-Brass) for these words from a dialogue with her partner, Victor Reece.

I'd like to acknowledge my debt to the scholarship and generous friendship of Dr. Marie Mauzé. I'd also like to thank Perry Eaton, Donald Ellis, Aube Elléouët, Alan Hoover, Hadrien Laroche, Jean-Jacques Lebel, Peter McNair and Judith Penner.

COLIN BROWNE is a poet and filmmaker whose most recent books of poetry are *The Shovel* (2007) and *Ground Water* (2002). His documentaries include *Linton Garner: I Never Said Goodbye, Father and Son* and *White Lake*. "Scavengers of Paradise" is drawn from a book and film project that explores the Surrealists' romance with the Northwest coast of British Columbia and Alaska. He's currently writing a dramatic text that imagines a visit by André Breton to Vancouver in the late 1930s. A new book, *Vestle*, is due next year. Browne teaches in the School for the Contemporary Arts at Simon Fraser University in Vancouver.

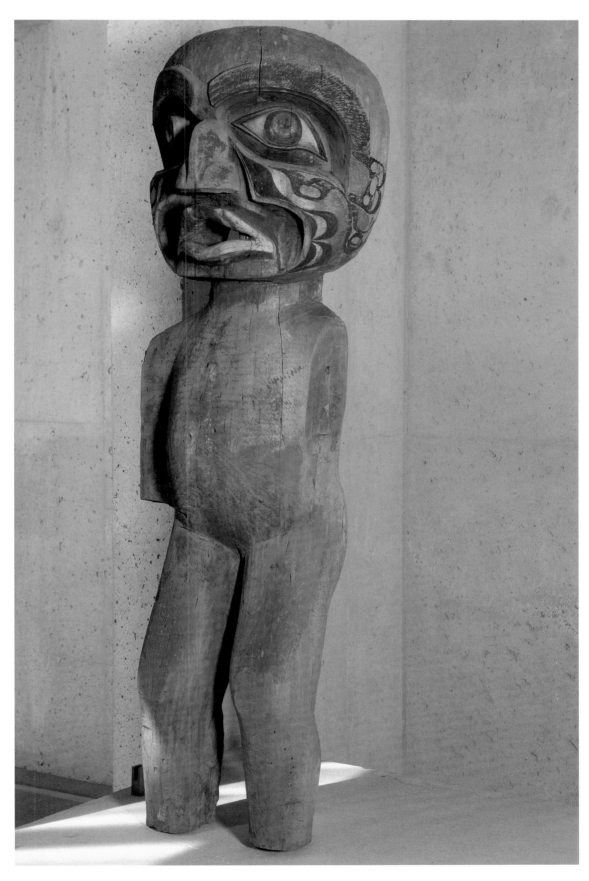

KWAKWAKA'WAKW *Yaḵan'takw* (Speaking-through post), c. 1890, The Museum of Anthropology,
The University of British Columbia, Vancouver

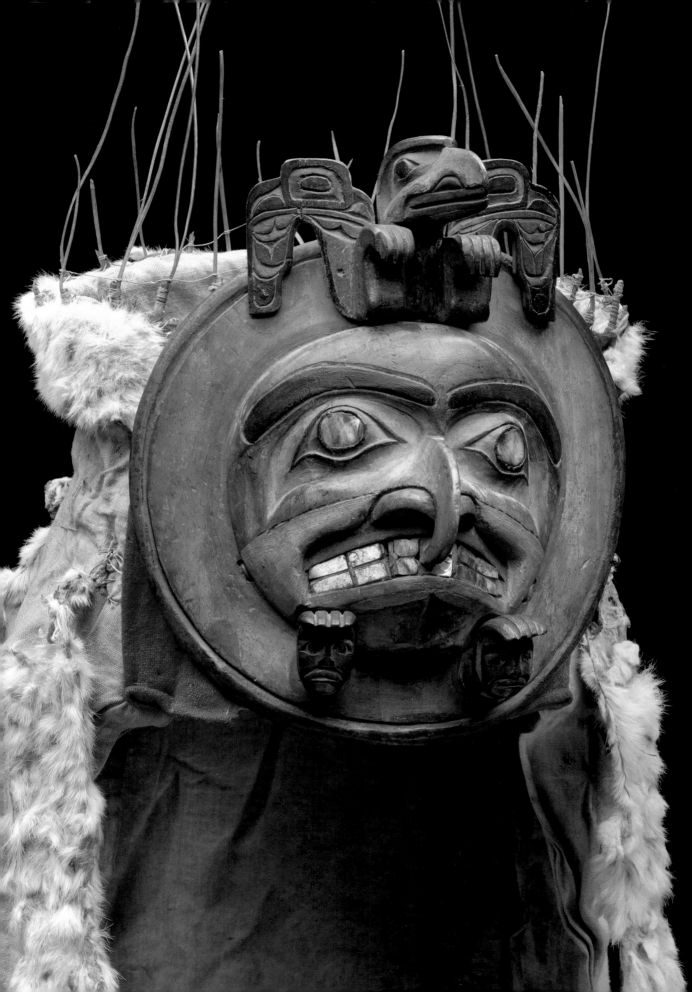

A KWAKWAKA'WAKW HEADDRESS IN ANDRÉ BRETON'S COLLECTION

MARIE MAUZÉ

The Kwakwaka'wakw headdress (*yaxwiwe'*), featuring a humanoid hawk surmounted by a raven with spread wings, has had many lives from the time it was carved by a Native artist of the Northwest coast of British Columbia in the late 1800s. It has been construed successively as a ceremonial treasure, an evil object, an ethnographic specimen, a work of art and an object of cultural patrimony. It has also come to epitomize for the Surrealists the non-western objects they admired the most and were eager to acquire.

First created to be danced by a Kwakwaka'wakw chief in the Peace Dance (or Chief Dance) the ceremonial headdress was confiscated in 1922 by the Canadian government after the illegal organization of a potlatch, a ceremony banned since 1885. Part of the legal settlement included a suspended sentence for the convicted chiefs who were forced to give up their ceremonial regalia. That same year various confiscated regalia entered the ethnological collections of the National Museum in Ottawa (now Museum of Civilization), the Royal Ontario Museum in Toronto and the Museum of the American Indian in New York.

The headdress followed a separate route from the approximately 450 artifacts confiscated from the Kwakwaka'wakw at the time and does not properly belong to the core collection of masks acquired by the Surrealists and their friends during their American exile (1941–1946). Nor did it come to the attention of Breton through Julius Carlebach, the 3rd Avenue New York antique dealer discovered by Max Ernst in 1942, who provided many of the Surrealists with the bulk of their collections. However, it did share the temporary home of other pieces in the Surrealists' collections, the Museum of the American Indian. It was bought in 1926 by the famous New York collector and founder of the MAI, George Heye (1874–1957), from the wife of Donald Angermann,

the policeman who had arrested the Native chiefs in 1921. With the complicity of local authorities Angerman rewarded himself by keeping several of the seized pieces. De-accessioned in 1957, the headdress came into the hands of Edward Primus, a Los Angeles gallery owner, before being taken to France.[1] A year before his death in 1966, the French poet André Breton bought it from a Parisian gallery of (so-called) *primitive art*, where it had been exhibited erroneously as a "haida mask" in 1964 and 1965.[2]

Having sold *The Child's Brain* by Giorgio de Chirico (which he had kept for most of his adult life) to the Museum of Modern Art in Stockholm in 1964, Breton was anxious to find other works that would make up for its absence. With part of the proceeds of the painting's sale he bought two carved figures from Melanesia and the Kwakwaka'wakw headdress. When he first saw it in the dealer's gallery Breton immediately felt a sensual connection; he was mesmerized by the softness of the silky ermine fur covering the back of the headdress and the shimmering brightness of the abalone shell decorating the eyes and the teeth of the hawk.[3] Clearly, the meaning he attributed to the headdress was closely linked to the two carvings from Melanesia: an Uli figure from New Ireland featuring a hermaphrodite being with breasts and an erect penis, and a Tolai ancestor effigy from New Britain, with a long penis and raised arms. For Breton these three pieces may have worked as a collective protection device when he was reading or writing.

Breton's studio was inhabited by all kinds of things: fetishes, masks, sculptures from Oceania and the Americas, paintings, found objects, pebbles, roots, insects, etc. Works of art were not displayed according to a formalist or æsthetic protocol, but rather according to a string of meanings undergoing transformation through his own gaze. Breton, a maker of meanings, staged his own décor according to analogical relations that he perceived between objects foreign to one another, as well as remote in space and time.[4] "And besides, isn't the true meaning of a work not the one people think they have given it but rather the one it is liable to take on in relation to its surroundings?"[5] Rather than arrange things haphazardly or in a row, in the manner of many art exhibits today, Breton placed selective objects side by side so they would act upon each other to reveal new correspondences and meanings. More than his writings or the political activities that played a major role in his life, Breton's studio was, according to Jean-Jacques Lebel, the real expression of the poet's genius.[6] Not only were all arts envisioned as equal whatever their origins or makers, but through magic agency Breton made them interact in a dialogue. The assemblage of apparently heterogeneous things to which he attributed magic qualities made up his mental landscape.

Set on top of a small Haida box, the headdress was situated in a central position, just across from Breton as he sat at his desk. His friends remarked later that he spent long hours watching it in the sleepless nights before he died.[7] In September 2003 Breton's daughter, Aube Elléouët, returned to the Kwakwa̱ka'wakw this headdress that had been in her father's collection for almost forty years. Having been ceremonially welcomed at the U'Mista Cultural Centre in Alert Bay, it now plays the role of an ambassador of the French Surrealists in its own territory of British Columbia.

[1] Marie Mauzé in "Trois destinées, un destin," *Gradhiva 7*, 2008, 100–119. [2] See the two catalogues produced by Jacques Kerchache gallery, *Arts primitifs* (n.d., although the exhibit took place in 1964), and *Art primitif. Amérique du Nord* (1965). [3] Personal communication from Jean-Jacques Lebel, April 24, 2004. [4] See Werner Spies, "Le 'Mur' d'André Breton," in *L'œil, le mot* (Paris: Christian Bourgeois éditeur), 2007; Agnès de la Beaumelle, "Le grand atelier," in *André Breton, La beauté convulsive* (Paris: Musée national d'art moderne, Centre George Pompidou, 1991), 48–63. [5] André Breton, "The Disdainful Confession," *The Lost Steps*, trans. Mark Polizzotti (Lincoln: University of Nebraska Press, 1996), 6. Originally published as: "…la signification propre d'une œuvre n'est-elle pas, non celle qu'on croit lui donner, mais celle qu'elle est susceptible de prendre par rapport à ce qui l'entoure," in André Breton, "La confession dédaigneuse," *Les Pas Perdus* (Paris: Gallimard, 1924), 16. [6] Personal communication from Jean-Jacques Lebel, April 24th, 2004. [7] Personal communication from Jean Benoît and Jean-Michel Goutier, April 30, 2004.

MARIE MAUZÉ is Anthropologist and Senior Researcher at CNRS, Laboratoire d'anthropologie sociale, Collège de France, Paris. Well known as a scholar, lecturer and writer in the field of Northwest Coast ethnology, anthropology of art and æsthetics, material culture studies, history of collecting, museums and representation of indigenous societies, Mauzé is currently writing *A Double Vision of Northwest Coast Art*, a book that draws on her extensive research on the indigenous cultures of the British Columbia coast and Alaska. "Surrealists in Exile," for the catalogue *Collection Robert Lebel* (2006), is one of her many important contributions.

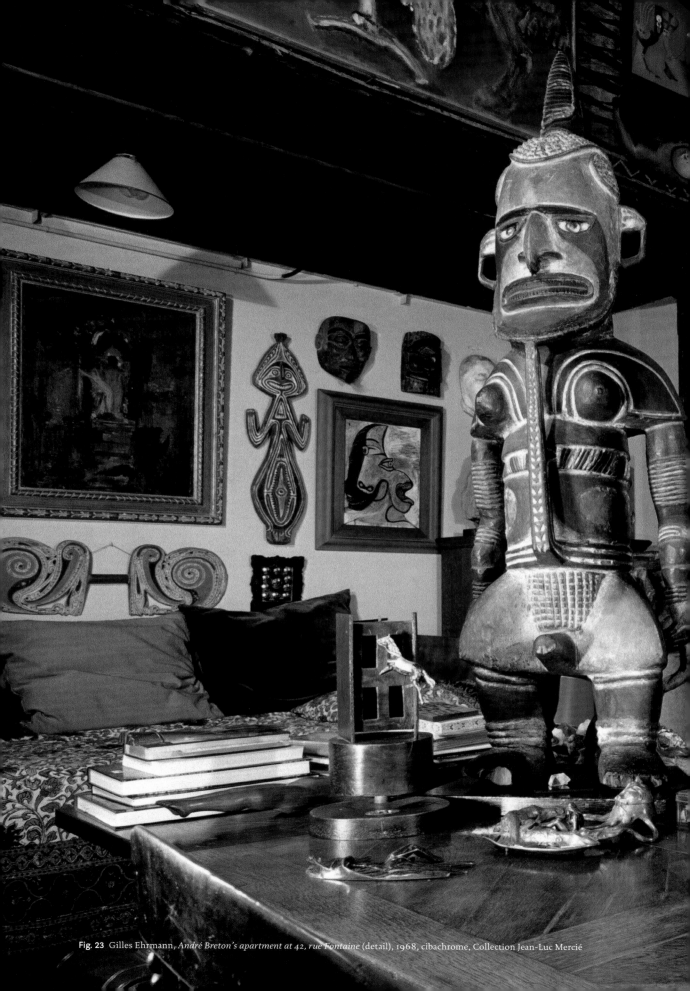

Fig. 23 Gilles Ehrmann, *André Breton's apartment at 42, rue Fontaine* (detail), 1968, cibachrome, Collection Jean-Luc Mercié

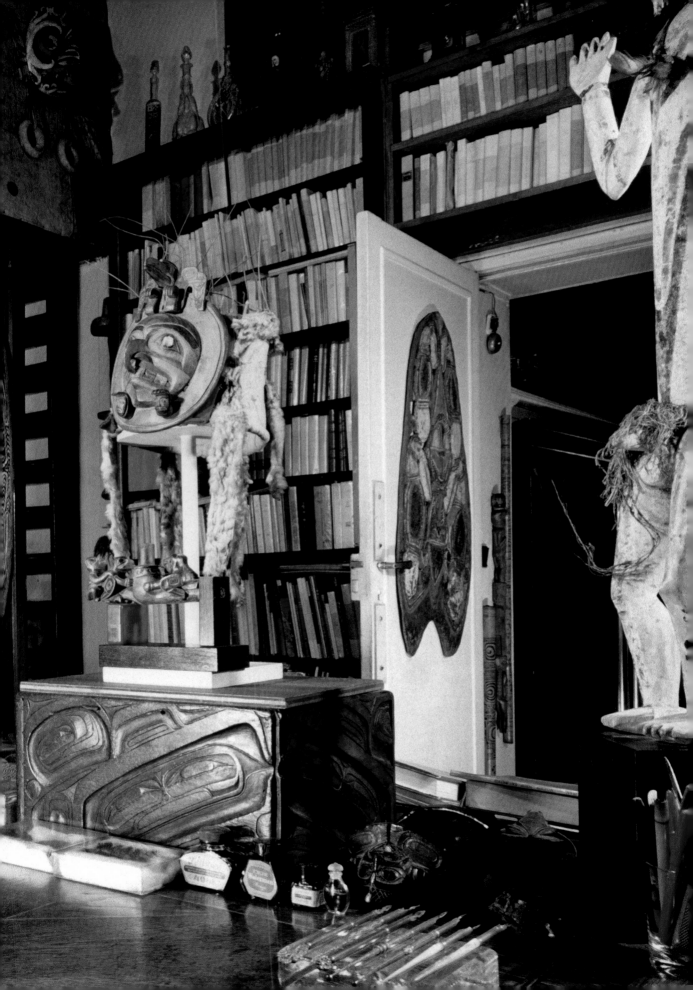

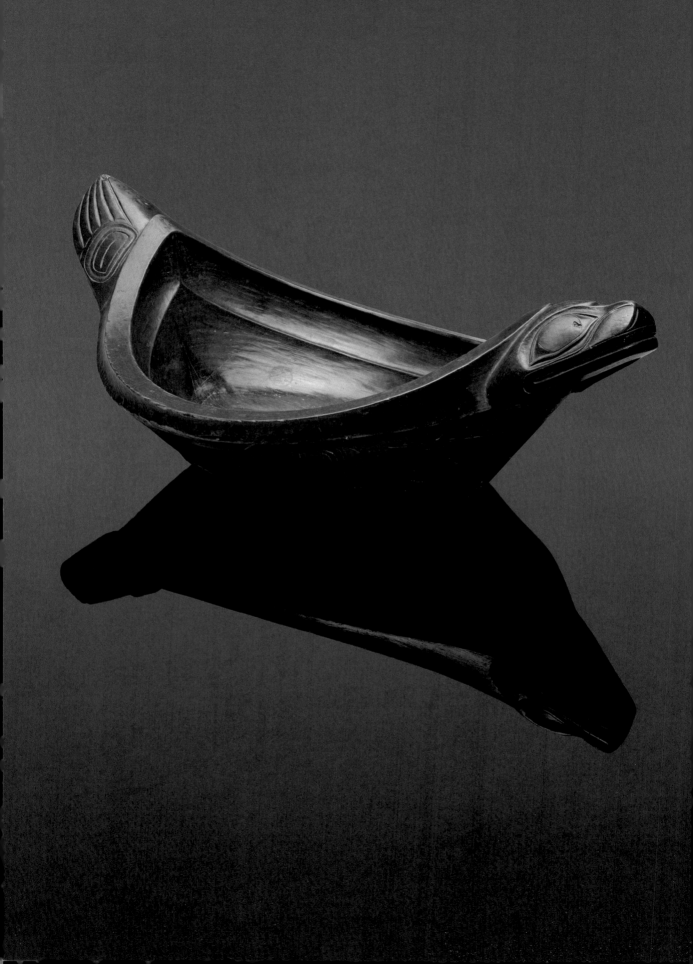

SHAPE-SHIFTING IMAGES

ROBERT HOULE

During the first half of the twentieth century European modernity changed as a result of the challenges of the interwar period. The Surrealists, for example, devised a general theory of semiotics for the analysis of human cultures and behaviour.[1] Many left for America before World War II began, while others managed to escape later, some to regroup with local artists in an association of ideas that led to Abstract Expressionism, and some to continue their surrealist ideals. A renewed Modernism began in Turtle Island, the mythical First Nations name for North America, which mined the shape-shifting images of Northwest Coast art as a vital source of inspiration for a reframing of the old continent's Modernism. The shifting perspectives and images in their revolutionary photomontages, fantastical assemblages and erotic-kinetic objects are tangible visual associations with autochthonous shamanistic art. Indigenous art of the New World was an inoculation of hope into utopian ideas recently refuted by war.

The Haida *Wood Feast Bowl* (19th century), once owned by Enrico Donati, an Italian-born American Surrealist who died in 2008, and the cast bronze *Disagreeable Object* (1931) [p. 272] by Alberto Giacometti, are remarkably similar. Although of different materials, each depends on a kind of shape-shifting: a piece of humble cedar is transformed into a seal that is a bowl; a plaster form is marked with erotic simulacra and cast in bronze to become a piece of sculpture. Both works recall the sensual stone sculptures of the Northwest Coast that were shown at the Art Gallery of Greater Victoria in the 1970 exhibition *Images Stone B.C.*

The combination of logical thought and inexplicable coincidence made Surrealism not just an odd combustion, a contradiction. Its cleansing fire of renewal was balanced

HAIDA *Wood Feast Bowl*, 19th century, Private Collection, Vancouver, Courtesy Donald Ellis Gallery, Dundas, ON and New York, NY, Formerly Enrico Donati Collection

271

Fig. 24 Alberto Giacometti, *Objet désagréable* [Disagreeable Object], 1931, bronze, Collection of Fondation Giacometti, Paris (1994-0018), ©Estate of Alberto Giacometti/SODRAC (2011). Photo: Jean-Pierre Lagiewski

by its notion of crisis. It was a lifestyle philosophically based in the spirit of revolution and anarchy, but anchored to objective chance, where reason and ritual, modernism and primitivism, co-mingle.

The Surrealists knew that the ceremonial life and culture of the Pacific Northwest at the time was largely untouched by colonialism; to them it was exotic, otherworldly, fantastical. Haida art, for example, was an uninterrupted art tradition. George McDonald aptly describes it:

The Haida fashioned for themselves a world of costumes and adornments, tools and structures, with spiritual dimensions appropriate to each. The decorations on the objects they created were statements of social identity, or reminders of rights and prerogatives bestowed on their ancestors by supernatural beings, or of lessons taught to them through mythic encounters with the animals, birds, fish or other beings whose likenesses were embodied in the crests passed down through generations.[2]

As more settlers appeared and started building, different kinds of encounters took place. By the time the feast bowl was carved sometime during the nineteenth century,

Fig. 25 Alberto Giacometti, *Objets mobiles et muets*, in *Le surréalisme au service de la revolution,* Paris, no. 3, 1931, pp. 18–19, © Estate of Alberto Giacometti/SODRAC (2011)

Haida culture had adapted to new tools and metals, which allowed for greater refinement. Nonetheless, Haida and Western remained two different ideas of art. It makes sense to explore why so many Surrealists were drawn to Haida and other aboriginal works. Did they see these as uninhibited by patriarchal modernity? André Breton, Max Ernst, Enrico Donati and many other artists were serious collectors. Breton owned a Haida transformation mask and Ernst a Kwakwa̱ka̱'wakw house post, both now part of the Musée du Quai Branly collection in Paris. The stunning monumental house post with a frontal view of the breastfeeding mother is presently on display in the Port des Lions Louvre, as a masterpiece from art of the Americas.

Like others, Giacometti collected pieces he kept in his studio for reference. Some of his own artworks, in particular a 1933 sketch in pen and ink on writing paper and a 1952 lithograph on thick paper with an image of a rough sketch of a *disagreeable object*, and various other works as well as photos of him surrounded by his collection, show that he was also inspired by non-Western arts and cultures. The bronze *Disagreeable Object*, for example, is reminiscent of prehistoric igneous stone sculptures with their

Shape-shifting Images

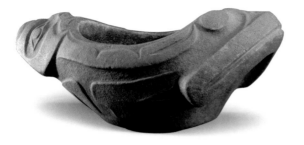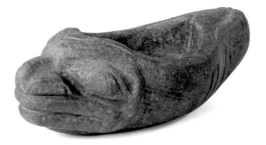

Fig. 26 Left: Haida, *Mortar*, 1500–1800, basalt, red ochre pigment, McCord Museum, Montreal, ACC1205A

Fig. 27 Right: Tlingit, *Mortar*, stone, Department of Anthropology, Smithsonian Museum, cat. no. E45961

simple expressive forms and erotic associations. Carvings on the original plaster leave traces of turmoil on the finished piece. The claws and whiskers on opposite ends, the decoration on the sides, suggest a shifting ambiguous creature. What are the connotations? The associations? Is the phalliformic club a weapon? Is it a mutation? Giacometti's work acts as a powerful analogy of trauma, where memory is just the intersection of mind and matter. By creating this zoomorphic form, one that serves as a site where disparate cultures meet, he turns the transformative force of seeking other art traditions into one of healing.

The Haida bowl may be traced to two prehistoric tobacco mortars[3], one from the Smithsonian in Washington, DC and the other from the McCord Museum in Montreal. The combination of incision and relief on the Smithsonian mortar changes its abstracted seal within an oval-shaped stone into a clearly defined image with incised fins on the sides and the tail. In the classic idiom of transformation the McCord mortar tells a story of a human and a frog, often the helper in folklore, working together to form a seal. The stone is an example of sublime simplicity, a balance between real and magic, an object of twilight, when people, animals, objects and places appear indefinite and mysterious.

The sinuous lines and forms of these prehistoric mortars echo in the Haida cedar bowl, while the rough markings and erotic associations of the later bronze reflect the bowl maker's treatment of form and transformation. The latter works are both shape-shifting objects. The Haida piece is perfectly symmetrical: the carver has seen and revealed in the grain of the cedar a naturalistic seal emoting fluidity, with its elegant head and tailfins. A symbol of wealth and abundance, the bowl with its hollow back is an appropriate container for ceremonial food. Its zoomorphic abstraction, although it comes from outside modernity, can be compared to the embryonic form of the Giacometti work.

THE PACIFIC NORTHWEST

The Surrealists used the regenerative power of the mundane, with its shifting shadows, in paintings, photographs and sculptures, and illuminated ambiguity through multiple ways of seeing and revealing. Their writings on Automatism define the meeting of external causality and internal finality. It was the resonance with this cultural focus that Giacometti and other Surrealists responded to in the art of the Pacific Northwest. Inspired by the use of form in non-Western art, its new ways of seeing, he eventually broke away from the formal idioms of abstraction and Conceptualism to search for a new vision of the human figure.

Modernity's rational perspective and the syntax of fractured reality proposed by surrealist art, with its incompatible aims of exploring and liberating the creative unconscious and formulating a policy of practical action for society, made this period of art history a radical time. The aboriginal perspective was one of sharing, a traditional tribal value that nurtured the Surrealists' desire for renewal and healing. The trauma in old Paris led to the shift to New York and, in that moment when indigenous art traditions were about to change forever, North America's ancient cultures became the new frontier of creativity.

[1] Speaking as an Anishnabe my perspective clearly signifies an epistemological difference from Judeo-Christian modernity. For us, other phenomena are experienced through the magic and reality of shamanism and mythology, away from rationalism. Remember, we believe animals are relatives and weather can be sign or symbol, even a spirit name. (R.H.) [2] George F. MacDonald, *Haida Art* (Vancouver: Douglas and McIntyre / Hull: Canadian Museum of Civilization, 1996), 9. [3] Wilson Duff, *Images Stone B.C.: Thirty Centuries of Northwest Coast Indian Sculpture* (Toronto: Oxford University Press, 1975), 144 (Figure 127) and 153 (Figure 130).

ROBERT HOULE, a Toronto-based contemporary Anishnabe artist, teacher and curator, has played a significant role in defining First Nations identity in Canada since he began exhibiting his work in the early 1970's, drawing on Western art conventions to tackle lingering aspects of European colonization. His most recent exhibition was the multi-media installation *Paris/Ojibwa* at the Canadian Cultural Centre in Paris that is soon to tour North America. He now lectures on indigenous abstraction at OCAD University and continues to work on drawings based on memory and trauma of elementary residential school.

ANATOMIES
OF DESIRE

HANS BELLMER *Untitled*, from *Les Jeux de la Poupée* [The Doll's Games], 1935,
Courtesy of Virginia Lust, New York

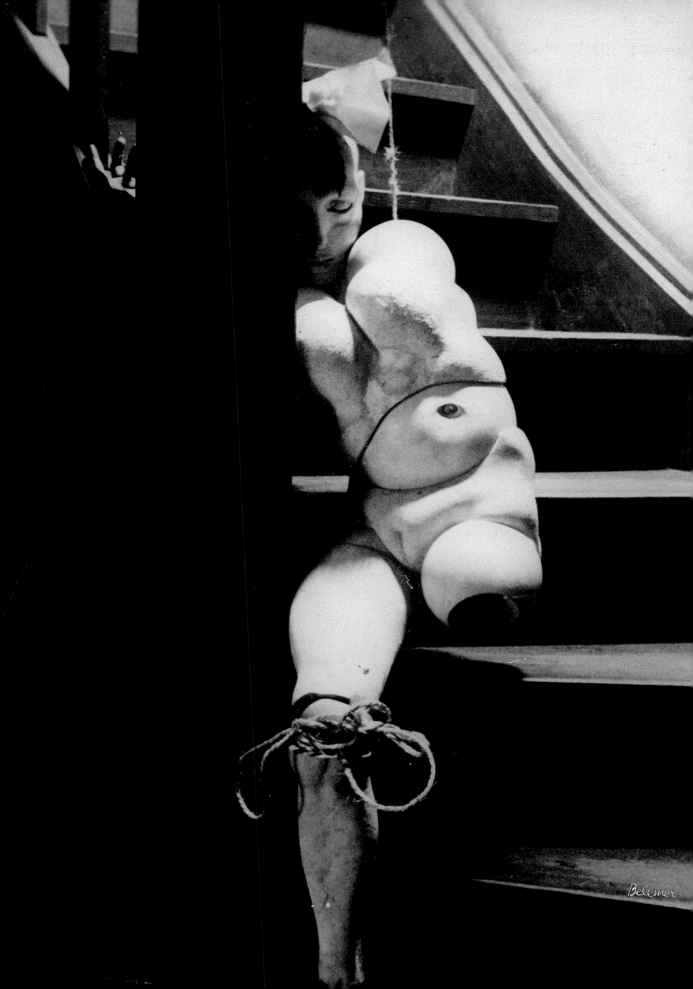

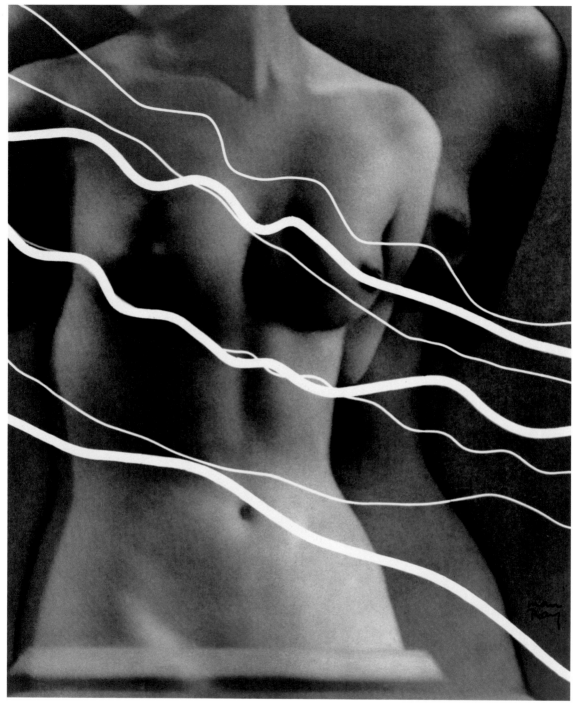

MAN RAY *Electricité*, 1931, Victoria and Albert Museum, London, Purchased with the generous support of the Friends of the V&A and the National Art Collections Fund

"I confess without the slightest embarrassment my profound insensibility before natural spectacles and works of art which do not, immediately, procure in me the physical sensation of a breath of wind on the temples, causing a real shiver. I have never been able to prevent the recognition of a relationship between this sensation and that of erotic pleasure and find between them only differences of degree. Although I have never managed to analyze exhaustively the elements that cause this sensation — it must take advantage of my deepest repressions — what I do know about it assures me that sexuality alone presides there." — André Breton, *L'amour fou*, 1937

Surrealism's attitude to women has been highly controversial: however admired, they seem to be set apart, objectified and voiceless. Women were eventually to take a major part in surrealist activities, as poets, writers and artists, but there is no denying that much surrealist imagery is dominated by the female body. Whereas in surrealist poetry, and in books like Breton's *Nadja* and *L'amour fou* (Mad Love), the woman is celebrated, her representation in art is more ambiguous. In surrealist paintings, sculpture and photographs she seems either to be the adored object of the male gaze or, more frequently, the victim of violence — bodies fragmented, distorted or truncated.

An interesting defence is that the Surrealists were among the first to challenge and deconstruct the notion of Woman as the Eternal Feminine, the embodiment of Nature to male Culture. It was certainly the case that the Surrealists, male as well as female, confronted gender stereotypes and assumptions about sexual *normality*, instinctively siding with the idea that there is no such thing as pure femininity or masculinity in either a biological or psychological sense, as well as believing in the profound power of desire, of which the female body can be the symbol. Eros was associated with the life drive as opposed to Thanatos, the death drive.

In 1928 *La révolution surréaliste* published the first two sessions of a series of group conversations about sexuality. These "Recherches sur la sexualité" are extraordinarily frank with a wide range of opinions: they are a more personal, eccentric, sometimes

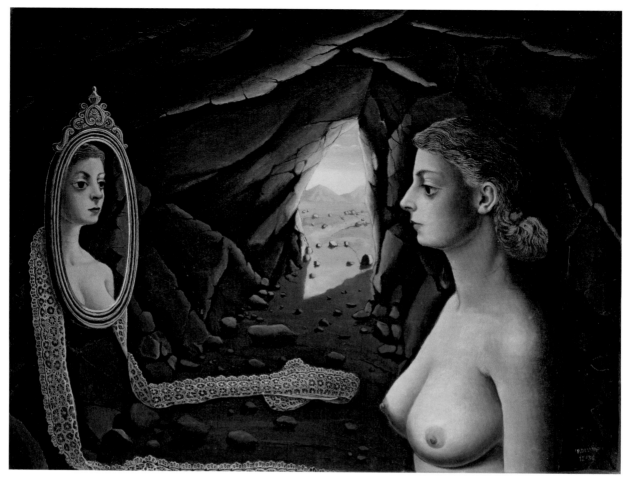

PAUL DELVAUX *Mujer ante el espejo* [Woman in the Mirror], 1936, Museo Thyssen-Bornemisza, Madrid

bitter, often hilarious version of the sociological studies of sex and gender beginning in this period. No women were present in the first sessions, a fact criticized by Louis Aragon. Despite Breton's notorious outburst against the discussion of it, homosexuality remained a regular topic. Ten further sessions took place but remained unpublished until 1990. In place of the promised continuation in the next, and last, issue of *La révolution surréaliste* there was a Questionnaire on Love, asking: " What kind of hope do you place in love?" For the Surrealists, scientific investigations into sexuality and the celebration of romantic love were equally important, as love and sex are both aspects of desire, which is at the core of human life.

[D.A.]

ANATOMIES OF DESIRE

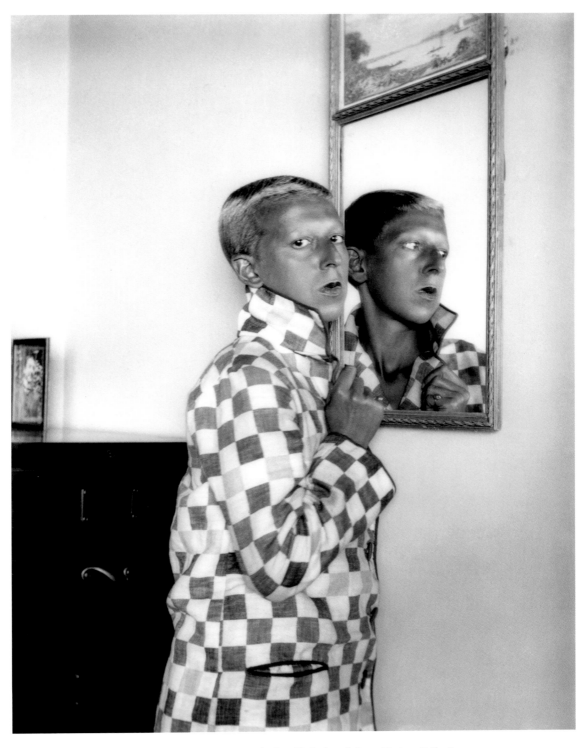

CLAUDE CAHUN *Self portrait* [reflected image in mirror, checkered jacket], 1928, Jersey Heritage Collection

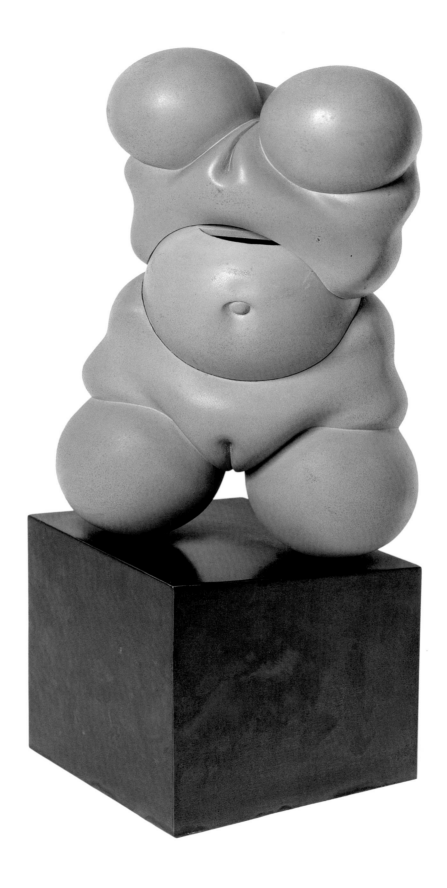

HANS BELLMER *La Poupée* [The Doll Centre], 1935, cast 1965, Courtesy of Virginia Lust Gallery, New York

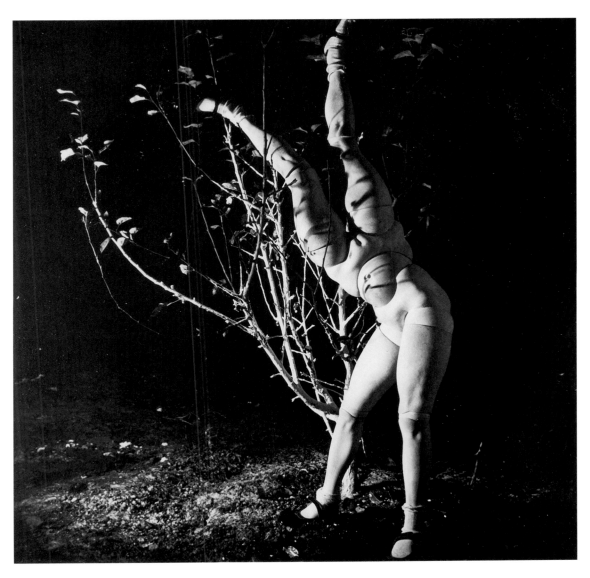

HANS BELLMER *La Poupée* [The Doll], 1937, Collection of Harry and Ann Malcolmson

"The 'Anatomy of Love' establishes among other things that an object such as a woman's foot is only real when desire does not insist on regarding it as a foot." — Hans Bellmer, "A Brief Anatomy of the Physical Unconscious or The Anatomy of the Image," *The Doll* (1963), 2005

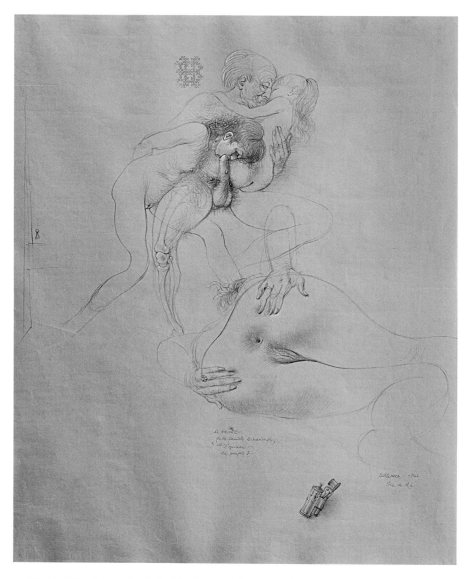

HANS BELLMER *Le Travail de la famille laborieuse* [The Labour of the Hard Working Family], 1963,
Courtesy of Virginia Lust Gallery, New York

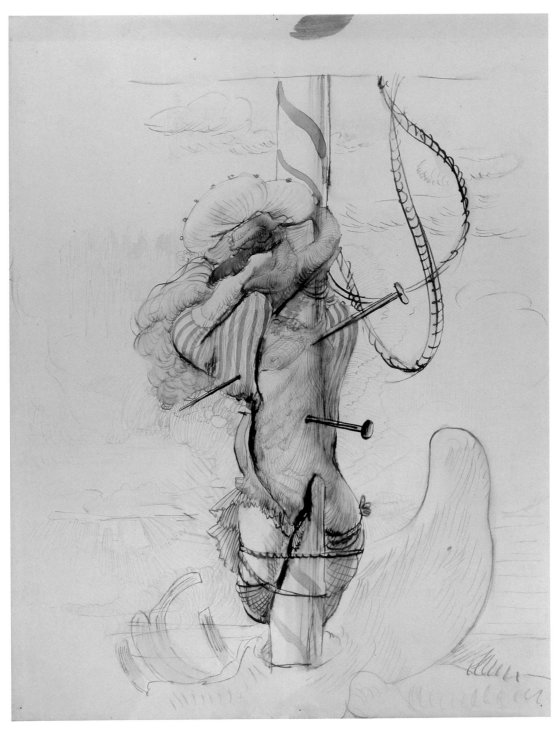

HANS BELLMER *Untitled*, c. 1934, Private Collection, Courtesy Ubu Gallery, New York & Galerie Berinson, Berlin

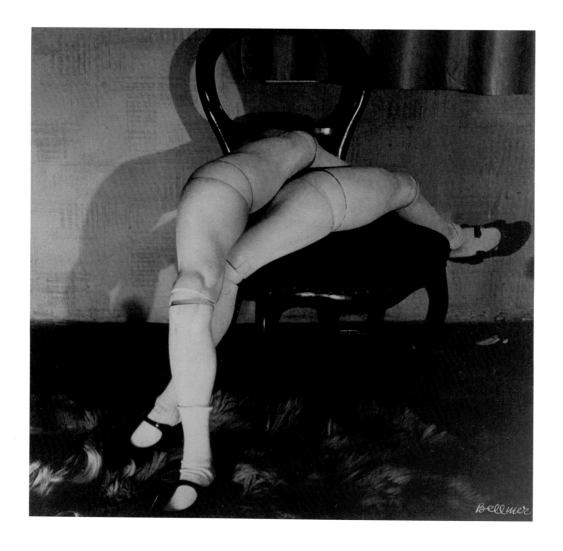

HANS BELLMER *La Poupée* [La Bouche] [The Doll [The Mouth]], 1936,
printed 1949 or earlier, Ubu Gallery, New York & Galerie Berinson, Berlin

HANS BELLMER *La Poupée* [The Doll], 1935,
Ubu Gallery, New York & Galerie Berinson, Berlin

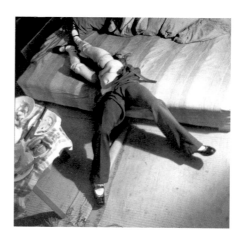

ANATOMIES OF DESIRE

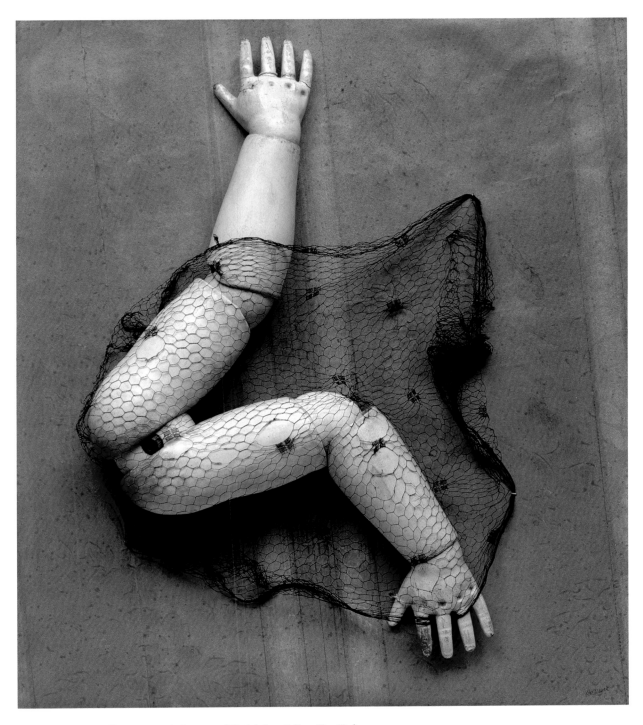

HANS BELLMER *Ball Joint*, 1935–36, Courtesy of Virginia Lust Gallery, New York

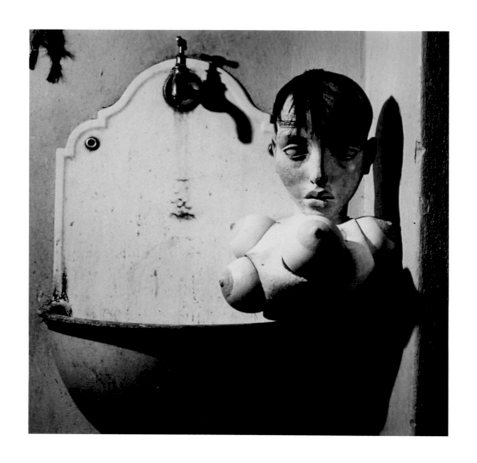

HANS BELLMER *La Poupée* [The Doll], 1935,
Ubu Gallery, New York & Galerie Berinson, Berlin

HANS BELLMER *La Poupée* [The Doll], 1934,
Ubu Gallery, New York & Galerie Berinson, Berlin

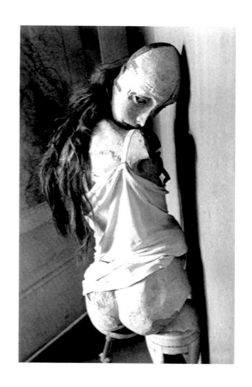

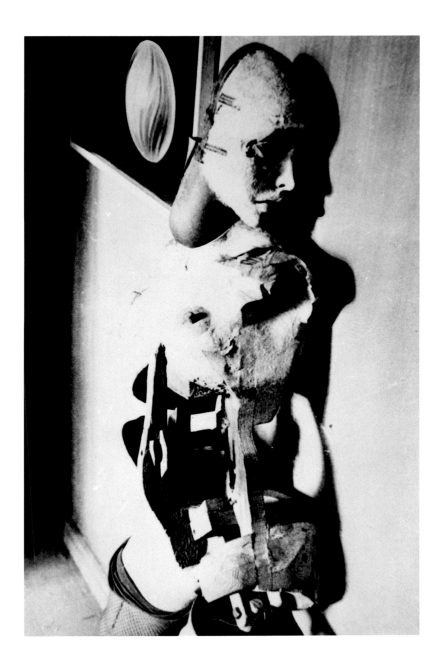

HANS BELLMER Left: *La Poupée* [The Doll], 1935, printed c. 1936,
Ubu Gallery, New York & Galerie Berinson, Berlin

HANS BELLMER Above: *La Poupée* [The Doll], 1934,
Collection of Conrad Lust, New York

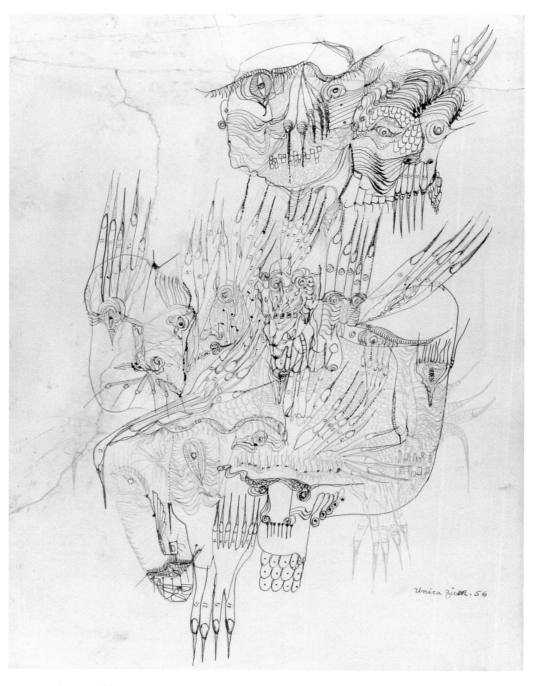

UNICA ZÜRN *Untitled*, 1956, Ubu Gallery, New York & Galerie Berinson, Berlin

ANATOMIES OF DESIRE

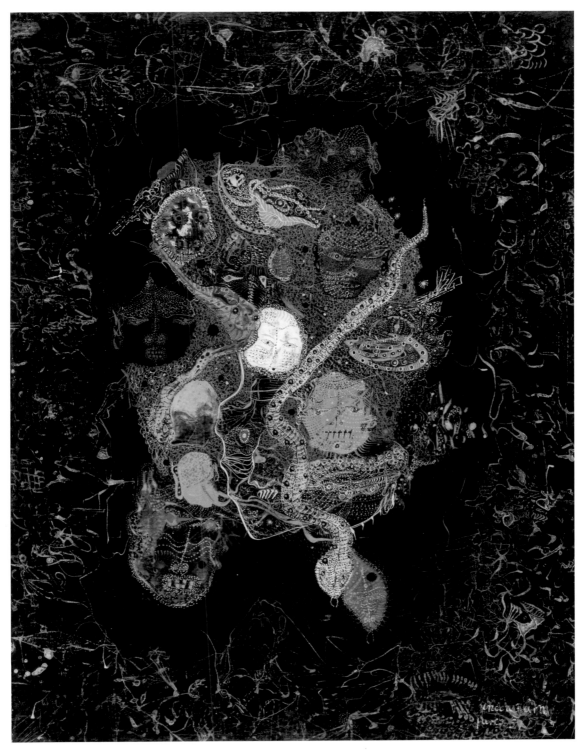

UNICA ZÜRN *Untitled*, 1957, Ubu Gallery, New York & Galerie Berinson, Berlin

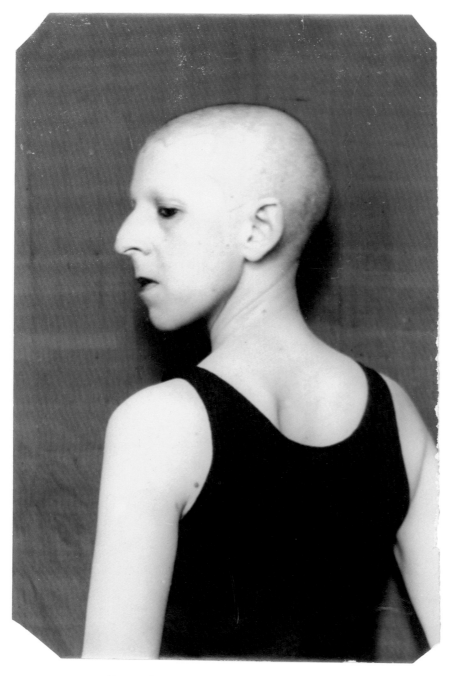

CLAUDE CAHUN *Self portrait* [with shaved head], c. 1920, Jersey Heritage Collection

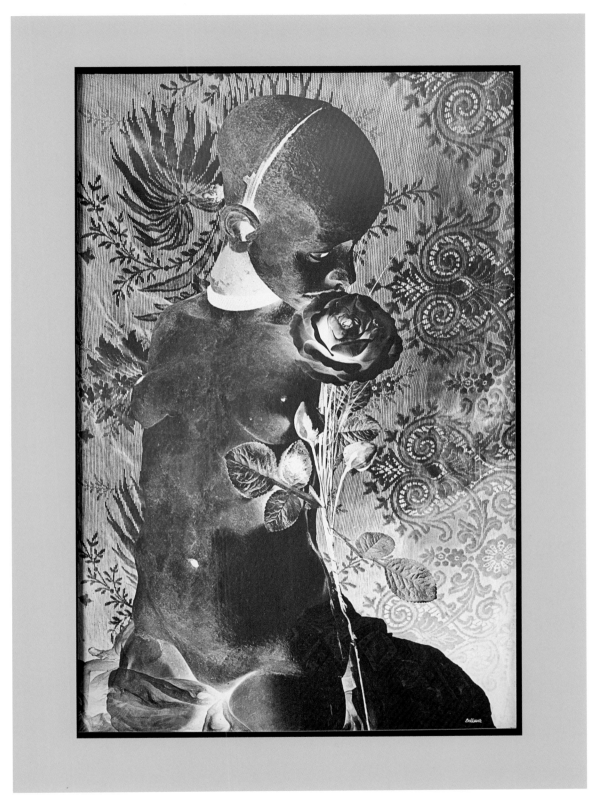

HANS BELLMER *La Poupée* [The Doll], 1934/1955, Collection of Conrad Lust, New York

"ANDROGYNE — Being uniting in itself the characteristics of both sexes: many plants are androgynous The idea of a primitive androgyne, which the human couple aims to reconstitute, is at the origin of platonic and neo-platonic concepts of Love. Far from being a superficial fantasy, the Androgyne plunges its roots into the unconscious and represents a clearly characterised phase in sexual development: Freud saw in it a projection of the desire to match the parental couple. Others have seen the projection of the narcissistic desire for self-sufficiency, endlessly almost attained and endlessly called into question: the Androgyne would be the asymptotic state of sexuality." — "Lexique succinct de l'érotisme," *Exposition InteRnatiOnale du Surréalisme* [EROS], 1959

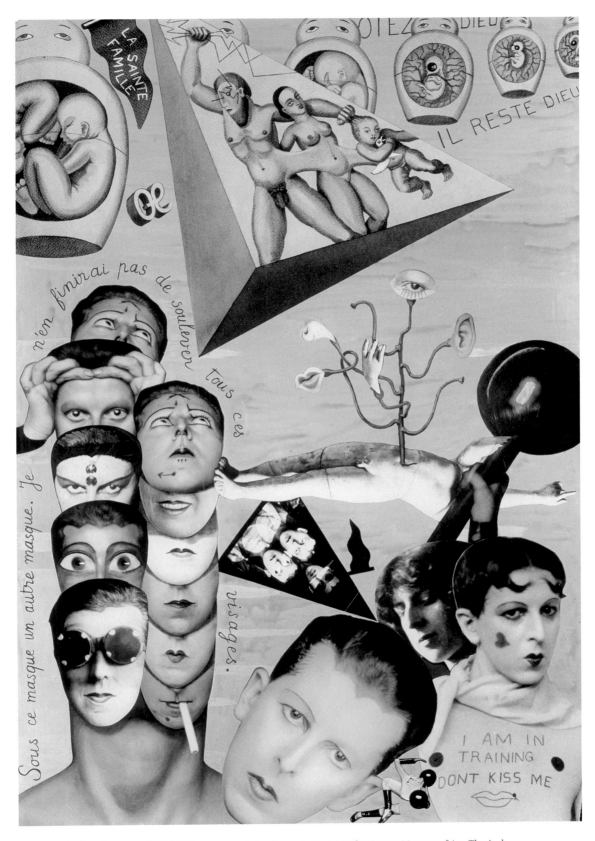

Fig. 28 Claude Cahun, *I.O.U. (Self-Pride)*, 1929–30, gelatin silver print, Los Angeles County Museum of Art, The Audrey and Sydney Irmas Collection, Image ©2009 Museum Associates/LACMA/Art Resource, NY

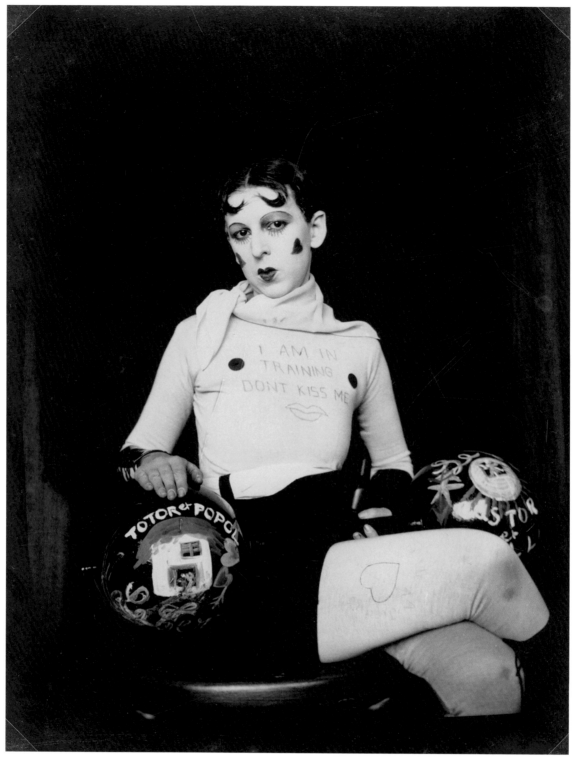

CLAUDE CAHUN *Self portrait* [as weight trainer], 1927, Jersey Heritage Collection

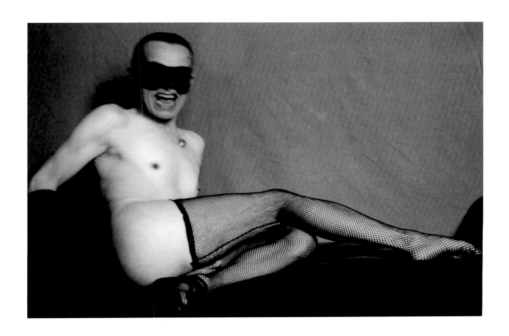

PIERRE MOLINIER *Untitled (self-portrait)*, c. 1966–68, Ubu Gallery, New York & Galerie Berinson, Berlin

PIERRE MOLINIER *Untitled (manipulated self-portrait)*, c. 1966–68,
Ubu Gallery, New York & Galerie Berinson, Berlin

GEORGES HUGNET *La Mailloche Dorée* from the series *La vie amoureuse des Spumifères* [The Golden Meshlican from the series *The Love Life of the Foamifers*], c. 1948, Ubu Gallery, New York & Galerie Berinson, Berlin

GEORGES HUGNET *La Ribulute Vertébrée* from the series *La vie amoureuse des Spumifères* [The Vertebrate Ribalet from the series *The Love Life of the Foamifers*], c. 1948, Ubu Gallery, New York & Galerie Berinson, Berlin

ITHELL COLQUHOUN *The Pine Family*, 1941, The Israel Museum, Jerusalem,
The Vera and Arturo Schwarz Collection of Dada and Surrealist Art in the Israel Museum

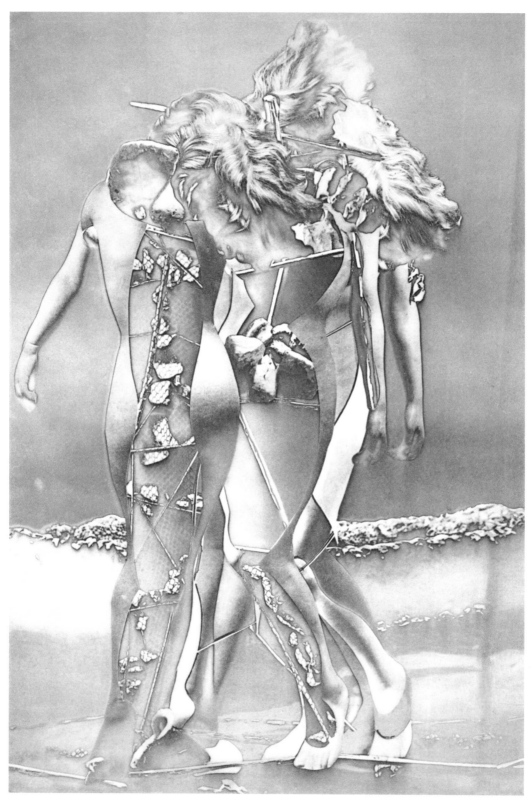

RAOUL UBAC *Untitled* [variation of *Les vases communicants*], 1937/1980s,
San Francisco Museum of Modern Art, Funds of the 80s purchase

ANATOMIES OF DESIRE

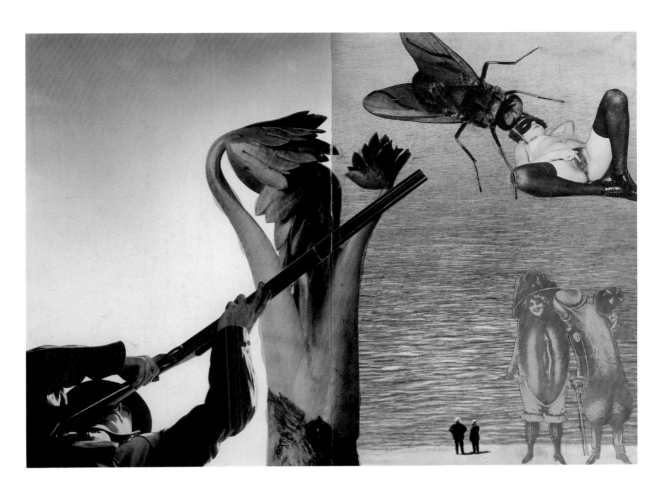

JINDŘICH ŠTYRSKÝ *Vilém Tell* [William Tell; maquette for *Eroticka revue*], 1931, Ubu Gallery, New York & Galerie Berinson, Berlin

JINDŘICH ŠTYRSKÝ *Untitled* [maquette #1 for *Emilie Comes to Me in a Dream*], 1933, Ubu Gallery, New York & Galerie Berinson, Berlin

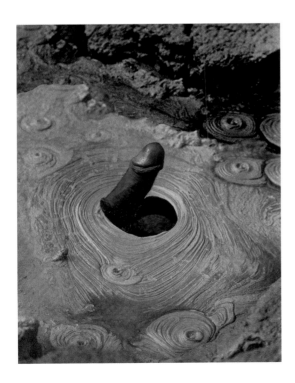

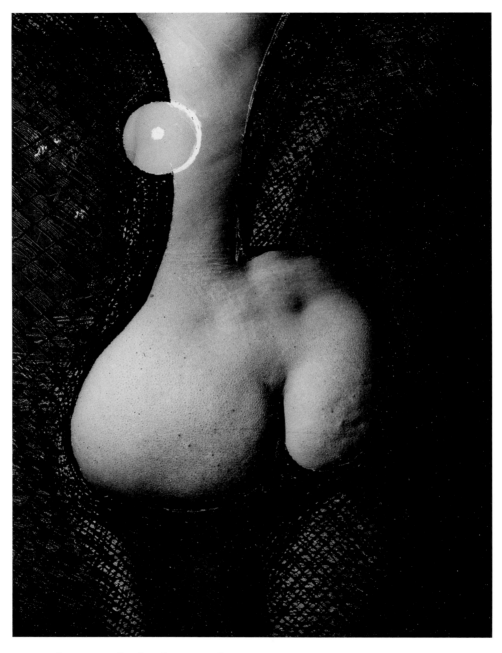

BRASSAÏ *Femme-Amphore* [Amphora-Woman], 1934–35, The Art Institute of Chicago, Restricted Gift of Mr. and Mrs. Gaylord Donnelly and Mr. and Mrs. Ralph J. Mills

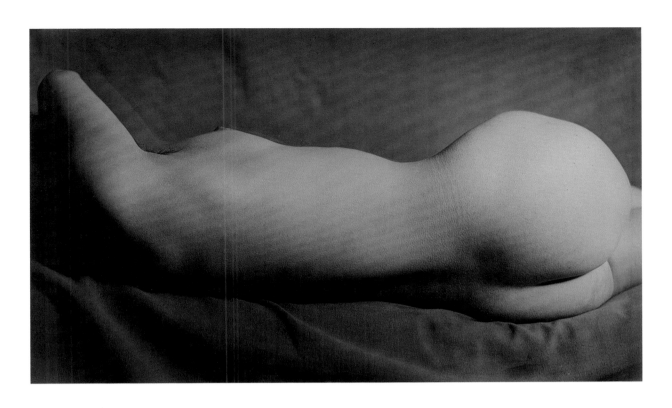

BRASSAÏ *Nude*, 1931–34, The Metropolitan Museum of Art, Twentieth-Century Photography Fund, 2007

PAUL ÉLUARD *Femme Volcanique* [Volcanic Woman], 1932, Collection of Timothy Baum, New York

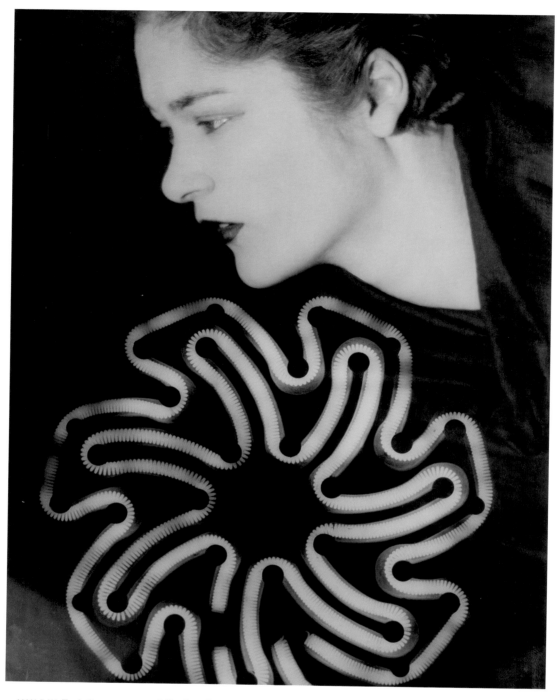

MAN RAY *Tanja Ramm*, c. 1930s, Collection of Harry and Ann Malcolmson

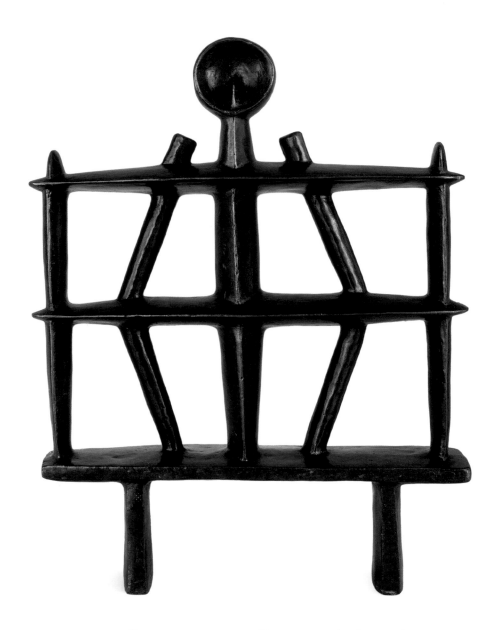

ALBERTO GIACOMETTI *Man*, 1929, cast c. 1950–56, Hirshhorn Museum and Sculpture Garden, Smithsonian Institution, Washington, DC, Gift of the Joseph H. Hirshhorn Foundation, 1966

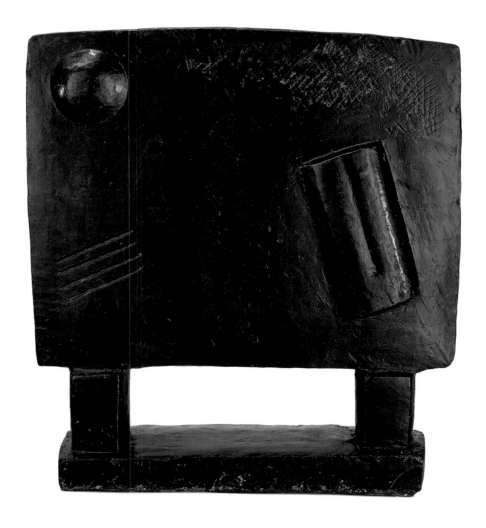

ALBERTO GIACOMETTI *Woman*, 1928, cast 1929, Hirshhorn Museum and Sculpture Garden, Smithsonian Institution, Washington, DC, Gift of the Joseph H. Hirshhorn Foundation, 1972

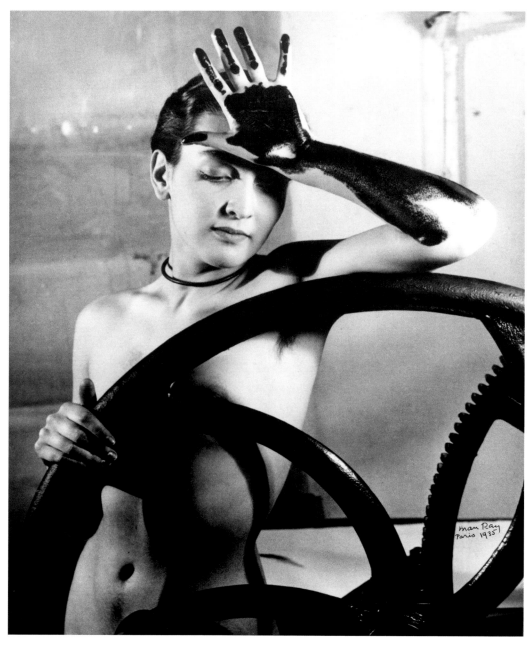

MAN RAY *Érotique Voilée* [Veiled Erotic], 1933/1935, Collection of Karen Amiel Baum, New York

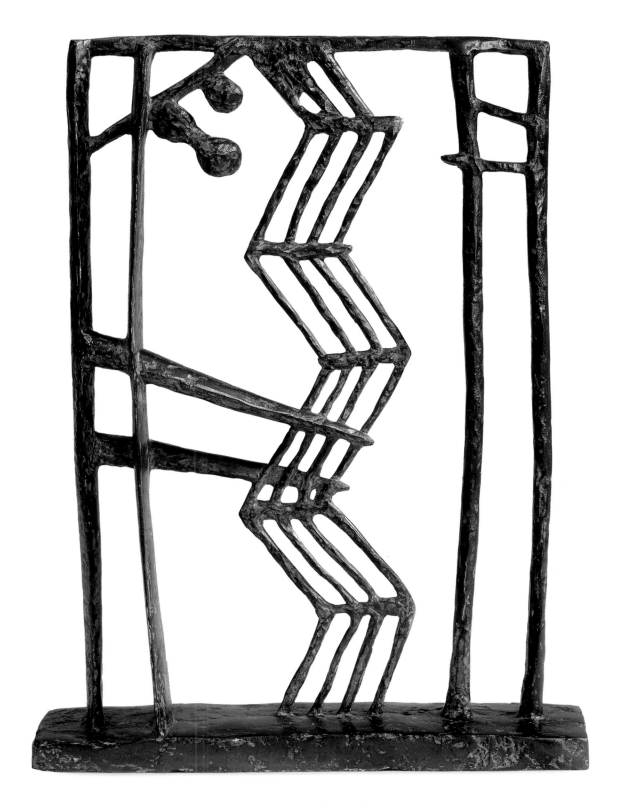

ALBERTO GIACOMETTI *Three Figures Outdoors*, 1929, Art Gallery of Ontario, Toronto, Purchased 1984

THE HUMAN CONDITION

Magritte painted many versions of *The Human Condition*, all of which share the key feature of an easel with a picture placed in front of a window or aperture. What is outside, hidden by the picture, may be supposed to be identical to what is represented, in this case a marine landscape with a white pebble or ball in the foreground. For the spectator, Magritte wrote, the scene and its elements are

both inside the room in the picture and, at the same time, conceptually outside in the real landscape. This is how we see the world, we see it outside ourselves and yet the only representation we have of it is inside us.[1]

Magritte's images express a fundamental human dilemma: "our gaze always wants to penetrate further so as to see at last the reason for our existence."[2]

[1] Magritte, "La ligne de vie" (1938), in Sarah Whitfield, *Magritte* (London: South Bank Centre, 1992), cat. no. 62, (n.p.). [2] Magritte, ibid.

[D.A.]

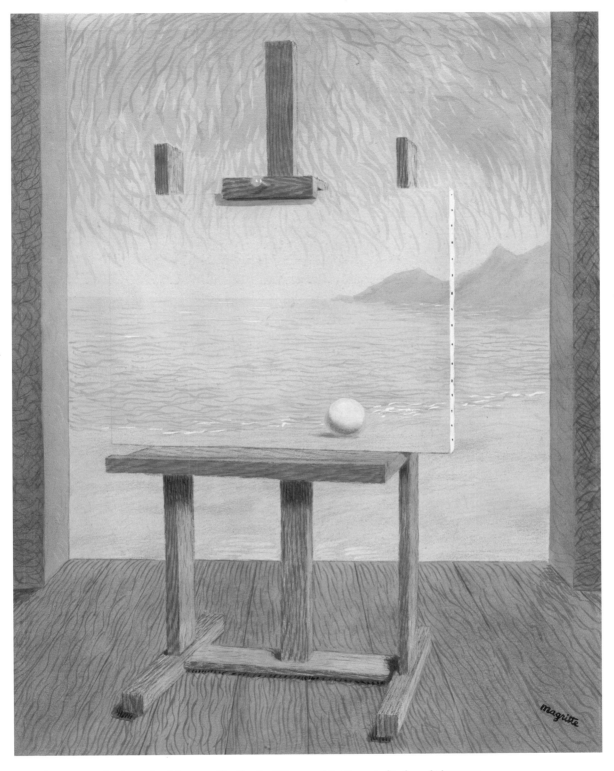

RENÉ MAGRITTE *The Human Condition*, 1945, The Cleveland Museum of Art, Bequest of Lockwood Thompson

LOUISE BOURGEOIS *Untitled*, 1947–49, Courtesy of Cheim & Read and Hauser & Wirth

RENÉ MAGRITTE *L'Anniversaire* [The Birthday], 1959, Art Gallery of Ontario, Toronto, Purchase, Corporations' Subscription Endowment, 1971

RENÉ MAGRITTE *The Six Elements*, 1929, Philadelphia Museum of Art, The Louise and Walter Arensberg Collection, 1950

JOAN MIRÓ *Untitled*, 1933, Collection of Timothy Baum and Karen Amiel Baum, New York

JOAN MIRÓ *Metamorphose G* [Metamorphosis G], 1936, The Pierre and Tana Matisse Foundation Collection, New York

LIST OF WORKS

Dimensions: height precedes width precedes depth; n.d. indicates no date

ALVAREZ BRAVO, MANUEL

Escala de escalas [Ladder of Ladders], 1931
gelatin silver print
25.5 × 20.2 cm
Vancouver Art Gallery,
Gift of Charles J. Savedoff
and Steven Katz

Worker Killed in Strike,
c. 1934, printed 1942
gelatin silver print
24.2 × 19.2 cm
Wilson Centre for
Photography, London

Retrato póstumo
[Posthumous Portrait], 1939
gelatin silver print
24.0 × 19.3 cm
Collection of Harry and
Ann Malcolmson

*Payaso de Carnaval,
Mexico 1444* [The Carnival
clown, Mexico 1444],
c. 1940
gelatin silver print
100.0 × 71.0 cm
Wilson Centre for
Photography, London

Cruce de Chalma [The
Cross at Chalma], 1942,
printed c. 1978
gelatin silver print
25.4 × 20.32 cm
San Francisco Museum of
Modern Art, Gift of Mr. and
Mrs. René Woolcott

Los agachados [The Crouched
Ones], 1943
gelatin silver print
17.2 × 23.8 cm
Vancouver Art Gallery,
Gift of Claudia Beck and
Andrew Gruft

Pintor de negro [Painter
of Black], 1972
gelatin silver print
19.0 × 23.0 cm
Collection of Harry and
Ann Malcolmson
© Colette Urbajtel/Asociación
Manuel Alvarez Bravo
(page 49)

ARP, JEAN (HANS)

Two Heads, 1927
oil and cord on canvas
35.0 × 27.0 cm
The Museum of Modern Art,
New York, Purchase, 1936
© Estate of Hans Arp/
SODRAC (2011)
Image © The Museum of
Modern Art/Licensed by
SCALA/Art Resource, NY
(page 68)

*Sculpture to be Lost in the
Forest*, 1932, cast c. 1953–58
bronze
9.0 × 22.2 × 15.4 cm
Tate, Accepted by H.M.
Government in lieu of tax and
allocated to Tate Gallery, 1986

ARTAUD, ANTONIN

*Sort à Lise Deharme,
5 septembre 1937* [Spell, for
Lise Deharme, September 5,
1937], 1937

ink on burned paper
26.9 × 20.8 cm
Chancellerie des Universités
de Paris — Bibliothèque
littéraire Jacques Doucet, Paris
© Estate of Antonin
Artaud/SODRAC (2011)
(page 208)

ATGET, EUGÈNE

Boulevard de Strasbourg,
1912, printed c. 1935
gelatin silver print
23.3 × 16.9 cm
National Gallery of Canada,
Ottawa, Gift of Dorothy
Meigs Eidlitz, St. Andrews,
New Brunswick, 1968

*Boulevard de Strasbourg,
10th Arrondissement*, 1912
gelatin silver print
22.2 × 17.3 cm
National Gallery of Canada,
Ottawa, Purchased 1974

*Fille publique faisant le quart,
La Villette, 19ᵉ arrondissement*
[Prostitute Taking her Shift, La
Villette, 19th Arrondissement],
April 1921, printed c. 1935
gelatin silver print
23.5 × 17.5 cm
National Gallery of Canada,
Ottawa, Gift of Dorothy
Meigs Eidlitz, St. Andrews,
New Brunswick, 1968

*Café, Boulevard Montparnasse,
6th and 14th Arrondissement*,
June 1925
gelatin silver print
17.4 × 22.1 cm
National Gallery of Canada,
Ottawa, Purchased 1970

BELLMER, HANS

La Poupée [The Doll], 1934
gelatin silver print
11.0 × 7.0 cm
Collection of Conrad Lust,
New York
© Estate of Hans Bellmer/
SODRAC (2011)
(page 289)

La Poupée [The Doll], 1934
gelatin silver print
9.2 × 6.2 cm
Ubu Gallery, New York &
Galerie Berinson, Berlin
© Estate of Hans Bellmer/
SODRAC (2011)
(page 288)

La Poupée [The Doll], 1934,
printed c. 1955
gelatin silver print
151.0 × 100.0 cm
Collection of Conrad Lust,
New York
© Estate of Hans Bellmer/
SODRAC (2011)
(page 293)

Untitled, c. 1934
ink and watercolour on paper
32.0 × 23.9 cm
Private Collection, Courtesy
Ubu Gallery, New York &
Galerie Berinson, Berlin
© Estate of Hans Bellmer/
SODRAC (2011)
(page 285)

La Poupée [The Doll], 1935
gelatin silver print
5.7 × 6.3 cm
Ubu Gallery, New York &
Galerie Berinson, Berlin
© Estate of Hans Bellmer/
SODRAC (2011)
(page 286)

La Poupée [The Doll], 1935
gelatin silver print
11.2 × 11.2 cm
Ubu Gallery, New York &
Galerie Berinson, Berlin
© Estate of Hans Bellmer/
SODRAC (2011)
(page 288)

Untitled, from *Les Jeux de la
Poupée* [The Doll's Games],
1935
gelatin silver print
73.7 × 50.8 cm
Courtesy of Virginia Lust
Gallery, New York
© Estate of Hans Bellmer/
SODRAC (2011)
(page 277)

La Poupée [The Doll], 1935,
printed c. 1936
gelatin silver print
31.0 × 7.1 cm
Ubu Gallery, New York &
Galerie Berinson, Berlin
© Estate of Hans Bellmer/
SODRAC (2011)
(page 289)

Ball Joint, 1935–36
assemblage
52.0 × 45.5 × 7.0 cm
Courtesy of Virginia Lust
Gallery, New York
© Estate of Hans Bellmer/
SODRAC (2011)
(page 287)

La Poupée [The Doll Centre],
1935, cast 1936
cast aluminum painted and
on a brass base
63.5 × 30.8 × 30.5 cm
Courtesy of Virginia Lust
Gallery, New York
© Estate of Hans Bellmer/
SODRAC (2011)
(page 282)

La Poupée [La Bouche] [The
Doll [The Mouth]], 1936,
printed 1949 or earlier
hand-coloured gelatin silver
print
14.2 × 14.5 cm

Ubu Gallery, New York &
Galerie Berinson, Berlin
© Estate of Hans Bellmer/
SODRAC (2011)
(page 286)

La Poupée [The Doll], 1937
gelatin silver print
13.5 × 13.7 cm
Collection of Harry and
Ann Malcolmson
© Estate of Hans Bellmer/
SODRAC (2011)
(page 283)

*Le Travail de la famille
laborieuse* [The Labour of the
Hard Working Family], 1963
pencil heightened with white
gouache on grey ingres paper
65.0 × 42.0 cm
Courtesy of Virginia Lust
Gallery, New York
© Estate of Hans Bellmer/
SODRAC (2011)
(page 284)

BOIFFARD,
JACQUES-ANDRÉ

Gros orteil [Big Toe], 1929,
printed 1982
gelatin silver print
31.0 × 23.9 cm
Centre Pompidou, Paris,
National Museum of Modern
Art/Centre for Industrial
Creation, Donated by
Mme. Denise Boiffard, 1986

BOURGEOIS, LOUISE

The Three Graces, 1947
bronze, painted white, and
stainless steel
205.7 × 63.5 × 30.4 cm
Courtesy of Cheim & Read
and Hauser & Wirth

Untitled, 1947–49
bronze, painted white and
blue, and stainless steel
173.3 × 30.4 × 30.4 cm
Courtesy of Cheim & Read
and Hauser & Wirth
Photo: Christopher Burke
(page 312)

The Winged Figure, 1948,
cast 1991
bronze
179.1 × 95.3 × 30.5 cm
National Gallery of Art,
Washington, DC, Gift of
Louise Bourgeois
(1992.101.1)

BRASSAÏ

Night View of Paris Street, 1931
gelatin silver print
22.54 × 16.83 cm
San Francisco Museum of
Modern Art, Accessions
Committee Fund, Gift of
Susan and Robert Green
and Mr. and Mrs. Robert I.
MacDonnell

Nude, 1931–34
gelatin silver print
14.1 × 23.5 cm
The Metropolitan Museum
of Art, Twentieth-Century
Photography Fund, 2007
(2007.226)
© Estate Brassaï/RMN
Image © The Metropolitan
Museum of Art/Art
Resource, NY
(page 303)

*Involuntary Sculpture
(Elementary Rolling Taken
from a Retarded Person)*,
1932
gelatin silver print
17.1 × 23.2 cm
The Metropolitan Museum
of Art, Purchase, The Horace
W. Goldsmith Foundation
Gift, through Joyce and Robert
Menschel, 2001 (2001.411)
© Estate Brassaï/RMN
Image © The Metropolitan
Museum of Art/Art
Resource, NY
(page 172)

Untitled [Shadows and
Sidewalk, Quai Malaquais,
Paris], c. 1932
gelatin silver print
17.5 × 23.5 cm

The Art Institute of Chicago,
Restricted Gift of Leigh B.
Block
© Estate Brassaï/RMN
(page 111)

Coquillage [Shell], 1933
gelatin silver print
17.0 × 23.0 cm
Centre Pompidou, Paris,
National Museum of Modern
Art/Centre for Industrial
Creation, Donated by
Mme. Gilberte Brassaï, 2002
© Estate Brassaï/RMN
Photo: Philippe Migeat,
CNAC/MNAM/Dist. Réunion
des Musées Nationaux/Art
Resource, NY
(page 173)

Transmutations, c. 1934
2 silver prints from
cliché-verres
30.5 × 39.8 cm
Wilson Centre for
Photography, London

Femme-Amphore [Amphora-
Woman], 1934–35
gelatin silver print
23.8 × 17.8 cm
The Art Institute of Chicago,
Restricted Gift of Mr. and
Mrs. Gaylord Donnelly and
Mr. and Mrs. Ralph J. Mills
© Estate Brassaï/RMN
(page 302)

Paris Exposition Universelle
[Paris Universal Exhibition],
1937
gelatin silver print
24.7 × 17.9 cm
The Art Institute of Chicago,
Gift of Michael Glicker
© Estate Brassaï/RMN
(page 50)

Graffiti, Paris, 1944–45,
printed late 1940s–1953
gelatin silver print
28.0 × 22.0 cm
The Metropolitan Museum
of Art, Gift of the Artist,
1980 (1980.1029.9)

BRAUNER, VICTOR

Auxerre, 1937
collage on paper
15.0 × 20.5 cm
Collection of Timothy
Baum, New York

Personnification de la nuit
[Personification of Night], 1947
gouache on paper
25.0 × 12.5 cm
Collection of Clo and Marcel
Fleiss, Paris

BRAUNER, VICTOR AND
ANDRÉ BRETON

Hommage à André Breton,
1938–39
ink drawing on buff paper
26.2 × 17.8 cm
Collection of André Baum,
New York

BRAUNER, VICTOR,
JACQUES HÉROLD AND
YVES TANGUY

Cadavre exquis [Exquisite
Corpse], c. 1935–36
pencil and collage on paper
26.7 × 19.8 cm
Collection of Timothy
Baum, New York
© Estate of Victor Brauner/
SODRAC (2011)
© Estate of Jacques Hérold/
SODRAC (2011)
© Estate of Yves Tanguy/
SODRAC (2011)
(page 155)

BRETON, ANDRÉ

Nadja, 1928
first edition book
18.8 × 12.5 cm
Collection of Timothy
Baum, New York

Le revolver à cheveux blancs
[The White-haired Revolver],
1932
first edition book
19.2 × 14.2 cm

Collection of Timothy
Baum, New York

Les vases communicants
[Communicating Vessels], 1932
first edition book
18.5 × 13.5 cm
Collection of Timothy
Baum, New York

L'amour fou [Mad Love], 1937
first edition book
19.5 × 14.5 cm
Collection of Timothy
Baum, New York

Drawing of a de Chirico
(The Scholar), 1939
coloured pencil on paper
11.4 × 8.6 cm
The Gordon Onslow Ford
Collection, Courtesy of Lucid
Art Foundation, Inverness, CA

*I Saluted at Six Paces
Commander Lefebvre des
Noettes* [from *VVV Portfolio*],
1942, published 1943
collage of colour lithograph
postcard, coloured thread,
sequins, brush and silver ink,
pen and black ink on paper
45.8 × 35.6 cm
Baltimore Museum of Art,
Gift of Sadie A. May
(BMA 1948.54.1)
© Estate of André Breton/
SODRAC (2011)
(page 144)

Decalcomania, c. 1946
ink on paper
19.0 × 13.0 cm
Collection of Adele Donati,
New York
© Estate of André Breton/
SODRAC (2011)
(page 53)

BRETON, ANDRÉ, ÓSCAR
DOMINGUEZ, WIFREDO
LAM AND JACQUELINE
LAMBA (BRETON)

Dessin collectif [Collective
Drawing], 1940

coloured pencil and ink on
paper
20.0 × 29.0 cm
Collection of Clo and Marcel
Fleiss, Paris
© Estate of André Breton/
SODRAC (2011)
© Estate of Óscar Dominguez/
SODRAC (2011)
© Estate of Wifredo Lam/
SODRAC (2011)
© Estate of Jacqueline Lamba/
SODRAC (2011)
(page 158)

BRETON, ANDRÉ, MARCEL
DUHAMEL, MAX MORISE
AND YVES TANGUY

Cadavre exquis [Exquisite
Corpse], 1928
coloured pencil on paper
27.5 × 20.0 cm
Collection of Clo and Marcel
Fleiss, Paris
© Estate of André Breton/
SODRAC (2011)
© Estate of Yves Tanguy/
SODRAC (2011)
(page 160)

BRETON, ANDRÉ,
VALENTINE HUGO
and three unknown artists

Brésil, Cadavre exquis
[Exquisite Corpse], c. 1930
coloured pencil on black paper
31.5 × 48.0 cm
Collection of Clo and Marcel
Fleiss, Paris
© Estate of André Breton/
SODRAC (2011)
© Estate of Valentine Hugo/
SODRAC (2011)
(page 158)

BRETON, ANDRÉ, SUZANNE
MUZARD, JEANNETTE
TANGUY, PIERRE UNIK,
GEORGES SADOUL AND
YVES TANGUY

Le Jeu de L'oie [The Goose
Game], 1929
ink and gouache on paper

48.0 × 54.0 cm
Private Collection, Courtesy
of Galerie 1900–2000,
Paris
© Estate of André Breton/
SODRAC (2011)
© Estate of Yves Tanguy/
SODRAC (2011)
(page 163)

BRETON, JACQUELINE,
YVES TANGUY AND
ANDRÉ BRETON

Cadavre exquis [Exquisite
Corpse], 1938
collage on paper
27.8 × 14.0 cm
Collection of Timothy
Baum, New York
© Estate of Yves Tanguy/
SODRAC (2011)
© Estate of André Breton/
SODRAC (2011)
(page 156)

BRETON, ELISA

Untitled, 1970
assemblage (embalmed bird,
spring and dice in a box)
25.7 × 34.8 × 5.2 cm
The Israel Museum,
Jerusalem, The Vera and
Arturo Schwarz Collection
of Dada and Surrealist Art in
the Israel Museum
Image © The Israel Museum,
Jerusalem
(page 195)

CAHUN, CLAUDE

Self portrait [with shaved
head], c. 1920, printed 2011
inkjet print
23.6 × 14.9 cm
Jersey Heritage Collection
(page 292)

Self portrait [as weight
trainer], 1927, printed 2011
inkjet print
12.0 × 9.0 cm
Jersey Heritage Collection
(page 296)

Self portrait [reflected image in mirror, checkered jacket], 1928, printed 2011
inkjet print
10.5 × 8.0 cm
Jersey Heritage Collection
(page 281)

Self portrait [in cupboard], c. 1932, printed 2011
inkjet print
11.0 × 9.0 cm
Jersey Heritage Collection

Untitled [Surrealists ELT Mesens, Roland Penrose, André Breton, David Gascoyne and Claude Cahun, London], 1936, printed 2011
inkjet print
9.5 × 12.1 cm
Jersey Heritage Collection
(page 38)

Heure des fleurs [The Hour of Flowers], 1936
gelatin silver print
12.7 × 17.8 cm
Ubu Gallery, New York & Galerie Berinson, Berlin
(page 181, end papers)

Rendent hélas éternels [Alas, Rendered Eternal], c. 1936
gelatin silver print mounted on brown stock
29.5 × 22.2 cm
Ubu Gallery, New York & Galerie Berinson, Berlin
(page 180)

CARRIBEAN BASIN

Objects from the Eruption of Mt. Pelée, n.d.
glass and metal
94.0 × 57.0 × 14.0 cm
Musée du Quai Branly, Paris
(X421489)

CARRINGTON, LEONORA

Untitled [from *VVV Portfolio*], 1942, published 1943
etching on paper
20.3 × 25.1 cm

Baltimore Museum of Art, Gift of Sadie A. May
(BMA 1948.54.3)

Untitled, c. 1942
pencil and gouache on paper
21.4 × 27.9 cm
Collection of Timothy Baum, New York

The House Opposite, 1945
oil on canvas
34.0 × 83.5 cm
The Edward James Trust
© Leonora Carrington/SODRAC (2011)
(pages 92–93)

Forbidden Fruit, 1969
oil on canvas
45.0 × 49.0 cm
Collection of Madame Antonin Besse

COLQUHOUN, ITHELL

The Pine Family, 1941
oil on canvas
46.0 × 54.0 cm
The Israel Museum, Jerusalem, The Vera and Arturo Schwarz Collection of Dada and Surrealist Art in the Israel Museum
© The Estate of Ithell Colquhoun, Courtesy the National Trust, Bodmin
Image © The Israel Museum, Jerusalem
(page 299)

CORNELL, JOSEPH

Untitled [bell jar with angel entrapped by spring], c. 1936
mixed media construction
5.5 × 3.5 × 3.5 cm
Collection of Timothy Baum and Karen Amiel Baum, New York
© The Joseph and Robert Cornell Memorial Foundation/SODRAC, Montreal/VAGA, New York (2011)
(page 185)

Souvenir Case (Lucile Grahn as "La Sylphide"), early 1940s
painted wooden box filled with an assortment of random objects and a photographic portrait of Lucile Grahn framed with cover
10.2 × 10.2 × 2.5 cm
Collection of Timothy Baum, New York
© The Joseph and Robert Cornell Memorial Foundation/SODRAC, Montreal/VAGA, New York (2011)
(page 187)

Untitled [ballet case with blue glass/Taglioni souvenir case], c. 1942
box construction
3.2 × 13.7 × 7.6 cm
Seattle Art Museum, Gift of Joseph and Robert Cornell Memorial Foundation

Beehive (Thimble Forest), 1943–48
box construction
8.9 × 19.1 cm
Collection of Richard L. Feigen, New York

Crystal Cage (Portrait of Berenice), c. 1943 – mid 1960s
valise construction
39.7 × 50.3 × 11.0 cm
Courtesy of Richard L. Feigen & Co., New York
© The Joseph and Robert Cornell Memorial Foundation/SODRAC, Montreal/VAGA, New York (2011)
(pages 188–189)

Grand Hotel de la Boule d'Or, early 1950s
wood, paint, newsprint and glass
48.9 × 34.92 × 9.86 cm
Dallas Museum of Art, Foundation for the Arts Collection, Gift of Mr. and Mrs. Alan M. May
© The Joseph and Robert Cornell Memorial Foundation/SODRAC, Montreal/VAGA, New York (2011)
(page 191)

Toward the Blue Peninsula (For Emily Dickinson), c. 1953
box construction
36.8 × 26.0 × 14.0 cm
The Robert Lehrman Art Trust, Collection of Aimee and Robert Lehrman, Washington, DC
© The Joseph and Robert Cornell Memorial Foundation/SODRAC, Montreal/VAGA, New York (2011)
(page 192)

Trade Winds No. 2, c. 1956–58
box construction
27.9 × 42.7 × 10.3 cm
The Robert Lehrman Art Trust, Collection of Aimee and Robert Lehrman, Washington, DC
© The Joseph and Robert Cornell Memorial Foundation/SODRAC, Montreal/VAGA, New York (2011)
(page 186)

Untitled [bird habitat, orange glass], c. 1960
box construction with light
32.1 × 23.3 × 12.7 cm
Seattle Art Museum, Gift of the Joseph and Robert Cornell Memorial Foundation
© The Joseph and Robert Cornell Memorial Foundation/SODRAC, Montreal/VAGA, New York (2011)
Photo: Paul Macapia
(page 194)

Untitled [Ship with Nude], c. 1964–66
collage on paper
29.2 × 21.6 cm
The Robert Lehrman Art Trust, Collection of Aimee and Robert Lehrman, Washington, DC
© The Joseph and Robert Cornell Memorial Foundation/SODRAC, Montreal/VAGA, New York (2011)
(page 190)

Untitled, 1940
sandbox with assorted
found objects
10.5 × 13.0 × 1.9 cm
Collection of Timothy
Baum, New York
© The Joseph and Robert
Cornell Memorial Foundation/
SODRAC, Montreal/VAGA,
New York (2011)
(page 195)

Untitled, c. 1945
painted daguerrotype with
jewel in period thermoplastic
case
8.3 × 9.3 × 1.6 cm
Collection of Timothy
Baum, New York
© The Joseph and Robert
Cornell Memorial Foundation/
SODRAC, Montreal/VAGA,
New York (2011)
(page 187)

CREVEL, RENÉ

Dalí ou l'anti-obscurantisme,
1931
first edition book (inscribed
copy)
22.0 × 16.2 cm
Collection of Timothy
Baum, New York

DALÍ, SALVADOR

Sin título [Abstract
Composition], c. 1928
oil, collage with rope on
canvas
148.0 × 198.0 cm
Museo Nacional Centro de
Arte Reina Sofía, Madrid
© Salvador Dalí, Fundació
Gala-Salvador Dalí/
SODRAC (2011)
(page 70)

La Femme visible [The
Visible Woman], 1930
first edition book with original
heliogravure by the artist
28.3 × 22.3 cm
Collection of Timothy
Baum, New York

Agnostic Symbol, 1932
oil on canvas
54.0 × 65.2 cm
Philadelphia Museum of Art,
The Louise and Walter
Arensberg Collection, 1950
© Salvador Dalí, Fundació
Gala-Salvador Dalí/
SODRAC (2011)
(page 114)

Le Revolver à cheveux blancs
[The White-haired Revolver],
1932
etching and heliogravure
on paper
25.0 × 33.0 cm
Collection of Timothy
Baum, New York

*Objet surréaliste à
fonctionnement symbolique —
le soulier de Gala*
[Surrealist object that
functions symbolically —
Gala's Shoe], 1932/1975
shoe, marble, photographs,
clay, mixed media
121.9 × 71.1 × 35.6 cm
San Francisco Museum of
Modern Art, Purchase by
exchange through a Gift of
Norah and Norman Stone
© Salvador Dalí, Fundació
Gala-Salvador Dalí/
SODRAC (2011)
(page 138)

Enfant sauterelle
[Grasshopper Child], 1933
engraving on paper
36.8 × 30.2 cm
Trustees of the British
Museum, London

*Gala and the Angelus of
Millet Immediately Preceding
the Arrival of the Conic
Anamorphoses*, 1933
oil on wood
24.2 × 19.2 cm
National Gallery of Canada,
Ottawa, Purchased 1975
© Salvador Dalí, Fundació
Gala-Salvador Dalí/
SODRAC (2011)
(page 94)

Metronome, 1944
wooden metronome with chalk
on paper eye attached to the arm
22.0 × 16.0 × 12.0 cm
Museum Boijmans Van
Beuningen, Rotterdam

DALÍ, SALVADOR AND
EDWARD JAMES

Lobster Telephone, 1938
painted plaster, telephone
17.8 × 33.0 × 17.8 cm
The Edward James Trust
© Salvador Dalí, Fundació Gala-
Salvador Dalí/SODRAC (2011)
(pages 166–167)

DE CHIRICO, GIORGIO

Le cerveau de l'enfant
[The Child's Brain], 1914
oil on canvas
80.0 × 65.0 cm
Moderna Museet, Stockholm
© Estate of Giorgio de
Chirico/SODRAC (2011)
(page 60)

The Piazza, 1914
oil on canvas
33.66 × 50.8 cm
Seattle Art Museum, Gift of
Mrs. John C. Atwood, Jr.
© Estate of Giorgio de
Chirico/SODRAC (2011)
Photo: Paul Macapia
(page 127)

Langage de l'Enfant
[The Child's Language], 1916
oil on canvas
41.3 × 27.9 cm
The Pierre and Tana Matisse
Foundation Collection,
New York
© Estate of Giorgio de
Chirico/SODRAC (2011)
Photo: Christopher Burke Studio
(page 182)

*Furies s'apprêtant à
poursuivre un assassin par un
clair après-midi d'automne*
[The Furies Pursuing a
Murderer on a Fine Autumn
Afternoon], c. 1924

ink drawing on buff paper
27.0 × 22.1 cm
Collection of Timothy
Baum, New York

Reclining Abstract Figure,
1926–27
conté crayon on paper
28.6 × 45.7 cm
Baltimore Museum of Art,
Gift of Sadie A. May
(1935.13.1)

DELVAUX, PAUL

Mujer ante el espejo [Woman
in the Mirror], 1936
oil on canvas
71.0 × 91.6 cm
Museo Thyssen-Bornemisza,
Madrid
© Estate of Paul Delvaux/
SODRAC (2011)
(page 280)

El viaducto [The Viaduct],
1963
oil on canvas
100.3 × 130.8 cm
Collection of Carmen Thyssen-
Bornemisza, on loan at
Museo Thyssen-Bornemisza
Museum, Madrid
© Estate of Paul Delvaux/
SODRAC (2011)
(page 126)

DOMINGUEZ, ÓSCAR

Souvenir de Paris [Memory
of Paris], 1932
oil on canvas
38.0 × 46.0 cm
Museo Nacional Centro de
Arte Reína Sofia, Madrid
© Estate of Óscar Dominguez/
SODRAC (2011)
(page 126)

Decalcomania: Le léon
[Decalcomania: The Lion],
c. 1935
gouache on coated black paper
20.3 × 25.0 cm
Collection of Timothy
Baum, New York

Femme aux Bicyclette
[Woman on a Bicycle],
c. 1935–36
etching embellished with
pencil drawing on paper
35.5 × 20.6 cm
Collection of Timothy
Baum, New York

Paysage cosmique [Cosmic
Landscape], 1939
oil on board, in a frame
designed by Georges Hugnet
8.6 × 5.1 cm
Collection of Timothy
Baum, New York

DOMINGUEZ, ÓSCAR
AND GEORGES HUGNET

Cadavre exquis [Exquisite
Corpse], 1937
ink on paper (a sheet of
stationery from the Café de
la Poste, Paris)
27.1 × 20.8 cm
Collection of Timothy
Baum, New York

DONATI, ENRICO

Le Roi de Mandragora [The
King of Mandragora], 1945
oil on canvas
91.4 × 76.2 cm
Collection of Adele Donati,
New York
(page 129)

Pour un autel [For an Altar],
1945
bronze
48.3 × 20.3 × 14.0 cm
Collection of Adele Donati,
New York

Shoes, 1945
oil on leather shoes
14.6 × 28.6 × 19.7 cm
Collection of Adele Donati,
New York
(page 146)

Fist, 1946
bronze and glass
40.6 × 24.1 × 28.6 cm

Collection of Rowland
Weinstein, Courtesy of
Weinstein Gallery,
San Francisco
(page 147)

Untitled, n.d.
pencil on paper
25.4 × 30.5 cm
Collection of Adele Donati,
New York

DUCHAMP, MARCEL

Boîte-en-valise [Box in a
Suitcase], 1936–68
mixed media
41.0 × 38.0 cm
Courtesy of Francis M.
Naumann Fine Art, New York
© Estate of Marcel Duchamp/
SODRAC (2011)
(pages 142–143)

ÉLUARD, PAUL

Femme Volcanique
[Volcanic Woman], 1932
collage and photomontage
on paper in nineteenth-
century frame
9.0 × 14.0 cm
Collection of Timothy
Baum, New York
(page 303)

ÉLUARD, NUSCH

Untitled, c. 1935
photo collage
13.7 × 8.7 cm
Collection of Karen Amiel
Baum, New York

ERNST, MAX

Ascenseur Somnambule I
[Sleepwalker Rising I], 1921
gouache over nineteenth-
century anatomical engraving
on paper
19.6 × 12.0 cm
Collection of Timothy
Baum, New York
© Estate of Max Ernst/
SODRAC (2011)
(page 19)

Pietà or Revolution by Night,
1923
oil on canvas
116.2 × 88.9 cm
Tate, Purchased 1981
© Estate of Max Ernst/
SODRAC (2011)
Photo: Tate, London/
Art Resource, NY
(page 59)

The Forest, 1923
oil on canvas
73.0 × 50.3 cm
Philadelphia Museum of Art,
The Louise and Walter
Arensberg Collection, 1950
© Estate of Max Ernst/
SODRAC (2011)
(page 131)

Roter Akt [Red Nude], c. 1923
oil on canvas
65.0 × 54.0 cm
Courtesy of The Mayor
Gallery, London
© Estate of Max Ernst/
SODRAC (2011)
(page 71)

Whip Lashes or Lava Threads,
c. 1925
graphite frottage on paper
26.0 × 42.4 cm
Baltimore Museum of Art,
Gift of Mme. Helena
Rubinstein (1953.91)
© Estate of Max Ernst/
SODRAC (2011)
(page 57)

Histoire Naturelle [Natural
History], 1926
three collotypes after frottage
from a portfolio of thirty-four
50.8 × 35.6 cm
The National Gallery of Art
Library, David K.E. Bruce
Fund, Washington, DC

La femme 100 têtes [The
100-headless Woman], 1929
first edition book
25.3 × 19.2 cm
Collection of Timothy
Baum, New York

Untitled, c. 1929
collage on paper
17.2 × 17.2 cm
Collection of Timothy
Baum, New York

*"...ou en bàs, cette indécente
amazone..." Rêve d'une petite
fille qui voulait entrer au Carmel*
["...or below that indecent
amazon..." A little girl dreams
of taking the veil], 1929–30
collage on paper
19.7 × 19.3 cm
Collection of Timothy
Baum, New York
© Estate of Max Ernst/
SODRAC (2011)
(page 20)

*Rêve d'une petite fille qui
voulut entre au Carmel*
[A little girl dreams of taking
the veil], 1930
first edition book
23.5 × 18.7 cm
Collection of Timothy
Baum, New York

Forest and Sun, 1931
cut-and-pasted cardboard
with oil, gouache and pencil
on paperboard
41.1 × 28.9 cm
The Museum of Modern Art,
New York, Gift of Lily
Auchincloss and the Lillie P.
Bliss Bequest (by exchange)

Lop Lop presents..., 1931
pencil drawing and frottage,
with collage on paper
65.0 × 50.0 cm
Collection of Timothy
Baum, New York

Une semaine de bonté
[A Week of Kindness], 1934
first edition book in five
separate volumes
27.9 × 22.2 cm
Collection of Timothy
Baum, New York

La Ville entière [The Whole
City], 1935
oil on paper mounted on board

23.2 × 31.0 cm
Private Collection,
Courtesy of Timothy Baum,
New York
© Estate of Max Ernst/
SODRAC (2011)
(page 134)

Chimeras in the Mountains,
1940
oil on canvas
24.1 × 19.1 cm
Baltimore Museum of Art,
Bequest of Sadie A. May,
(1951.296)
© Estate of Max Ernst/
SODRAC (2011)
(page 135)

Day and Night, 1941–42
oil on canvas
112.0 × 146.0 cm
The Menil Collection,
Houston, Purchased with
funds provided by Adelaide
de Menil Carpenter
© Estate of Max Ernst/
SODRAC (2011)
Photo: Hickey-Robertson,
Houston
(pages 132–133)

The Bird People [from *VVV
Portfolio*], 1942, published
1943
black crayon frottage
reworked with coloured
crayon on paper
45.7 × 35.6 cm
Baltimore Museum of Art,
Gift of Sadie A. May
(BMA 1948.54.4)
© Estate of Max Ernst/
SODRAC (2011)
(page 202)

The Table Is Set, 1944,
cast 1954
bronze
30.8 × 56.2 × 60.3 cm
Hirshhorn Museum and
Sculpture Garden,
Smithsonian Institution,
Washington, DC, Gift of the
Joseph H. Hirshhorn
Foundation, 1966

Hermes and Dorothea, 1947–48
collage on paper
13.1 × 7.7 cm
Collection of Timothy
Baum, New York
© Estate of Max Ernst/
SODRAC (2011)
(page 51)

**ERNST, MAX, MAX MORISE
AND ANDRÉ MASSON**

Cadavre exquis [Exquisite
Corpse], March 18, 1927
coloured pencil on paper
20.0 × 15.0 cm
Collection of David and
Marcel Fleiss, Galerie
1900–2000, Paris
© Estate of Max Ernst/
SODRAC (2011)
© Estate of André Masson/
SODRAC (2011)
(page 161)

FINI, LEONOR

*The Alcove: An Interior with
Three Women*, 1939
oil on canvas
89.5 × 69.5 cm
The Edward James Trust
© Estate of Leonor Fini/
SODRAC (2011)
(page 91)

FREDDIE, WILHELM

La prière [The Prayer], 1940
oil on canvas
82.0 × 61.0 cm
Collection of Clo and Marcel
Fleiss, Paris
© Estate of Wilhelm Freddie/
SODRAC (2011)
(page 119)

GIACOMETTI, ALBERTO

Femme cuillère [Spoon
Woman], 1926, cast 1954
bronze
143.8 × 51.4 × 21.6 cm
Solomon R. Guggenheim
Museum, New York
© Estate of Alberto
Giacometti/SODRAC (2011)
(page 305)

Woman, 1928, cast 1929
bronze
40.9 × 37.8 × 8.7 cm
Hirshhorn Museum and
Sculpture Garden,
Smithsonian Institution,
Washington, DC, Gift of the
Joseph H. Hirshhorn
Foundation, 1972
© Estate of Alberto
Giacometti/SODRAC (2011)
Photo: Lee Stalsworth
(page 307)

Man, 1929, cast c. 1950–56
bronze
39.4 × 31.7 × 9.7 cm
Hirshhorn Museum and
Sculpture Garden,
Smithsonian Institution,
Washington, DC, Gift of the
Joseph H. Hirshhorn
Foundation, 1966
© Estate of Alberto
Giacometti/SODRAC (2011)
Photo: Lee Stalsworth
(page 306)

Three Figures Outdoors, 1929
bronze
51.5 × 38.5 × 9.0 cm
Art Gallery of Ontario,
Purchased 1984
© Estate of Alberto
Giacometti/SODRAC (2011)
(page 309)

La table surréaliste [The
Surrealist Table], 1933
ink on paper
22.2 × 18.4 cm
Collection of Michael and
Judy Steinhardt, New York
© Estate of Alberto
Giacometti/SODRAC (2011)
(page 34)

GOERG, ÉDOUARD

Les Oiseaux chassés du ciel
[The Birds Hunted from the
Sky], 1938
etching on paper
29.6 × 44.8 cm
Trustees of the British
Museum, London

HAIDA

Panel Pipe, 1830–65
argillite
10.1 × 33.0 × 2.0 cm
Private Collection, London,
UK, Courtesy Donald Ellis
Gallery, Dundas, ON and
New York, NY
Formerly André Breton
Collection
(page 216)

Spoon, before 1903
mountain sheep horn,
abalone shell and metal
19.7 × 3.9 × 4.1 cm
The Museum of Anthropology,
The University of British
Columbia, Vancouver,
Barnabus Cortland and Ida
Freeman Collection

Spoon, n.d.
mountain goat horn and
abalone shell
5.6 × 18.5 × 4.9 cm
The Museum of Anthropology,
The University of British
Columbia, Vancouver

Wood Feast Bowl, 19th century
wood
20.3 × 59.0 × 35.0 cm
Private Collection, Vancouver,
Courtesy Donald Ellis
Gallery, Dundas, ON and
New York, NY
Formerly Enrico Donati
Collection
Photo: Trevor Mills,
Vancouver Art Gallery
(page 270)

HARE, DAVID (Editor)

Cover for *VVV Portfolio*,
1942, published 1943
letterpress and relief print
on paper
46.0 × 35.8 cm
Baltimore Museum of Art,
The Cone Collection, formed
by Dr. Claribel Cone and
Miss Etta Cone of Baltimore,
Maryland (1950.12.758.1-11)

HEILTSUK

Mask, n.d.
abalone shell, wood, paint
and adhesive
22.5 × 19.0 × 16.0 cm
The Museum of Anthropology,
The University of British
Columbia, Vancouver,
The Walter and Marianne
Koerner Collection of First
Nations Art

HENRY, MAURICE

Silence, Hospital!, c. 1950
telephone and cloth bandage
13.0 × 20.0 × 17.0 cm
The Israel Museum,
Jerusalem, The Vera and
Arturo Schwarz Collection
of Dada and Surrealist Art
in the Israel Museum
© Henry Maurice/SODRAC
(2011)
Image © The Israel Museum,
Jerusalem
(page 151)

HUGNET, GEORGES

Untitled, 1947
gelatin silver print
16.4 × 12.3 cm
National Gallery of Canada,
Ottawa, Purchased 1996

La Ribulute Vertébrée from
the series *La vie amoureuse
des Spumifères* [The Vertebrate
Ribalet from the series *The
Love Life of the Foamifers*],
c. 1948
gouache on vintage postcard
14.3 × 8.6 cm
Ubu Gallery, New York &
Galerie Berinson, Berlin
© Estate of Georges Hugnet/
SODRAC (2011)
(page 298)

La Mailloche Dorée from the
series *La vie amoureuse des
Spumifères* [The Golden
Meshlican from the series
The Love Life of the Foamifers],
c. 1948

gouache on vintage postcard
8.6 × 14.3 cm
Ubu Gallery, New York &
Galerie Berinson, Berlin
© Estate of Georges Hugnet/
SODRAC (2011)
(page 298)

HUGO, VALENTINE

*1ᵉʳ projet pour un portrait
d'André Breton* [1st project for
a portrait of André Breton],
1934
pencil and watercolour on
paper
40.3 × 32.6 cm
Collection of André Baum,
New York

JEAN, MARCEL

The Spectre of the Gardenia,
1936/1968
plaster covered in felt,
zipper, film
27.0 × 18.0 × 22.0 cm
The Israel Museum,
Jerusalem, The Vera and
Arturo Schwarz Collection
of Dada and Surrealist Art
in the Israel Museum
© Marcel Jean/SODRAC (2011)
Image © The Israel Museum,
Jerusalem
(page 141)

Decalcomania, c. 1946
gouache on paper
32.7 × 24.8 cm
Collection of Timothy
Baum, New York

KERTÉSZ, ANDRÉ

Wooden Horses, Paris, 1929
gelatin silver print
24.2 × 17.5 cm
Collection of Harry and
Ann Malcolmson

Distortion Study No. 16, 1933
silver print
23.4 × 16.5 cm
Wilson Centre for
Photography, London

KWAKWAKA'WAKW

K̲wak'wanigamł [Heron
headdress], c. 1890
red cedar, nails and paint
66.0 × 34.3 × 43.2 cm
Seattle Art Museum, Gift of
John H. Hauberg (91.1.31)
Photo: Paul Macapia
(page 253)

Yaxwiwe' [Peace Dance
headdress], c. 1922
maple, abalone, paint, cloth,
ermine fur, sea lion whiskers
22.0 × 19.5 × 9.0 cm
U'Mista Cultural Society
Photo: Trevor Mills,
Vancouver Art Gallery
Formerly André Breton
Collection
(page 264)

Feast Dish, n.d.
paint, cedar wood and metal
30.0 × 66.2 × 37.5 cm
The Museum of Anthropology,
The University of British
Columbia, Vancouver
Photo: Trevor Mills,
Vancouver Art Gallery
(pages 254–255)

Feast Dish, n.d.
paint, cedar wood and metal
35.0 × 70.0 × 43.0 cm
The Museum of Anthropology,
The University of British
Columbia, Vancouver

Yak̲an'takw (Speaking-
through post), c. 1890
painted wood and cedar
230.0 × 60.0 × 50.0 cm
The Museum of Anthropology,
The University of British
Columbia, Vancouver
(page 263)

LAM, WIFREDO

Deity, 1942
opaque watercolour and
charcoal on paper
104.8 × 84.5 cm
Baltimore Museum of Art,
Bequest of Sadie A. May
(1951.318)

© Estate of Wifredo Lam/
SODRAC (2011)
Photo: Mitro Hoo
(page 198)

Untitled, 1942–44
gouache on paper [recto verso]
108.0 × 74.0 cm
Private Collection, Courtesy
of Mary-Anne Martin Fine
Art, New York
© Estate of Wifredo Lam/
SODRAC (2011)
(pages 206, 207)

Seated Woman, 1955
oil and charcoal on canvas
130.8 × 97.7 × 9.3 cm
Hirshhorn Museum and
Sculpture Garden,
Smithsonian Institution,
Washington, DC, Gift of
Mrs. Bernard Gimbel, 1978

LEBEL, ROBERT

Sketchbook of Yup'ik masks,
1942–46
notebook, 58 pages
20.5 × 13.0 × 1.3 cm
Musée du Quai Branly, Paris
(PA000305)
Photo: Musée du Quai Branly/
SCALA/Art Resource, NY
(pages 238–239)

**LEFÉBURE, NADINE,
J.F. CHABRUN, LAURENCE
ICHÉ, ROBERT RIUS AND
MANUEL VIOLA**

La plante, Dessin communiqué
[The Plant, Collective
drawing], c. 1941–42
pencil on paper
22.0 × 26.5 cm
Collection of David and
Marcel Fleiss, Galerie
1900–2000, Paris

LOTAR, ELI

Aux abbatoirs de La Villette
[Slaughterhouses at La
Villette], 1929
gelatin silver print
22.2 × 16.2 cm

The Metropolitan Museum
of Art, Gilman Collection,
Purchase, Denise and
Andrew Saul Gift, 2005
(2005.100.303)
Image © The Metropolitan
Museum of Art/Art
Resource, NY
(page 48)

Untitled, c. 1931
gelatin silver print
21.9 × 16.3 cm
The Art Institute of Chicago,
Julien Levy Collection,
Gift of Jean Levy and the
Estate of Julien Levy

MAAR, DORA

*Three Statues Clothed with
Covers*, c. 1930s
gelatin silver print
39.8 × 29.6 cm
Baltimore Museum of Art,
Purchase with exchange funds
from the Edward Joseph
Gallagher III Memorial
Collection, and partial gift
of George H. Dalsheimer,
Baltimore (1999.111)

Père Ubu, 1936
gelatin silver print
39.7 × 29.2 cm
The Metropolitan Museum
of Art, Gilman Collection,
Purchase, Gift of Ford Motor
Company and John C.
Waddell, by exchange, 2005
(2005.100.443)
© Estate of Dora Maar/
SODRAC (2011)
Image © The Metropolitan
Museum of Art/Art
Resource, NY
(page 179)

MAGRITTE, RENÉ

The Six Elements, 1929
oil on canvas
73.0 × 99.8 cm
Philadelphia Museum of Art,
The Louise and Walter
Arensberg Collection, 1950

© Estate of René Magritte/
SODRAC (2011)
(page 314)

L'ombre et son ombre [The
Shadow and its Shadow], 1932
gelatin silver print
7.8 × 8.0 cm
The Israel Museum,
Jerusalem, Gift of Mr. Eduard
and Mrs. Joyce Straus to
American Friends of the
Israel Museum

La Géante [The Giantess], 1936
graphite on paper
28.9 × 23.9 cm
Trustees of the British
Museum, London, Purchased
with the aid of the Art Fund
and British Museum Friends

*Self-Portrait with "The
Barbarian,"* 1938
gelatin silver print
18.8 × 25.0 cm
Baltimore Museum of Art,
Purchase with exchange funds
from the Edward Joseph
Gallagher III Memorial
Collection, and partial gift
of George H. Dalsheimer,
Baltimore (1988.550)

The Human Condition, 1945
watercolour, crayon over
graphite, ink and gouache
on paper
42.2 × 32.2 cm
The Cleveland Museum of
Art, Bequest of Lockwood
Thompson, 1992.274
© Estate of René Magritte/
SODRAC (2011)
(page 311)

L'Anniversaire [The Birthday],
1959
oil on canvas
89.1 × 116.2 cm
Art Gallery of Ontario,
Toronto, Purchase,
Corporations' Subscription
Endowment, 1971
© Estate of René Magritte/
SODRAC (2011)
(page 313, front end papers)

MAGRITTE, RENÉ AND
PAUL NOUGÉ

Cadavre exquis [Exquisite
Corpse], 1929
pencil on paper
9.0 × 21.0 cm
Collection of David and
Marcel Fleiss, Galerie
1900–2000, Paris
© Estate of René Magritte/
SODRAC (2011)
© Estate of Paul Nougé/
SODRAC (2011)
(page 161)

MALLO, MARUJA

Tierra y excrementos
[Earth and Excrement], 1932
oil on cardboard
43.0 × 55.0 cm
Museo Nacional Centro de
Arte Reina Sofia, Madrid
© Estate of Maruja Mallo/
SODRAC (2011)
(page 111)

MAN RAY

*Joseph Stella and Marcel
Duchamp*, 1920
gelatin silver print
20.5 × 15.6 cm
The J. Paul Getty Museum,
Los Angeles

Hand in Hair, c. 1920s
gelatin silver print
22.8 × 17.1 cm
Collection of Harry and
Ann Malcolmson

Untitled Rayograph [Kiki
and Filmstrips], 1922
gelatin silver, rayograph
print
23.8 × 17.8 cm
The J. Paul Getty Museum,
Los Angeles
© Man Ray Trust/SODRAC
(2011)
(page 56)

Untitled Rayograph, 1922
gelatin silver print
21.7 × 17.0 cm

The J. Paul Getty Museum,
Los Angeles

Indestructible Object, 1923,
remade 1933, editioned
replica 1965
metronome with photograph
(by Man Ray) of an eye affixed
thereupon
22.5 × 11.2 × 11.5 cm
Collection of Timothy
Baum, New York
© Man Ray Trust/SODRAC
(2011)
(page 150)

Untitled [Peony and Glove],
1924
gelatin silver print
27.9 × 21.0 cm
Philadelphia Museum of Art,
The Lynne and Harold
Honickman Gift of the Julien
Levy Collection, 2001

Swedish Landscape, c. 1924–25
oil on canvas
45.6 × 65.0 cm
Courtesy of The Mayor
Gallery, London

Barbette Making up, 1926
gelatin silver print
22.1 × 16.2 cm
The J. Paul Getty Museum,
Los Angeles

Untitled Rayograph [Scissors
and cut paper], 1927
gelatin silver, rayograph print
25.2 × 30.0 cm
The J. Paul Getty Museum,
Los Angeles
© Man Ray Trust/SODRAC
(2011)
(page 29)

Untitled [Frames from *Emak-
Bakia* [Leave me alone]], 1927
gelatin silver print
17.4 × 15.0 cm
The Metropolitan Museum
of Art, Ford Motor Company
Collection, Gift of Ford
Motor Company and John C.
Waddell, 1987 (1987.110.161)

André Breton, c. 1930
gelatin silver print
23.18 × 18.1 cm
San Francisco Museum of
Modern Art, Sale of Paintings
Fund purchase
© Man Ray Trust/SODRAC
(2011)
(page 22)

Tanja Ramm, c. 1930s
gelatin silver print
29.2 × 22.7 cm
Collection of Harry and
Ann Malcolmson
© Man Ray Trust/SODRAC
(2011)
(page 304)

Electricité, 1931
photogravure
61.0 × 50.8 cm
Victoria and Albert Museum,
London, Purchased with
the generous support of the
Friends of the V&A and the
National Art Collections
Fund
© Man Ray Trust/SODRAC
(2011)
Photo: V&A Images, London/
Art Resource, NY
(page 278)

*Solarized portrait of Méret
Oppenheim*, 1933
gelatin silver print
57.5 × 42.3 cm
Victoria and Albert Museum,
London

Érotique Voilée
[Veiled Erotic], 1933,
printed 1935
gelatin silver print
29.0 × 22.7 cm
Collection of Karen Amiel
Baum, New York
© Man Ray Trust/SODRAC
(2011)
(page 308)

Untitled [Elsa Schiaparelli],
c. 1933
gelatin silver print
23.97 × 18.26 cm

San Francisco Museum of
Modern Art, The Helen
Crocker Russell and William
H. and Ethel W. Crocker
Family Funds Purchase

Main Ray, 1935
assemblage
23.0 × 10.0 cm
The Israel Museum,
Jerusalem, The Vera and
Arturo Schwarz Collection
of Dada and Surrealist Art in
the Israel Museum
© Man Ray Trust/SODRAC
(2011)
Image © The Israel Museum,
Jerusalem
(page 183)

Portrait of André Breton,
1936
India ink on paper
35.8 × 25.8 cm
Collection of André Baum,
New York

*Bubble emerging from Clay
Pipe and Frosted Leaf*, 1937
gelatin silver print,
photogram
40.0 × 29.7 cm
The Cleveland Museum of
Art, John L. Severance Fund,
1984.23

*Self-portrait in Antibes
studio*, 1938
gelatin silver print
13.3 × 8.7 cm
Collection of Timothy
Baum, New York
© Man Ray Trust/SODRAC
(2011)
(page 149)

Studio Door, 1939
oil on canvas
65.0 × 49.7 cm
Scottish National Gallery
of Modern Art, Edinburgh,
Bequeathed by Gabrielle
Keiller, 1995
© Man Ray Trust/SODRAC
(2011)
(page 127)

Object of my Affection, 1944
found readymade object
fashioned of metal and wood
components
14.4 × 6.8 × 3.5 cm
Collection of Timothy
Baum, New York
© Man Ray Trust/SODRAC
(2011)
(page 148)

Les Grandes Vacances [The
Long Holidays], 1947
bottle rack, readymade with
three articulated wooden
lay figures
98.0 × 51.0 cm
Courtesy of The Mayor
Gallery, London
© Man Ray Trust/SODRAC
(2011)
(page 149)

Puericulture II, 1964
painted bronze
29.2 × 10.0 × 10.0 cm
Collection of Timothy
Baum, New York
© Man Ray Trust/SODRAC
(2011)
(page 137)

*Blue Bread — Favourite food
for the Blue Birds*, 1966
painted plastic on plexiglas
71.0 × 27.0 cm
Courtesy of The Mayor
Gallery, London
© Man Ray Trust/SODRAC
(2011)
(pages 148–149)

MARTINIE, HENRI

*Portrait of Paul and Nusch
Éluard*, early 1930s
gelatin silver print
21.6 × 14.9 cm
Collection of Timothy
Baum, New York

MASSON, ANDRÉ

Furious Suns, 1925
ink on paper
42.2 × 31.8 cm

The Museum of Modern Art,
New York, Purchase, 1935
© Estate of André Masson/
SODRAC (2011)
Image © The Museum of
Modern Art/Licensed by
SCALA/Art Resource, NY
(page 54)

Délire végétal [Vegetable
Delirium], c. 1925
India ink on paper
42.5 × 30.5 cm
Private Collection, Paris
© Estate of André Masson/
SODRAC (2011)
(page 26)

La Goutte de Sang [Drop
of Blood], 1927
oil on canvas
27.0 × 35.0 cm
Private Collection, Paris

Paysage au serpent
[Landscape with Snake], 1927
oil and charcoal on canvas
65.0 × 46.0 cm
Courtesy of The Mayor
Gallery, London
© Estate of André Masson/
SODRAC (2011)
(page 88)

Massacres, 1933–34
ink on paper
26.0 × 28.0 cm
Private Collection, Paris

Paysage aux prodiges [The
Landscape of Wonders], 1935
oil on canvas
76.5 × 65.4 cm
Solomon R. Guggenheim
Museum, New York, Bequest,
Richard S. Zeisler, 2007
© Estate of André Masson/
SODRAC (2011)
(page 82)

Ophelia, 1937
oil on canvas
113.7 × 146.7 cm
Baltimore Museum of Art,
Bequest of Sadie A. May
(1951.328)

© Estate of André Masson/
SODRAC (2011)
(pages 84–85)

The Metaphysical Wall, 1940
pen and black ink and
watercolour on paper
47.0 × 60.3 cm
Baltimore Museum of Art,
Bequest of Sadie A. May
(1951.331)

The Donkey and the Flower,
1941
pen and black ink on paper
64.1 × 49.1 cm
Baltimore Museum of Art,
The Cone Collection, formed
by Dr. Claribel Cone and
Miss Etta Cone of Baltimore,
MD (1938.819)

Meditation on an Oak Leaf,
1942
tempera, pastel and sand
on canvas
101.6 × 83.8 cm
The Museum of Modern Art,
New York, Given
anonymously, 1950
© Estate of André Masson/
SODRAC (2011)
Image © The Museum of
Modern Art/Licensed by
SCALA/Art Resource, NY
(page 87)

Fruits of the Abyss
[from *VVV Portfolio*], 1942,
published 1943
etching and softground
etching on paper
30.2 × 20.2 cm
Baltimore Museum of Art,
Gift of Sadie A. May
(1948.54.7)

MATTA, ROBERTO

Forms in a Landscape, 1937
crayon and graphite on
paper
48.9 × 64.9 cm
Baltimore Museum of Art,
Gift of Sadie A. May
(1938.819)

Star Travel (Space Travel),
1938
graphite, coloured pencil
on paper
49.8 × 64.6 cm
The Gordon Onslow Ford
Collection, Courtesy of Lucid
Art Foundation, Inverness, CA
© Roberto Matta Estate/
SODRAC (2011)
(page 115)

Listen to Living, 1941
oil on canvas
74.9 × 94.9 cm
The Museum of Modern Art,
New York, Inter-American
Fund, 1942
© Roberto Matta Estate/
SODRAC (2011)
Image © The Museum of
Modern Art/Licensed by
SCALA/Art Resource, NY
(page 122)

From *Birth of the Twins*
series, 1943
pencil and coloured crayons
on paper
24.0 × 11.7 cm
Collection of Timothy
Baum, New York

Black Mirror, 1947
oil on canvas
86.4 × 76.2 cm
Collection of Rowland
Weinstein, Courtesy of
Weinstein Gallery,
San Francisco

MILLER, LEE

Untitled, 1930
gelatin silver print
19.5 × 17.0 cm
The Art Institute of Chicago,
Julien Levy Collection, Gift
of Jean Levy and the Estate
of Julien Levy

Exploding Hand, 1930
gelatin silver print
23.8 × 29.8 cm
Victoria and Albert Museum,
London

© Lee Miller Archives, England
2011. All rights reserved.
www.leemiller.co.uk
(page 115)

Untitled, 1931
gelatin silver print
21.1 × 22.4 cm
The Art Institute of Chicago,
Julien Levy Collection, Gift
of Jean and Julien Levy

*Portrait of Space, near Siwa,
Egypt*, 1937, printed 2011
digital inkjet print from the
original work
13.3 × 12.4 cm
Lee Miller Archives, Sussex, UK
© Lee Miller Archives, England
2011. All rights reserved.
www.leemiller.co.uk
(page 109)

*From the top of the Great
Pyramid, Giza*, 1938, printed
2011
digital inkjet print from the
original work
5.8 × 5.3 cm
Lee Miller Archives, Sussex, UK

MIRÓ, JOAN

*Photo: Ceci est la couleur de
mes rêves* [Photo: This is the
Colour of My Dreams], 1925
oil on canvas
96.5 × 129.5 cm
The Metropolitan Museum
of Art, The Pierre and
Maria-Gaetana Matisse
Collection, 2002
© Successió Miró/SODRAC
(2011)
Image © The Metropolitan
Museum of Art/Art
Resource, NY
(pages 72–73, cover)

Personnage [Person], 1925,
summer
oil and egg tempera on canvas
130.0 × 96.2 cm
Solomon R. Guggenheim
Museum, New York, Estate of
Karl Nierendorf, By purchase

© Successió Miró/SODRAC
(2011)
(page 67)

Le fou du roi [The King's
Jester], 1926
oil, pencil and charcoal
on canvas
114.0 × 146.0 cm
Milwaukee Art Museum,
Gift of Mr. and Mrs. Maurice
W. Berger (M1966.142)

Untitled, 1933
pencil and collage on paper
63.0 × 47.0 cm
Collection of Timothy Baum
and Karen Amiel Baum,
New York
© Successió Miró/SODRAC
(2011)
(page 315)

Metamorphose G
[Metamorphosis G], 1936
aquarelle and collage on
paper
48.01 × 64.01 cm
The Pierre and Tana Matisse
Foundation Collection,
New York
© Successió Miró/SODRAC
(2011)
Photo: Christopher Burke
Studio
(page 316)

*Deux personnages et une
libellule* [Two Figures and a
Dragonfly], February 1936
gouache, watercolour and
graphite on paper
42.7 × 33.8 cm
Solomon R. Guggenheim
Museum, New York, Bequest,
Richard S. Zeisler, 2007

Shooting Star, 1938
oil on canvas
65.2 × 54.4 cm
National Gallery of Art,
Washington, DC, Gift of
Joseph H. Hazen (1970.36.1)
© Successió Miró/SODRAC
(2011)
(page 81)

Personnage de la nuit
[Person of the Night], 1944
oil on canvas
17.0 × 23.5 cm
The Pierre and Tana Matisse
Foundation Collection,
New York
© Successió Miró/SODRAC
(2011)
Photo: Christopher Burke
Studio
(page 80)

MOLINIER, PIERRE

Untitled (manipulated self-portrait), c. 1966–68
gelatin silver print
(photomontage)
7.9 × 12.1 cm
Ubu Gallery, New York &
Galerie Berinson, Berlin
© Estate of Pierre Molinier/
SODRAC (2011)
(page 297)

Untitled (self-portrait),
c. 1966–68
gelatin silver print
9.5 × 12.4 cm
Ubu Gallery, New York &
Galerie Berinson, Berlin
© Estate of Pierre Molinier/
SODRAC (2011)
(page 297)

NADJA

Fleur d'amour [Love Flower],
c. 1927–28
pencil on paper
20.7 × 15.0 cm
Collection of Timothy
Baum, New York

NASH, PAUL

Harbour and Room, 1932–36
oil on canvas
91.4 × 71.1 cm
Tate, Purchased, 1981

NAVILLE, PIERRE

Poisson surréaliste
[Surrealist Fish], 1924
pencil and India ink on paper

19.7 × 13.7 cm
Collection of Timothy
Baum, New York

NOUGÉ, PAUL

from *La subversion des images*
[The Subversion of Images],
1929–30, printed by Marc
Trivier, 1995:
Cils coupés [Cut Eyelashes],
Femme dans l'escalier
[Woman on the Stairs],
La bras révélateur
[The Revelatory Arm],
La jongleuse
[The Female Juggler],
La naissance de l'objet
[The Birth of the Object],
Oiseaux vous poursuivent
[Birds Pursue You]
six gelatin silver prints
each 24.0 × 30.0 cm
Courtesy of M. Trivier and
Archives & Musée de la
Littérature, Brussels
© Estate of Paul Nougé/
SODRAC (2011)
(pages 112–113, titlepage)

NUXALK

Mask, c. 1860–80
wood, metal, mirror, cord, red,
black and blue/green pigment
25.0 × 72.4 × 23.5 cm
Collection of Michael Audain
and Yoshiko Karasawa,
Vancouver
Photo: Trevor Mills,
Vancouver Art Gallery
(page 219)

ONSLOW FORD, GORDON

Man on a Green Island, 1939
oil on canvas
72.7 × 91.4 cm
The Gordon Onslow Ford
Collection, Courtesy of Lucid
Art Foundation, Inverness, CA

Propaganda for Love, 1940
oil on canvas
104.8 × 168.9 cm
The Gordon Onslow Ford
Collection, Courtesy of Lucid

Art Foundation, Inverness, CA
(pages 120–121)

PAALEN, WOLFGANG

Pays Interdit [No Entry, or
Forbidden Country], 1936–37
oil on canvas
115.0 × 83.0 × 5.0 cm
Private Collection, Germany
© Succession Wolfgang
Paalen, Paalen Archiv, Berlin
(page 234)

Voyage Totemique [Totemic
Journey], 1937
oil on canvas
45.7 × 36.8 cm
The Gordon Onslow Ford
Collection, Courtesy of Lucid
Art Foundation, Inverness, CA

Taches Solaires [Sun Spots], 1938
oil and fumage on canvas
129.5 × 99.0 cm
Courtesy of Frey Norris
Contemporary & Modern,
San Francisco
© Succession Wolfgang
Paalen, Paalen Archiv, Berlin
(page 228)

PALENCIA, BENJAMÍN

Composición [Composition],
1933
mixed media on linen
72.5 × 98.5 cm
Museo Nacional Centro de
Arte Reina Sofia, Madrid

PARRY, ROGER

Untitled, c. 1930
gelatin silver print
22.9 × 16.7 cm
The Art Institute of Chicago,
Julien Levy Collection, Gift
of Jean Levy and the Estate
of Julien Levy

PENROSE, ROLAND,
EILEEN AGAR AND
JOHN BANTING

Cadavre exquis [Exquisite
Corpse], c. 1945

pencil on paper
8.5 × 22.8 cm
Collection of David and
Marcel Fleiss, Galerie
1900–2000, Paris

PÉRET, BENJAMIN

*Anthologie des mythes,
légendes et contes populaires
d'Amérique* [Anthology of
Myths, Legends and Popular
Tales from the Americas],
1960
first edition book
20.2 × 13.7 × 3.3 cm
University of Victoria
Libraries

PÉRET, BENJAMIN,
ANDRÉ BRETON AND
NICOLAS CALAS

Dessin communiqué
[Transmitted Drawing],
c. 1937–39
ink on paper
24.5 × 21.0 cm
Collection of David and
Marcel Fleiss, Galerie
1900–2000, Paris
© Estate of André
Breton/SODRAC (2011)
(page 162)

PICASSO, PABLO

Figures surréalistes II
[Surrealist Figures II],
1933
etching on paper
19.4 × 26.7 cm
Private Collection,
Courtesy of Timothy Baum,
New York
© Picasso Estate/SODRAC
(2011)
(page 28)

Baboon and Young,
October 1951, cast 1955
bronze
53.3 × 33.3 × 52.7 cm
The Museum of Modern Art,
New York, Mrs. Simon
Guggenheim Fund, 1956

RIMMINGTON, EDITH

The Oneiroscopist, 1947
oil on canvas
51.0 × 41.0 cm
The Israel Museum,
Jerusalem, The Vera and
Arturo Schwarz Collection
of Dada and Surrealist Art
in the Israel Museum
Image © The Israel Museum,
Jerusalem
(page 128)

**RIUS, ROBERT,
BENJAMIN PÉRET AND
ANDRÉ BRETON**

Dessin communiqué
[Transmitted Drawing],
c. 1937–39
ink on paper
34.5 × 13.0 cm
Collection of David and
Marcel Fleiss, Galerie
1900–2000, Paris

RIVERA, DIEGO

Les vases communicants
[Communicating Vessels], 1938
gouache on paper fixed
to canvas
93.0 × 121.0 cm
Centre Pompidou, Paris,
National Museum of Modern
Art/Centre for Industrial
Creation, Purchased 2003
Photo: Jean-Claude Planchet,
CNAC/MNAM/Dist. Réunion
des Musées Nationaux/Art
Resource, NY
(pages 46–47)

ROY, PIERRE

A Naturalist's Study, 1928
oil on canvas
92.1 × 65.4 cm
Tate, Bequeathed by Boris
Anrep, 1969

SAGE, KAY

The Upper Side of the Sky,
1944

oil on canvas
58.4 × 71.4 cm
The Israel Museum,
Jerusalem, The Vera and
Arturo Schwarz Collection
of Dada and Surrealist Art
in the Israel Museum
Image © The Israel Museum,
Jerusalem
(page 125, frontispiece)

Study for I Saw Three Cities,
1944
pencil on paper
35.2 × 22.8 cm
Collection of Timothy
Baum, New York

SÁNCHEZ, ALBERTO

Mascarilla de la mula [Mule
Mask], 1926–30
graphite and coloured pencil
on paper
20.8 × 13.3 cm
Museo Nacional Centro de
Arte Reina Sofía
© Alberto Sánchez/SODRAC
(2011)
(page 205)

SELIGMANN, KURT

Mat totem de Gitenmaks Hill
[Totem Pole of Gitanmaax
Hill], n.d.
gelatin silver print
16.8 × 11.8 cm
Musée du Quai Branly, Paris
(PP0003112)
© 2011 Orange County
Citizens Foundation/
SODRAC
Photo: Musée du Quai Branly/
SCALA/Art Resource, NY
(page 226)

*Mat totem de Gitemraldo à
Gitenmaks Hill* [Totem Pole
of Gitemraldo at Gitanmaax
Hill], n.d.
gelatin silver print
16.7 × 11.0 cm
Musée du Quai Branly, Paris
(PP0003114)

*Mat totem de Gitemraldo à
Gitenmaks Hill* [Totem Pole
of Gitemraldo at Gitanmaax
Hill], n.d.
gelatin silver print
16.8 × 11.0 cm
Musée du Quai Branly, Paris
(PP0003115)

*Mat totem de Gitemraldo à
Gitenmaks Hill* [Totem Pole
of Gitemraldo at Gitanmaax
Hill], n.d.
gelatin silver print
17.0 × 11.2 cm
Musée du Quai Branly, Paris
(PP0003113)

*Deux des quatres totems de
Gitenmaks Hill* [Two of Four
Totems of Gitanmaax Hill],
n.d.
gelatin silver print
16.8 × 11.3 cm
Musée du Quai Branly, Paris
(PP0003106)

Mat totem tombé [Fallen
Totem Pole], 1932
gelatin silver print
17.0 × 11.3 cm
Musée du Quai Branly, Paris
(PP0003117)
© 2011 Orange County
Citizens Foundation/SODRAC
Photo: Musée du Quai Branly/
SCALA/Art Resource, NY
(page 227)

La rencontre des éléments [The
Meeting of the Elements], 1939
oil on glass
71.0 × 87.0 cm
Courtesy of The Mayor
Gallery, London

*Melusine and the Great
Transparents*, 1943
oil on canvas
74.5 × 61.0 cm
The Art Institute of Chicago,
Mary and Earle Ludgin
Collection
© 2011 Orange County
Citizens Foundation/SODRAC
(page 123)

Alaska, 1944
oil on board
76.0 × 66.0 cm
Courtesy of The Mayor
Gallery, London
© 2011 Orange County
Citizens Foundation/SODRAC
(page 227)

Prometheus, 1946
oil on canvas
89.5 × 123.0 cm
The Israel Museum,
Jerusalem, The Vera and
Arturo Schwarz Collection
of Dada and Surrealist Art
in the Israel Museum

The Four Temperaments,
1946
oil on canvas
43.2 × 99.7 cm
Courtesy of The Mayor
Gallery, London

ŠTYRSKÝ, JINDŘICH

Vilém Tell [William Tell;
maquette for *Eroticka revue*],
1931
collage of gelatin silver print
and halftone cut-outs affixed
to buff stock
28.6 × 39.7 cm
Ubu Gallery, New York &
Galerie Berinson, Berlin
(page 301)

Untitled [maquette #1 for
*Emilie Comes to Me in a
Dream*], 1933
collage of gelatin silver print
and halftone cut-outs affixed
to original mount
24.4 × 18.7 cm
Ubu Gallery, New York &
Galerie Berinson, Berlin
(page 301)

Le cabinet ambulant
[Stehovaci Kabinet] [The
Mobile Cabinet], 1934
collage on paper
42.5 × 33.0 cm
Collection of Clo and Marcel
Fleiss, Paris

Untitled [Crystal Ball with Doll], 1934, printed 1941
gelatin silver print
9.5 × 8.9 cm
San Francisco Museum of Modern Art, Accessions Committee Fund purchase
(page 178)

TANGUY, YVES

Untitled, 1926
ink on paper
43.0 × 26.0 cm
Courtesy of Virginia Lust Gallery, New York
© Estate of Yves Tanguy/ SODRAC (2011)
(page 25)

Automatic Drawing, 1926
India ink on paper
46.2 × 29.2 cm
Collection of Timothy Baum, New York

Death Watching his Family, 1927
oil on canvas
100.0 × 73.0 cm
Museo Thyssen-Bornemisza, Madrid
© Estate of Yves Tanguy/ SODRAC (2011)
(page 79)

Automatic Drawing, 1927
India ink on paper
29.4 × 20.0 cm
Collection of Timothy Baum, New York
© Estate of Yves Tanguy/ SODRAC (2011)
(page 55)

Dormir, dormir dans les pierres [To Sleep, to Sleep among the Stones], 1927
first edition book with hand-coloured cover and illustrations
22.5 × 17.5 cm
Collection of Timothy Baum, New York

Second Message III, 1930
oil on canvas
64.0 × 73.0 cm
Collection of Rowland Weinstein, Courtesy of Weinstein Gallery, San Francisco
© Estate of Yves Tanguy/ SODRAC (2011)
Photo: Nick Pishvanov
(pages 116–117)

The Doubter, 1937
oil on canvas
60.0 × 80.5 cm
Hirshhorn Museum and Sculpture Garden, Smithsonian Institution, Washington, DC, Gift of Joseph H. Hirshhorn, 1972
© Estate of Yves Tanguy/ SODRAC (2011)
Photo: Lee Stalsworth
(page 118)

Untitled, 1938
oil on canvas
7.0 × 22.9 cm
The Gordon Onslow Ford Collection, Courtesy of Lucid Art Foundation, Inverness, CA

Plein ciel [Full Sky], 1947
etching and aquatint
17.5 × 12.6 cm
Trustees of the British Museum, London

TANGUY, YVES, ANDRÉ BRETON AND JACQUELINE LAMBA (BRETON)

Cadavre exquis, 9 février 1938 [Exquisite Corpse], 1938
collage of engravings and magazine illustrations on paper
31.0 × 42.3 cm
Centre Pompidou, Paris, National Museum of Modern Art/Centre for Industrial Creation, Purchased 1986
© Estate of Yves Tanguy/ SODRAC (2011)

© Estate of André Breton/ SODRAC (2011)
© Estate of Jacqueline Lamba/SODRAC (2011)
Photo: Georges Meguerditchian, CNAC/MNAM/Dist. Réunion des Musées Nationaux/Art Resource, NY
(page 157)

TANGUY, YVES, ANDRÉ MASSON and three unknown artists

Cadavre exquis [Exquisite Corpse], 1925
pencil and coloured pencil on paper
27.7 × 21.0 cm
Collection of David and Marcel Fleiss, Galerie 1900–2000, Paris

TLINGIT

Mask, c. 1820–40
wood (cedar), paint, metal, leather
27.0 × 18.7 × 10.2 cm
The Metropolitan Museum of Art, The Michael C. Rockefeller Memorial Collection, Bequest of Nelson A. Rockefeller, 1979
Image © The Metropolitan Museum of Art/Art Resource, NY
Formerly Wolfgang Paalen Collection
(page 250)

Amulet, 1820–50
ivory
9.9 × 5.4 × 2.2 cm
The Metropolitan Museum of Art, The Michael C. Rockefeller Memorial Collection, Bequest of Nelson A. Rockefeller, 1979
Image © The Metropolitan Museum of Art/Art Resource, NY
Formerly Wolfgang Paalen Collection
(page 260)

Headdress Finial, c. 1840
wood, paint, human hair and abalone shell
22.9 × 1.9 × 10.0 cm
Courtesy of Donald Ellis Gallery, Dundas, ON and New York, NY
(page 244)

TSIMSHIAN

Statue de chaman [Statue of a Shaman], early 20th century
weathered wood, painted deer skin, leather, bear claws, mole fur, copper, fox teeth
82.0 × 32.0 × 32.0 cm
Musée du Quai Branly, Paris (71.1951.35.2)
Photo: Musée du Quai Branly/SCALA/Art Resource, NY
Formerly Claude Lévi-Strauss Collection
(page 247)

TZARA, TRISTAN, PAUL ÉLUARD AND NUSCH ÉLUARD

Cadavre exquis [Exquisite Corpse], 1931
coloured pencil on black paper
32.0 × 23.5 cm
Collection of David and Marcel Fleiss, Galerie 1900–2000, Paris

TZARA, TRISTAN, VALENTINE HUGO AND ANDRÉ BRETON

Cadavre exquis [Exquisite Corpse], c. 1930
coloured chalks on black construction paper
30.5 × 23.8 cm
Collection of Timothy Baum, New York
© Estate of Valentine Hugo/ SODRAC (2011)
© Estate of André Breton/ SODRAC (2011)
(page 159)

UBAC, RAOUL

Affichez vos poèmes/Affichez vos images [Post your Poems/Post your Images], 1935
offset lithograph
26.4 × 33.0 cm
San Francisco Museum of Modern Art, Purchase through gifts of Tony Hooker and K.C. Chiang and Joseph B. Hershenson

Untitled [variation of *Les vases communicants*], 1937, printed 1980s
collotype
39.2 × 25.0 cm
San Francisco Museum of Modern Art, Funds of the 80s purchase
© Estate of Raoul Ubac/ SODRAC (2011)
(page 300)

UMBO (OTTO UMBEHR)

Untitled, 1928
gelatin silver print
29.6 × 20.9 cm
The Art Institute of Chicago, Julien Levy Collection, Gift of Jean and Julien Levy

VAIL, LAURENCE

Perfect Lady, 1942
collaged bottle
35.8 × 8.0 × 8.0 cm
Collection of Timothy Baum, New York
© The Estate of Laurence Vail (2001)
(page 150)

VARO, REMEDIOS, FLORA ACKER, ADOLPHE ACKER AND GEORGES MOUTON

Dessin communiqué [Transmitted Drawing], c. 1937–39
pencil and ink on paper [recto verso]
27.0 × 22.0 cm

Collection of David and Marcel Fleiss, Galerie 1900–2000, Paris

YUP'IK

Complex Mask, c. 1890–1905
wood, pigments, sinew, vegetal fibre, cotton thread, replaced feathers
86.4 × 50.8 × 25.4 cm
Private Collection, Courtesy of Donald Ellis Gallery, Dundas, ON and New York, NY
Formerly Enrico Donati Collection
(page 8)

Mask, c. 1890–1910
wood, feathers, vegetal fibres, black, white, blue-green and red pigments
58.4 × 50.5 × 9.5 cm
Courtesy of Donald Ellis Gallery, Dundas, ON and New York, NY
Formerly Robert Lebel Collection

Complex Mask, late 19th century
wood, feathers and white and red pigments
106.7 × 96.5 × 30.0 cm
Collection of Susan and Leonard Feinstein
Formerly Enrico Donati Collection
(page 243)

Mask, 19th century
wood, ochre, red, black and white paint
29.0 × 13.0 cm
Private Collection, Courtesy of Donald Ellis Gallery, Dundas, ON and New York, NY
Formerly Robert Lebel Collection
(page 236)

Mask, 19th century
wood, feather, leather, ochre, red and white paint
20.0 × 14.0 cm

Private Collection, Courtesy of Donald Ellis Gallery, Dundas, ON and New York, NY
Formerly Robert Lebel Collection
(page 257)

ZÜRN, UNICA

Untitled, 1956
ink and gouache on paper (torn drawing reassembled by Hans Bellmer)
24.1 × 18.4 cm
Ubu Gallery, New York & Galerie Berinson, Berlin
© Brinkmann & Bose Publisher, Berlin (1998)
(page 290)

Untitled, 1957
oil on paper mounted on wood
40.9 × 30.8 cm
Ubu Gallery, New York & Galerie Berinson, Berlin
© Brinkmann & Bose Publisher, Berlin (1998)
(page 291)

CATALOGUES AND PERIODICALS

Dyn, nos. 4 and 5, Dec. 1943
28.5 × 22.4 cm
Collection of Timothy Baum, New York
© Wittenborn Art Books, San Francisco, www.art-books.com
(page 233)

Exposition internationale du surréalisme, Galerie des Beaux-Arts, 1938
23.8 × 15.4 cm
Collection of Timothy Baum, New York

La peinture surréaliste, Galerie Pierre Collé, 1925
14.0 × 10.7 cm
Collection of Timothy Baum, New York

La révolution surréaliste, Paris, nos. 1, 4, 12, Dec. 1924, July 1925, Dec. 1929
29.3 × 20.0 cm

Collection of Timothy Baum, New York
(page 24)

Le surréalisme au service de la révolution, Paris no. 3, 1931
27.5 × 19.0 cm
Collection of Timothy Baum, New York

Minotaure, Paris, nos. 1–13, 1933–39
32.0 × 25.0 cm
Collection of Timothy Baum, New York
(pages 43, 45, 170, 223)

Tableaux de Man Ray et les objets des îles, April 1926
24.0 × 15.7 cm
Collection of Timothy Baum, New York
(page 31)

Tanguy et Objets d'Amérique, Galerie surréaliste, 1927
18.2 × 13.8 cm
Collection of Timothy Baum, New York
(page 32)

VVV, New York, nos. 2 and 3, 1943
28.0 × 22.0 × 3.3 cm
Collection of Timothy Baum, New York

FILMS

Borowczyk, Walerian and Chris Marker
Les Astronautes, 1959
35 mm film, colour
12 minutes
© 1959 Argos Film

Buñuel, Luis
Le Fantôme de la liberté (trailer) [The Phantom of Liberty], 1974
35 mm film, colour
3 minutes, 13 seconds

Buñuel, Luis and Salvador Dalí
L'âge d'or [Age of Gold], 1930
35 mm film, black and white
60 minutes
Kino International

Buñuel, Luis and
Salvador Dalí
Un chien andalou [An
Andalusian Dog], 1929
35 mm film, black and white
16 minutes

Chapdelaine, Gérard
*Le sel de la semaine (entretien
de André Breton et Judith
Jasmin)*, 1961
film, black and white
25 minutes, 40 seconds
Les Archives de Radio-Canada

Chapdelaine, Gérard
*Rushes non montés de la
camera (entretien de André
Breton et Judith Jasmin)*,
1961
film, black and white
1 minute, 40 seconds
Les Archives de Radio-Canada

Chaplin, Charlie
A Day's Pleasure, 1919
35 mm film, black and white
19 minutes
Janus Films

Cornell, Joseph
Rose Hobart, 1936
16 mm film, colour
18 minutes, 42 seconds
Rights Courtesy The
Museum of Modern Art

Freddie, Wilhelm and
Jørgen Roos
*Det definitive afslag på
anmodningen om et kys*
[Definitive Refusal of a Kiss],
1949
film, black and white

1 minute, 48 seconds
Courtesy Birger Raben-Skov

Fleischer, Dave
Bimbo's Initiation, 1931
animated film, black and white
6 minutes, 27 seconds

Fleischer, Dave
Betty in Blunderland, 1934
animated film, black and white
6 minutes, 40 seconds

Keaton, Buster and
Edward F. Cline
One Week, 1920
35 mm film, black and white
19 minutes
The Rohauer Collection/
Douris UK Ltd.
(In Administration)

Man Ray
Retour à la raison [Return
to Reason], 1923
film, black and white
2 minutes, 51 seconds
The Rohauer Collection/
Douris UK Ltd.
(In Administration)

Man Ray
Emak-Bakia [Leave me alone],
1926
35 mm film, black and white
18 minutes
The Rohauer Collection/
Douris UK Ltd.
(In Administration)

Man Ray
L'étoile de mer [The Starfish],
1928
35 mm film, black and white

15 minutes, 35 seconds
The Rohauer Collection/
Douris UK Ltd.
(In Administration)

McLaren, Norman
*A Little Phantasy on a Nine-
teenth Century Painting*, 1946
animated film, black and white
3 minutes, 37 seconds
National Film Board of Canada

Méliès, Georges
Le Voyage dans la lune
[A Trip to the Moon], 1902
35 mm film, black and white
14 minutes

Moerman, Ernst
Monsieur Fantômas, 1937
film, black and white
17 minutes, 27 seconds

Murnau, F.W.
*Nosferatu: Eine Symphonie
des Grauens* [Nosferatu:
A Symphony of Horror], 1922
35 mm film, black and white
94 minutes
Kino International

Painlevé, Jean
Crabes et crevettes [Crabs
and Shrimps], 1929
35 mm film, black and white
14 minutes
© Les Documents
Cinématographiques

Prévert, Pierre
Paris la belle [Paris the
Beautiful], 1960
35 mm film, black and white
and colour

24 minutes
© 1959 Argos Film

Richter, Hans
Vormittagsspuk [Ghosts
before Breakfast], 1928
35 mm film, black and white
8 minutes, 45 seconds
Art acquest

Richter, Hans with Max Ernst
Desire from *Dreams that
Money can Buy*, 1947
16 mm film, colour
99 minutes
Art acquest

Storck, Henri
Sur les bords de la camera [On
the Edges of the Camera], 1932
35 mm film, black and white
10 minutes, 45 seconds
Fonds Henri Storck

Švankmajer, Jan
Historia Naturæ, Suita
[Natural History, Suite], 1967
animated film, colour
8 minutes, 38 seconds
Krátký Film Praha

Švankmajer, Jan
Do pivnice [Down to the
Cellar], 1983
35 mm film, colour
15 minutes
© Slovak Film Institute

Zimbacca, Michel and
Jean-Louis Bédouin
L'invention du monde, 1952
film, black and white
24 minutes, 35 seconds
© Choses Vues 2010

ACKNOWLEDGEMENTS

This exhibition is the result of a remarkable collaboration between the staff of the Vancouver Art Gallery, a number of committed private collectors and a large group of very generous colleagues at museums and galleries around the world. Kathleen Bartels, director of the Gallery, had the excellent idea to organize a major exhibition on Surrealism. We are indebted to her for her ambitious vision and for being an unequivocal champion of the exhibition.

We extend our gratitude to all the staff members who made heroic efforts to bring this project to fruition. Daina Augaitis deserves recognition first of all, for her extraordinary generosity and tireless advice and encouragement throughout the years of the project's gestation. With impressive skill and diplomacy, Emmy Lee coordinated the demanding array of details related to the loans and installation. Jenny Wilson faced the daunting challenges of registration with her usual exacting standards and good cheer, while Bruce Wiedrick superbly managed the administration aspects of the project and coordinated the planning process. With clarity and vigour, Kimberly Phillips wrote the interpretive materials, which contribute enormously to the visitor's understanding of Surrealism. Glen Flanderka, Rory Gylander and the entire Preparations staff oversaw all aspects of installing this complex exhibition with skill, patience and good will. Wade Thomas and Susan Perrigo displayed creativity and ingenuity in developing the extensive graphics and audiovisual components of the exhibition. Monica Smith and Kathy Bond lent their conservation expertise in dealing with the exceptional array of loans, and Kristin Fung assisted the curatorial team with a myriad of administrative details.

Others at the Gallery who deserve our thanks are Paul Larocque and the Finance/Administration staff; Tom Meighan and the Security/Visitor Services staff; Heidi Reitmaier and the Public Programs staff; Jessica Bouchard, Scott Elliott and the staff of the Development department; Dana Sullivant and the Marketing staff; Suzana Barton and the staff in the Gallery Store; Debra Nesbitt and the Human Resources department; and Deborah Lagueux in the director's office.

Karen Love organized the mammoth undertaking of this book — the Gallery's largest to date — with courage, dedication and considerable aplomb. Trevor Mills, Rachel Topham and Danielle Currie provided excellent oversight of photography, image management and rights and reproduction issues for the publication.

We would like to recognize a number of talented individuals from outside the Gallery. An impressive group of scholars, in addition to Dawn Ades, has contributed to this book: Quentin Bajac; Timothy Baum; Colin Browne; Whitney Chadwick; Robert Houle; Sharon-Michi Kusunoki; Yves Le Fur; David Lomas; Marie Mauzé; Andreas Neufert; Michael Richardson; Anthony Shelton; and Anne Umland. We are indebted to all of them for their insight and their perspectives on various aspects of Surrealism. We extend sincere thanks to Judith Penner, who contributed astute editing of the texts, and to Mark Timmings, who created the elegant book design; both harnessed unparalleled resourcefulness in completing this publication. We were very fortunate to work with Darren Carcary and Kirsti Wakelin of Resolve Design. The sophisticated installation design created for the exhibition by this highly-talented team provides a richly nuanced setting in which to view these superb works of art. We would also like to recognize, with special thanks, Stephanie Forsythe and Todd MacAllen at molo design, ltd., who generously provided the Gallery with a number of the company's spectacular products that were used to great effect in the installation. Our thanks go to Donna Roberts and Tomas Sharman for their early work on the project. We wish to express our appreciation to Kathleen Hill for her unfailing cooperation on securing several object loans. We also want to recognize Marc Porter, Allison Whiting and Vanessa Fusco at Christie's for their valuable assistance.

We extend our gratitude to Bill McLennan, Colin Browne, Charlotte Townsend-Gault and Lyle Wilson

for their very helpful advice regarding interpretation of the First Nations art in this exhibition. Their input regarding the cultural significance of these works was illuminating and very much appreciated.

To all of the lenders who responded so generously to our requests we would like to offer special thanks. Without their enthusiastic responses to our requests, this show would, of course, not have been possible. We are thankful for the opportunity to exhibit their stunning works of art in Vancouver. In particular we would like to recognize the enormous contribution of Timothy Baum, who shared numerous loans as well as his passionate knowledge of Surrealism. Donald Ellis not only lent generously to the exhibition but also provided invaluable advice related to the spectacular pieces of indigenous art of the Pacific Northwest owned by surrealist artists. We would also like to offer special thanks to Marc Quaghebeur, Laurence Pieropan and Marc Trivier at the Archives & Musée de la Littérature; Matthew Teitelbaum at the Art Gallery of Ontario; James Cuno, Stephanie D'Allesandro and Matthew Witkovsky at the Art Institute of Chicago; Michael Audain and Yoshiko Karasawa; Doreen Bolger, Rena Hoisington, Katy Rothkopf and Steven Mann at the Baltimore Museum of Art; André Baum; Karen Amiel Baum; Madame Antonin Besse; Marie-Dominique Nobécourt Mutarelli at Chancellerie des Universités de Paris – Bibliothèque littéraire Jacques Doucet; Neil MacGregor, Antony Griffiths, Stephen Coppel and Jonathan King at the British Museum; Alfred Pacquement, Agnès Saal and Quentin Bajac at Centre Pompidou; Wendy Williams at the Louise Bourgeois Studio; John Cheim, Howard Read and Maria Bueno at Cheim & Read; Griffith Mann at the Cleveland Museum of Art; Bonnie Pitman and Heather MacDonald at the Dallas Museum of Art; Adele Donati; Richard L. Feigen and Frances Beatty at Richard L. Feigen & Co.; Clo and Marcel Fleiss; David Fleiss, Marcel Fleiss and Rodica Sibleyras at Galerie 1900–2000; Raman Frey, Wendi Norris and Melissa Bernabei at Frey Norris Contemporary & Modern; Judith Keller at the J. Paul Getty Museum; Richard Armstrong and Susan Davidson at the Solomon R. Guggenheim Museum; Richard Koshalek and Valerie Fletcher at the Hirshhorn Museum and Sculpture Garden; James Snyder and Tanya Sirakovich at The Israel Museum;

Sharon-Michi Kusunoki at The Edward James Foundation; Val Nelson at Jersey Heritage Collection; Aimee and Robert Lehrman at The Robert Lehrman Art Trust; Fariba Bogzaran at Lucid Art Foundation; Conrad, Herbert and Virginia Lust; Harry and Ann Malcolmson; Mary-Anne Martin at Mary-Anne Martin Fine Art; Alessandra Carnielli at the Pierre and Tana Matisse Foundation Collection; James Mayor and Christine Hourdé at The Mayor Gallery; Josef Helfenstein and Clare Elliott at The Menil Collection; Thomas Campbell, Malcolm Daniel, Julie Jones and Gary Tinterow at The Metropolitan Museum of Art; Antony Penrose and Ami Bouhassane at Lee Miller Archives; Daniel Keegan and Brady Roberts at the Milwaukee Art Museum; Lars Nittve and Iris Müller-Westermann at Moderna Museet; Yves Le Fur at the Musée du Quai Branly; Manuel Borja-Villel and Rosario Peiró Carrasco at Museo Nacional Centro de Arte Reina Sofia; Guillermo Solana at Museo Thyssen-Bornemisza; Anthony Shelton and Bill McLennan at the Museum of Anthropology, Vancouver; Sjarel Ex and Margreet Wafelbakker at Museum Boijmans Van Beuningen; Anne Umland and Connie Butler at The Museum of Modern Art; Harry Cooper at the National Gallery of Art and Lamia Doumato at the National Gallery of Art Library, Washington; Marc Mayer at the National Gallery of Canada; Francis Naumann at Francis M. Naumann Fine Art; Michael Taylor and Peter Barberie at the Philadelphia Museum of Art; Neal Benezra, Ruth Berson, Sandra Phillips and Gary Garrels at the San Francisco Museum of Modern Art; Simon Groom and Patrick Elliott at the Scottish National Gallery of Modern Art; Derrick Cartwright and Marisa Sánchez at the Seattle Art Museum; Michael and Judy Steinhardt; Nicholas Serota and Matthew Gale at the Tate; Carmen Thyssen-Bornemisza; Adam Boxer, Heinrich Berinson and Caitlin Suarez at Ubu Gallery, New York & Galerie Berinson, Berlin; Karen Estrin at U'mista Cultural Society; Marietta Mitchell at University of Victoria Libraries; Linda Lloyd-Jones and Julius Bryant at the Victoria and Albert Museum; Rowland Weinstein and Jasmine Moorhead at Weinstein Gallery; Michael Wilson, Polly Fleury and Hope King at the Wilson Centre for Photography; and the private collectors who wish to remain anonymous.

We are extremely grateful for the participation and dedication of all of these individuals.

Thomas Padon, Assistant Director/Director of International Partnerships
Dawn Ades, Guest Curator

LENDERS TO THE EXHIBITION

Archives & Musée de la Littérature, Brussels

Art Gallery of Ontario, Toronto

The Art Institute of Chicago

Michael Audain and Yoshiko Karasawa, Vancouver

Baltimore Museum of Art

André Baum, New York

Karen Amiel Baum, New York

Timothy Baum, New York

Madame Antonin Besse

British Museum, London

Centre Pompidou, Paris, National Museum of Modern Art/Centre for Industrial Creation

Chancellerie des Universités de Paris — Bibliothèque littéraire Jacques Doucet, Paris

Cheim & Read

The Cleveland Museum of Art

Dallas Museum of Art

Adele Donati, New York

Donald Ellis Gallery, Dundas, ON and New York, NY

Richard L. Feigen & Co., New York

Richard L. Feigen, New York

Clo and Marcel Fleiss, Paris

David and Marcel Fleiss, Galerie 1900–2000, Paris

Frey Norris Contemporary & Modern, San Francisco

The J. Paul Getty Museum, Los Angeles

Solomon R. Guggenheim Museum, New York

Hauser & Wirth

Hirshhorn Museum and Sculpture Garden, Smithsonian Institution, Washington

The Israel Museum, Jerusalem

The Edward James Trust

Jersey Heritage Collection

The Robert Lehrman Art Trust, Collection of Aimee and Robert Lehrman, Washington, DC

Lucid Art Foundation, The Gordon Onslow Ford Collection, Inverness, CA

Conrad Lust, New York

Virginia Lust Gallery, New York

Harry and Ann Malcolmson

Pierre and Tana Matisse Foundation Collection

The Mayor Gallery, London

The Menil Collection, Houston

The Metropolitan Museum of Art, New York

Lee Miller Archives, Sussex, UK

Milwaukee Art Museum

Moderna Museet, Stockholm

Musée du Quai Branly, Paris

Museo Nacional Centro de Arte Reina Sofia, Madrid

Museo Thyssen-Bornemisza, Madrid

The Museum of Anthropology, The University of British Columbia, Vancouver

Museum Boijmans Van Beuningen, Rotterdam

The Museum of Modern Art, New York

National Gallery of Art Library, Washington

National Gallery of Art, Washington

National Gallery of Canada, Ottawa

Francis M. Naumann Fine Art, New York

Philadelphia Museum of Art

Private Collection, Courtesy of Timothy Baum, New York

Private Collection, Courtesy of Galerie 1900–2000, Paris

Private Collection, Courtesy of Mary-Anne Martin Fine Art, New York

Private Collection, Courtesy Ubu Gallery, New York & Galerie Berinson, Berlin

Private Collection, Germany

Private Collection, Paris

Private Collection, Vancouver

Private Collections, Courtesy of Donald Ellis Gallery, Dundas, ON and New York, NY

San Francisco Museum of Modern Art

Scottish National Gallery of Modern Art, Edinburgh

Seattle Art Museum

Michael and Judy Steinhardt, New York

Tate

Carmen Thyssen-Bornemisza

Ubu Gallery, New York & Galerie Berinson, Berlin

U'mista Cultural Society

University of Victoria Libraries, Victoria, BC

Vancouver Art Gallery

Victoria and Albert Museum, London

Rowland Weinstein, Courtesy of Weinstein Gallery, San Francisco

Wilson Centre for Photography, London

Published in conjunction with *The Colour of My Dreams: The Surrealist Revolution in Art*, an exhibition organized by the Vancouver Art Gallery, curated by Dawn Ades and presented May 28 to September 25, 2011.

Publication management: Karen Love,
Manager of Curatorial Affairs, Vancouver Art Gallery

Editing: Judith Penner

Cover and interior design: Mark Timmings,
Timmings & Debay Design

Digital image preparation: Trevor Mills, Rachel Topham,
Vancouver Art Gallery

Additional image preparation: Ernst Vegt,
Coast Imaging Arts Inc., New Westminster, BC

Rights and Reproductions: Danielle Currie,
Vancouver Art Gallery

Printed and bound in Canada by Friesens

IMAGE CREDITS

Cover: Joan Miró, *Photo: Ceci est la couleur de mes rêves* [Photo: This is the Colour of My Dreams], 1925 (detail), The Metropolitan Museum of Art, The Pierre and Maria-Gaetana Matisse Collection, 2002

Front endpapers: René Magritte, *L'anniversaire* [The Birthday], 1959 (detail), Art Gallery of Ontario, Toronto, Purchase, Corporations' Subscription Endowment, 1971; and

Claude Cahun, *Heure des fleurs* [The Hour of Flowers], 1936 (detail), Ubu Gallery, New York & Galerie Berinson, Berlin

Frontispiece: Kay Sage, *The Upper Side of the Sky*, 1944 (detail), The Israel Museum, Jerusalem, The Vera and Arturo Schwarz Collection of Dada and Surrealist Art in the Israel Museum

Title page: Paul Nougé, *Cils coupés* de *La subversion des images* [Cut Eyelashes from *The Subversion of Images*], 1929–30, printed by Marc Trivier, 1995, Courtesy of M. Trivier and Archives & Musée de la Littérature, Brussels

Back endpapers: Claude Cahun, *Heure des fleurs* [The Hour of Flowers], 1936 (detail), Ubu Gallery, New York & Galerie Berinson, Berlin; and

Brassaï, *Nude*, 1931–34 (detail), The Metropolitan Museum of Art, Twentieth Century Photography Fund, 2007

LIBRARY AND ARCHIVES CANADA CATALOGUING IN PUBLICATION

The colour of my dreams : the surrealist revolution in art / Dawn Ades, general editor.

ISBN 978-1-895442-87-8

1. Surrealism. 1. Ades, Dawn 11. Vancouver Art Gallery

N6494.S8C65 2011 709.04'063 C2011-902763-1

Distributed by Douglas & McIntyre
An imprint of D&M Publishers Inc.
2323 Quebec Street, Suite 201, Vancouver, BC, Canada V5T 4S7
www.douglas-mcintyre.com

The Vancouver Art Gallery is a not-for-profit organization supported by its members; individual donors; corporate funders; foundations; the City of Vancouver; the Province of British Columbia through the BC Arts Council and Gaming Revenues; the Canada Council for the Arts; and the Government of Canada through the Department of Canadian Heritage.

The Colour of My Dreams: The Surrealist Revolution in Art is supported by the Canada Travelling Exhibitions Indemnification Program of the Department of Canadian Heritage. It is also generously funded by:

Presenting Sponsor: Supporting Sponsor:

750 Hornby Street
Vancouver, BC, Canada V6Z 2H7
www.vanartgallery.bc.ca